**The
Compendium**

Pentagram

Thoughts, essays and work from the
Pentagram partners in London,
New York and San Francisco

Editor
David Gibbs

The Compendium

Pentagram
Design.

Φ

Phaidon Press Limited
140 Kensington Church Street
London W8 4BN

First published 1993
Reprinted 1993

© 1993 Phaidon Press Limited

ISBN 0 7148 2812 2

A CIP catalogue record for this book is
available from the British Library.

Design editor
David Hillman

Designer
Julie Fitzpatrick

Acknowledgements
Special thanks to Peter Wood, Nick Turner
and all the other photographers of
Pentagram's work, to Mary Alexander for the
original gathering and interviewing, to
Pentagram's archive staff in London, New
York and San Francisco for their continual
delving and delivering, to the Pentagram Mac
operators for their indulgence.

Text typeset in Monotype Baskerville.
Captions and sidebars typeset in Monotype
Baskerville Italic and Neue Helvetica.

Printed in Hong Kong

Part of Pentagram's enduring strength is its inherent capacity to respect and allow the differences between its partners. Whatever the incongruities between the individuals, there are two points of convergence: a common belief that design is fundamentally a process of ideas, and a mutual interest in an organization that serves them and their clients so well.

Pentagram gives coherence to the extraordinary array of attitudes and ideas of its partners; their different reputations, styles, egos, and personal and professional aspirations. So *The Compendium* becomes a definition of Pentagram itself: a single representation of seventeen designers in three cities.

The way *The Compendium* has been assembled also reflects Pentagram's own management practice. A democratic process defined the principles; then an increasingly autocratic, albeit consultative, process executed the compilation. Different styles, different ways of thinking, different ways of writing have not been homogenized. Under the general rules of the publisher's house-style, the idiomatic language and spelling of each contribution has been left alone according to whether it emanated from the USA or the UK – a mixture of expression that has been called 'Pentaspeak'.

The Compendium is not intended to be a comprehensive portfolio of Pentagram's design, but it does represent a good sample. Except in historical essays, the work selected has mostly appeared since *Living by Design,* Pentagram's last major representative book, published in 1978. The credits that accompany the illustrated work include names of partners, and anyone else who made a special or essential creative contribution: associates and designers from the partners' groups, and illustrators, artists, photographers, and other specialists from outside.

DAVID GIBBS
November 1992

10 **Foreword**	**Knowledge and method**	**Designers' thinking**
12 **About Pentagram**	25 **Introduction**	71 **Introduction**
	26 **Making faces** Beyond caricature	72 **The figurative wit** Puns, metaphors, clichés, analogies
	32 **Being paid to talk** Design consultancy	100 **Notes on design** Thoughts and views
	36 **Image as strategy** Graphic power	102 **Parody and Zeitgeist** Present from the past
	42 **Designed to be made** Product economics	110 **3-D thoughts** Designing products
	46 **From A to B** Making maps and diagrams	112 **Architect as art director** Artists for buildings
	56 **Measure for measure** Recreating the Globe Theatre	116 **Storytelling in pictures** Images as messages
	66 **Character development** Evolution of letters	122 **Reading between the lines** Interpreting the brief

Fields of work

127 **Introduction**

128 **Is it what it appears to be?**
Corporate identity

134 **Making marks**
Symbols and logotypes

142 **Where, what, how**
Signs

150 **Cover to cover**
Books

160 **The shop as product**
Stores

166 **All wrapped up**
Packaging

174 **Important doesn't have to
mean boring**
Corporate literature

182 **How to make a date**
Calendars

188 **The reader is always right**
Magazines

Client varieties

197 **Introduction**

198 **The client as patron**
Five visionaries

204 **Crossing cultures**
Outside the English-speaking world

210 **Instant international**
Polaroid Corporation

216 **Details aren't details**
Unilever House

222 **Talking to yourself**
Printers and papermakers

230 **Home from home**
Hotels

234 **Place settings**
Restaurants

242 **Design for art's sake**
Museums and galleries

254 **More than meets the eye**
The *Guardian*

260 **Minding our business**
The design industry

Pentagram and partners

271 **Introduction**

272 **Under cover**
Pentagram publications

282 **Out of thin air**
The designer as producer

290 **Distinguishing features**
Portraits and obsessions

298 **Index**

Foreword

RALPH CAPLAN

MY OWN FAVORITE FOREWORD TO A DESIGN book is the one Arthur Drexler wrote for George Nelson's *Problems of Design*. It begins, 'George Nelson is unique. He is an industrial designer with a sense of humor.' Drexler may have overstated the case somewhat. There were at the time several industrial designers with a sense of humor, and there must be at least a score of them now. Graphic designers however are a different story. Even in groups they tend to revel in the comic aspects of design life, as witness PushPin, M & Co, and Grapus. Pentagram, whose partners include an industrial designer and two architects (and once included George Nelson, who was both), is not unique in having a corporate sense of humor, but in having one that has survived their status as a major institution in the international design establishment.

Not that their work isn't serious. By a sense of humor I don't mean a capacity for creating, responding to, or re-packaging jokes. Rather I mean a way of looking at situations that keeps them in perspective. For it is perspective that permits the humor inherent in situations to be identified; and that is a serious business. Kingsley Amis writing about Peter De Vries (or maybe it was Peter de Vries writing about Kingsley Amis) remarked 'how funny, and therefore how serious, the work is'.

A paradox, but so is professional design. People whose training, and therefore whose view of the world, is rooted in art and craft hire themselves out as professional enhancers of business. People whose basic skill is drawing are propelled by that very skill into corporate boardrooms where the medium of choice is talk. People whose success is based on design talent are lifted by that very success to the management of design offices, where they have no time to design. People whose personal style is fiercely individual become responsible for the identities of mammoth impersonal corporations. People with very little formal education become major contributors to the world of historical exhibitions, the world of science museums, the world of art galleries, the world of publications, the world. People whose value to clients is lodged in their distance, their outside perspective, their differences, attract clients by pretending to be, or in some cases actually becoming, just like them.

The authors of this book cope with these seeming contradictions through an organization as paradoxical as the profession in which they happily find themselves. Because no designer can work alone on projects of contemporary scale and complexity, design practice today is almost invariably collaborative, with work distributed unequally among associates and partners. Although design partnerships imply the sacrifice of stardom (only so many names can fit on a door unless it's the door of a law office), Pentagram is a veritable federation of stars, combining bigness – by design office standards – with individual distinction and even celebrity.

Despite the firm's size and global presence, the partners operate as if they were independent designers or the heads of small design offices. The misnomer Pentagram is a fact of design life, although there are now many more partners than five. They are different enough in personality, and perhaps even in character, that it is hard to imagine any of them subordinating autonomy to the operation of a fairly large business. In fact, it isn't easy to imagine them sitting for long in the same room.

They do though, in regular meetings at which all the partners present what they are working on, much as the partners do at the beginning of each episode of *L A Law*. And, for all I know, with the same sort of conflicts, the same ultimate enjoyment in dealing with other people's problems. Design, after all, is a business to be enjoyed. The design process can be excruciatingly difficult and frustrating, but I have never worked on a project in which I have not at some point thought how nice it is to be paid for doing what we like to do.

The enjoyment of design is intrinsic to Pentagram. From its inception the firm had its own kitchen and dining room in London, and a first-rate cook – an arrangement that simultaneously extended the pleasure of the design process while addressing head-on one of the constant irritants of contemporary business life: where to eat. This is not irrelevant. For one thing, the way to a client's heart is sometimes through the stomach. More importantly, the way to a client's head is sometimes through the heart. How a design firm relates to its clients does not depend on such amenities as lunch, but it is reflected in the feel of an office. Here

again, a paradox. After years of working with graphic designers, I am struck by the proportion of meetings held in the designer's office, rather than the client's. Usually in a client-consultant relationship, your-place-or-mine? is a question conventionally resolved in favor of power, which the client always has. You go the boss's office, he doesn't come to yours.

Except. Except in design projects, where clients pile into limos and corporate jets for early morning meetings with designers. Ostensibly they come because the artwork is in the design office. But artwork is portable, and designers are used to the indignity of lugging incredibly cumbersome carrying cases through the airport security and into cabs. Ostensibly they come because the model is there, but relatively few meetings require the presence of the model in the meeting room.

No, I think something else is going on. I think clients make the trip simply because designers' offices are more fun than their own. The walls are loaded with images. The work surfaces are loaded with playthings. It is a permissible return to childhood, permissible because this fairytale environment of pencils and paper and scissors and magic markers and rubber cement is part of real business. In that tradition, Pentagram's client meetings are usually held in their own offices, a pattern made understandable by the firm's extraordinary effectiveness in communicating. Since so much of design is communication, you might expect designers to be good at it. Don't. Many are not, especially when communicating about themselves and their work.

The more the practice of design changes, the more it stays the same in one respect: the difficulty of describing what designers do. There is, to be sure, no shortage of designer-generated literature directed to this end. As design offices grow increasingly competitive, the capability brochures issued in praise of their own services proliferate. So do the excruciatingly clever announcements (we're moving, we've moved, we have acquired a new partner, a new account, a new fax machine, we wish you a merry Christmas) that swell the class of literature that is not good enough to keep but looks too good to throw away immediately. These often are stunning examples of graphic technology, but tend to be as dull as the capability brochures and annual reports that the same designers prepare for their clients. And for the same reason: they begin with the question 'What is the message?' instead of 'Where is the interest?'

That's why the literature a design firm sends out may be the least important thing about them, and at best is an unreliable guide to what they do and how well they do it. This is not an argument for more market research into what readers of promotional literature want. (Chances are, what they want is not to be sent promotional literature.) But promotional literature is most compelling when the approach to it is editorial, based on the premise that readers will be interested in what the writers are interested in. To work from an editorial approach is to distinguish between having something to sell and having something to say.

It is a distinction that Pentagram appears to make quite naturally. The firm publishes more material than any other design office I know of, all of it charged with the conviction that it is interesting to the Pentagram partners. This does not necessarily mean that you and I will be interested in it, but it tilts the odds that way.

Although they have produced book-length books, four editions of a designer's travel guide called *Feedback,* and several pint-sized presentations of their work, Pentagram's publishing staple for years has been the *Pentagram Papers,* a series of casual publications promising 'examples of curious, entertaining, stimulating, provocative and occasionally controversial points of view'. In general they make good on that promise. Modestly handsome, mostly black and white, written with a comfortable intelligence, the *Pentagram Papers* are refreshingly unpretentious both in substance and execution.

Most refreshing of all, they betoken the engaged mind, suggesting that what matters to, and about, these designers is the quality of their thinking. Their subjects include brushes (for shoes, teeth, floors, tennis balls, and the necks of champagne bottles), Mao buttons, American flags, accidentally anthropomorphic product design, graphic clichés. The quirky diversity of these publications is a reflection of the diversity of Pentagram's own practice, which also has no single style.

The Compendium meets all the criteria of the other Pentagram publications. Its table of contents is an index to the kinds of things designers care about. What they care about is the difference between looking and seeing, the nature of storytelling, collaboration, the problems of bigness. What they care about, in other words, is, broadly understood, the business they are in. Instead of cataloguing Pentagram's multifarious projects, they use selected projects to illustrate the variety of premises from which design problems can be approached. In the process, they show us something of what it means to practice design today, and like it.

Ralph Caplan is a writer and communications consultant in New York. He is author of *By Design* and *The Design of Herman Miller*, and writes 'Counterpoint', a regular column in *International Design* magazine.

About Pentagram

COLIN FORBES

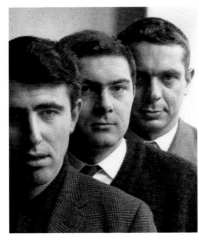

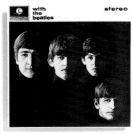

Bob Gill, Alan Fletcher and Colin Forbes were photographed for Vogue *by Robert Freeman soon after they started working together in 1962. Freeman liked the composition so much he used it again for his famous record cover shot of the Beatles.*

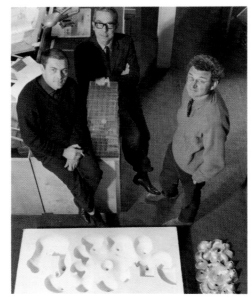

Alan Fletcher, Colin Forbes and Theo Crosby with interior models of the British Pavilion for Expo 67 in Montreal.

We are a group of seventeen partners operating in three cities – London, New York and San Francisco. Our partnership works well. It is financially secure. It has an international reputation, and most worth while of all, we enjoy what we do. One of the tribulations of success is that we are regularly asked questions about how it happened. Luckily they are often simple ones: How did you begin? How do you get work? How do you divide the work? How do creative people manage to get on with each other?

My story begins in London in 1962 when Alan Fletcher, Bob Gill and I formed the graphic design consultancy Fletcher, Forbes and Gill. We were individual freelance designers; Alan and I are British, Bob is American. We felt that we could present a better face to business as a partnership than as individuals. It was a very important period for graphic design and we did one or two things that most designers, certainly in England, didn't do: we invested in our offices, albeit modestly, and we invested in self-promotion.

We all began with much the same background – modest living standards, not much to lose, odd freelance jobs, underpaid employees of other designers, some part-time teaching. By the time we started we had individual freelance practice in common. Gradually we had each built our reputations, generating work by our own efforts, then implementing it to a standard that at least led to another job. With any luck, we finished each year solvent. These are the necessary skills that make for being a good partner.

Timing affects the formation of business. Age is also very important and the three of us were the perfect age, in our early thirties. Everything was right. The year 1962 in England was a very special one. I am talking about the coming of the Beatles, John Osborne, Kingsley Amis, and Mary Quant. There was an enormous amount of creative activity then. We were children during the war, but we were mostly protected from the horrors of it. Ours was a fresh generation. There was a cultural revolution in England of which we were a part, and the market for graphic design was growing rapidly.

After we had been in business for two or three years and were in some ways more successful than we had hoped, we looked at the business and decided that we were doing something wrong. Half of our business was troubleshooting for advertising agencies. These were jobs that came to us when an agency was in danger of losing an account or wanting to gain an account or something of the kind. They would typically come in on a Friday and want the job by Monday. We were being used as a 'hot shop' to build somebody else's business. So we took a hard look at ourselves and asked whether we should be an advertising agency or a design firm, as we knew that they were really two different businesses. Since we had neither the interest nor the skills to be an advertising agency, we decided that we ought to move more into the mainstream of design.

At that time we were working on the graphics for an exhibition in Milan in collaboration with an architect, Theo Crosby, who was also the exhibition convener. We knew that the skills of graphic designers and three-dimensional

designers or architects are often needed in combination, as, for example, in exhibitions. We also reasoned that anybody who needed a letterhead also had some kind of environment, whether a showroom, an office, a shop, or whatever. We got on extremely well with Theo and decided to join forces. Two large multidisciplinary consultancy projects followed – Cunard and British Petroleum.

The BP project included the design of service stations for the 1970s and we approached product designer Kenneth Grange to help us develop the pump equipment. The success of this project led to conversations with Kenneth about joining together in the partnership.

Kenneth had built a practice specializing in product design but, like ourselves, he had turned his hand to any commission from murals to interiors and exhibitions. Through this latter, the single biggest opportunity in his life came from criticizing the cameras in a display he was arranging. He was overheard by the sales director of Kodak, who gave him what every designer needs: the chance to design a camera and subsequently a long-term consultancy. We had first met him when he sat on the client's side of the table for Kodak to interview different graphic teams.

By this time, Bob Gill had left and we were using the names Crosby/Fletcher/Forbes, but Mervyn Kurlansky had joined us to help with our increasing load of graphic design projects for Rank Xerox, Reuters and Roche. Mervyn, a South African, had been art director for Knoll International and ran his own practice in London. We decided that we needed a new name, and after much discussion and thumbing through a thesaurus, Alan found the name Pentagram in a book on witchcraft!

The formation of Pentagram was a major event in the business. Looking back to 1972 when Pentagram was founded, I like the way Michael McNay, writing in the British magazine *Design*, described the origins of the group.

The 1964 Pirelli Calendar: design and art direction by Colin Forbes and photography by Peter Knapp.

The design project for BP established collaboration between Crosby/Fletcher/Forbes and Kenneth Grange.

13

Crosby/Fletcher/Forbes knew they had arrived when they could afford to run a Xerox machine. Not much of an event maybe, for men whose credo announces that their ambition is to be universal men; but as the world goes, a banner hoisted. Actually the Crosby/Fletcher/Forbes triangle has become a five-sided figure: Crosby/Fletcher/Forbes/Kurlansky/Grange, thankfully to be referred to hereafter as Pentagram. The principal significance of the switch is that it marks the merger of the CFF organization with that of Kenneth Grange: he is the industrial designer who designed the Kenwood food mixer and the Kodak Instamatic. Up to now CFF has made its reputation principally on graphic and architectural design and the areas where the two overlap: exhibition design, working out corporate identities from letterheads to brand names, and images on the sides of petrol tankers or transatlantic liners.

That new name cost them as much effort as designing the industry section for Britain at Expo 67 and the observation lounge of the QE2 put together. They came up with options like Building, Industrial, and Graphic Design (BIG D). Too jokey. Then Grand Union (the canal runs behind the office). Not jokey enough for Continental clients, who sensed something either political or just very large. Regretfully the partnership settled for Greek roots: Pentagram at least is pronounceable all over the European market, and that's what the quinumvirate have their sights set on.

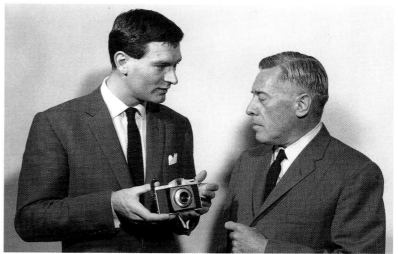

Kenneth Grange, left, designed the European version of the Kodak Instamatic camera in 1966; the US version came from Tod Clements, right, Head of Industrial Development at Eastman Kodak.

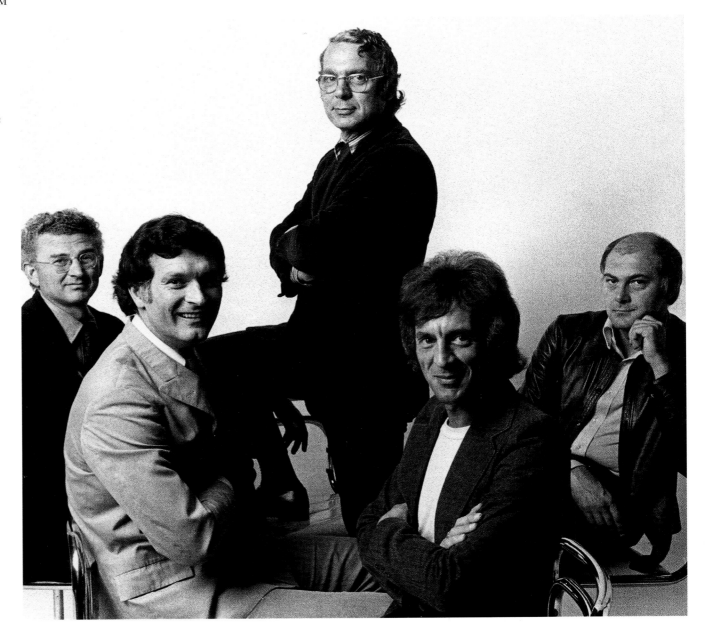

The founder members of Pentagram in 1972, left to right: Theo Crosby, Kenneth Grange, Colin Forbes, Mervyn Kurlansky, Alan Fletcher. Photograph by Donald Silverstein.

14

The question of the firm's size is a delicate one. The whole point of an organization in the first place was that looking ahead 20 years from 1962, Alan Fletcher and Colin Forbes dimly perceived that big companies would be more interested in dealing with other organizations than with freelancers. They were right, but even so Bob Gill, one of the original three partners, left when the firm began to swing into the middle of the stream. When Theo Crosby joined in 1965 he was involved in a project for Hereford town centre. Gill asked him when the first buildings would go up. 'About 1973,' Crosby said. 'That's a long time to have to wait for a proof,' Gill said, and shortly after departed.

All the partners who joined since the original coterie of Fletcher Forbes Gill have very similar war stories to tell of how they established their practices.

The advantage that has arisen from our partnership is the freedom of owning one's own business combined with the security of belonging to a stronger unit. The intention was to set up an organization which would enable an individual to work for a group yet still establish his own identity. Working together enables the partners to cover the ground faster and to draw on the 'strength in numbers', but the major difference from most other design firms is that, however the work is split, the partners are equal.

The equality issue was a founding principle of the partnership and it was therefore decided early on that any prospective partner must already have established a reputation in his or her own right and should also have had the experience of running a viable business. Equality between partners is considered

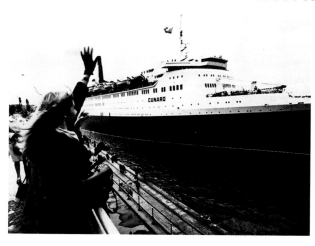

fundamental because it is felt that no one can really judge the true value of an individual's contribution – being able to say the right thing at the right time or to make the right move can make all the difference to a project. Bob Gill expressed it well when he said, 'How can you possibly equate those different contributions in terms of money when the client is an old school friend of Colin's, the work is carried out by Alan, but was transformed into a gold medal winner in the later stages by a casual conversation with me?'

A new identity was designed for Cunard to coincide with the introduction of the QE2.

All of us recognize the important practical advantages of being a multi-disciplinary partnership, but we also emphasize the equally important psychological reasons for this pattern. Like all designers, each of us was a prisoner of the specialization in which he was trained. Our body of knowledge was small and our awareness of what else there was to know was correspondingly small. Luckily we were the kind of people who wanted to learn, so it was inevitable that each of us should begin to dabble in design areas for which we were certainly not trained. From the very beginning, we were attracted to a multi-disciplinary approach, as it made us more aware of how much there was to learn. Pentagram is therefore different from a consortium or loosely knit association of different skills put together to solve a problem. That often doesn't work because professional egos prevent constructive collaboration. Not that we, of course, are immune from the occasional collision of oversized egos.

Many writers and designers have identified our multi-disciplinary structure as a key feature of Pentagram's success. But although the multi-disciplinary approach is a reality at policy level, experience over the years has shown that this is limited at operational level. Multi-disciplinary discussions, briefings and reviews are productive and fruitful, but the business of getting the job done is so technically specialized that the work must be managed by a person skilled in that particular discipline. It is there that the dream turns to disillusion for the young student aspiring to be Renaissance Man.

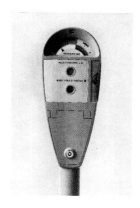

'If we have to have them, they may as well look good.' Kenneth Grange redesigned the American parking meter that appeared in Britain during the 1960s.

Being a partner represents something different and special for each member of the group. John McConnell always describes the partnership structure as 'being in a kind of perpetual think tank where there's a regular exchange of ideas around a table, and on a more impromptu basis, just walking around the studio and asking "David, have you got five minutes, can you help me?" or the unsolicited comment, "Why are you still mucking about with that?"' Whereas Alan usually emphasizes the benefits of a regular exchange of different views: 'It's very stimulating to work with people that you admire and respect, and to listen to their views of what you're doing – even if you don't take any notice. For me Pentagram has been the next logical dimension in the work that I do.'

Joining a larger group can also arouse fears about potential loss of identity and independence after being in individual freelance practice for some time. As Mervyn puts it, 'I knew I was joining a group with outstanding work and I knew that I would learn, but it was both challenging and daunting to join forces with the three heavyweights of the design industry. But, interestingly, after a while, a psychological shift takes place and you feel yourself to be part of Pentagram and no longer worrying about not being king of your own smaller outfit.' David Hillman, who joined Pentagram in 1978, stresses the importance for a designer of 'not being insular', adding that 'what keeps such a group of diverse individuals together is the personal growth that comes from being part of a club, and this growth develops from getting better at what you do.' Kenneth too, reflecting on his initial concern about loss of individual reputation, describes how he saw the partnership as 'a way of broadening my design experience...the corporate identity work that the graphics partners do has broadened my understanding of the

How to Play the Environment Game, *an exhibition conceived, written and designed by Theo Crosby, explored the nature and origin of environmental influences. It was held at London's Hayward Gallery in 1973. Poster by Alan Fletcher.*

16

Donna Muir's view of the studios in North Wharf Road, Pentagram's London home from 1972 to 1984.

'We the undersigned...', Colin Forbes' 1970 poster was a response to the UK government's intention of introducing charges for entry to museums and galleries.

companies I design products for. It's given me an insight into how they work, why they need a product and how they'll sell it.'

Individuality and self-reliance within a centralized organizational and financial structure – this is the unusual Pentagram combination. Perhaps it also helps to explain the diverse range of work within the group which defies a stylistic label. We believe the solution to a creative problem lies within the problem, and that there are many styles and many visual ways of solving that problem. We do not sell a single style. Therefore, each solution is unique to that particular problem. We also believe there is a synergy from being generalists. If you produce only one product, you devise a method and you design by method. In the short run, that may be very productive and profitable. But in the long run, it leads to stagnation.

Among design consultancy offices, the mixture of skills and strengths is never exactly the same. Some include market research; others, public relations; and there are those that act as print buyers or include large production studios. Pentagram knows its business is design. This is not perhaps as limiting as it seems. For one thing, it embraces most kinds of design activity in which its customers are likely to be involved: their products, their environments, their communication needs, and their corporate identities. For another, the design activity – its creative solution and its effective interpretation – is founded on a depth and range of work which is not commonly offered to an individual designer.

Nevertheless, we are often described as 'the designer's designer', and we warm to that expression for reasons which are more practical than egotistical. For it is certainly true that much of our business has come through the recommendation of somebody associated with design. We like it that way. If we ever had to define a market in order to go out and sell, it would list as chief targets those companies where, in addition to a design problem, there was also a senior manager inclined towards a creative solution.

A few years ago, Jenny Towndrow wrote an article for an Australian magazine, *Graphics World*, entitled 'Simply Pentagram', giving an outsider's view of the group's special characteristics. It provides a good insight of what we at least hope we are trying to achieve, and, although embarrassingly laudatory in parts, it highlights the aspects of our working environment that are important to us.

Just what is it that makes Pentagram so special? In the design community it is generally acknowledged that the Pentagram partners, in their different ways, are the very pinnacle of excellence. A survey in the *Financial Times* had them rated by their peers as the 'Rolls-Royce of Design' and as a New York graphic designer commented at the Aspen design conference last year, 'They really are the tops – there's no one like them.'

Being a self-confessed fan of Pentagram, their work and what they stand for, there was a fear that there would be a degree of difficulty in remaining impartial when profiling the partnership. However, when it came to it, there was a feeling of relish at being given the opportunity to look closely at this pre-eminent practice.

But where does one begin? In Pentagram's studio perhaps. It's a big barn of a place, open, airy; a lot of internal planting on a large scale, exposed brick with blonde sheet plywood partitioning, all

rather late '60s and craftsy in feeling; cosy. This is the work of architectural partner Theo Crosby who has also contributed an important collection of masks to grace the main conference room. There are lots of framed Pentagram graphic triumphs elsewhere. No other art on the walls apart from some historic ephemera in the comfortable eating area.

Upstairs is one vast open-plan studio with partners at their drawing boards cheek-by-jowl with their teams of bright young juniors. This is Pentagram's famous horizontal structure in action. And it works. There are no individual sealed-off offices to impede the interchange of ideas. Sometimes outsiders are invited into this creative arena, and can witness work in progress. I don't think Pentagram realize how rare this is today, when the usual form for a visitor to a design studio is to be given a slick slide presentation by a marketing man in a suit in an empty boardroom.

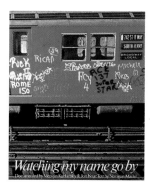

Watching my name go by, *Mervyn Kurlansky's study of New York graffiti, produced in collaboration with photographer Jon Narr; text by Norman Mailer. Published by Matthews Miller Dunbar, UK and USA, 1974.*

Individual freedom for partners is a central tenet of the Pentagram philosophy, and in order to achieve this, an extremely sophisticated series of checks and balances has been built into the group structure. It works on a 'freedom and blame' principle. At partners' meetings each partner must account for the profitability of each separate group although profit sharing is equal in each office. Each group is a profit center and is carefully monitored with a sophisticated accounting system. We are a commercial organization and the pressure to be more commercial could conflict with the demands of the quality of the work, but profit is only one of the criteria. Although the system is disciplined in terms of how the individual partner's activities are accounted for, its great strength is to provide freedom in day-to-day decisions and freedom from bureaucracy in negotiating such issues as staff salaries. The system ensures that these decisions will be reflected in partner profitability which is one of the measurements of performance. In a way, financial management has become easier rather than more difficult since Pentagram has grown. There are more likely to be confrontations between two partners; once twelve or more are involved, there is a forum of rationality.

John McConnell was designer for Biba, Barbara Hulanicki's archetypal Sixties fashion shop.

We have in our time tried and discarded different methods of working. We have eschewed teams that are put together to work on a specific project but include some members working on other projects at the same time. The failure here was always one of accountability. We eventually developed a system where each person in the office is responsible to only one of the partners and that partner is responsible for the job. He or she makes all the critical decisions with the client, works out a contract and generally supervises the entire project. The principle is simple – if something goes wrong it has to be somebody's fault. It ensures that we meet our promises and our deadlines. Most of us divide our own groups into smaller groups or teams and each of us supervises two or three senior designers. Then there is another level below that, of assistant or junior designer.

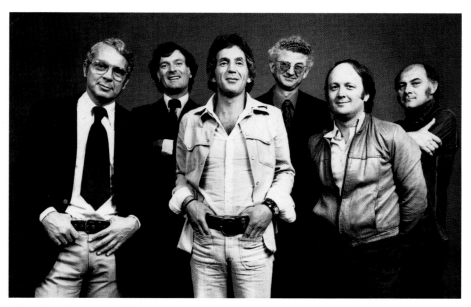

John McConnell (second from right) became a Pentagram partner in 1974.

Each new client who comes to Pentagram is seen directly by a partner, often accompanied by a project coordinator. A partner is also responsible for

David Hillman was art director and deputy editor of Nova *for seven years in the 1970s.*

Peter Harrison's 1968 design for American Export Lines was inspired by second world war marine camouflage. The program transformed the Independence *from a transatlantic liner to a cruise ship, using little more than paint and upholstery.*

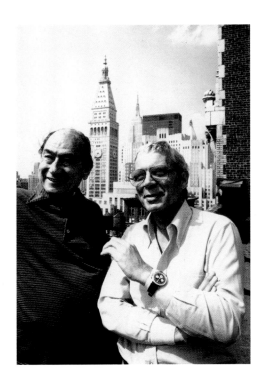

Colin Forbes and George Nelson in New York, 1978.

presenting the job to the client with a member of the design team. We see this as a critical incentive for quality. It also keeps us in constant direct contact with design work which is essential for personal creative renewal and development. Prospective clients often come to Pentagram because of a previous association or the reputation of a particular partner. Sometimes the inquiry is impersonal, but after a meeting with more than one of us, it is usually obvious where the rapport lies and we leave it that way. There is also a certain amount of natural selection in this process. If a partner is really overburdened, he won't be around to talk about prospective business. Whichever partner eventually works on the project, major projects are discussed and shared between the contact partner and other members of the group in that office, and frequently with our other offices. The flexibility of this arrangement benefits the client but is dependent on the collective commitment of the partners to make collaborative designing work. Outsiders are often intrigued by this aspect of willing collaboration between such a cast of individualistic creative characters. Writing in the Swiss

magazine *Graphis*, designer Henry Wolf has described our arrangement as 'kaleidoscopic', encouraging a changing cast of characters and deterring sameness, 'unlike the imperial plan where one talent dictates an overall style'.

Partners' meetings have always been a very important part of the fabric of Pentagram, but even more so now with offices in London, New York and San Francisco. These meetings perform a dual role of determining policy, and also of reinforcing creativity. All this is done by consensus – not an easy thing to do amongst a group of equals. Twice a year, all of us meet for a long weekend far away from the office in the depths of the countryside in Europe or the USA. Serious business is combined with a little fun and good food and, as Mervyn always emphasizes, 'it creates a situation which helps build friendships among us'. Formal business includes discussion of group profitability, international organization, forthcoming events including exhibitions and publications, and new projects which can be discussed in a relaxed open forum. More recently this has developed into a symposium where two or three of the partners are asked to make a major presentation from which they consider the other partners can learn. We have also started to invite outside experts to talk to us about a particular aspect of design or business. My description of these occasions must sometimes appear rather pompous, as was apparent in an interview with journalist Serge Barret in the French magazine *BAT* describing me as '*grand maître de la collegiale* Pentagram' and, in an aside to the reader, asking, '*Mais quelle est donc cette secte?*'

At these meetings we have come to understand the importance of separating operational decisions from policy decisions. The importance of this division cannot be over-emphasized, as we found that there was a natural human tendency to avoid the really important issues and to get sidetracked into detailed technical points on which it is often easier to make a decision; all elementary stuff for J. P. Sloan in *My Years at General Motors*, but hard lessons for us. We learned that you have to accept the fact that you shouldn't need to argue all the minor points if you were a party to the policy decision in the first place.

We have operations committees for finance, communications, and policy administration. An individual partner is designated one of these committees as his responsibility. These committees deal with all the routine problems, ranging from chasing debtors to deciding which material to send to *Communication Arts* magazine. When we meet at the partners' meeting as a policy committee, we try to discuss those things which are policy – including the quality of the work going out and what we should be doing in the next five years. This involves raising our

eyes to the blue skies for a long look at the future and casting them down for a good long session of introspective self-indulgence. Oddly enough, the mixture is a help. It satisfies our need for consensus, without which we would no longer be a partnership. Votes are anathema to us. We would rather drift together than set course with a minority voice. Everything is easy if you are always rational, adult and intelligent. Except that, like all entrepreneurial people, we are often irrational and childlike with only occasional flashes of insight or inspiration.

Growth and the maintenance of design quality raises very critical questions for us. The expansion of the partnership to New York back in 1978 was a major landmark. There were a number of reasons for it, some of them personal to me. I had always wanted to live in New York and had been absolutely mesmerized by the city during a visit twenty years earlier. I also felt that it would be wonderful to recreate the enthusiasm and energy of starting all over again. There were also several sound business reasons for becoming more trans-Atlantic. One, there is a lot of business in Europe for American companies. It seemed to us that we would have a better chance to get business in Europe if we had an American base. Secondly, fifty per cent of the Fortune 500 companies are located within the tri-state area (New York/New Jersey/Connecticut) – this has to be the biggest market for design services in the world. Thirdly, there is an international market for design. We were doing a couple of projects for Japanese firms in our London office at the time and we wanted to do more. Also, we had expected the European Common Market to be a good marketplace, but it had been a disappointment to us.

Pentagram New York started out in 1978 sharing space in George Nelson's offices. We had previously been friends and had collaborated years before on the international project for BP. Soon afterwards, I met Peter Harrison, an English graphic designer who had been living in the USA since 1957 and was running a small freelance practice from Fire Island, New York. Interestingly, Alan had sent me an issue of *Idea* magazine featuring Peter's work in an article on 'Emerging US Designers'. The timing was perfect. He wanted to broaden the scope of his design work and was becoming increasingly frustrated with the commute to Manhattan. Within twenty-four hours of my phone call asking if he would be interested in joining the partnership, he agreed. We planned our new office space together and were committed to creating a quality of environment similar to that of Pentagram in London. The scale of investment came as a shock to all of us, because for the first time we were making expansion plans on the assumption that business would follow.

In an interview entitled 'The Americanization of Pentagram', which appeared in New York's *Metropolis* magazine after the move, Patricia Leigh Brown reveals how we perceived our first phase of expansion and how our arrival was perceived by others at the time; for in retrospect there's no understating the risk as well as the challenge that was involved.

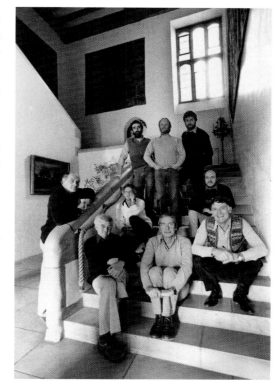

The 1980 partners' weekend was held at Leeds Castle in England. Standing, left to right: Alan Fletcher, David Hillman, John McConnell, Peter Harrison. Sitting, left to right: Theo Crosby, Mervyn Kurlansky, Colin Forbes, Ron Herron, Kenneth Grange.

From Mies van der Rohe to the Vignellis, influence from abroad has always profoundly affected design in the United States. And Americans, too, are seeking an increasingly visible presence in Europe. But due to the size of the American market and its intimidating reputation, no major European design firm had ever opened up a branch in this country until 1978, when Pentagram Design ventured forth from London to New York.

Pentagram's New York move has puzzled some observers. Colin Forbes, who orchestrated the move to what his partner Theo Crosby calls 'the most marvellous, romantic, squalid city in the world...the world's lint-filled navel' shrugged, 'People told me I was crazy to come

Photographer Bruce Davidson's views from Pentagram's New York office on Fifth Avenue became one of the Pentagram Papers.

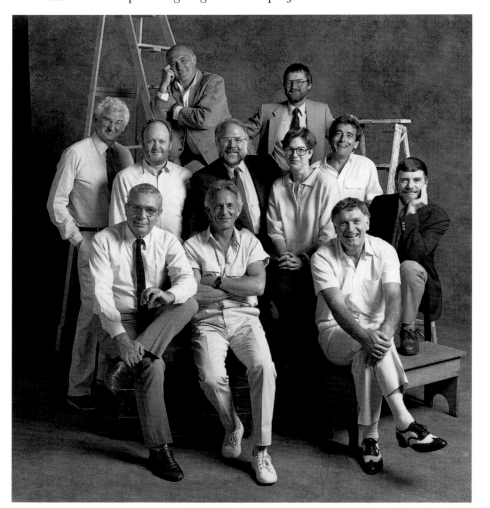

Kit Hinrichs' '49 Ford poster for the AIGA California Design Exhibition in 1983. Photograph by Terry Heffernan.

20

Neil Shakery became associate art director of Look *magazine in 1970.*

here. I'm out to prove them wrong.' Forbes is conducting his quiet assault on the New York market from a headquarters overlooking Madison Square which he shares with graphic design partner Peter Harrison, an Englishman who joined up after having lived in New York for twenty-five years.

As the new kid in town, Forbes is aiming to position Pentagram between what he considers to be two highly distinct groups: specialized 'business-oriented' design/marketing operations, such as New York's massive Lippincott & Margulies, and more traditional 'design-oriented' firms. 'There are design offices that are organized like advertising agencies, where design is a minor part of the process and the majority of principals are not designers,' he explains. 'Then you have another group of firms that are dominated by designers. We belong to that latter group, but we believe we can organize better in a managerial sense.'

Given the scale of the US market, Pentagram's biggest challenge undoubtedly lies in European 'generalists' breaking into what has become a rather specialized milieu, with its abundance of annual reports experts, *et al.* As an outsider looking in, Forbes is optimistic. After twenty years in which their dominance was eclipsed by in-house design departments, independent design consultants, he believes, are on the rise. It's now up to people like him to take these possibilities a step further, to convince big business to start incorporating designers into the initial planning stages of their projects.

The new San Francisco partners Kit and Linda Hinrichs (centre), and Neil Shakery (back right) photographed with the others in 1986 by John Blaustein.

How Pentagram will fare in this regard will be of great interest to members of the New York design fraternity – several of whom, when asked what Pentagram's continued presence contributes to the New York scene, roguishly responded, 'Competition'.

21

Woody Pirtle's K-9, a 1986 promotional piece for his company Pirtle Design in Dallas, Texas, featured extraordinary images of dogs.

Our expansion to the west coast of America followed eight years later in 1986, when Kit and Linda Hinrichs and Neil Shakery joined us to open a Pentagram San Francisco office. We joined forces because we share a similar design philosophy and way of working. The expansion westwards has also strengthened our existing client contacts in the Pacific basin and has helped to create new ones. Writing in November 1986 shortly after the San Francisco announcement, the British magazine *Design Week* wrote:

> When is Pentagram not a pentagram? When it is a hendecagon. With the addition of three new partners in San Francisco, to add to the pair already well-established in New York, the original five-a-side Pentagram line-up has now increased to a full football team's worth of 11. The three new additions from San Francisco to the Pentagram partnership are Kit and Linda Hinrichs (a husband and wife team) and Neil Shakery, all three of whom have estimable reputations as designers in the US.
>
> There is a traditional tension in the US between the East and West coasts which stems from the time when little of any cultural or commercial significance happened outside New York and New England. So, after graduating from college in Los Angeles, both Kit and Linda Hinrichs followed the well worn path of all Californian designers. They went in the opposite direction to the frontier settlers – in other words, back to New York.
>
> When, in 1976, they decided to leave their successful practice in New York and return to San Francisco, the reaction from others was one of incredulity. Kit Hinrichs explains: 'All our friends in New York said, "Once you're across the Hudson, you may as well be in Saudi Arabia. All the work you'll get out there will be hot tub and leather shop ads, and maybe a couple of wine labels." New York is very chauvinistic about California.'

Size is the creative dilemma of all kinds of organizations. As a good idea grows larger and people grow older and both become more complicated, how does the 'creative' survive? There are very few large design firms that consistently produce high-quality work. The size of the group and the challenge of how best to introduce new blood are important future issues we have all agonized over.

Pentagram cannot continue without change. Patterns of change are emerging in the industry and in the structure of the group itself. Pentagram's origins were forged from the coming together of small individual practices and we are inevitably changing our culture and developing as an organization. Our traditional two-tier structure of partner and assistant eventually evolved into a third administrative tier with delegation of certain responsibilities to our company secretary and project team coordinators. More recently, we have developed an associate status for those senior designers who have made a substantial contribution to client relationships and who have demonstrated exceptional design talent combined with the ability to control and monitor projects. Eligibility for associates is judged not on age or length of service but on performance. There are currently a number of associates and we believe that this arrangement will enable us to cultivate and retain gifted younger designers within our organization.

The annual Pentagram Prize was instituted in 1991 with Graphis *magazine to 'encourage the development of research and communications skills for designers'. The Prize is open to design students and is awarded to the writer of the best one-thousand-word essay on design. The award also includes publication of the essay in* Graphis, *a four-week internship at a participating design studio, and cash funds.*

Peter Saville's cover and liner for New Order's 1985 album Low Life *on the Factory label, of which he is art director and co-founder.*

We expanded again by one in 1987 when Etan Manasse joined the New York office. Etan trained as an industrial designer and specialized in exhibitions work. His teaching activities at Pratt Institute and his interest in communicating messages in space widened the graphic activities of the New York office. A year later, graphic designer Woody Pirtle joined the partnership and relocated in New York after running his own design office in Dallas. One of the great benefits of the design community lies in meeting new people through conferences and judging activities. Alan and Woody had met years before at an Alliance Graphique Internationale meeting judging and gradually Woody developed friendships with other Pentagram partners. I remember I talked to him about joining Pentagram eight years ago and later wrote a piece in *Graphis* magazine describing his work as 'exceptional because it combines two qualities rarely combined: good ideas (usually with an element of wit) and impeccable attention to detail and production'. The timing came right in 1988 when he wanted to move to New York.

John Rushworth, who was the first designer to be made an associate of Pentagram in 1987, was also the first to be elected partner from within the firm in early 1990. John Rushworth was an associate in John McConnell's team and became primarily responsible for the consultancy with Polaroid, which he managed to the satisfaction of both the partners and the client. He also showed extraordinary initiative in producing posters for Art & Architecture Ltd.

In late 1990, Peter Saville also joined the London office. He had established his reputation as one of the stars of a new generation of graphic designers in the UK and there was some comment in the press about why he should join Pentagram. In *Blueprint* Rick Poynor reported:

'Your Best Shot' is Michael Bierut's 1987 poster inviting members of the New York Chapter of the American Institute of Graphic Arts (AIGA) to submit a single slide of their best work from the previous year.

> The union of Peter Saville and Pentagram is not, on first hearing, the most obvious of marriages. The prince of the 1980s stylists welcomed as an equal partner in the stronghold of graphic ideas: five years ago the notion would have been unthinkable. A year ago it might, in a pinch, have been thinkable, but few would have believed it likely to happen.

Probably the biggest changes for Pentagram occurred in the USA in 1991 when we added four partners in one year. Michael Bierut had gone straight from the University of Cincinnati's College of Design, Architecture, Art and Planning to Vignelli Associates and worked there for ten years. He made a name for himself by the force of his energy in the New York design community. One evening during a purely social dinner with Woody Pirtle, the idea of his coming to Pentagram was born. Soon after, Woody also put the same proposition to Paula Scher. By coincidence, Michael and Paula Scher were co-chairing the upcoming American Institute of Graphic Arts (AIGA) National Conference and for a while they exchanged their doubts and enthusiasms about joining before deciding. They were both known to most of the partners, not only through the design community but also by reputation. Paula first made her reputation at CBS Records and then in her partnership Koppel & Scher. She has won more accolades than most graphic designers in New York.

We then had the terrible shock of the death of Etan Manasse, who was killed by a car in February 1991 when he was crossing the road late one evening on his way to his country house in Pennsylvania. Other changes were to follow, the most important being the resignation of Linda Hinrichs, who is now running the Powell Street Studio in San Francisco. Meanwhile, Paula Scher introduced us to James Biber, a young independent architect who designed Paula's offices at Koppel & Scher in addition to a number of other graphic design studios, restaurants, offices,

and residences. We shared a mutual interest in the multi-disciplinary approach, and Jim's joining the New York office has taken Pentagram further towards the ambition of being a balanced multi-disciplinary design office in the USA.

To complete the sequence, Lowell Williams decided to relocate from Houston and join Pentagram's San Francisco office at the turn of the year. Lowell had been a good friend of Woody's for many years in Texas and was well-respected throughout the national graphic design community. Lowell ran a very successful practice in Houston, and his joining Pentagram is evidence that the concept of Pentagram in the USA has gained credibility.

With these additions I believe that we have largely solved the problem of succession. In an article for *ID* magazine, Hugh Aldersey-Williams quoted Kit Hinrichs as saying, 'We are not an organization that has to be here forever, but I think it's an interesting idea that a design organization could continue beyond its founding partners. And this is an idea that those founding partners themselves find interesting.'

To summarize, we believe that Pentagram is a service of individual skills, and that the balance between the desire to do the job well and to be financially remunerated is a very delicate one – in fact, you cannot separate the motivation of the two. Growth will enable Pentagram to reinforce its traditional way of doing business. As an international organization, we must have sufficient size to attract new partners who can develop individual reputations. A larger firm has greater prominence in a crowded marketplace of numerous small design firms. We still believe in the importance of being a multi-disciplinary partnership and have survived the challenge of entering the more specialist, segmented American market. For we are convinced that there is a future for a few organizations which are able to undertake wide-ranging cultural and environmental projects along with the purely commercial.

We have worked hard to develop an organizational and financial structure which allows for individual ability and self-reliance. For as John McConnell has commented, 'The partners will never be rich. With one guy at the top, he's going to be much richer. We share equally, so Lear jets and country mansions are forfeit; on the other hand, in life and in lifestyle, we're immensely wealthy.'

I believe that Pentagram's success was inevitable because of the personalities involved. There is a collective ambition in there somewhere. We share a passion for design, an entrepreneurial spirit, an interest in business, and an interest in the kind of collaborative efforts that we find in a community of designers. The rate of additions to the partnership is increasing, and there will be subtractions due to age. We are at a point of transition fom one generation to another: Alan Fletcher is now working out of his mews in Notting Hill, Mervyn Kurlansky is in Copenhagen, and Peter Saville is leaving for Los Angeles. David Pocknell, a graphic and interior designer, and Daniel Weil, an industrial designer and architect, are joining London. These changes will have a radical effect... but that is another story.

Paula Scher's 1981 Elvis Costello poster for CBS Records has become a collectors' item.

23

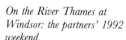

James Biber used imagery inspired by high-tech work-out machines in his 1989 design for the Plus One Fitness Clinic in New York's World Financial Center.

On the River Thames at Windsor: the partners' 1992 weekend.

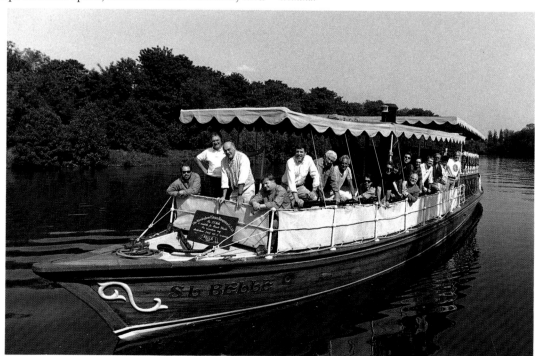

Knowledge and method

Knowledge begins with interest, and never ends. Knowledge may tell you why there are twenty-six letters in the alphabet, or how a seventeenth-century theatre was built, even who put a moustache on the Mona Lisa. It may also tell you which shapes are aggressive and which are passive, how different colours affect perceptions of space, or what paper to use for letterpress printing or litho.

But knowledge in itself is only enough to equip the commentator or critic. The designer needs method as well, also learned but arguably finite. A repertoire of techniques is at the designer's disposal, some formal and universal, some more esoteric – a designer's personal tricks and short cuts.

Representing experience, knowledge and method combine to give the designer insight and a sure understanding of what is possible and what is not. Equipped thus, the designer can advise with authority, judge with conviction and persuade on the right course of action, even in the face of solid preconceptions and prejudices. And when the body of knowledge and method is shared, the power and thus benefit to designer and client are greatly compounded.

Making faces

The face is the transmitter: all human expression emanates from here. Endlessly variable, it is an inexhaustible source of inspiration for the graphic designer, as for artists and writers down the ages.

Faces give us the opportunity to indulge in the sheer enjoyment of graphic design. Once you have understood that you can see faces in the most unlikely juxtapositions of images and/or objects, you can play the game of making faces to your heart's content. Make a face and somebody will smile at the wit, or at the pleasure of just 'seeing it'.

My fascination with the face has spilled over into plenty of projects, and I enjoyed fostering one of the first *Pentagram Papers* by Jean Robert on faces hidden in found objects (see page 276). It is such a simple image in one sense – a circle, two dots and a couple of lines will do – yet the variations are practically inexhaustible.

JOHN MCCONNELL

RIGHT: The 1993 Pentagram Calendar is based on the animals of the Chinese horoscope, made as collages of ephemera – this one: a monkey.
Partner, Alan Fletcher
Associate, Thomas Manss

ABOVE LEFT: *Peter Harrison commissioned twelve different designers to illustrate the 'birthday' theme of a calendar for the printer Applied Graphics. John McConnell chose the anniversary of New York's change of name from New Amsterdam (see also page 185).*
Partner, John McConnell
ABOVE CENTRE: *A poster for Icograda 1992. Each year the International Council of Graphic and Design Associates hosts a lecture by eminent designers for students, chaired by Alan Fletcher.*
Partner, Alan Fletcher
ABOVE RIGHT: *The October page from Pentagram's 1990* Signs of the Zodiac *calendar.*
Partner, Alan Fletcher

Face Calendars

Where the theme remains constant, each new variation becomes the challenge and the enjoyment. This is epitomized by the Face saga. Before I joined Pentagram, I helped to found the typesetting company Face and I designed their first calendar using the face as a theme. These faces for Face have become something of an esoteric institution. Every year since the early 1970s I have produced face-based promotions which have explored practically every graphic possibility and contortion. The work has continued year after year and is the most longlasting continuous project I have been involved in. It's an annual habit that has produced a collection which is now quite formidable.
John McConnell

28

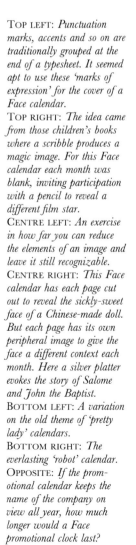

Top left: *Punctuation marks, accents and so on are traditionally grouped at the end of a typesheet. It seemed apt to use these 'marks of expression' for the cover of a Face calendar.*
Top right: *The idea came from those children's books where a scribble produces a magic image. For this Face calendar each month was blank, inviting participation with a pencil to reveal a different film star.*
Centre left: *An exercise in how far you can reduce the elements of an image and leave it still recognizable.*
Centre right: *This Face calendar has each page cut out to reveal the sickly-sweet face of a Chinese-made doll. But each page has its own peripheral image to give the face a different context each month. Here a silver platter evokes the story of Salome and John the Baptist.*
Bottom left: *A variation on the old theme of 'pretty lady' calendars.*
Bottom right: *The everlasting 'robot' calendar.*
Opposite: *If the promotional calendar keeps the name of the company on view all year, how much longer would a Face promotional clock last?*

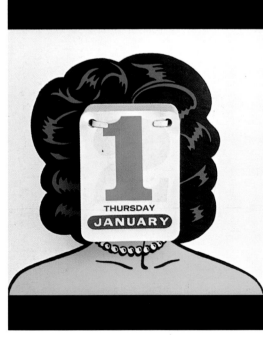

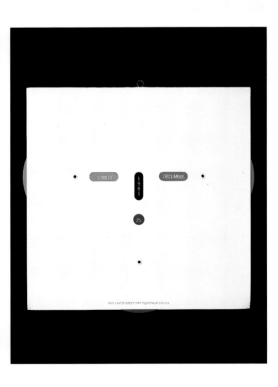

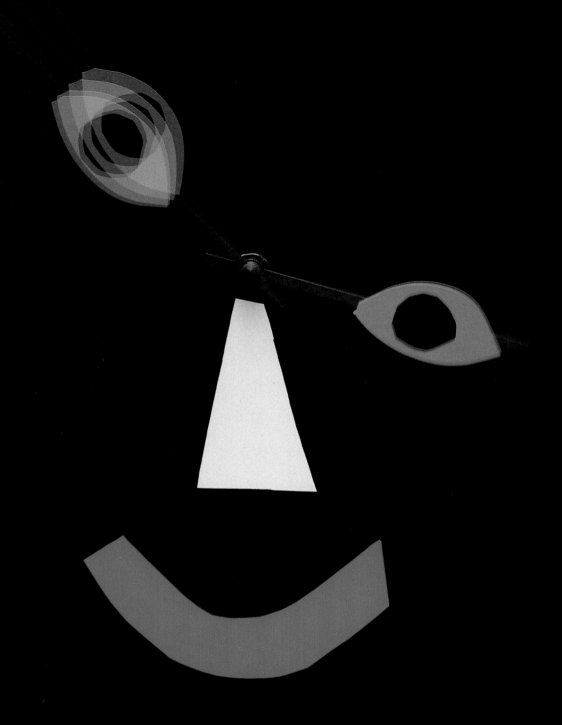

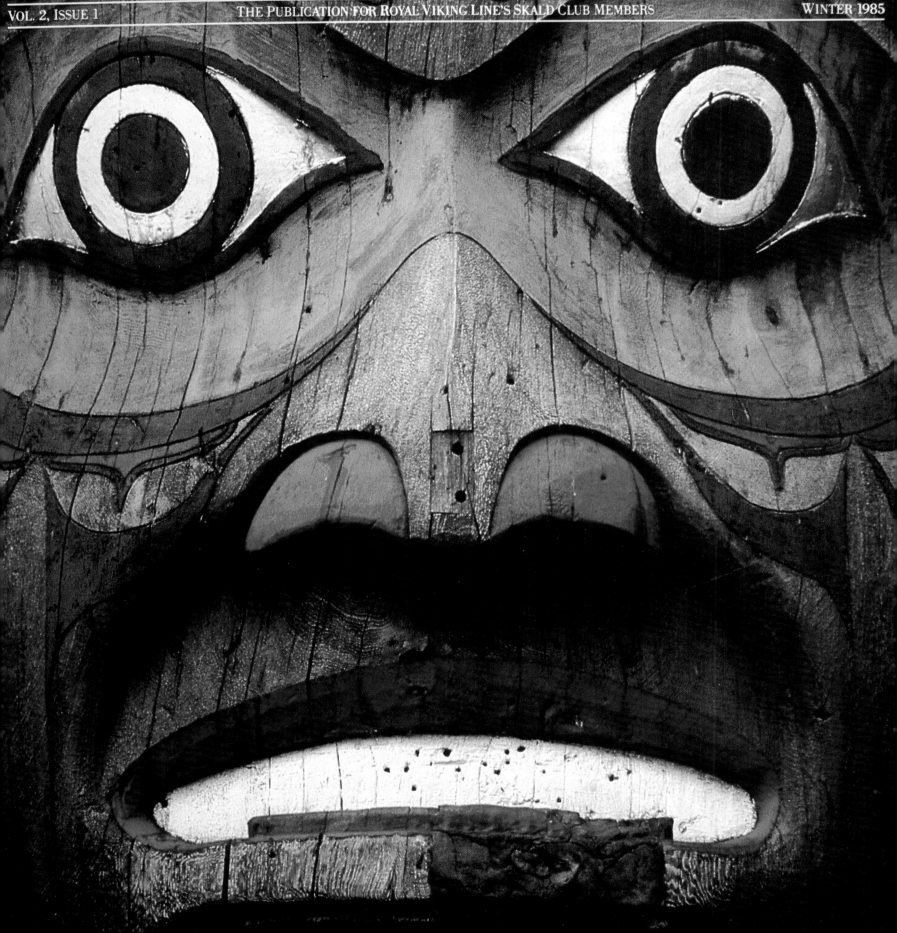

SKALD

VOL. 2, ISSUE 1 — THE PUBLICATION FOR ROYAL VIKING LINE'S SKALD CLUB MEMBERS — WINTER 1985

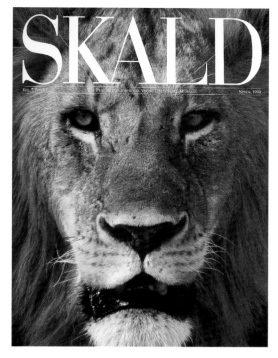

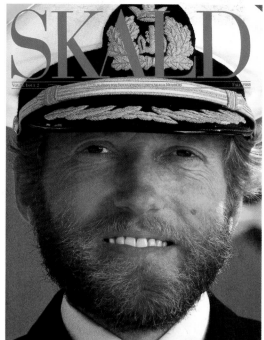

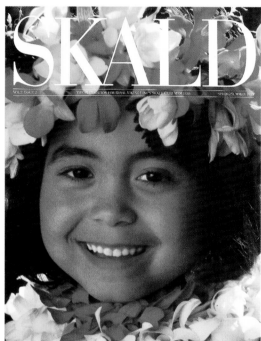

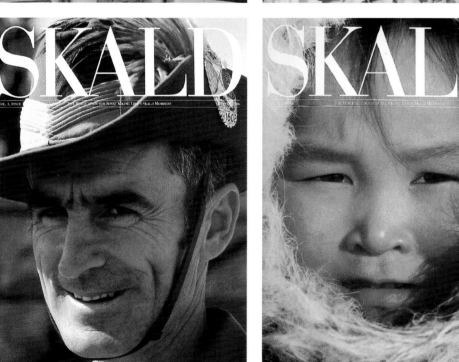

SKALD MAGAZINE

*Destination, destination, destination –
the driving word of the travel industry.
So when asked to design* Skald, *a
magazine for Royal Viking Line's past
passengers, we were determined to meet
the destination challenge in a completely
unique way.*

*No matter how special the
photography might be of the world's most
dramatic vistas, it was inevitably the
expected solution. Cultural 'faces' gave us
not only a way to solve the 'destination'
problem, but also added a memorable
icon to the magazine covers. We didn't
leave our interpretations of cultural faces
to human faces alone, but quickly added
an Alaskan totem, African lion and
Egyptian sarcophagus.*
KIT HINRICHS

TOP LEFT TO BOTTOM
RIGHT: *Photographers,
Cornstock Inc, Will
Mosgrove, Lee Boltin,
Tom Tracy, David Stahl
(APA Photo), Herman
Hines (Masterfile)*
OPPOSITE: *Photographer,
Brian Vikander*

Being paid to talk

As a designer's career advances, experience accumulates to the point where his value as an adviser can outweigh his value as a designer. JOHN MCCONNELL, COLIN FORBES and KENNETH GRANGE view different aspects of design consultancy.

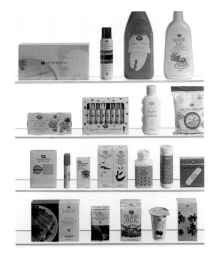

Appointed in the mid-1980s as a consultant to Boots The Chemists, the UK's largest pharmacy chain, John McConnell draws on designers throughout the industry when commissioning packaging design. Designers are picked according to their feeling for simplicity and their ready understanding of the aims and values of the Boots image. Thus individual variety and personality are achieved within an overall family look for the range. Designers used for the packaging shown were Howard Brown, Newell & Sorrell, Lambie-Nairn and Company, Lewis Moberly, The Partners, Lippa Pearce, Workhouse, and Pentagram.

CONSULTANT VERSUS PRACTITIONER

Today nearly every design company calls itself a design 'consultancy'. In my view this is a misuse of the word. There are many good design practitioners, but not all are 'consultants'. Consultancy means advising a client on how to go about using design and assessing whether the results are right or wrong; it does not mean advising and doing it yourself. You can't play the role honestly from two sides of the table.

As a consultant, my job is to take a very broad-based view of what a particular corporation stands for, and to assess what I think it should be doing in the long term. But as a practitioner, I respond to the design brief by listening to the short-term anxieties and needs of my client. Mixing the two functions together runs the risk of putting long-term gain in jeopardy by reaching for short-term advantages. It can distort the problem.

JOHN MCCONNELL

BOTH ANALYST AND PRAGMATIST

I'm a doer, a manager, and a pragmatist. But I don't like the term 'consultancy'. This probably dates back to when I was collaborating on a project with Jay Doblin, a Chicago-based consultant whom I greatly admired. Doblin was an imaginative and academic thinker, whereas I was the pragmatist, always trying to move things along and deliver the goods. A year later we still hadn't produced any results. He once described the differences between us to one of my friends by saying, 'I'm a consultant and Colin's a vendor!'

A consultant's responsibility is to ask clients, 'What is it you want to be?' I believe consultancy is an adjunct to other things we do. Designers have a positive advantage in their education. It bridges the two thinking processes, defined by Peter Gorb: the theoretical, analytical approach on the one hand, and the practical, pragmatic learning by trial and error, on the other. The designer must be aware of all the relevant information, but must also be good at separating out what will be useful. The academic and theoretically trained person tends to get too absorbed in ideas, which of course are more interesting in an abstract sense. Combining the best of the two makes for a good consultant.

COLIN FORBES

DESIGNER AS CONSULTANT TO THE BOARD

We hear more and more about the growth of design management. While this is vastly overdue, the fact remains that a place for the designer in the boardroom is the only way to ensure that industry's design standards are raised. The object is not merely to raise the status of the designer and his ideas, but – quite as important – to compel him to share in the whole commercial endeavour and be held responsible for his own work.

The role of consultant design director with ready access to top management in the various divisions of a company gives new strength to the function of the designer. It means that the client has on hand an outside view, free from politics and pressures, and in turn it provides staff designers with the support they invariably lack.

Consultancy for the self-employed gives welcome security in the larger, secure corporation and assures some security of revenue since a consultancy is invariably for an annual fee. Above all, it flatters by the implication that we hold a valuable amalgam of knowledge and experience that we can distribute to others.

From the purchaser's side, there are different benefits. Buying the consultant's skill as needed has a great financial and political advantage over employing him or her on a full-time basis. It is cheaper than the salary, office and its accoutrements and certainly more cheaply disposable. Politically, it represents no boardroom threat to another's power, and because, in a consultant's role, we do surrender our open-market independence, the employer, by securing our services, also prevents potential competitors from using our consultant's skill.

These are the realities of the business relationship. The temperamental, emotional, spiritual, aesthetic, and personal rewards are something different. The professional title we choose – design consultant or consultant designer – is itself a wonderful example of the designer's unquenchable enthusiasm for argument. Among our peer group in England in the 1970s a great debate raged as to the difference between these two. One, it was argued, was a man or woman, more a skilled manipulator and observer of design – an impresario, more than the other, a skilled performer turned adviser – a sort of prima ballerina turned choreographer.

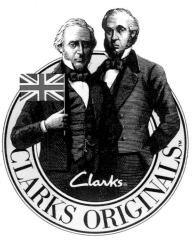

But either title will do, and the consultant can simply be a valuable sounding board for the Chief Executive to test out the value of design to his corporate ambitions, or may also stand in place of the design manager. This is perhaps the consultant's most common use today: somebody who advises on when and how to employ design. Such advice may be combined with some hands-on examples of what the client should do – which may prove to be the cornerstone of a visible stance in design. A corporate identity would naturally spawn an ongoing consultancy. The designer who has conceived the identity and persuaded the board to adopt it will have become familiar with the company's plans and potential.

Without a doubt, one of the great attractions in employing a design consultant is that he will probably produce something, and moreover something attractive, something conceivably even elegant and beautiful. Such qualities are rare indeed in the boardroom community. Therein lies a great strength for our profession and whilst we may talk strategy and market share and perceived value we can, by enjoying the privileged of the valuable consultant, actually enhance the lives of our hard-pressed managers. Of course few designers can ever resist giving that free bit of advice, a sort of unpaid consultancy, in the euphoria after the presentation of the commissioned work. This is the moment when the Chairman, arm around shoulder says, 'Now dear boy, what do you think about our idea for a new range of perfumed plant pots?' Who can resist giving that free advice, an easy exchange for the board leader's friendship?
KENNETH GRANGE

DESIGNER AS NON-EXECUTIVE DIRECTOR
The principal difference between non-executive directors and corporate consultants is that the former should participate in central decision-making as well as giving advice. As they have a wider remit, they will inevitably get involved in aspects of the business which are outside traditional design decision-making. Though you are appointed for your design expertise and experience, the relevance of your design background only gains force when you prove yourself as a businessman equal to your colleagues on the board. You have to demonstrate that you under-stand their organization, are sensitive to their problems, and can talk sensibly about them in order to help improve performance. I have been fortunate enough to play such a role as a director of both Faber and Faber in the UK, and Clarks of England in the USA.

In my view, the appointment of a non-executive design director represents a more powerful demonstration of commitment to design than assigning full-time design responsibility to a senior manager. A board appointment signals an acknowledgement of the resource at the highest level, which goes beyond the reputation of the individual appointed. You can't change an organization fundamentally from the outside, and certainly not by putting up boards of pretty visuals as a means of showing how design can make a contribution. You have to get inside and change the way things are looked at; this often means having to reform the decision-making processes that impinge on design. When senior managers are committed to something, it filters down in some way or another. The 'push-through' process that most designers pursue is incredibly hard work.

I want to promote the view that design activity pervades all business enterprises, and should be part of everyone's life. It must be stressed that design does not take place in confined areas of a company, involving only a special handful of staff: all can contribute to the corporate design effort. The non-executive design director or corporate design consultant can fill the vital role of integrator, bringing people together who would not normally talk to each other. Design often represents neutral territory through which it is possible to explore the interfaces between different functions – particularly where decisions in one area have important implications in others.

If the advice that I offered was ignored too frequently in a way that would damage my credibility, integrity and reputation, then I would resign. There is, after all, a dignity in these roles which must be maintained, and a limit beyond which you must not compromise. Thus it must be an 'understood' condition of an appointment that I have direct access to all the important decision-makers, that my advice will be listened to and considered seriously.
JOHN MCCONNELL

Clarks of England is the North American distribution company of branded Clarks shoes. Reputation and sales in the USA had declined from a high point in the 1950s and '60s when Desert Boots and Wallabies were market favourites. When Robert Wallace, president of Clarks of England, began to formulate plans to rejuvenate the brand in the late 1980s, he enlisted John McConnell as a director to advise on the new image.
Design work was carried out by the Pentagram partner Kit Hinrichs in San Francisco who concentrated on the Englishness of the brand, giving prominence to the figures of Victorian founders Cyrus and James Clark. The device has been used extensively in merchandising presenters, advertising and trade shows. More recently design efforts have been concentrated on creating and sourcing Clarks branded shoes exclusively for the American market.

John McConnell was initially commissioned by Matthew Evans and John Bodley of UK publishers Faber and Faber to design a new corporate image for the company. The work led to redesigning the books themselves (see also page 150). Finally he was appointed a director responsible for all aspects of the company's design and production.

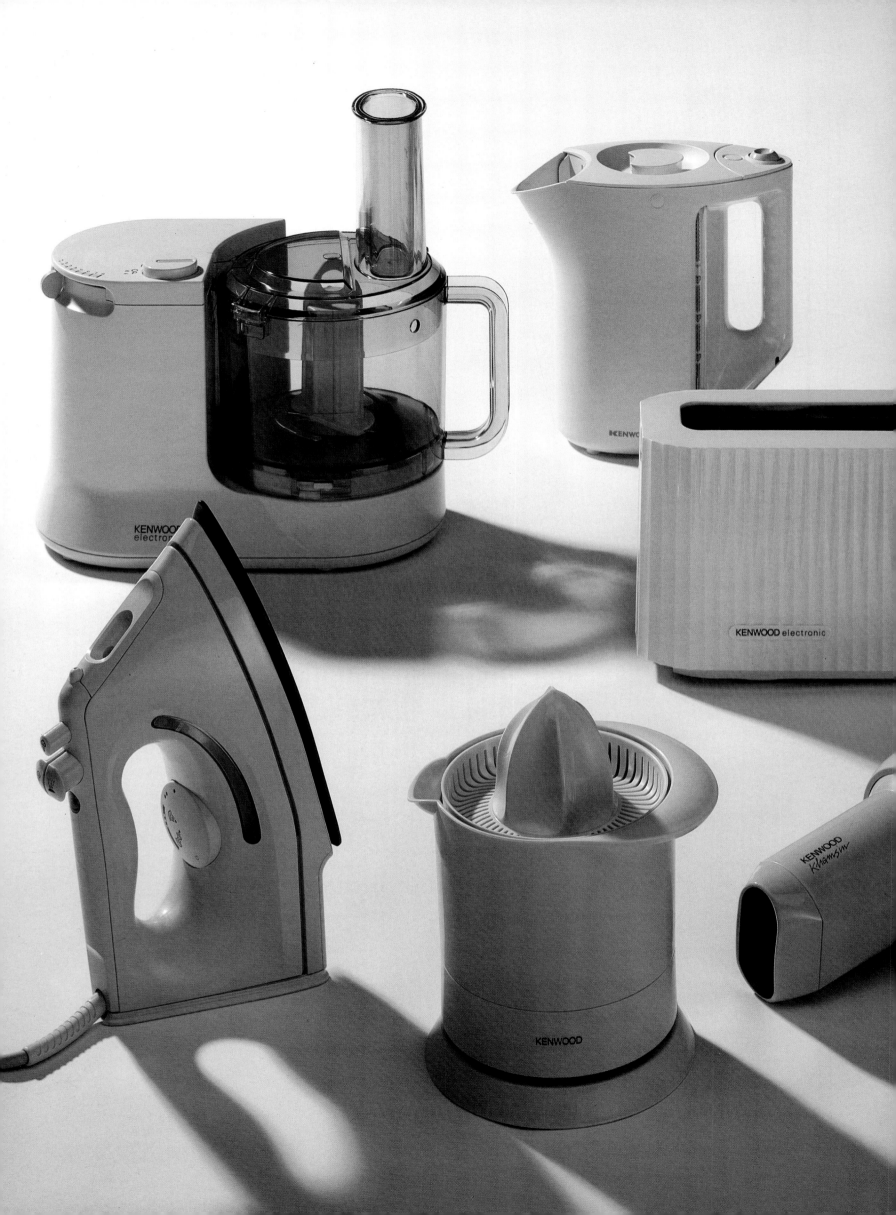

A DESIGN CONSUMER GOODS
COMPANY

*Kenwood, the domestic appliance
manufacturer, survived for a long time on
the reputation of its visionary founder
and his creation the Kenwood Chef (see
page 201). More recently the company
won its independence from Thorn EMI
in a management buy-out and began to
expand and diversify its product range.
Under the direction of Tim Parker,
Kenwood continued to prosper and, in the
teeth of the recession, it was floated on
the London stock exchange in 1992.
The company's attention to design has
been a major factor in this success. The
product range has been expanded from its
traditional all-purpose kitchen machine to
include food processors, kettles, toasters,
irons, juice extractors, ionizers, hair
dryers, mini ovens, and water filters.
Tim Parker enlisted my help to amplify
and restate their new design approach. As
the* Financial Times *put it: 'Through
Kenneth Grange, who has been working
with Kenwood for 31 years, the company
has developed what it calls a Kenwood
look.' In 1986 the company had twenty
products and profits were negligible on
sales of £55 million. By 1992 there
were 120 products and profits had risen
to £9 million on sales of £90 million.
It is significant that Tim Parker now
calls Kenwood a 'design consumer goods
company'.*
KENNETH GRANGE

Image as strategy

LOWELL WILLIAMS demonstrates how the power of the graphic image is controlled and turned to precise effect to serve the essential aims of a project.

There is a point in the design process – usually somewhere in between the brief and production – where strategy translates to image. The image in this sense is graphic, as in an illustration or photograph, rather than a pervading aura of perception. The most meaningful images, certainly the images in this book, have an idea behind them – an idea in direct response to a strategy that in turn is linked to a mission or a message.

In today's society, where any given audience is constantly bombarded with messages, and where many messages are practically the same, whether any message is communicated or not depends on how it is presented. This simply puts more importance on the link between strategy and image.

For example, in the commercial real estate boom of the 1980s, virtually all developers had the same messages: value, location, architecture and the like. Thus solutions were sought to establish difference through individuality. In our own work we were instrumental in the development of highly distinctive composite photographs – the process of separately shooting a model of a building and its intended site, then combining the two by computer to create the image of the real building. As this procedure rapidly became commonplace, we then looked for another way to establish individuality. Not content with traditional 'architectural renderings' and the imposition of a single style for all buildings, we taught ourselves to draw buildings and their details in a style that respects the particular architecture itself. By the time this technique became established, the development boom was fizzling out and the problem of distinguishing individuality had consequently become less of an issue.

Wherever the image is used as strategy, the designer plays the additional roles of producer and director: conceiving, testing and explaining the idea, carefully choosing the right photographer and/or illustrator, and monitoring and guiding all the creative and technical processes through to printing.

The image that has artistic or aesthetic value is difficult enough to achieve. But it is not enough. It also has to work as strategy, where the appeal, relevance and distinctiveness of the idea is as strong as the visual impact.

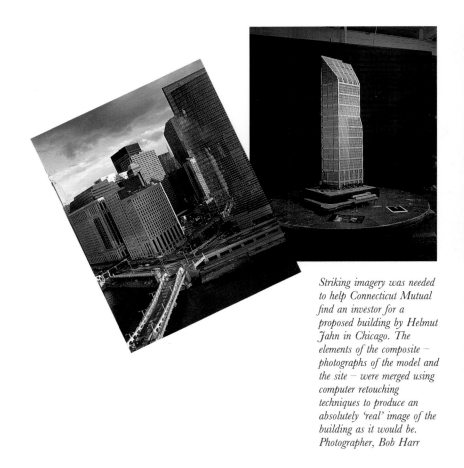

Striking imagery was needed to help Connecticut Mutual find an investor for a proposed building by Helmut Jahn in Chicago. The elements of the composite – photographs of the model and the site – were merged using computer retouching techniques to produce an absolutely 'real' image of the building as it would be. Photographer, Bob Harr

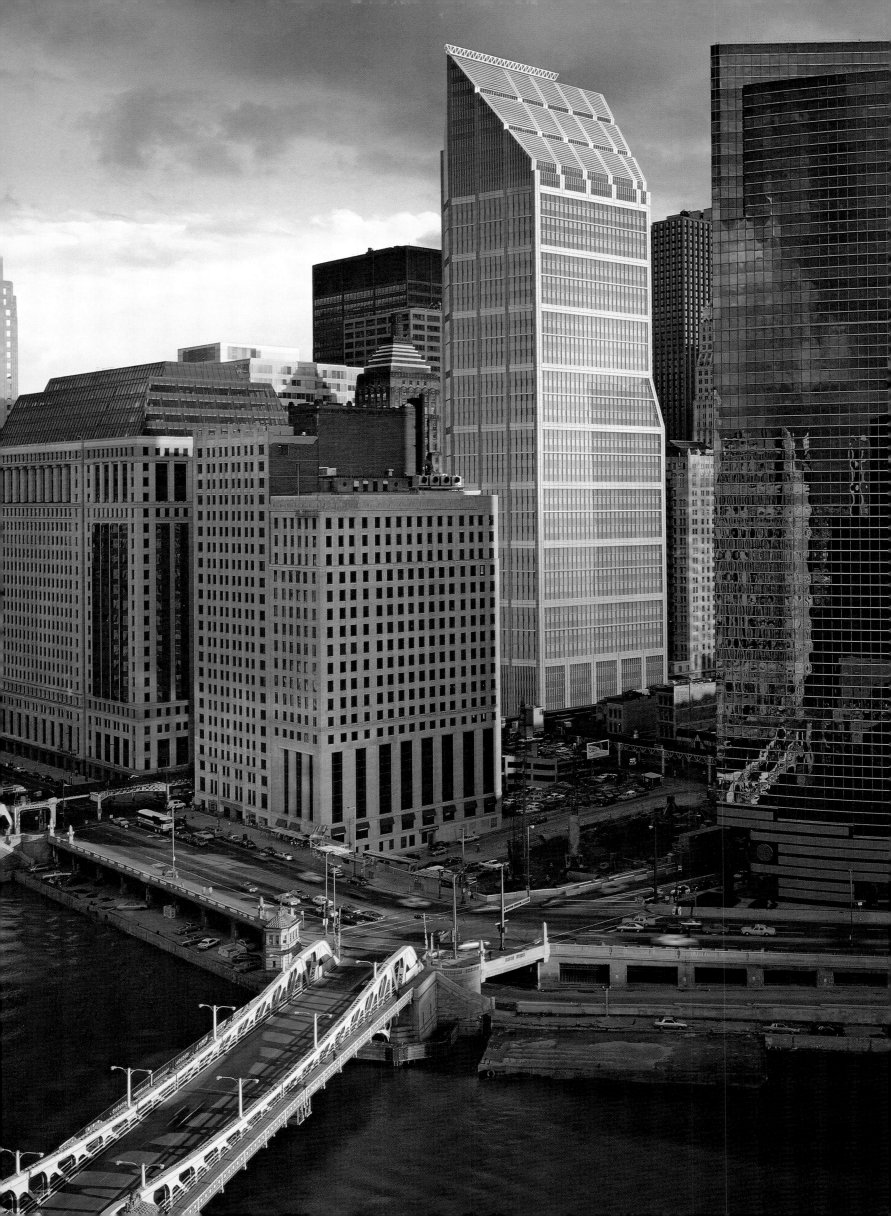

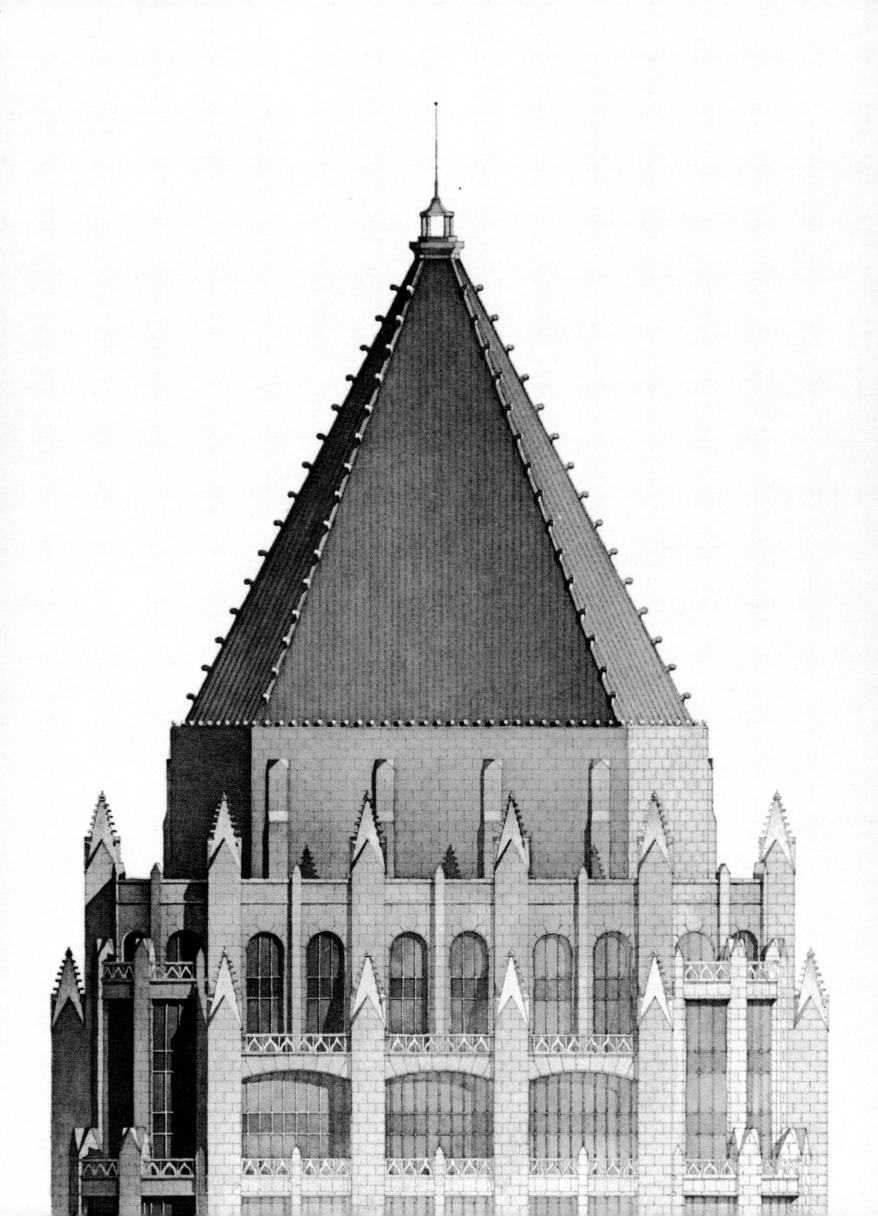

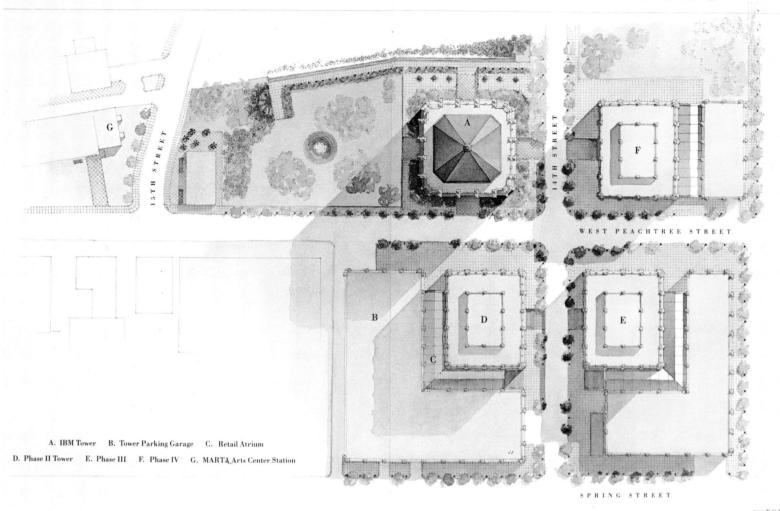

A T L A N T I C C E N T E R M A S T E R P L A N

A. IBM Tower B. Tower Parking Garage C. Retail Atrium

D. Phase II Tower E. Phase III F. Phase IV G. MARTA Arts Center Station

15TH STREET

14TH STREET

WEST PEACHTREE STREET

SPRING STREET

NORTH

OPPOSITE: *The IBM tower at the Atlantic Center, Atlanta, Georgia, a joint development by IBM and Prentiss Properties. Model photography would not have done justice to the characteristic design of the building by Philip Johnson and John Burgee. The fine illustration, largely in watercolor, suited the style far better.*
ABOVE AND LEFT: *The plan and tower base illustrations used the same technique.*
Designer, Bill Carson
Illustrator, Lana Rigsby

40

A capabilities brochure for Morse Diesel, international construction managers, featured a series of skyline and detail images so that the emphasis was on the construction work itself, with no distractions from the actual buildings.
Photographer, Jim Sims

Solana, between Dallas and Fort Worth, Texas, is a joint development by IBM and Maguire Thomas. While still unfinished the IBM building was carefully photographed, concentrating on skyline shots and details.
Photographer, Jim Hedrich

Designed to be made

KENNETH GRANGE considers some lessons learned, and carried over from one project to another, in the pursuit of balance between a product's appeal and its cost.

Although I have no intention of giving up the pleasure and reward of designing objects, I can now indulge in a retrospective view of those products and people which have been memorable: Kodak cameras and Dr Pitt; domestic appliances and a succession of Kenwood men, not least the splendid and generous founder Kenneth Wood; Norman Saunders, a brilliant engineer who made a razor which alone pitchforked me into the world of shaving that now, fourteen razors later, I feel is my territory; and the witty and kind head of development of the railways, James Cousins, who gave me the opportunity to design the High Speed Train and gave me a frontispiece to my life's portfolio.

I cannot now remember how Parker approached me with the commission to design a pen but it certainly became a significant product – highly profitable and one which came with formal steps and processes. The brief given was to produce a fountain pen for the undergraduate population – it was expected they would enjoy a move from the ubiquitous ballpoint pen back to nibs and ink. In the end it did become popular, but on the way picked up a bigger customer group. Somehow in combination with the excellence of Parker engineering we just touched the stylistic nerve of the age.

The clip that encircles the cap of the Platignum Accountant and keeps the pen in the pocket was originally designed to be drawn out of sheet steel. Surprisingly, machining was found to be more economical. Designer, Peter Foskett

Parker had an established ethos and considerable sophistication. The highly profitable child of an American parent company, they had superb engineering and quality standards, which were matched by a powerful distribution system and sales force. The Parker 25, no longer a student pen, became a great success and remains so to this day. But now the Parker world is different. A management buy-out in 1986 took the company from the USA and though we have had an attempt, our other designs have not succeeded, torpedoed I fear by anxiety over guaranteed success and the cautions arising from that.

While for Parker we never repeated the success, we did receive great rewards in both quantities and royalties from a much smaller company, managed by a former Parker manager. This man, David Leeming, took over the leadership of a firm called Platignum and had no funds to pay for fees but instead agreed a royalty and made a great success from an unlikely cheap pen whose inspiration came from the robust shape of the clip from our drawing board. We designed others too, but none made in the great numbers of the Plat Pen for the Platignum company.

It is possible to learn from every project, and one of the Platignum pens, the Accountant, showed how unlikely can be the economies of production. In one technology we learn and must adhere rigorously to the given wisdom, then it is overturned by an invention in another industry. An example here is in the clip that encircles the cap and holds the pen in our pocket. We designed it to be drawn from sheet steel – a piece of knowledge indeed gained from Parker – yet when this was costed it was expensive, and so we revised our ideas and produced another design. But the client and his engineer persisted and found that with modern machining techniques, we could turn away almost ninety per cent of the stainless steel and leave the thin shell that we needed. It seems the antithesis of basic economics to throw away so much valuable material, yet the saving was huge, and no one who uses the pen would ever know of this unlikely twist of fundamental economics.

The Accountant pen is not the only example of this. A few years later for Plessey, we were given the task of producing a case for a military radio. This warranted high standards in the case construction, and normally such cases could be welded or cast into the shape. Again it was found

RIGHT: *The unit production cost of disposable razors has to be kept as low as possible to achieve a competitive retail price. As the market increasingly required safety, Wilkinson Sword introduced the Retractor with a blade cover. Design helped keep the cost of this 'extra' as low as possible. The handle and top cap are integral and the blade and blade platform one subassembly. The blade platform pivots on the top cap moulding, allowing the user to extend and retract the blade by pushing the platform up and down. Retractor's distinctive ribbed handle was also designed to achieve a more solid feel within the constraints of mass production tooling.*

that it was worth machining away ninety-five per cent of a solid block of metal to leave an unbroken metallurgical structure: an apparently flagrant waste of virgin metal.

These are the unknowns in designing even a simple object, and they only hint at the immense value in the mountain of effort and skill and unlikely byways of invention behind the simplest of our artefacts. Great capital cost precedes the simplest object that we buy in the street. The pharmaceutical industry some time ago mounted a clever PR campaign when the costs of drugs were criticized as exorbitant: it pointed out that every little tablet needs to carry its share of the costs of laboratories and inventors and experiments that came before the drug we buy – a fair and sound justification. Journalists who pride themselves on their social conscience have criticized manufacturers and therefore designers for constantly evolving new and improved versions of a product. They accuse them of designing for obsolescence and this may seem plausible. However, it is important to remember that a product may live an extended life undreamed of by its first producer. Having been conceived, tooled and manufactured in the wealthy West, it will then migrate around successively less affluent societies.

A camera designed for Kodak in 1965 has for twenty years had its tools moved on from place to place, and every time, in each place has been welcomed for its newness. How little it is realized what an elegant economy is at work! In India today they are making new the Morris Oxford car that was made in England from 1960 to 1965; and there it is a prestige vehicle. Its tooling has been paid for many times over and it is still good for many thousands of cars yet to come. It could still move on to wherever the world is less wealthy than India, to countries waiting to adopt the Morris Oxford as the newest example of affluence.

ABOVE: *The case for the Plessey military radio was machined out of a solid block, rather than conventional casting or welding. Associate, Johan Santer* OPPOSITE: *The Variset hat and coat system was designed for A J Binns. The well established technique of aluminium extrusion was adopted to meet the requirement for a minimal capital spend on the product. Relatively low capital cost plastic mouldings were also suitable. The market accepted the high initial price of the products, but as the range prospered and returns became available for further investment, more capital expenditure was made on tooling, giving greater room for price manoeuvre.*

From A to B

Maps and diagrams unravel complexities and make instructions and relationships readily understandable. The skill lies as much in finding the right imagery as in the ability to interpret.

We are currently obsessed with knowledge and its availability or lack of it. With our increasingly specialized professions it becomes more and more difficult to understand each other. Maps and diagrams are instruments for understanding. At best they can describe the apparently inexplicable. In his introduction to *The Shape of the World*, Simon Bertram asks, how could anyone rooted on earth, however ingenious, begin to work out what the world looked like? The answer is in the cumulative recording of measurements and in observation combined with remarkable intuitive leaps.

In the early 1960s Charles Eames made a multi-screen film for IBM to demonstrate the power of planning. The concept was characteristically simple and enlightening. The idea behind the film was a hostess planning a dinner party and her instrument was a table plan. The plan was depicted on one screen with the names around a rectangle; the other screens showed guests sitting at dinner. The voice-over mused that Mrs So-and-so had a disagreement about something or other with Mr What's-his-name. The hostess made the correction on the table plan and the people on the live-action screens were immediately rearranged and continued in animated conversation. The point was dramatically made that a diagram is an explanation of a part of reality and that the implementation of an idea or plan has consequences.

The diagram can be more than an explanation of facts or an established theory: it can also be a tool in the analytical process of refining an idea. There are occasions when the drawing of a diagram or plan reveals flaws in the theory or concept. It may be because I've spent a lifetime working in a visual field, but often 'I don't understand it unless I can draw it.'

With his book *Envisioning Information* (1990), Edward Tufte has become the authority on the design of complex information. His success comes not only from his refined graphic talent but, most uniquely, from being a statistician. He understands the information and its interpretation; he analyses and translates it for us. Tufte allows he's been inspired by a three-dimensional pyramid that Euclid made to explain triangular geometry. The genius in the mathematics and the genius of the diagram are inextricable.

I was once given directions to someone's house in the outer suburbs and got hopelessly lost – we were more than an hour late. Finding the route was complicated by country roads at night but that was not the problem. After the second cocktail and going over the directions, our host admitted that he should have said the third left, not the second left on leaving the highway. We didn't have a map, and getting from A to B is not simple if you are at C.
COLIN FORBES

LEFT: *Diagrammatic representations of Reuters' developing worldwide communications network were designed for successive wall charts. The 1986 version used a computer-generated design to show Reuters' satellite communications system, which enables twenty-four-hour market trading by transmitting prices and information between the major financial centres of the world.*
Partner, Mervyn Kurlansky
RIGHT: *Demonstrating the size of an oil rig, from a book documenting half a century of engineering for the international engineering company Brown & Root.*
Partner, Lowell Williams
Illustrator, David Wilcox

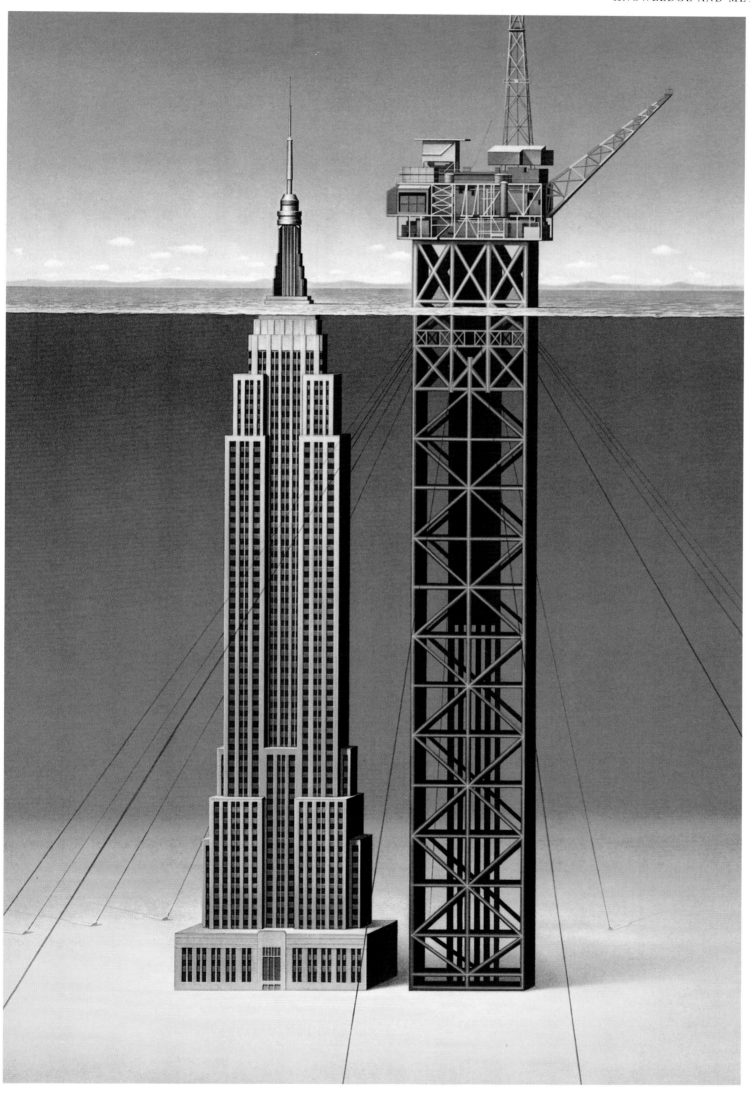

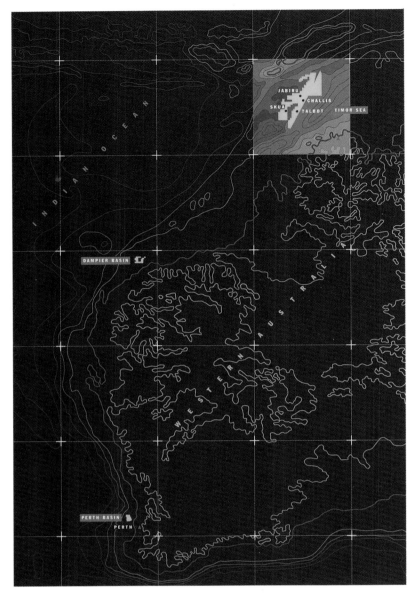

48

A satellite survey map of Western Australian oil resources is merged with a traditional topographical rendition, for the 1990 annual report of Canadian energy company Norcen. Partner, Kit Hinrichs Designers, Piper Murakami and Max Seaburgh

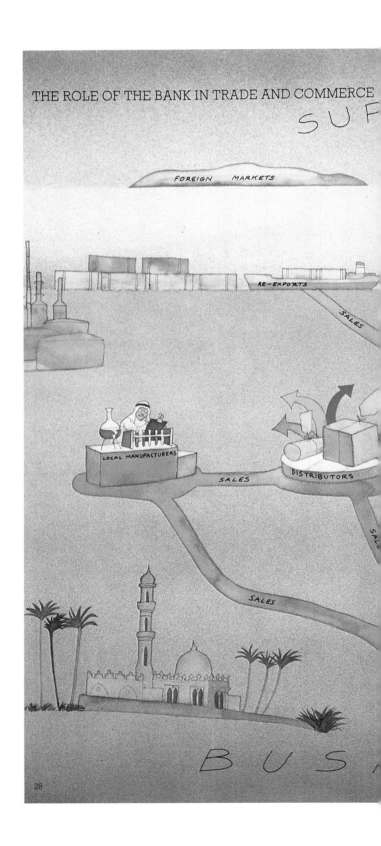

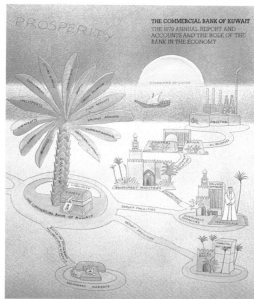

The cover and a spread from the 1979 Commercial Bank of Kuwait annual report, which was based on the theme of financial and economic inter-relationships.
Partner, Alan Fletcher
Illustrator, Michael Foreman, with acknowledgement to Saul Steinberg

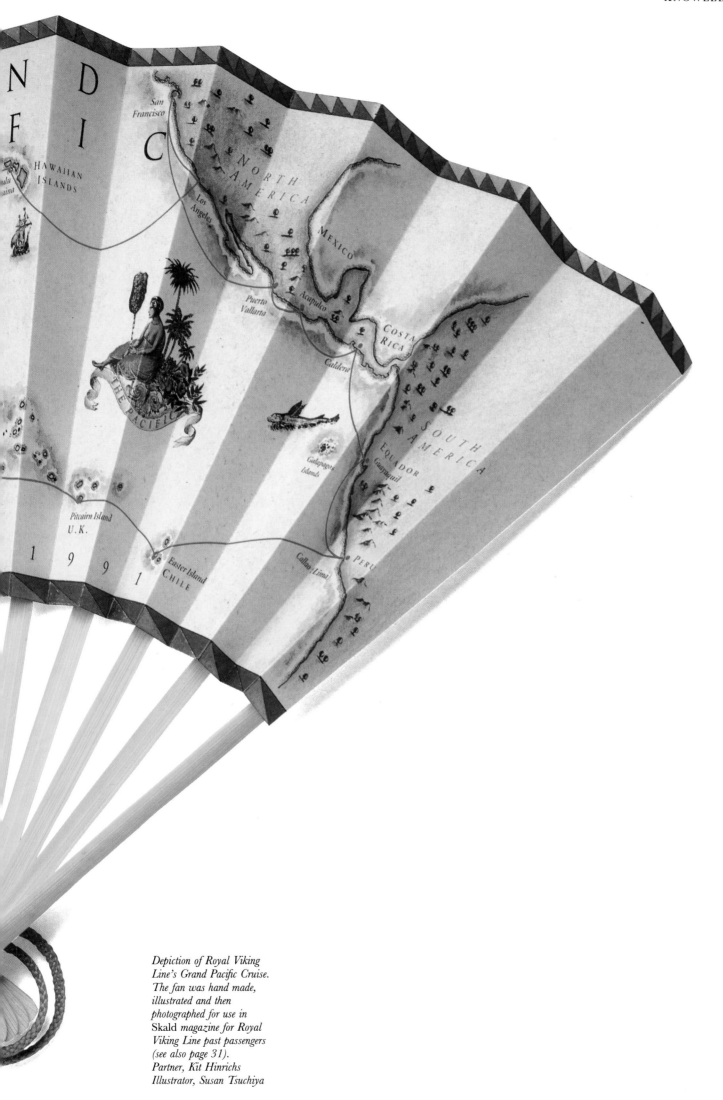

Depiction of Royal Viking
Line's Grand Pacific Cruise.
The fan was hand made,
illustrated and then
photographed for use in
Skald magazine for Royal
Viking Line past passengers
(see also page 31).
Partner, Kit Hinrichs
Illustrator, Susan Tsuchiya

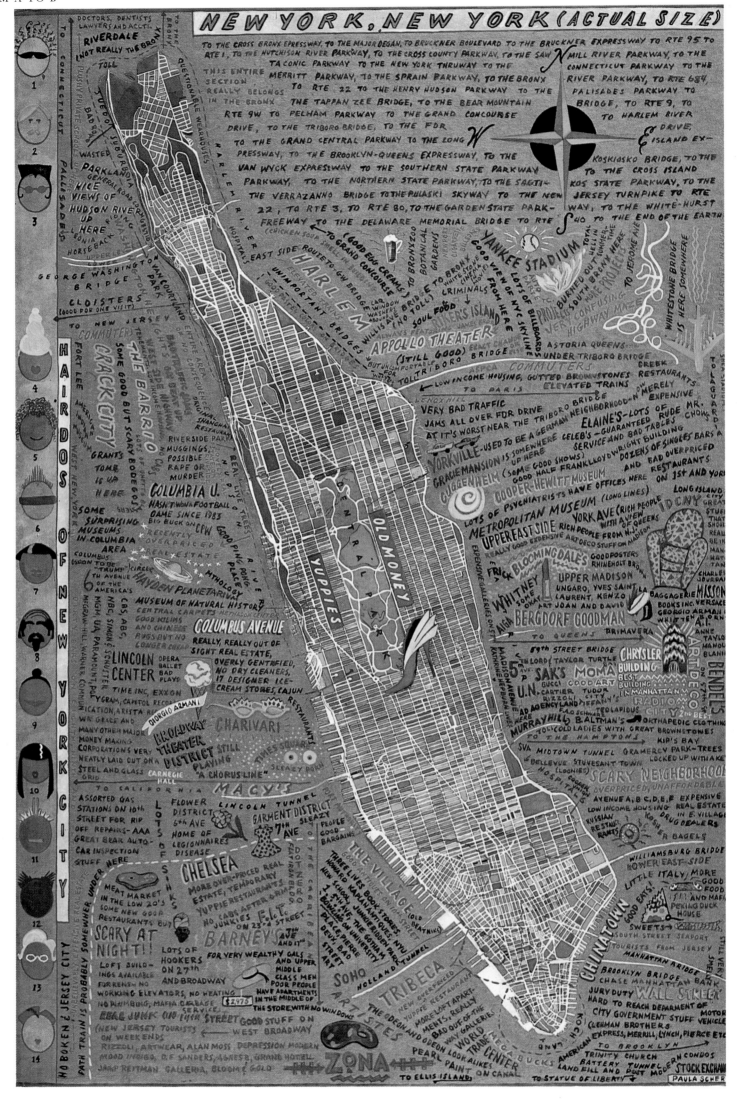

52

MCI Communications needed to improve perceptions of the organization's size and the scale and breadth of its telecommunications network activities. For the 1984 annual report, one image was conceived to show the company in its entirety.
Partner, Peter Harrison
Illustrator, Steven Guaranccia

LEFT: *A hand-painted satirical map, owned by Diana Graham, produced for auction to benefit the New York Chapter of the AIGA in 1989. It is one of a series of hand paintings by Paula Scher.*

600 Columbus Avenue is an
apartment building in New
York City's Upper West
Side. Twenty per cent of the
residents are on subsidized
rents, the rest pay in full,
which leads to an interesting
mix of tenants. The only
part of the building used by
all is the lobby, so its design
had to combine the right
kind of functionality with a
particularly wide appeal.
 The idea was inspired by
mythic Manhattan. The
overall style, with marble
walls and geometric light
fittings, echoes the city's
grand epoch of the 1920s
and '30s. The terrazzo floor
of the lobby is a map of the
locality, from Central Park
to Riverside Drive, with
streets of gold, blocks of
brownstone, blue water and
green park space. The idea
is not confined to the floor:
the concierge's desk emulates
an apartment building and
the light fixtures clouds in
the sky.
Partner, James Biber

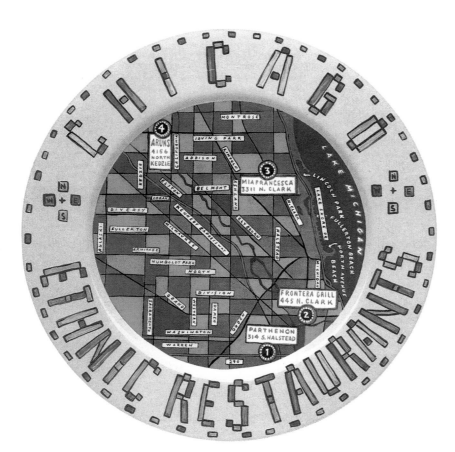

The Roving Gourmet is a
feature in the United Airlines
in-flight magazine
Hemispheres, which was
redesigned in 1992.
Partner, Kit Hinrichs
Designer, Jackie Foshaug
Illustrator, Paula Scher

Measure for measure

THEO CROSBY relates the long process involved in faithfully reproducing Shakespeare's Globe Theatre on the River Thames to a background of changing attitudes to city life and structure.

TOP: *A 1640 London panorama by Wenceslaus Hollar contains the most accurate representation of the second Globe Theatre, built in 1613 on the foundations of the first.*
CENTRE: *Professor John Orrell has proved that Hollar used a perspective glass for his London panorama. Thus the drawing is probably very accurate, allowing calculation of the Globe Theatre's orientation and diameter.*
ABOVE: *A possible setting-out diagram for the theatre, using the* ad quadratum *method well known to medieval builders. The latest evidence, however, suggests twenty rather than twenty-four sides.*
OPPOSITE: *A drawing of the Globe by Dennis Bailey.*

The nature, form, and experience of the city is not only the architect's province; it is the joy and life of all of us. We go, in vast and increasing numbers, to interesting places (and in the process destroy them), but we are also all much concerned with our own street, the neighbours' windows, the passing stranger, and the occasional burglar. This concern makes us all experts on city life. We know what we like.

Planners on the other hand have learned a complex discipline. They are the recipients of many theories, and attempting to order and quantify theories as complicated as those relating to a city makes them either revolutionary, or resigned. The revolutionaries want to simplify, to order, to make statements. The resigned rather like the state of mild chaos, and know that whatever they do will probably only make things worse.

My concern for city life and structure was born during the Second World War, as an innocent soldier wandering in blessed paradisial Italy, where urban life is natural and unaffected, where buildings are kind to people and form an outdoor theatre for commercial drama. Here one could see natural growth, the easy fitting-together of structures from many periods, with a mutual respect, and also the communal buildings – churches, halls, civic structures, often wild, gestural, ornamental – offered to the common man to enhance his civility and increase his communal pride. These buildings, offered perhaps as the Medicis made offerings in expiation of the sin of usury, set the tone of a culture and a time, draw one's heart and mind. In the hopeful years of post-war England, planning was popular, and we all worked on the new towns and on many another brave project with an innocent energy. At the same time we pursued theoretical studies, welcomed and tested the ideas of Gropius, Hilbersheimer and Le Corbusier, as well as continuing the home-grown planning inheritance of Howard, Unwin and Geddes.

Out of these studies came the British contributions to the 10th Congrès International d'Architecture Moderne (CIAM) in 1956, and ultimately the self-destruction of that great engine of Modernism. The suicide of CIAM removed the formal order and structure of the movement, which soon drifted into statist authoritarianism, or into fragmented and powerless groups and individuals. The former launched the great

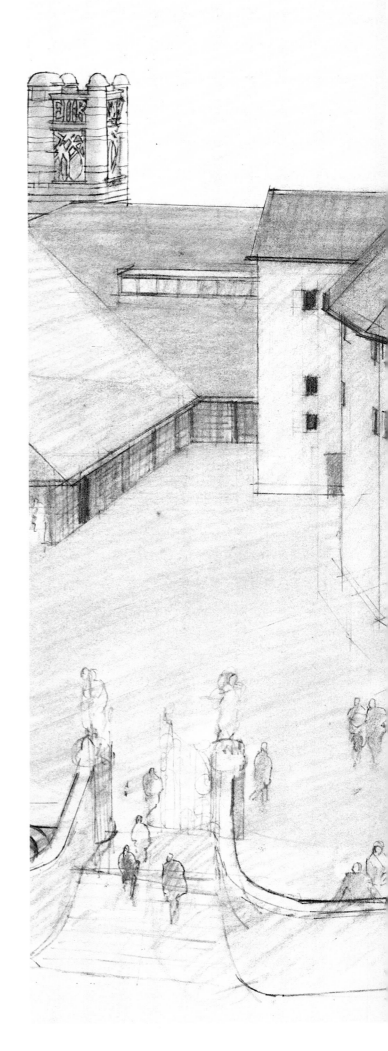

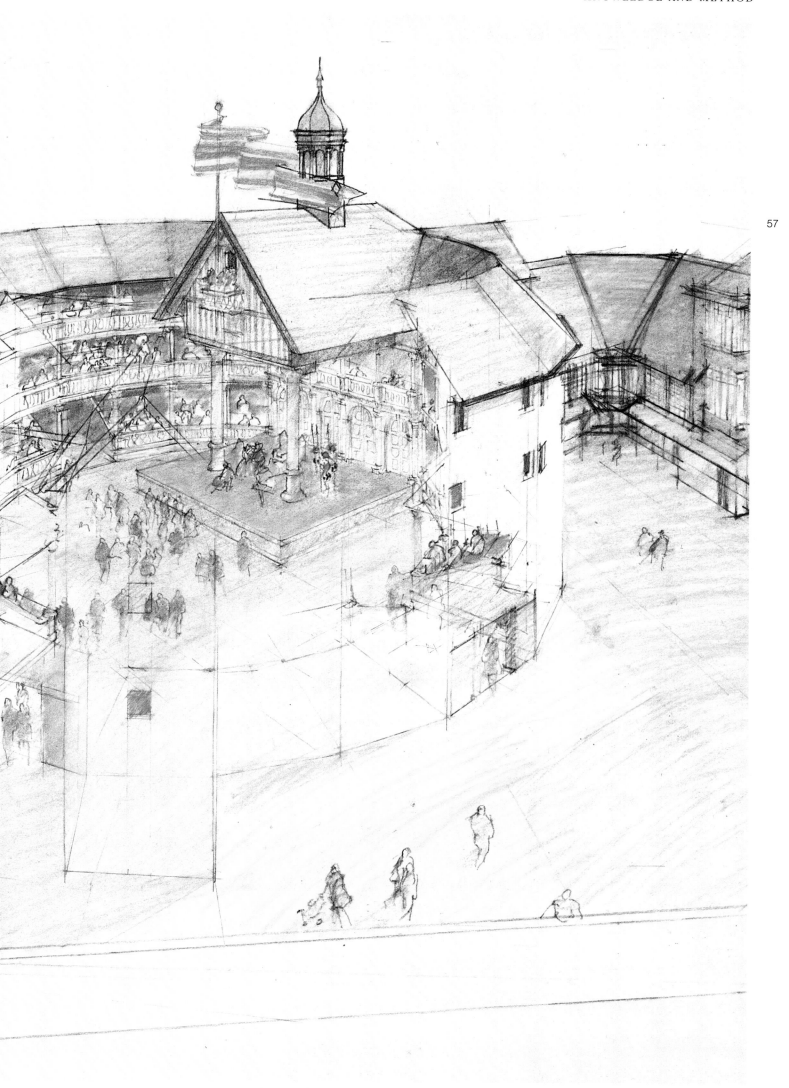

58

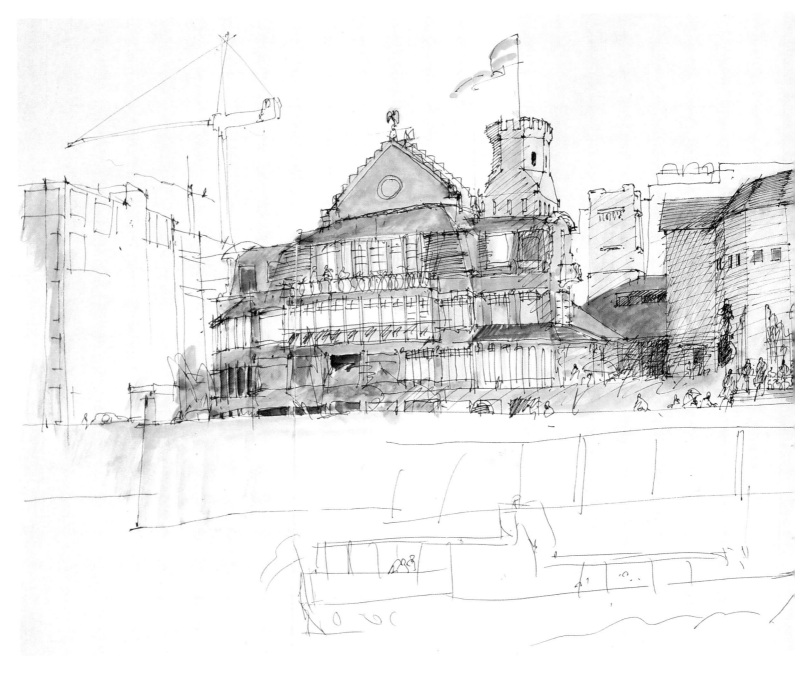

ABOVE: *A drawing of the Globe complex from the River Thames by Dennis Bailey.*
RIGHT: *The photograph shows the site in 1989; today it is more closely surrounded by modern buildings.*

Modernist social and commercial programmes of the 1960s; the latter took refuge in the universities, where they still swim in ever-decreasing circles. The first adjustment of the real world came with the publication of Jane Jacobs' *Death and Life of Great American Cities* in 1961. Mrs Jacobs looked at the new and drew conclusions about social inadequacy and technical hubris from which we still suffer some thirty years later.

My own involvement as a journalist, and from 1961 as an architect in charge of London's Euston Station project, produced the first of several books: *Architecture: City Sense*, 1965. I subsequently became, through Lord Kennet, a member of the Preservation Policy Group, which established basic conservation studies and some essential legislation. From this experience came *The Necessary Monument*. The Arts Council provided a platform for a major exhibition, *How to Play the Environment Game*, 1973, and this travelled around the country with a Penguin publication as its catalogue. The effect of these, and many other publications of course, has been gradually to affect the climate in which architecture and planning are perceived.

We have built so much since 1945 that old buildings are now in the minority. What we have built is so bad, without order or quality, that it has become imperative that we should hang on to every scrap of the pre-modern

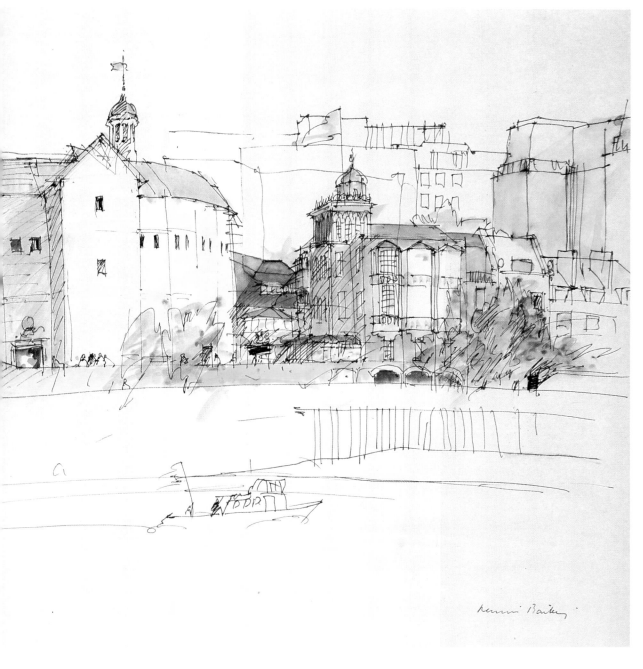

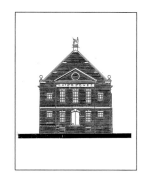

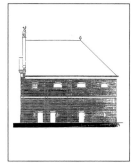

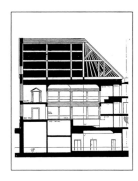

Elevations and sections of the Inigo Jones Theatre. The original size of the interior has been retained within a proportionately enlarged shell to allow for modern regulations.

world. In fact the problem is now to colonize, to civilize the new world in which we find ourselves. To be an architect in the late twentieth century is to experience a moment rich in ambiguities. The experience is particularly acute to one nurtured in the rigours of Modernism, with its puritanical imperatives, its unswerving traditions, its carefully manufactured history, its inevitability.

There was, however, even in the moment of Modernism's triumph after the war, a stirring of doubts, of unease at such a simple and conclusive victory. The war released such a burst of energy, of good intentions suddenly made official, that even the carefully prepared ideologies of planning, social organization and communal involvement were overwhelmed. The profession grew rapidly, all its members educated in the new ways of the Bauhaus, of basic design, of an architecture created from logic, standards and mass production.

Dissensions first appeared in Italy, where Modernism had been the accepted official style since the 1920s, and where many masterpieces had been built. Already in 1940 Gio Ponti was writing about identity (that is, the expression of individual identity in mass-produced building), and by 1948, Ernesto Rogers was building the Torre Velesca. This was the first post-Modern building, raising a graceful historicism over the roofs of Milan, a gentle, civilized, complementary building. It was something new and extraordinary, but it had little immediate import.

The rush to modernize, to fill cities with the demonstrably new, was aided by new laws and regulations and by the bureaucracy that became the largest employer. In twenty years the Greater London Council had grown the largest architectural organization on earth – with two thousand architects, each with an administrator in attendance. The impact of this machine on the environment was unbelievable;

60

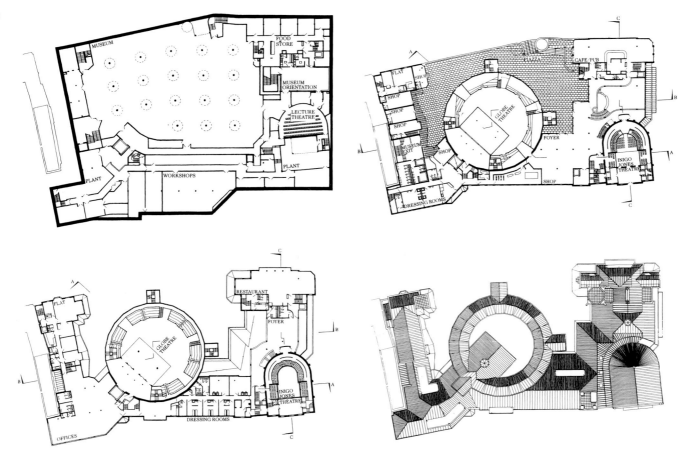

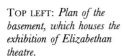

TOP LEFT: *Plan of the basement, which houses the exhibition of Elizabethan theatre.*
TOP RIGHT: *Plan of the piazza level; the Globe is surrounded by subsidiary buildings, with a pub on the street corner.*
ABOVE LEFT: *The first-floor plan, with the dressing rooms linking the two theatres.*
ABOVE RIGHT: *The roof plan shows the complexity of the project.*

it affected great areas of southern England from Basingstoke to Peterborough.

The result was uniformly disastrous: the countryside was spoiled, the old inner cities neglected, excellent environments destroyed or sterilized. Of course we are too polite to do much about it, but from the beginning of the 1960s the disenchantment with facile Modernism began in earnest.

In the 1940s the key book was Rudolf Wittkower's *Architectural Principles of the Age of Humanism,* published in 1949. It explained something of the how and why of classical architecture and was a revelation to Modernists brought up on simple grids. Classicism was complex, intricate, full of meanings and resonances that had been forgotten. Even one of the high priests of the Modern movement, Siegfried Giedion, ventured to research Egyptian and Roman building and to publish his remarkable trilogy, *The Eternal Present,* 1962-4.

Yet the undermining of the Modernist philosophy came not from the academics and practitioners. It came from the consumers,

groups concerned with improving their surroundings. Their objections were based on their simple observation of new buildings which were uglier, cruder and generally less efficient than the old. They put forward legislation to conserve the environment; the architectural profession responded with post-Modernism, contextualism and deconstruction. Such exercises find a willing following among students and young architects denied consistent leadership, but produce buildings equally alienating and unpopular. The engagement of new with old buildings; their juxtaposition, replacement, refurbishment, remains an area of deep ambivalence and intellectual insecurity. Yet here is precisely the most interesting and demanding task of our time.

It skirts the forbidden whirlpools of academicism and the rocks of kitsch. Both these dirty words are being revalued. Beaux Arts drawings fetch inflated prices, and popular art burgeons in spite of evermore erudite artistic disciplines. Architecture has always flourished by looking at the past and present; out of this conjunction comes something new.

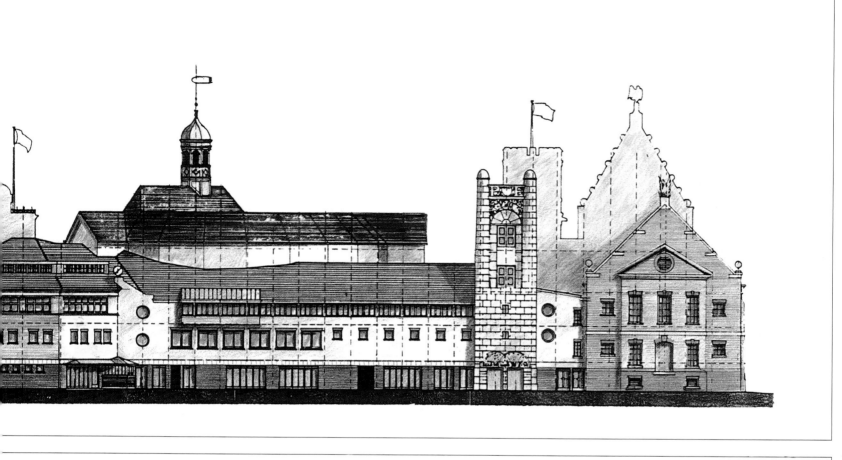

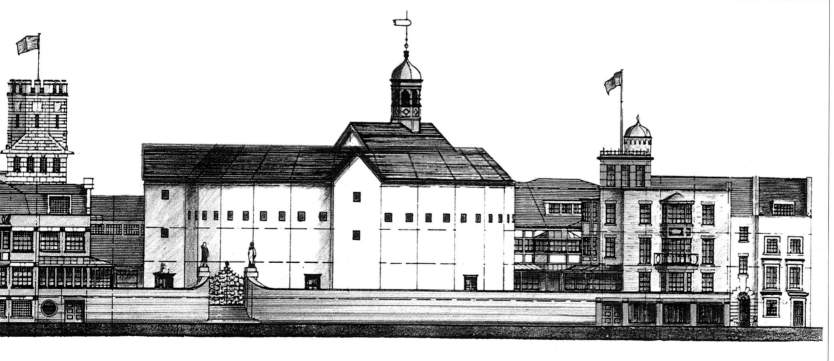

TOP: *The Skinmarket Place (south) elevation consists mostly of offices and dressing rooms linking the two theatres (with the Inigo Jones Theatre on the right).*

ABOVE: *The Bankside (north) elevation with the pub on the left and the flats on the right adjoining the tiny house used by Christopher Wren when building St Paul's.*

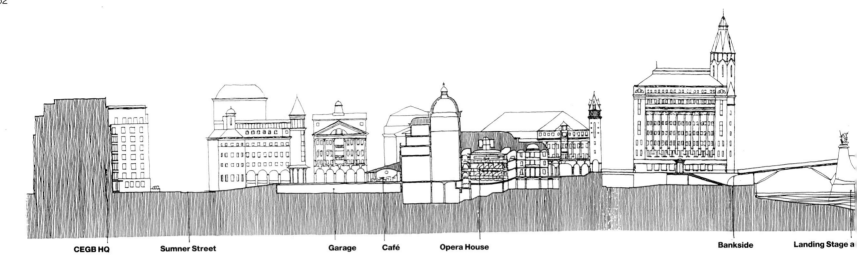

| CEGB HQ | Sumner Street | | Garage | Café | Opera House | | Bankside | Landing Stage a |

TOP: *A long section of the Bankside power station site adjoining the Globe, showing the housing, opera house, offices and bridge to St Paul's Steps on the north bank.*
ABOVE: *The view from the proposed bridge, which has been designed by Ian Liddell of Buro Happold.*

The project to rebuild Shakespeare's Globe fits precisely into this area of rich ambiguity and resonance, and its twenty-five-year history faithfully reflects the pressures of the times. In 1967 Sam Wanamaker saw the ruined South Bank of the Thames and went to look for the site of the Globe, part of which is under the old Courage Brewery headquarters, Albion Terrace, and Southwark Bridge Road. There was, and is, a bronze plaque, but nothing else to suggest that here once stood the greatest theatre in the world, and that this area had once been London's playground. He was determined to rebuild the theatre near the original site. There were endless vicissitudes, and many failures, but some twenty-one years later work on the project began.

Initially the thought was to honour the Bard with the best new theatre, but in the interim the Young Vic, the National Theatre and the Barbican have been built – more than enough new theatres, and they have become notorious examples of theatrical luxury and caprice. Sam Wanamaker turned to the scholars and it was agreed that the first Globe, which had seen the first performances of most of Shakespeare's plays, and which burned down in 1613, would be reconstructed. The problem was that no very satisfactory data about this theatre exist, though a drawing by Hollar shows the second Globe 'erected on the same foundations'. Thanks to much research by John Orrell, described in his book *The Quest for Shakespeare's Globe*, we arrived at an agreed design. Such agreement among scholars is a rare thing.

A major problem lies in the treatment of the adjacent buildings. The Globe is a simple white plastered building, tiny by modern standards, but it carries an astonishing authority in the collective memory of literate mankind. Everyone knows about and carries a mental image of it. To fulfil this dream, it has to be placed in an appropriate setting, to give it presence and scale. Its role in the city will be as a magnet for visitors come to taste the myth of Shakespeare and hoping to take away a memory, even some learning. Certainly one major function will be as a background for holiday photography.

The buildings around, therefore, are doubly important: they have to sustain the illusion of the physical importance of the Globe, and provide a complex visual background to counter its formal simplicity. At the same time, these buildings take up the scale and pattern of the existing area, or what remains of it. Along Bankside there used to be a terrace of three-storey houses, replaced in part by larger four- and five-storey warehouses. The site was bombed during the war and subsequent clearances left only the double house belonging to Southwark Cathedral, and the tiny Wren house adjoining the site. The former is a very elegant dark red brick terrace, with white string course and trims; the latter is a medieval timber building, cased during the Regency period in a white-painted plastered brick skin.

The other buildings nearby are mostly post-war, much larger in scale and of a grimly utilitarian nature. To the west is Sir Giles Gilbert Scott's Bankside power station, huge and overbearing, with a large riverside frontage. The design is good but vastly overscaled in the context of

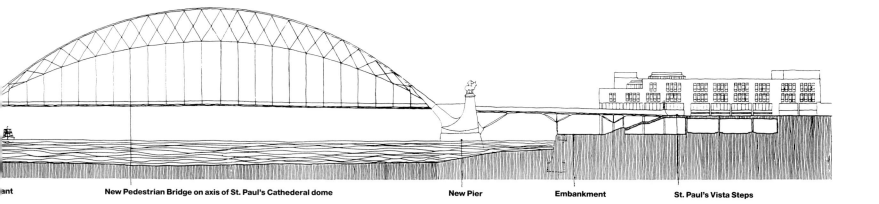

ant New Pedestrian Bridge on axis of St. Paul's Cathederal dome New Pier Embankment St. Paul's Vista Steps

London. Listing has been refused and it will be demolished, to make room, it is to be hoped, for a mixed commercial and housing development.

The Globe and its attendant buildings attempt to re-establish the earlier pattern, to achieve a small and complex scale for the area which will inevitably become largely pedestrian and concerned with entertainment. Thus the various elements are designed as separate buildings, each with its own character. The housing block adjoining the Wren house has a tower with a flagstaff to form the terrace and turn it southwards to make a piazza for the Globe. The latter is raised two metres above Bankside, to elevate the theatre above the river wall, and thereby ensure that it will be visible from the north bank. The pub/restaurant building is divided into three elements: the public rooms, the service areas, and a tower for access, flags, and floodlighting.

The main entrance to the complex, and particularly to the exhibition space which occupies the whole site area of the basement, is in Emerson Street. It is a 'modern' linkage, quiet and unemphatic, between the more important buildings, the Inigo Jones Theatre, and the restaurant complex. The boiler room, water tanks, and cooling plant are contained in a tower rising through this link building. It has its own character or story, to contrast with Inigo Jones-style Classicism. Each building or fragment thus has its own voice, to avoid blurring the individuality of the theatres by imitating their styles. The styles are deliberately disparate, and inevitably somewhat inaccurate and ad hoc. They attempt

a dangerous game of contrast and unification, and avoid large, bold statements (or works of art) in favour of small-scale complexity and detail.

The interiors of the Globe and the Inigo Jones Theatres will be elaborately marbled and painted, intended, as traditionally they were, to simulate the luxury of the ancients. In contrast, those of the foyers (the new buildings) will be restrained. The restaurant complex (if the gods are favourable) will be as rich and complex as possible: a demonstration of modern crafts all set to work on the Shakespearian theme of 'Time: melancholy, unstable, transitory. All the world's a stage.' These buildings, like the Globe, are seen as handmade, or at least hand-finished. They will contain a great number of small, touchable works of art and decoration, not necessarily very grand or precious, but engaging.

The initial works, a diaphragm wall down to the London clay to seal off the underground water flows, were completed in 1988. The foundation works and the concrete basement structure are under way, to be followed by more complex buildings, and the exhibition fit-out. As a trial, a two-bay section of the Globe was erected on the site in June 1992. It explores the medieval construction methods, and is intended to expose a number of theories to academic dissection.

Soon after the first essential element in the construction programme, the diaphragm wall, had begun, the adjoining site was sold to the Midland Bank. It had previously been allotted to housing by the local authority, but they could no longer afford this option and were glad to have a company that promised jobs in the area.

RIGHT: *A cross frame laid out in the carpenter's yard. The bays were prefabricated and pre-assembled in three-dimensional portions, following the methods of the original carpenters.*
BELOW: *The fitting of queen struts and purlins into the principal rafter during the final assembly of the complete three-dimensional frame on site.*

OPPOSITE: *Two experimental bays of the Globe were erected on site and inaugurated by HRH Prince Edward on 16 June, 1992. The completed playhouse will comprise twenty such bays.*

In the event the bank has built a cheque-clearing factory that will brutalize the surroundings and tend to dominate the Globe.

The response of the Trustees of the International Globe Centre Trust was to protest (and some modifications have been incorporated), and to think positively about a more congenial plan for the area. We produced sketch proposals for a financial centre, linked to St Paul's Steps by a handsome footbridge. The proposals stake a claim for a Fleet Line station, and extend the cultural reach of the Globe with a new small opera house and a home for the Cumin Museum, Southwark's collection of antiquities, a hotel and conference facility on the riverside, with blocks of modest offices around the opera piazza, and housing on the southern perimeter. The axis of St Paul's transept aligns with the existing Central Electricity Generating Board building and locates the opera house with precision.

To develop a new style was the great hope and intention of the nineteenth century. In our time we have seen the beginning of such a new, universal architecture, and found it inadequate. The inevitable response is towards an eclecticism within which something more complex and satisfying can be forged. Modernism has discovered too many interesting things for an innocent return to the past, and our training in old skills has dissipated. We can only find a way by cautious experiment. The Globe project is an attempt at popular architecture, with the admission that such a project is a very difficult thing to undertake.

The project for a financial centre extends this modest beginning as a basis for civilized city growth, with a great variety of building types and uses, and the opportunity to involve many architects of individual talent. The bridge provides the essential City linkage, extending high city values and rentals to an area currently very much on the fringe. The future of Bankside Power Station is the key to the area. It has been vested with the state-owned Nuclear Electric organization and its site is in the gift of the government. It is, however, the last central London riverside site and should be made an exemplary model of city building for the next century.

Character development

Alan Fletcher takes a look at the origins of writing, the formation of letters, and their relation to meaning.

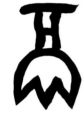

The image of a three-legged pot evolves through the pictogram to the ideogram. Philip B Meggs, A History of Graphic Design, Allen Lane, London, 1983.

Towards writing

Mythologies attribute the invention of writing to any number of deities: the Cretans to Zeus, the Jews to Yahweh, the Sumerians to Nabû, the Arabs to Allah, the Mayans to Itzamna. Legend has it that Sanskrit was invented by the goddess Kali, each letter represented by one of the skulls in her necklace. The Egyptians attributed the invention to Thoth who (as an ibis) scratched marks in the sand with his beak. The Greeks reckoned it was Hermes seeing cranes flying across the sky, while the Chinese credit Ts'and Kie, who thought of it seeing the tracks of a bird in the snow. The truth is more prosaic. Writing arose out of primitive signs cobbled up to record tithes and tributes – an invention of accountants. They were not writing. Writing is a system in which signs are used as components to communicate a sequential thread of thought – a graphic counterpart of speech, which also has the effect of formalizing language.

The first step towards writing began when *pictograms*, which are rudimentary pictures, were used to represent an object, or word for an object. Things like a circle to represent the sun. The second step is when they assume an abstract value – a circle to represent light. These are *ideograms*. And the third step is when a sign becomes independent of its illustrative references and stands solely for a sound. These are *phonograms*. Phonograms come in two sorts: those which represent syllables (fa-mi-ly) and those which represent basic sounds (f-a-m-i-l-y). These are *letters*. Of course the development was neither clearcut nor simple, and early scripts were a mixture of signs – some invented, some borrowed, some adapted from earlier primitive marks.

Writing transcended time and space and became the foundation of man's intellect. Without it there would be no Bible, no Shakespeare, no *Magna Carta* or *Bill of Rights*. No civilization.

Pictogram variations

When carved, pictograms are called *petroglyphs*, and when painted, *petrograms*. Hieroglyphs (sacred carved signs) are a particular kind of pictogram evolved in ancient Egypt. *Logograms* are signs which specifically represent words, such as a circle representing zero. Some others are: \$, %, &, +.

Sound and picture

Before the invention of hieroglyphs in ancient Egypt some five thousand years ago, the spoken word and written sign were completely unrelated and separate ways of communication. The hieroglyph, a specific kind of pictogram, reflected speech through writing. It worked like this. The hieroglyph was a simplified drawing of an object, which represented the sound of the name or word for that object.

Abstract thoughts which couldn't be directly illustrated were conveyed by combining signs – for example, these hieroglyphs of a bee and a leaf would (in English) yield 'belief'.

More complex ideas were expressed through analogy and metaphor: water by a wavy line or the sun by a circle.

Additional signs would indicate further information such as whether something was feminine or male, singular or plural.

Alpha beta

Rudimentary scripts appeared around five thousand years ago in the Middle East, at that time the crossroads of trade and culture, and the alphabet we use today is derived from the system developed by the Phoenicians. Despite amendments to form and shape, many letters still retain remnants of their early graphic reference to objects and things. The letter A owes its shape to the pictogram of the head of an ox *(aleph)*, the letter B to a pictogram of a house *(beth)*, and so on. The ancient Greeks adopted this early writing for their own use, and in translating *aleph* and *beth* into *alpha* and *beta*, gave us the word *alphabet*.

There are two explanations for the dollar sign. First, perhaps it was derived from the mythical pillars of Hercules (rock of Gibraltar and the peak of Jebel Muza) which carried a scroll with the legend *non plus ultra* (there is no more). The pillars, it is said, were converted into strokes, and the scroll became the S. The prosaic version attributes it to the *peso* of the Conquistadores. The sign for this was Ps. Adopted by settlers in North America to represent the dollar, the p was translated as two vertical lines superimposed with the S. The $ first appeared in print in 1717.

All characters were originally signs and all signs were once images. Human society, the world, man in his entirety is in the alphabet. Masonry, astronomy, philosophy, all the sciences start here.... A is the roof with its rafters and traverse-beam, the arch, or it is like two friends who embrace and shake hands. D is the back, and B is a D on a second D, that is a 'double-back' – the hump; C is the crescent, is the moon, E is the foundation, the pillar and the roof – all architecture contained in a single letter. F is the gallows, the fork, G is the horn, H is the façade of a building with its two towers, I is the war-machine that throws projectiles, J is the plough, the horn of plenty, K signifies one of the basic laws of geometry (the angle of reflection is equal to the angle of incidence), L is the leg and the foot, M is the mountain, or the camp within its tents, N is the door, closed with a cross-bar, O is the sun, P is the porter carrying a burden, Q is the croup and the tail, R signifies rest, the porter leaning on his stick, S is the snake, T is the hammer, U is the urn, V is the vase (that is why U and V are often confused). I have already said what Y signifies. X signifies crossed swords, combat – who will be victor? Nobody knows – that is why philosophers used 'X' to signify fate, and the mathematicians took it for the unknown. Z is the lightning – is God.... (Victor Hugo, *France et Belgique. Alpes et Pyrénées. Voyages et Excursions*, Paris, 1910.)

SIGNS OF ECONOMY

Abbreviations were introduced by scribes to save time. Scarcity and cost of parchment encouraged the custom. The rumour that a question mark is a tired exclamation mark is not true: it derives from *quaestio* (question). This was abbreviated by imposing the first and last letters over each other – q/o – which eventually ended up as ? The exclamation mark derives from *Io* (an exclamation of joy) which was abbreviated as I/o and in time became !

The invention of the sign & is attributed to Tiro (Cicero's secretary) and is an abbreviation of et (and), which can be clearly seen in the italic version. *Et cetera* was abbreviated as &c. The horn covers of early schoolbooks showed the complete alphabet followed by the notation *and per se* & to indicate it was a sign and not a letter – hence *Ampersand*.

Ampersand: the abbreviated form of the word and; also known as Am pussy and, curly and, round and, short and. (*A Dictionary of Graphical Symbols*, F C Avis, London, 1972.)

THE NUMBER OF LETTERS

The twenty-one letters of the early Latin alphabet were borrowed by the Romans from the Etruscans, who probably inherited them from the Greeks, who originally adopted them from the Phoenicians, who cobbled them up from Semitic scripts and Egyptian hieroglyphs. The Greeks introduced signs for vowels as the Phoenicians nly wrt wth cnsnnts. Other cultures changed, added and dropped letters to accommodate pronunciation. Spurius Carvilius Ruga, who opened the first school of grammar in Rome (*c.*250 BC), invented the letter G by adding a stroke to the C. During the Middle Ages W was created by putting two Vs together, the j adapted from i and so on and so forth. The English alphabet eventually ended up with twenty-six letters.

With these twenty-six units, there are a total of 620, 448,401,733,239,439,360,000 possible combinations. However, the need to combine vowels and consonants to make words curtails the options – the shortest coherent phrase containing all twenty-six letters is considered to be 'Jackdaws love my big sphinx of quartz.'

A B C D E F G
a b c d e f g
H I J K L M N
h i j k l m n
O P Q R S T U
o p q r s t u
V W X Y Z
v w x y z

68

THE SEQUENCE OF LETTERS

The sequence of the alphabet was established when letters were used to count; for instance A stood for one, B for two, C for three. The first record which spells this out is in *Psalm* 37, where the order of verses – in Hebraic – follows that of the alphabet: to some extent an answer to the man who always read the obituary column in his newspaper but could never figure out why famous people always died in alphabetical order. Letters which were added at a later date, such as XYZ, generally just got tacked on the end.

THE NAMES OF LETTERS

The names of letters derive from the initial sound of the object portrayed by the original pictogram; for example the modern pronunciation of A stems from the Greek pronunciation of *Alpha* which they adapted from the Phoenician *Aleph* (ox).

UPPER AND LOWER CASE

Driving through Greece from Patras to Kythira was difficult. The Greek alphabet is Cyrillic, an every-which-way collation of letters. The letters on the signs were in lower case and I soon discovered those on my road map were in CAPITALS. I lost my way (and temper) several times. Frustrated at being faced with two unfamiliar and seemingly unrelated sets of characters, it dawned on me that the Latin alphabet would be equally confusing to a foreigner in similar circumstances. Pursuing this thought – it was a long drive – I realized there aren't twenty-six letters in the alphabet but, with differences between capitals and lower case, there are fifty-two. Yet even that's not strictly correct. Eliminate a letter from each pair which are duplicate shapes such as S and s and one from those which are similar such as Y and y, and one is left with eleven pairs which often bear no relationship to each other. A doesn't look in the least like a. Later additions to the alphabet (VWXYZ) had the same form in capitals and lower case.

Contrary to what we are taught, the alphabet has forty-one different letters.

ROMAIN DU ROI

Louis XIII of France commissioned the design of an alphabet. I'm not clear whether he had a tidy mind or a desire to create a monopoly of the printed word. In any case the designers came up with a square divided into a grid of sixty-four units, which was further subdivided to form a lattice of 2,300 tiny squares. The objective was to fix a standard, so letters would remain proportionately constant in whichever size they were used.

The new alphabet, Romain du Roi, anticipated the computer by using the edges of the squares to draw the letters, but kept to the tradition of thick and thin strokes. The designs were engraved on copper plates and restricted for use by the Imprimerie Royale. Use by anybody else constituted a capital offence – a copyright for which nowadays a commercial corporation would give its right arm.

Romain du Roi, courtesy of St Bride's Printing Library, London.

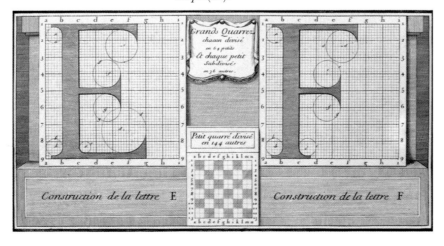

TYPE MATTERS

Most people read without seeing what they read. In all probability you – the reader – have no idea of the name of this typeface. Not that for most people it's of overwhelming importance. As David Ogilvy (advertising doyen) remarked, 'No housewife ever bought a new detergent because the advertisement was in Caslon.' However if a piece of text is difficult to scan, or looks unattractive, one isn't likely to read it either.

The graphic designer, who is preoccupied with such things, lives in a typographic world inhabited by serifs, counters, kerns and ligatures, where typefaces are exotically categorized into *Egyptian Expandeds, Latin Extendeds, Condensed Grotesques* and *Modern Romans.* Text is viewed in terms of colour and weight. Layouts deal with points, picas, and leads. The aesthetics involve space, proportion, scale, shape, balance, harmony, and order. There is more to it than meets the eye. Furthermore, the passions held by this fraternity can excite an intensity of opinion equalled only by medieval ecclesiastics arguing how many angels can dance on the head of a pin. Real passion surrounds ideological commitments to symmetrical or asymmetrical arrangements, fervent allegiances to particular typefaces, unremitting hatred of others, and even moral issues; 'Using bold caps', declares Paul Rand, 'is like wearing belt *and* suspenders.' (Hmmm!)

However, typography is not an esoteric cult practised by a lunatic fringe of the design community. It is, so Peter Behrens claimed, the most characteristic portrait of a period, and – among other things he was also a typographer – 'the most severe testimony of a nation's intellectual status'.

READING BETWEEN THE LINES

A desert explorer writes how a Bedouin examining camel tracks in the sand and crumbling dry droppings between his fingers was able to construct a scenario out of this meagre information. 'They were Awamir. There were six of them. They have raided the Hunuba on the southern coast and taken three of their camels. They have come here from Sahma and watered at Maghshin. They passed here ten days ago.'

Man could read long before he could write, and in his journey from tracking to writing developed many ingenious ways of recording thoughts and transferring messages. Apollinaire said that one can paint whatever one likes: 'pipes, stamps, postcards or playing cards, candlesticks, waxed cloth, collars, painted paper, newspapers'. The same applies to graphic messages. For instance tribes in the north of China would dispatch a piece of chicken liver, three pieces of chicken fat and a chili wrapped up in red paper. The import of this was 'prepare to fight at once'. Other systems were less messy. The Peruvian Incas had *quipus*, an elaborate system of strings which came in different lengths, thicknesses and colours, and were knotted at various intervals to signify something or other. African tribes threaded cowrie shells in different combinations and directions. The Iroquoi Indians made belts stitched with shells or beads – *wampum.* All systems to convey thoughts. This sad love letter found in Siberia, constructed out of birch bark, apparently says: 'You are far away, you love a Russian woman who stands in my way; there will be children, you will have joy and a family. I will always think of you even if another man loves me.' God knows how it was deciphered, but you have to take some experts on trust.

A collection of characters

Eleven are symmetrical, have neither back nor front, and look the same when reversed:

A H I M O T U V W X Y

Seven look the same upside-down:

H I N O S X Z

Nine read just as well even if flipped forward and over to stand on their head:

C D E H I K O X

The Siberian love letter made in birch bark meant a lot to someone.

Designers' thinking

Designers usually work to the requirements and constraints of a commission. The endless fascination of design is how the rational analysis of problems using training, knowledge and experience are used to conduct and temper the intuitive jumps of creativity. This is designers' thinking: left-hand and right-hand brain working together as perfect complements.

The designer is born with a mind's eye that can see form, shape, pattern, space and perspective without the aid of a paper and pen, or a computer program, screen and printer. This ability to design while walking down the street tends to give constancy to a designer's creativity.

There are recognized ways to elicit a creative idea from a brief; absolute originality is as rare as the blue moon. Designers may use figurative thinking to produce appropriate visual wit. Designers may use childhood thinking to cut through the blurring of jargon briefs. They may use pun images; they may parody styles out of context, or appropriate old ideas and styles in new contexts. It all involves different ways of looking: the antithesis of seeing without thinking.

The figurative wit

Puns, metaphors, clichés and analogies, although really literary definitions, also conveniently describe areas of figurative design whose images deal in meaning rather than description.

Pun: A humorous use of word or image to suggest different meanings.

Metaphor: The application of a description to an object, action or event to which it does not literally apply.

Cliché: Literally translated from the French, a printing plate; hence something that is repeated until it is hackneyed.

Analogy: A description derived from a process of reasoning from parallel or similar cases.

A visual idea is a pictorial response to an abstract problem. Through the marriage of word and image (or image and image), the designer creates an alluring shorthand to encourage viewer recognition. Through skilled manipulation, interpretation, and juxtaposition of disparate elements, the designer works to create new images which either literally or figuratively convey specific meaning.

The involvement of symbolism, analogy or metaphor may further serve to satisfy visual problems of particular intellectual demand. By visually linking disparate themes, an analogy may concisely present an idea which otherwise would take many words to explain. The visual symbol may reduce an idea to its essence.
WOODY PIRTLE

RIGHT: *Analogy: moving card for a silk screen printer. Partner, John Rushworth*

Pun: poster for a lecture by Woody Pirtle to the AIGA in Iowa. Partner, Woody Pirtle

Portraits of famous British Personalities from 1945 to the 1990's are on permanent exhibition at the 20th Century Galleries in the National Portrait Gallery.
Free admission. Open 10 to 5pm weekdays, 10 to 6pm Saturdays and 2 to 6pm Sundays.
Nearest ⊖ Leicester Square & Charing Cross

Metaphor: poster for the National Portrait Gallery in London. Partner, Alan Fletcher

Cliché: cover for a book by Tony Hendra on the 1990s before they happened, published by Avon Books, 1989. Partner, Paula Scher

MDC
PRINTS LTD
HAVE
MOVED
THE NEW
ADDRESS IS
UNIT 11
23-28
PENN STREET
LONDON
N1 5DL
TELEPHONE
729 7442
FAX
729 7932

Puns

**'The good pun has only
one careful owner, but
what you see is what
you don't get.'**

74

*A scatological variation
expresses, and maybe warns
of, a play's demeanour on a
poster for the Parallax
Theater in Chicago.
Partner, Michael Bierut
OPPOSITE: A 1980 poster
for Knoll Furniture.
Partner, Woody Pirtle*

Hot Seat

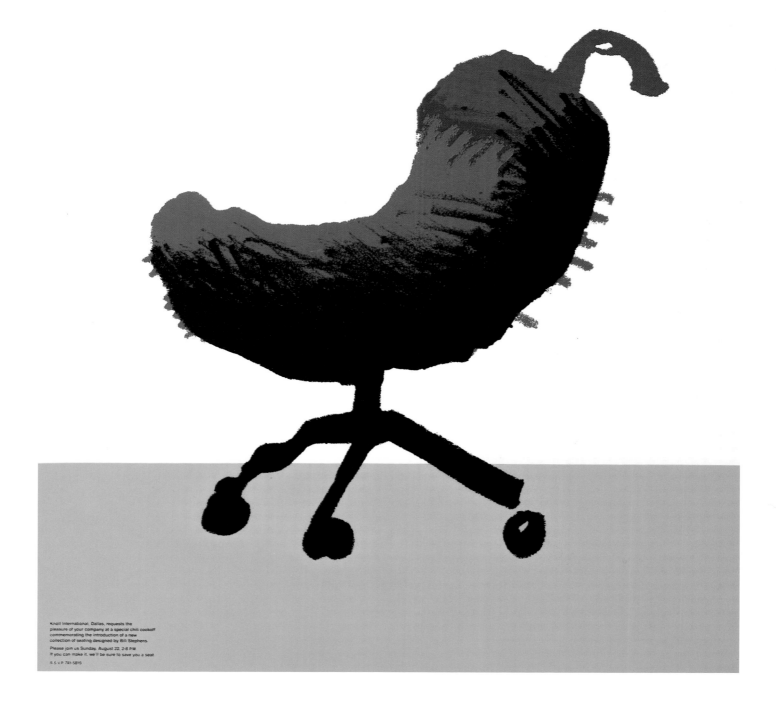

Knoll International, Dallas, requests the pleasure of your company at a special chili cookoff commemorating the introduction of a new collection of seating designed by Bill Stephens.

Please join us Sunday, August 22, 2-8 P.M. If you can make it, we'll be sure to save you a seat.

R.S.V.P. 741-5816

76

A blow-up of Pentagram's
own letterhead was used as
a poster inviting entries to
an exhibition of letterhead
design, held at a small
typographers' gallery in
Chicago.
Partner, Colin Forbes

The promotion of Father's
Day at Brookstone, the
specialty gift store.
Partner, Michael Bierut

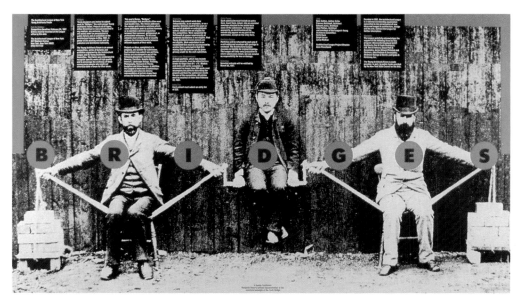

A call for entries from young
architects to a competition on
the theme of bridges, organized
by the Architectural League
of New York in 1987. (The
old photograph was taken to
demonstrate the engineering
integrity of the Firth of Forth
Bridge design.)
Partner, Michael Bierut

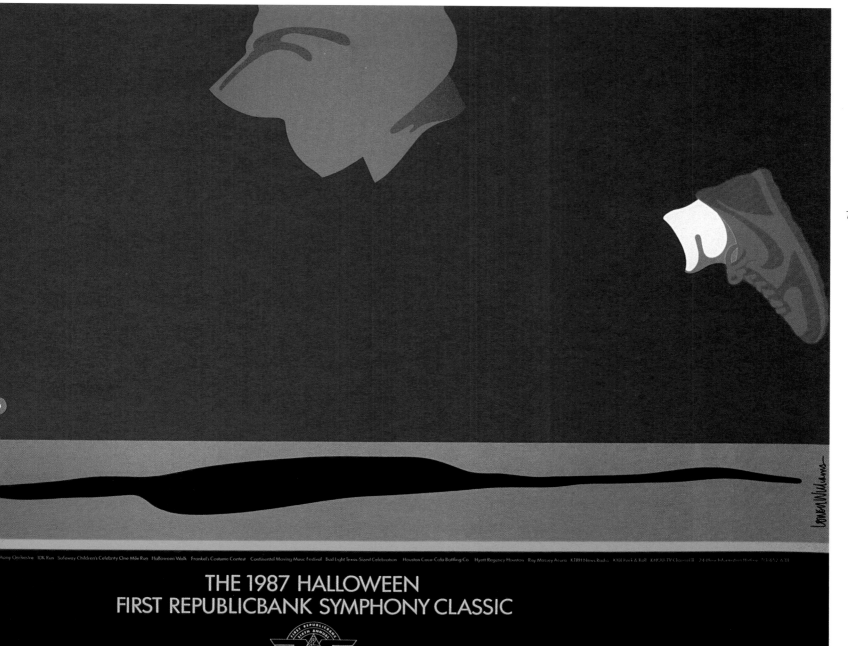

THE 1987 HALLOWEEN
FIRST REPUBLICBANK SYMPHONY CLASSIC

*A Halloween 'Run for
Symphony' fund-raising
campaign poster.
Partner, Lowell Williams
Illustrator, Andy Deewater*

78

A poster promoting a lecture to the Baltimore Chapter of the AIGA by Michael Bierut, who is used to having his name misspelt.
Partner, Michael Beeroot

Symbol for a New York breakfast club for women design managers.
Partner, Colin Forbes

The centre spread of a six-page advertisement for fashion designer Yohji Yamamoto in the Japanese magazine Zero 3. *The cityscape, which continued across all three spreads, is composed of the names and addresses of every one of the company's stores in the world.*
Partner, Peter Saville

The Shoshin Society in Washington DC invited a number of designers around the world to contribute to a series of international exhibitions marking the 40th anniversary of Hiroshima. The 'Peace' poster was contributed by Colin Forbes.

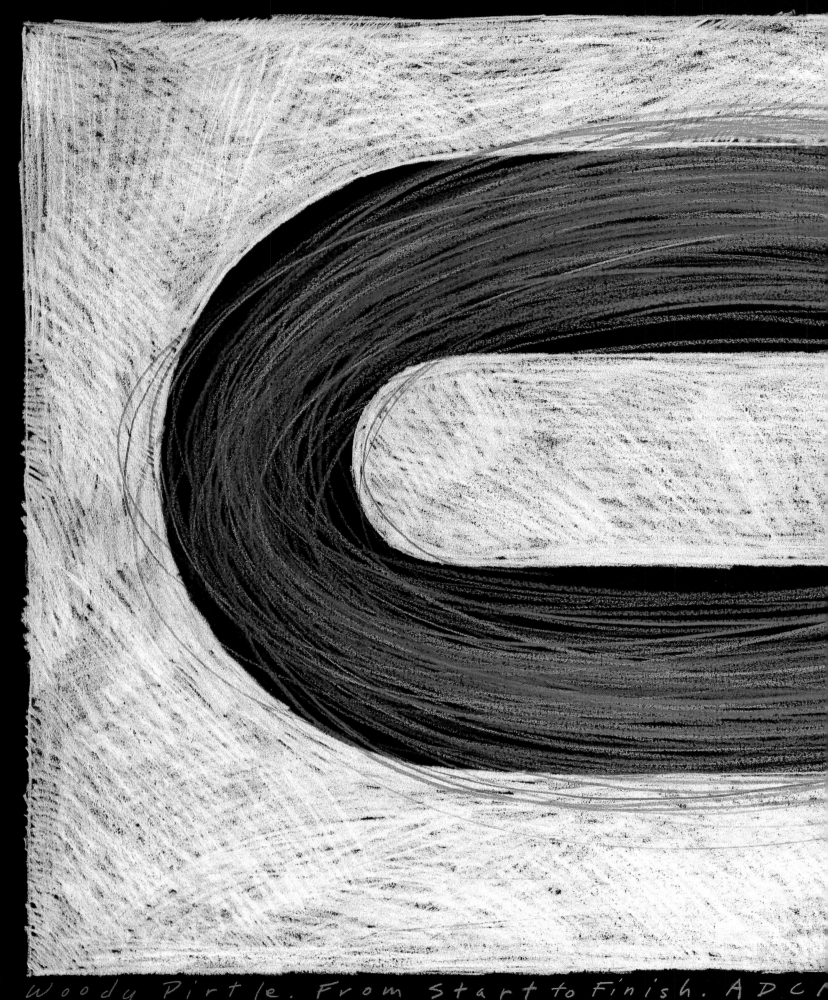

Woody Pirtle. From Start to Finish. ADC

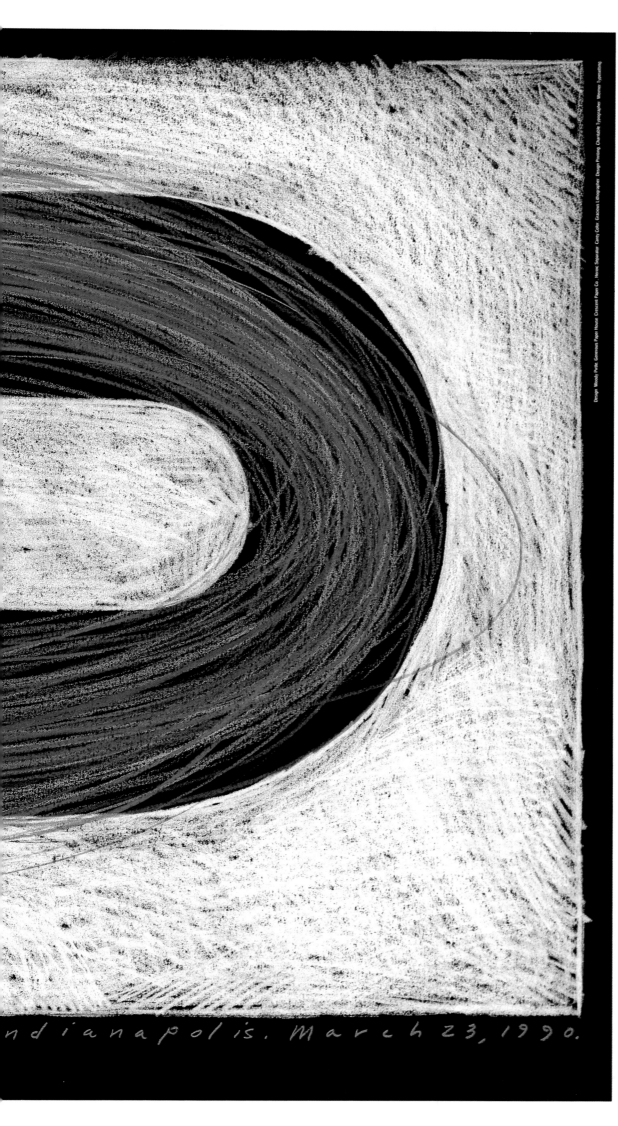

ndianapolis. March 23, 1990.

Design Woody Pirtle. Generosus Paper House. Crescent Paper Co. Heroic Separator Gerry Cofer. Gracious Lithographer Design Printing. Charitable Typographer Weimer Typesetting

A poster for a lecture in Indianapolis was inspired by the Indy 500 race, and done the night before the deadline, by hand, at home.
Partner, Woody Pirtle

Metaphors

'A metaphor starts with a jump and carries on down two roads at the same time.'

ABOVE: *A catalog cover for the University of California Los Angeles Winter Exhibition (it never snows in California). Partner, Woody Pirtle*
OPPOSITE: *The image for the 1989 summer school at the University of California, Los Angeles, was used on the poster as well as on the course catalog cover and T-shirts. Partner, Woody Pirtle Photographer, Bill Whitehurst*

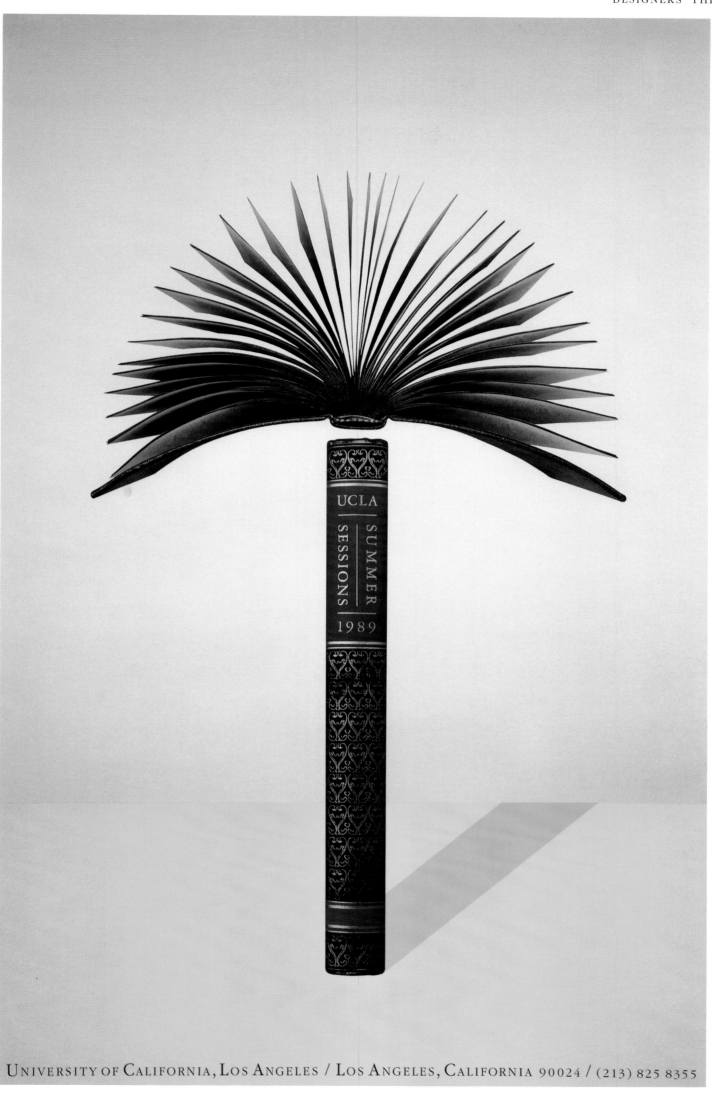

UNIVERSITY OF CALIFORNIA, LOS ANGELES / LOS ANGELES, CALIFORNIA 90024 / (213) 825 8355

84

Predictions, *a promotional folio of papers from the Simpson Paper Company, portrayed visionaries from different walks of life using the essence of their fame or talent as the basis for their illustration.*
LEFT TO RIGHT: *George Gallup, pollster; Henry Ford, automobile industrialist; Charles Richter, seismologist; Frank Lloyd Wright, architect. Partner, Kit Hinrichs Illustrators, John Craig (Ford), Dave Stevenson (Richter and Wright)*

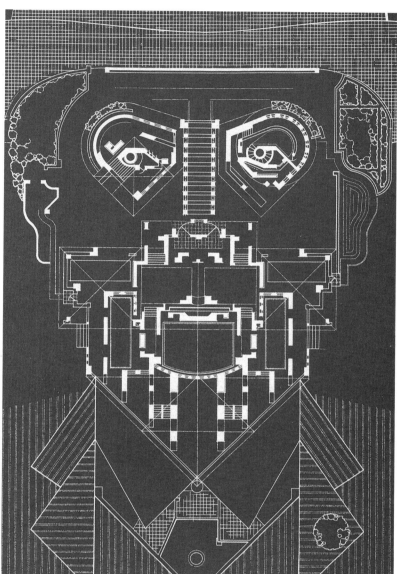

One of five posters donated by the graphic partners in London to SOS Kinderdorf, a network of villages in Germany for orphaned and abandoned children.
Partner, John Rushworth

Doublespace is a firm of two New York graphic designers who have a characteristic style based on collage. Their studio is arranged as a kind of disassembled collage, with each layer a thin, fat or curved wall. A passage divides the space into two halves, with one side occupied by the designer who is very neat and tidy, and the other side by the designer who is rather chaotic. The wall of the two designers' offices is specked with colored glass window holes – one side arranged tidily, the other chaotically.
Partner, James Biber

A 1986 poster for Daimler Benz marking the 100th anniversary of the automobile.
Partner, Alan Fletcher

LEFT: *A poster for Designers Saturday, when studios and showrooms opened their doors during the day and gathered for a huge party in the evening.*
Partner, Alan Fletcher

Clichés

'The good designer can stroke a cliché until it purrs like a metaphor.'

88

*Beer bottle label for
Watneys.
Partner, John McConnell*

*Papertalk is an A4-sized
notepad computer with a
touch screen, designed by
Kenneth Grange for the Eden
Group. The company also
commissioned Pentagram for
the product identity.
Partner, John Rushworth*

*The Good Diner is a
restaurant offering square
meals on 42nd Street,
New York.
Partner, Michael Bierut
Illustrator, Woody Pirtle*

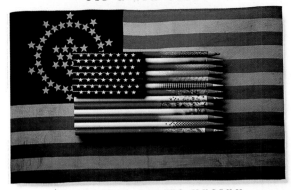

90

ABOVE: *The poster
promoting an exhibition
of old and new flag
memorabilia at the
California Crafts Museum.*
RIGHT: *The same imagery
is used on a poster for 'Ideas
on Design', a Tokyo
exhibition of Pentagram's
work.
Partner, Kit Hinrichs
Photographer, Bob Esparza*

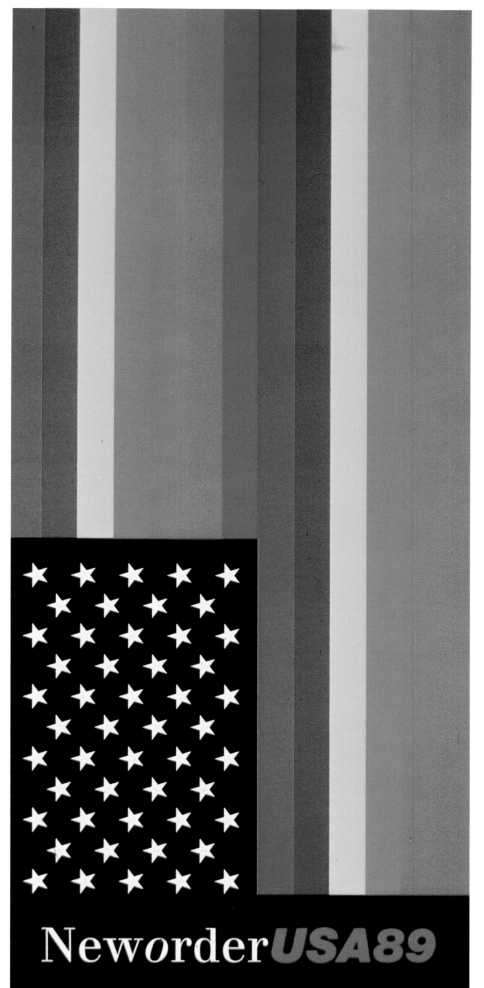

NeworderUSA89

The design for posters and
merchandizing celebrates the
arrival of the 'rave' culture
in the USA with the 1989
tour by New Order.
Partner, Peter Saville

UNION
JACK

The 1986 International
Design Conference in Aspen,
Colorado was on 'British
Design'. A variety of images
based on the Union flag was
produced – as actual flags as
well as postcards and other
print items.
Partner, David Hillman

Analogies

**'People can imagine a
fresh slice of bread if
they are shown a stale
one.'**

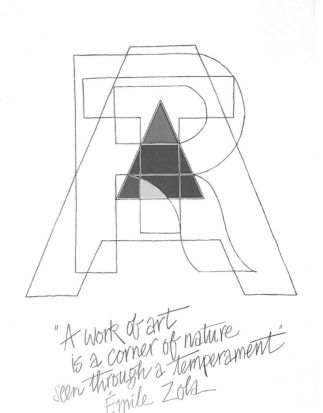

ABOVE AND OPPOSITE:
*Posters for IBM's corporate
art programme.
Partner, Alan Fletcher*

"Every work of art
is a child of its time."
—Wassily Kandinsky

94

NAEO

A poster commissioned by
NAPOLI 99 Foundation as a contribution
towards the cultural image of the city

*One of four poster designs
donated by different
Pentagram partners to
promote the Napoli
Foundation, established
in 1984 to combat the
deterioration of the city's
cultural assets.
Partner, John McConnell*

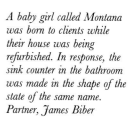

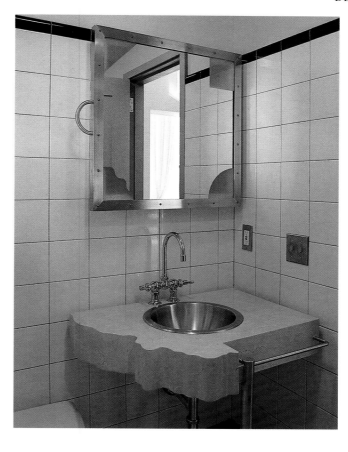

A baby girl called Montana was born to clients while their house was being refurbished. In response, the sink counter in the bathroom was made in the shape of the state of the same name. Partner, James Biber

LI

A proposal for a New York restaurant had tables in the shapes of the fifty states. Homesick out-of-towners would be able to book their home-state table; all the tables would be pushed together for a banquet celebration on July 4th. Partner, James Biber

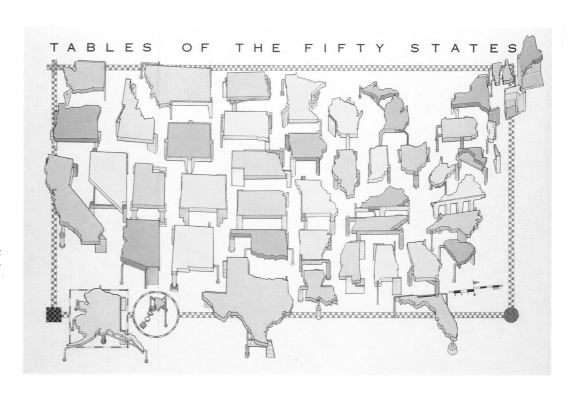

TABLES OF THE FIFTY STATES

*A poster for a 1984
architectural competition,
sponsored by the New York
State Council for the Arts, to
solve the problem of a vacant
lot in Harlem.
Partner, Michael Bierut*

*As an adjunct to an
exhibition on the history of
the Dutch PTT, the Design
Museum in London
commissioned a number
of designers, artists and
photographers to design
postage stamps on different
themes. 'Freedom' was the
theme chosen by partner
David Hillman*

Inner City Infill
A Housing Design Competition
for Harlem

Call for Entries
The New York State Council on the A
two-stage national open design com
housing on four adjacent sites in the
borhood of New York City. The comp
stress creative solutions to providin
mixed income, multiple site locatio
inner cities. Programmatic criteria w
mal—dealing with urban design an
a contextual sense; and social—de
issues of family, education, work ar
identity.

The first stage begins in July, 1985 v
due in October, 1985. The deadline f
September 9, 1985. The second sta
December, 1985 and end in Februar
intention of the sponsors to team th
appropriate developer and the city h
toward the construction of the winn

The four first stage winners will rec
each and proceed into the second a
The prizes for the second stage are
1st Prize $15,000
2nd Prize $7,500
3rd Prizes (two): $2,500 each

INNER CITY INFILL FLYER

Jury
Voting Members:
Max Bond, AIA, *Bond Ryder James Architects, P.C., New York*
Peter Calthorpe, AIA, *Calthorpe Associates, Sausalito*
Lewis Davis, FAIA, *Davis Brody Associates, New York*
Daniel Rose, *President, Rose Associates, New York*
Donald Stull, FAIA, *Stull and Lee Incorporated, Boston*
Ann Vernez-Moudon, *Professor of Urban Design, Univ. of Washington, Seattle*

Non-voting Members:
Donald J. Cogsville, *President, Harlem Urban Development Corp.*
Representative, *Manhattan Community Board 10*

Eligibility
Participation in the first stage is open to any architect registered in the United States. Associations of architects, designers, and their consultants who group together expressly for this competition will be admitted, provided that at least one member of the group is a registered architect. Members of the jury, the professional advisor, and the sponsor, together with their associates and employees are ineligible for this competition.

Registration and Questions
Requests for programs, completed registration forms, and all questions concerning the competition should be sent to:
Theodore Liebman, AIA
Professional Advisor
Inner City Infill Competition
c/o The Liebman Melting Partnership
330 W. 42nd Street
New York, N.Y. 10036

Fee for program is $25.00 and must accompany requests. A registration fee of $60.00 must accompany registration.
Information on the registration form (included in the program) will be used to determine eligibility by the Professional Advisor. His decision will be final.

This competition is sponsored by the New York State Council on the Arts, the Harlem Urban Development Corporation, Manhattan Community Board 10 and the New York Landmarks Conservancy.

Advisory Committee
Patricia Conway, *Kohn Pederson Fox Conway Associates*
Ghislaine Hermanuz, *Associate Professor of Architecture, Columbia University*
Pablo Vengoechea, *New York City Department of City Planning*
Townley McElhiney, *Director, Architecture, Planning & Design Program, New York State Council on the Arts*

Design: Michael Bierut
Printing: Kenner Printing

98

WOODY PIRTLE

CASSA
SEPT20
1990
SAN ANTONIO
MUSEUM
OF ART
6:00 PM

KIT HINRICHS

A poster for a lecture in Texas by partners Kit Hinrichs and Woody Pirtle on how partners in San Francisco and New York can collaborate effectively. The 'misery whip' saw format was drawn by Woody Pirtle, the detail of each half executed independently, and the two brought together for printing.
Partners, Kit Hinrichs and Woody Pirtle

K I T H I N R I C H S

W O O D Y P I R T L E

A double invitation for two 1984 events at IDCNY (International Design Center, New York): one for the Progress Architecture Furniture Awards reception, the other, a week later, for a lecture by NASA designers on spacecraft interiors. Partner, Michael Bierut

Notes on design

Alan Fletcher gathers some pertinent views and observations relating directly or indirectly to the design process.

Alwin Nikolai, choreographer: 'I prefer to drop a simple, single idea into my brain and let it rummage around for several months... two or three weeks before I begin to choreograph, I attempt to cast up the result of this Rorsach process. Then I like to choreograph swiftly and within a short span of time; I feel that in this out-pouring I keep the channels of my subject open.'

Bertrand Russell, philosopher: '...first is a problem, a puzzle involving discomfort. Then comes a concentrated voluntary application involving great effort. After this, a period without conscious thought, and finally a solution bringing with it the complete plan....'

Marianne Moore called poetry an imaginary garden inhabited with real toads. Ralph Caplan called design a real garden inhabited with imaginary toads, and suggested the designer's role is to realize the toads.

BLUE SKIES AND GREY BOXES

According to the late Jay Doblin, basically there are two kinds of designer: helicopters and vending machines. Helicopters fly around the landscape zooming in to investigate or backing off to get a better panoramic view. Vending machines tend to be inert until someone shoves money in the slot. They then produce a lot of buzzing, whirring, and clanking, until out pops a product. It is invariably the same as the previous one, and will be the same as the next. The only significant difference is that the next is usually staler than the one before, and so on.

WROUGHTING AND WRIGHTING

Bruce Archer's old great-aunt (he's a professor at the Royal College of Art) wrote that the catchy phrase of the three Rs (reading, writing and 'rithmetic) was coined in the early nineteenth century by a British Member of Parliament speaking on an issue of education. This, his aunt maintained, was a misquotation of an earlier aphorism: Reading and writing, reckoning and figuring, wroughting and wrighting.

From reading and writing we get literacy, and from reckoning and figuring comes numeracy. However there is no equivalent word for the ability to wrought and wright – the creation and making of things. At one time there was an effort to introduce the term Technics, but the only word in current use which gets anywhere near is Design – spelt with a capital D.

HAM AND EGGS

Design is what happens between the conceiving of an idea and the fashioning of the means to carry it out – whether the big stuff like painting a picture, composing an opera, writing a novel, conducting a military battle, or running a commercial enterprise; or even a small task like reorganizing a room. A few people also earn their living giving form to the amenities of life in the context of manufacture, communication, or place. They call themselves designers.

Whereas painters are concerned with solving their own problems, designers occupy themselves with solving those of other people. Actually that's an oversimplification. The real issue is the elegance of the solution. And that always leads to an intimate confrontation, as it is more of a personal challenge than a utilitarian discipline – a commitment rather than involvement. The difference, well exampled by ham and eggs, is where the pig is totally committed but the chicken is merely involved.

Konstantin Stanislavski, acting teacher: 'An actor must continually check his performance through line of action to make sure he has the right activity, order, logic, colour, contrast and that all these elements contribute to the projection of the super-objective.'

Anyway designers derive their rewards from 'inner standards of excellence, from the intrinsic satisfaction of their tasks. They are committed to the task, not the job. To their standards, not their boss' (Alvin Tofler). So whereas most people's lives are divided between time spent earning money, and time spending it, designers generally lead a seamless existence in which work and play are synonymous. In other words, as a designer I never work – all the time.

HANG TEN

Trying to describe how to ride a bicycle is notoriously difficult, and the same distance lies between experience and theory in trying to describe the design process. To my mind the current practice of defining design as 'problem-solving' smacks more of routine work than it does of creative thinking. In reality designers are committed to challenging situations where they can play with problems. And since that's a personal game, if someone asks a designer how he came up with an idea, you'll probably hear what he thinks you expect to hear. This can be anything from: it just popped up in his head; to the result of a mystical experience – like a lama levitating by reversing his polarities.

For myself I try to sum up the situation, back in edgeways, and cast around for ideas on which to hang further ideas. It's an intuitive process involving search, discovery, recognition, evaluation, and rejection or development. There are no specific rules or recipes. One might slip through a sequence of actions in seconds or sweat through step by step; start backwards, move randomly from one point to another, or do what surf riders call 'hang ten' – get your toes into the board and ride the waves.

However there is an essential condition: a capability for cerebral acrobatics so the mind can juggle the elements while freewheeling around the possibilities, a mindset which has the credulity of a child, the dedication of an evangelist and the spadework of a navvy – and all this dedicated to reach that 'condensation of sensations' which Matisse said 'constitutes a picture'.

SNAKES AND LADDERS

There is a sequence of stages in solving a problem. The initial one is getting the bits and pieces into some kind of order to point up the problem. The next move is to head off along the most likely route. The solution may be instantly evident, or lead to an exasperating period of hiatus when despite trying this and that, the answer remains elusive. Hopefully the germ of an idea eventually peeps through, but before leaping on it with relief let it incubate for a while. Here the mind works on it in some mysterious way. Either its potential evaporates, in which case one has to start all over again, or it emerges with 'a firm iridescent surface, and a notable increase in weight' (Henry James).

Not all so-called creative occupations conform to the same patterns of procedure. The complexities facing a designer differ in execution and timeframe from those of a painter or an architect, cook or music-maker.

Vivienne Westwood, fashion designer: 'I try one way of doing something, and then I try another, to see if that works. But even when I've done that I try its opposite, to see if that works.'

Mies van der Rohe, architect (according to a colleague): 'His solutions did not spring fully formed like Athena from the brow of Zeus but were painstakingly worked out, through a series of variations which he never tired of refining....'

Parody and Zeitgeist

The admiration of qualities found in earlier art and design may provide the basis for new ideas. Both parody and *Zeitgeist* respect and celebrate the orginals which inspire them.

One of the least understood forms of humor in graphic design is the parody. Often confused with influence, imitation or plagiarism, the intent of the parody differs drastically from all three. Particular graphic or literary influences may be appropriated as they relate to the subject matter. This eclectic approach to design problem-solving manifests itself in puns, similes, metaphors, and *Zeitgeist*. Imitation is the failed use of an influence, where a designer has pulled ideas from pre-existing sources but has not applied them in any way that creates something specific to the subject matter at hand, and has, therefore, created nothing original. This is most clearly inflected in the proliferation of styles exhibited by many designers, often used without any relation to content. Plagiarism is the nefarious act of stealing someone else's original work, concealing the source, and proclaiming it as one's own.

The intent of the parody is, however, never to conceal the source but to proclaim it loudly, change its context and thereby create the joke. While puns, similes and metaphors are subtle forms of humor, the parody exists to make the broad and obvious spoof. Parodies rely on surprise and absurdity for their humorous impact. They are most successful when the object of the parody is widely known in one form, and the parodist successfully twists its meaning. Parodies become most outrageous and controversial when the target is some form of icon that is viewed with reverence. One of the most famous examples is Marcel Duchamp's recreation of the Mona Lisa with a moustache painted on her angelic face. The graphic parodist is an imp with a sharp pin popping pompous balloons, for his or her own amusement and for the broad delight and amusement of others.

Zeitgeist is defined as the general intellectual, moral, and cultural climate of an era. For the visual artist, *Zeitgeist* becomes a tool of reference that helps him or her create a visual feeling that enhances an idea or enriches editorial material. The artist can make specific periodic references to create nostalgia, or may 'reinvent' an era in a contemporary context to create a new form. In some instances, appropriate use of *Zeitgeist* creates analogies, puns, and parodies. What remains constant is the artist's understanding of the tool as it relates to specific content. Without connection to content, *Zeitgeist* becomes merely the arbitrary use of style and decoration.
PAULA SCHER

TOP LEFT: *The poster for the US launch of the Swatch, after Herbert Matter's 1936 tourist poster. As many mistook the design for mere plagiarism rather than deliberate parody, the poster assumed a certain notoriety.*
Partner, Paula Scher
TOP RIGHT: *A poster for an exhibition on the work of Pentagram partner Kenneth Grange, after the ergonomic man by Henry Dreyfuss.*
Partner, David Hillman
BOTTOM LEFT: *A double parody poster for a lecture by Milton Glaser on 'inspiration'. It follows Milton Glaser's own well-known poster of Bob Dylan, itself a parody of a self-portrait by Marcel Duchamp.*
Partner, Woody Pirtle
BOTTOM RIGHT: *A poster for the D&AD 21st anniversary dinner at the Albert Hall in London, after Cassandre's man in a bathing costume for a 1930s Dubonnet poster.*
Partner, Alan Fletcher

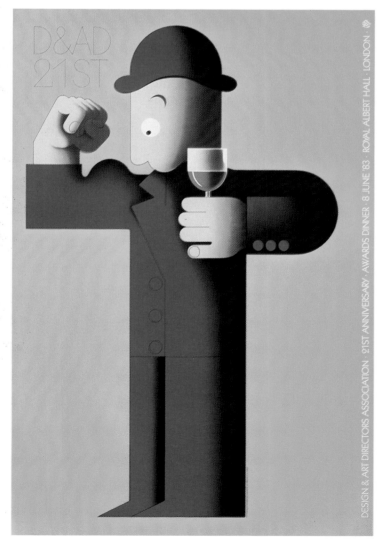

104

A spread from Information Resource Management (IRM), *a magazine published by Ericsson Information Systems, was derived from a page in a Polish pamphlet called* Reklama Mechano *designed in 1924 by Henry Berlewi.*
Partner, David Hillman

One of a series of summer workshops for design students run by Kent State University and Pentagram was on typography. The poster borrows from Cassandre's Bifur alphabet to produce a mosaic of geometric forms, requiring appropriate participation by the viewer.
Partner, Mervyn Kurlansky

A poster combining a number of record covers from a 1979 CBS series of jazz albums, each one using the characteristic angled wooden type of Constructivism.
Partner, Paula Scher

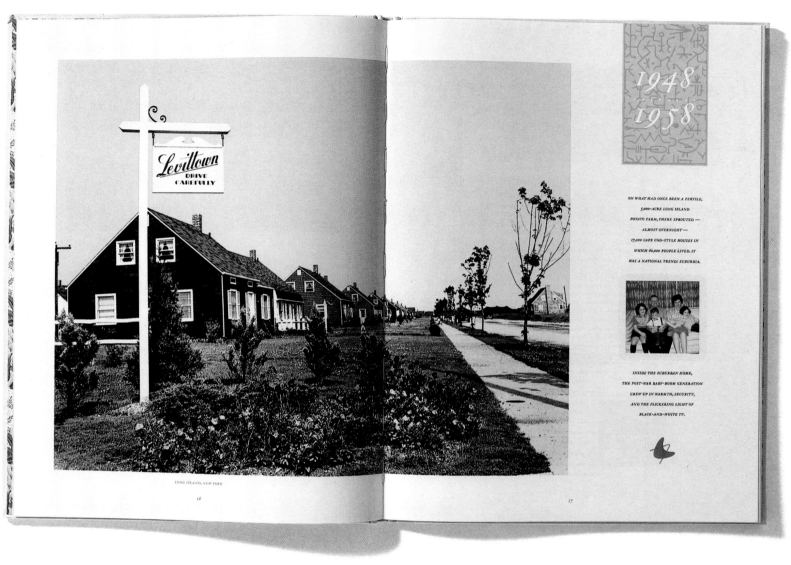

ON WHAT HAD ONCE BEEN A FERTILE, 3,000-ACRE LONG ISLAND POTATO FARM, THERE SPROUTED — ALMOST OVERNIGHT — 17,000 CAPE COD-STYLE HOUSES IN WHICH 82,000 PEOPLE LIVED. IT WAS A NATIONAL TREND: SUBURBIA.

INSIDE THE SUBURBAN HOME, THE POST-WAR BABY-BOOM GENERATION GREW UP IN WARMTH, SECURITY, AND THE FLICKERING LIGHT OF BLACK-AND-WHITE TV.

LONG ISLAND, NEW YORK
16

17

FANNIE MAE'S BIRTHDAY

Fannie Mae is one of America's great institutions. It was created by the Roosevelt administration during the years of the Great Depression as the Federal National Mortgage Association to provide mortgage funding for lower and middle income American families. In doing so Fannie Mae has enabled millions to realize the core component of the American dream – a home.

In 1988 Fannie Mae had its 50th anniversary. As part of the event is was decided to produce a booklet to celebrate Fannie Mae's role in the pursuit of this dream. Pentagram's brief was to work as a team with Fannie Mae to conceive, write, design, and produce the project. We proposed that the content be historical

and educative rather than corporate in character, and that we discuss problems as well as solutions and look to the future as well as the past. Our posture was to extend the understanding of how Fannie Mae works, and look at some significant economic and social events in America to which Fannie Mae has had to respond during its lifetime. It was a fascinating proposition and had strong emotional resonance for several members of the design team who have been able to own their own homes through mortgage financing.

The book opened with an introduction and was then divided into five major historical sections, each devoted to a decade. The pacing of the sections was conceived to give each decade its own

historical character. This was done through the use of nostalgic illustrative material from the period, which was chosen to emotionally orient the reader's imagination. The content is eclectic and varied: a mixture of photography, illustrations and historical cartoons. Not the least of the pleasures of the design process was researching and finding the pictorial and literary material which was woven into the fabric of the story. The finished book made a positive statement about the history of Fannie Mae, while showing that there are still many contemporary problems to be solved.
Associate, Susan Hochbaum
Writer, Jon Berendt
PETER HARRISON

106

The great sixteenth-century
Venetian architect Andrea
Palladio has been called 'the
most imitated architect in
history'. The Palladian style
is evoked in the design of the
Roschen Residence. Spaces
all relate to the rotunda,
centre of the home. Wings
contain the living room,
kitchen, garage with
bedrooms above. The
rusticated base, along with
the varying window sizes
and large entry space, give
the modestly-sized house a
grand scale.
Partner, James Biber

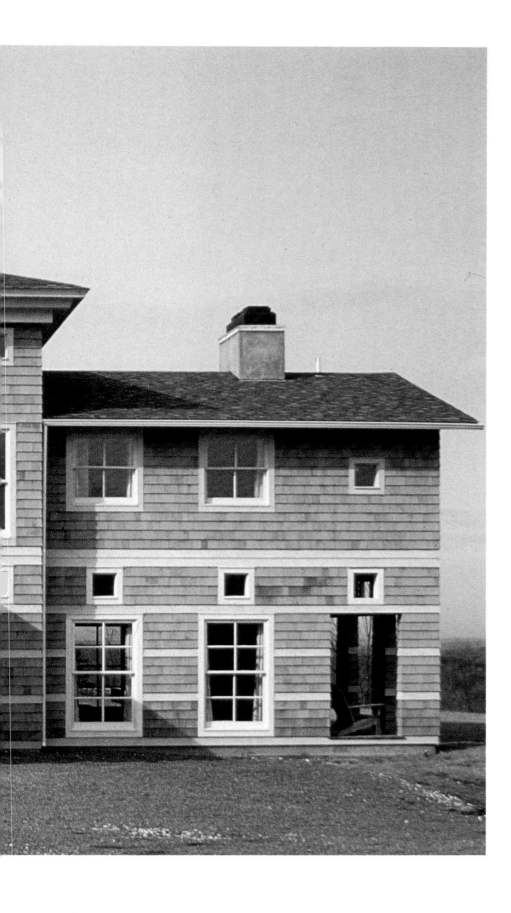

The jazz era of the 1940s is evoked by using the original logo for the 1984 relaunch of Manhattan Records' famous Blue Note record label.
Partner, Paula Scher

A record cover for New
Order's Thieves like Us.
The photograph was inspired
by Giorgio de' Chirico's Evil
Genius of a King. The
surrounding numbers are
from a table in Blair Castle
used for a medieval board
game, whose rules have since
been lost.
Partner, Peter Saville
Photographer, Trevor Key

a homage to Max Ponty

The French tobacco industry
body, SEITA, held a series
of annual exhibitions by
invited photographers,
designers, and artists. The
exhibit and poster for the
1989 designers' show is
taken from the Gitanes gypsy
motif by Max Ponty (one of
only two artists anywhere to
be credited on a cigarette
pack).
Partner, Alan Fletcher

An exhibition on the
Czechoslovak avant garde
in art, architecture and
design, which was shown at
the Design Museum, London
and the Museum of Modern
Art, Oxford. The poster and
catalogue borrow from the
Russian Constructivist
movement.
Partner, Mervyn Kurlansky

A proposal to provide a more substantial and meaningful form to the New York newspaper kiosk enlists the image of the campanile *bell tower and the spirit of the Vesnin Brothers' Pravda building, on a small-town, pedestrian scale.*
Partner, James Biber

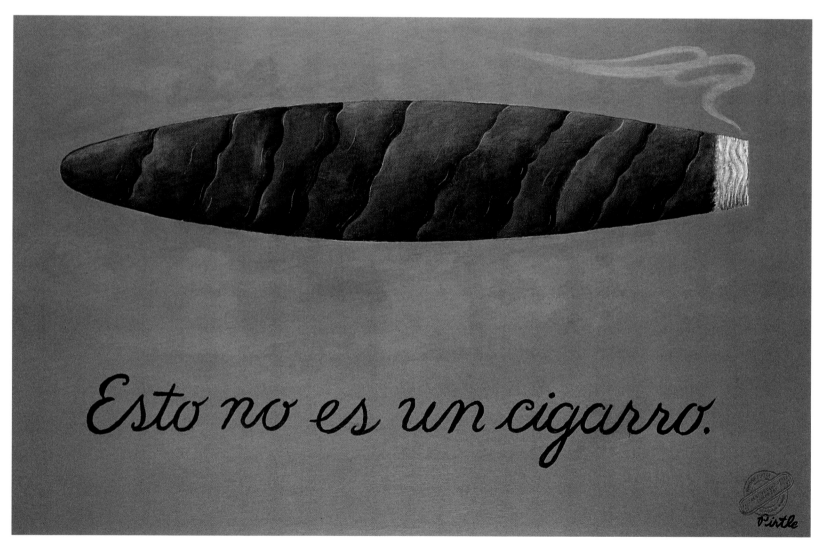

A poster for the Art Directors Club of Tampa, Florida, cigar-making city, after Magritte's The Treachery of Images.
Partner, Woody Pirtle

3-D thoughts

KENNETH GRANGE explains how many aspects of the problem have to be considered all at the same time in the design development of a product.

AGAINST CONSTRAINT

Twenty-one years in partnership with graphic and architectural designers have taught me that the boundaries between two- and three-dimensional design are constantly shifting, and are often spurious. For instance, the tactile quality of paper, or the sensory value of a matt or glossy varnish are revered in the graphic designer's world of imagery, communication and presentation. But are they so far removed from the obsessions for the roundness or finish of an object that are the province of the product designer? They are really different aspects of the same concern that all designers have for sensory experience.

Perhaps those who commission product design and graphic design within our clients' organizations have become so separated themselves that it is they who have enforced the separation of the product designer and graphic designer into constraining specializations. In our art and design colleges too, departmental definitions, rivalry and the focused nature of teaching keep students of different disciplines apart, although there is every reason to encourage and facilitate intermixing.

The value of cross-fertilization that comes from working in an office of different disciplines makes me wonder whether we ought to encourage the generalist again. The first industrial designers were architects, who often still regard themselves as generalists in the mould of 'Renaissance man'. It was the generalists' combination of skills that greatly helped the makers of furniture and fashion objects, Scandinavian and Italian in particular, to excel. The great generalists of design were certainly concerned with function, and their skill at presentation came as an inevitable bonus. Today we respect and admire the drawings of Leonardo da Vinci, but it is the purpose behind the drawings that makes him one of the great inventors of all time.

Product design is inevitably concerned with presentation, communication, and the appeal of the frontal image, but to this is added a concern for the back, the underside, the inside so that the product designer promotes the purpose of the product itself and how effectively it works. To describe the three-dimensional design process, therefore, is to chart the parameters of an activity which goes on within the boundaries of professional ground rules. As an industrial designer, one is combining the skills of an engineer, a craftsmen, an artist, and a marketing professional. In many ways it is a highly inter-disciplinary activity combining ways of working which, for other people, are highly specialized activities. Industry functions by orchestrating specialisms, and one of the designer's greatest contributions is an ability to range across these specialisms and to participate in all of them. Whatever their virtuosity, product designers must always carry fundamental credentials: those intuitive skills that defy systematization.

SYSTEMATIC OR INTUITIVE

Much has been written over the last twenty years in the cause of so-called systematization in attempts to make product design a rational, reductive activity which moves logically, like a scientific experiment, to a clearly defined end. In the 1960s much of this discussion was motivated by the desire to lend to design the same level of credibility that was attached to other business, industrial, and scientific disciplines. The 'cybernetic' revolution, so inspiring in its early phases, promised, amongst other things, the systematization of the design process. Academics – J Christopher Jones and Bruce Archer among them – published volumes on the specific nature of the rational design process based upon the activities of research, analysis, and synthesis. Archer invented the term the 'creative sandwich', and thereby reduced the intuitive act of creativity to an often slim filling between two wads of systematized and stodgy bread.

The ambition of these studies was to make design compatible with the more rational work undertaken by engineers and the other agents within the industrial process, and thence magically to fuse all the parallel processes into a single model. Inevitably reality fell short of these aims, and to a large extent design remains a much less clearly defined and more variable process than the other components of the manufacturing and mass-marketing process. Although I view the product designer's work as to some degree systematic, individual creativity remains paramount. The importance of very clear communications

between the members of the design and industrial teams necessitates a rational description of what is going on at all stages of the process; so product design is predominantly teamwork operating within a methodology that is clearly understood by all. But this cannot be allowed to subvert the creativity, the intuitive talent of the individual, that is the essence of design. While some aspects of designing products – sketching, making models, talking to production engineers, and so on – are inevitably common to every project, other aspects remain peculiar to the methods of particular individuals. My approach to the three-dimensional design process is both representative and special: when I am working as part of the team I follow the established methodology; when I am thinking and designing conceptually, creative short cuts and emotional involvement play their parts. Indeed, fundamental to the earlier stages of a design project is enthusiasm, and this motivates my early commitment to any project.

This essential emotional relationship with the level of potential associated with a project continues through the entire process of design. It characterizes the nature of my involvement with the process, however systematic it might be, or might appear to be, at certain stages. The excitement aroused by the act of invention is for me never dulled.

IMAGINATION FIRST
My working method is imbued with intuitive judgements: I light upon difficulties, such as mechanical incompatibilities, and resolve them as and when they emerge. I may be intrigued by the idea of making something more simply and cheaply. I may be preoccupied by the personality of a product or simply take pleasure in its function. Generally speaking I work from performance towards personality, although sometimes the former is so clear that I commence with the latter. Sometimes innovation consists simply in a change in a product's geography – moving something from one position to another; but the success of any design always depends in the way in which performance and personality complement one another, and in some senses become one and the same thing.

Very often the practice of product design yields many commissions merely to make an object more attractive, even beautiful, and thus potentially more profitable. This is a worthy enough occupation, but the potential to add invention is always there. This is the ultimate reward for the product designer – looking inside, looking behind, expecting the mechanics to be as beautiful as the cladding. My approach is related to the degree of attractiveness and usefulness offered by the envisaged product. At the early stages I make intuitive assessments, based on experience about the possible appearance of the product, the way it might be made, its price and its potential market. None of these can be considered in isolation, as it is their interrelationships which are the most important consideration of all. It is no good imagining a product which looks beautiful but which cannot be made economically or directed at a customer who both needs it and can afford it. The designer must always be aware of wider responsibilities.

Perhaps the most vital talent possessed by an industrial designer is this ability to think not only about half a dozen things at once but also about how they interact with each other. With experience, this can be done rapidly and spontaneously.

At some moments, for example, I may enjoy the sculptural problems presented by a product, and employ the skills of an artist to solve them. But where I differ from, say, a sculptor is in objectives: I am more concerned with discovering how to realize an overall aesthetic and functional ambition in any project. A chair, for instance, may be presented as a piece of sculpture and eulogized within the pages of design journals (whose purpose is ostensibly to comment on how industrial design affects a product's competitiveness in the marketplace), but we must also judge whether the chair will also provide a comfortable means of sitting and resting. And unlike engineers who define what a machine will do rather what it will look like, I will imagine the final product and then search for the techniques to realize it. Design can therefore be defined as: 'form made possible by materials', while engineering is better described as 'form dictated by materials'.

TOWARDS USEFULNESS
Ours is essentially a service industry, and our task is to create products which are both wanted and needed. So not only do product designers have to employ multi-faceted thinking: their loyalties also need to be focused in three directions at once. They must work in accordance with their own integrity; they must also satisfy the requirements of the manufacturer; and they must satisfy the members of the public who choose to live with the product that emerges. One way of resolving these three is to realize that if one focuses primarily on the needs of the consumer, then the manufacturer will also be well served and the product should then be able to sell easily.

At Pentagram we are all designers; we all work commercially for others and we all use the same intuitive creativity in our work. What makes us different is that we have all been given specialist name-tags. These have been imposed on us largely to explain ourselves to outsiders. Yet the product designer, perhaps more than any other, has a general role, with many particular responsibilities and many particular skills. It is the marshalling of all these at once that distinguishes product design. Although this inevitably means compromise as a way of life, the satisfactions are not diminished. And as experience gradually emerges through one's working life as the key determinant of success, compromise and the way it is handled actually become a positive part of the industrial design process. It is true that outrageous experiment has often been the spur to innovation in a common product; but experimentation should not be an end in itself, or not at least when the purpose of product design is to extend and enhance the value of design to industry.

Affluent, industrial societies will inevitably demand more invention and greater refinement in every man-made object, and this demand is bound to be transmitted to the designer. The creative mind that turns design toward production and away from design for the one-off will have what I regard as true inventiveness, and that instinct – together with inquisitiveness – lies at the core of what produces useful and pleasing product design.

Architect as art director

THEO CROSBY argues for a stronger relation of art to modern building, and illustrates the point with work for two recent buildings in The Netherlands.

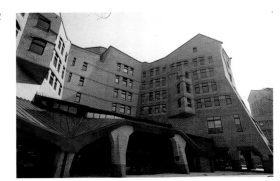

The PostBank NMB Headquarters lays claim to being the most energy-efficient new building in the world, integrating basic principles of thermal storage, recycling and solar energy.
OPPOSITE: *The VIP entrance lobby of the building features a stained glass window and original painting by Dutch artists.*

One of the constant preoccupations in our work is the relation of art to building. This relationship, which was ordinary and integral from the beginning of time until very recently, has largely disintegrated.

The separation of the arts began in the early nineteenth century with the invention of photography. The artist was gradually eased out of his main social function, the representation of contemporary reality. Artists were forced to look for another role: decorator, prophet, shaman. The first of these roles, the decorator's (the others still flourish), began to be undermined by the factory system, which made every aspect of decoration cheaply available, and in such quantities that it provoked an aesthetic reaction (the Modern Movement) of such power as to destroy the whole idea of decoration. After 1945 we began a process of simplification and austerity that simply shunted the artist into a marginal role. At the same time the host of decorative crafts, which had pleasurably employed many thousands of craftsmen, began to disappear quietly. By the 1970s 'decoration' and 'ornament', along with 'beauty', were forbidden words in the architectural lexicon.

It has become clear that the decorative impulse is the casualty of ever-increasing industrialization. The use and exaltation of technology makes for simple, interchangeable forms and for banal surfaces. These deliberately lack identity, so that they can be sold and used anywhere. The machine processes are so complex that it is impossible to manipulate the material at its source, except at enormous expense. Art is therefore placed outside the building, gesturing hopelessly in the piazza, or safely hung in corridors by the chairman's wife.

One of the restaurants in the NMB HQ with murals and quilted roundels by Polly Hope. She also provided the fabric for the curtains and the banquettes. The red granite tables and terracotta stained woodwork unify the room, whose theme is concerned with the earth, the dunes, the grasses and high sky of Holland.

It has slowly begun to dawn on architects that the world of catalogue architecture has its limitations. It has also become clear that the industrial process, with its ever-growing promotional, distribution and sales costs, has begun to price itself out of the market. It is now much more economical to use the traditional materials, to employ artists and craftspeople. These resources cost relatively little and the rewards in individuality and identity are great.

It is therefore no accident that we begin to see a slow but inevitable return to the arts and crafts, and architects begin to learn again the old process of collaboration. Because the profession has, in recent years, seen several sectors previously under its control slip away into the hands of engineers and project managers, or to the new professions of interior design and graphic art, architects are understandably reluctant to involve other disciplines. But there are many compensations. Artists offer a possibility of that new style that has eluded us. Mainstream Modernism, in which we are all now trained, carries overtones of authority and commerce which are distinctly unendearing to the public. There is also a desperate lack of language, of signification in our architecture to which art, decoration and ornament can provide new clues. We are forced to think again about our practice and intentions. We might do worse than trust our contemporaries in other disciplines, and make a role and a place for them in our buildings.

These arguments are illustrated in the work for the PostBank NMB Headquarters building in Bijlmermeer, south Amsterdam. Here the clients believed in art, in discussion, and collaboration, and set a careful, demanding, and individual brief. The result is that the artworks, murals, sculptures, floor patterns, and landscaping all fall into a natural and unassuming place in the building, which is in itself a *tour de force* in many dimensions. These dimensions are to do with low-energy consumption, daylit, and humane office spaces, a wonderful sense of communality, and shared public space.

Also in Holland, in the Plaza Centre in Rotterdam we were able to conduct an equally complex experiment. Here the identity of the place – offices, flats, a large casino and a small shopping centre – was established through the art works. Large gilt sculptures mark the entrances, whilst internally works of art serve as a focus within the atria containing the shops. There is much decorated glass to identify the casino. Opened in June 1992 it is too early to judge the success of this 'humanising' venture.

ABOVE: *The Casino entrance on the main axis of the building is announced by Theo Crosby's 'Flora' sculpture. A Goddess of Plenty she stands, like Fortune on a globe, supported by a capital of Dutch flowers, tulips and daffodils.* OPPOSITE: *One of the tall atria with floating, glare-free umbrella lights.*

TOP: *The Plaza Centre, opposite the railway station in Rotterdam is a sleek aluminium faced office building, with an arcade of shopping below, two atria and a large Casino. The shopping functions are signalled by the gilt roundels 3.3 metres in diameter by Bernard Sindall.*

Storytelling in pictures

Apart from realizing the imagination, there is a kind of spirit and wisdom in pictures that can complement or even supplant the words of a story.

As a child of five, I remember sitting in a circle with the rest of my peers eating Graham crackers and sipping milk from a wax-coated, half-pint, cardboard container while listening to Mrs Berger, my kindergarten teacher, regale us with tales of *The Three Bears, Hansel and Gretel,* and *The Ugly Duckling.* It wasn't just the stories she told, but the magical way she told them that made the experience so mesmerizing. Each 'bear' had its own bear-like voice, and Goldilocks, that silly twit of a girl, sounded as silly as she obviously was, going into a bear's home and eating their porridge. We followed along wide-eyed at the rich illustrations on each page, adding style and color to the voice and gesture of my teacher.

We've all grown up with, and remember in vivid detail, our own childhood experiences, and remember the long-term impact on our own individual lives through the medium of storytelling.

For thousands of years, stories have carried our cultural 'genes' from one generation to another. Today's storytellers, designers, film makers and television producers use new skills and sophisticated technology to educate, inform, entertain and persuade.

Man may no longer huddle beside the evening fire and watch the shadow play on a cave wall to learn or be entertained, but the flicker of light from the motion picture screen, television set, computer console, or reading lamp still captures the minds and emotions of the next generation of the children of the twenty-first century.
KIT HINRICHS

HEAVYWEIGHT CHAMPIONSHIP

OPPOSITE AND OVERLEAF: *Pentagram was asked by Hal Riney and Partners, an advertising agency in San Francisco, to design a souvenir program for the World Heavyweight Championship fight at the Mirage Hotel in Las Vegas. The concept was to use life-size photographs to show off the incredible physique of the contestants, Evander Holyfield and Buster Douglas.*

Bob Mizono had already photographed both fighters during training sessions in preparation for the fight. When he arrived at Buster Douglas' training camp, Buster, who was overweight and badly out of shape, refused to take off his T-shirt to be photographed. Fortunately Bob was somehow able to get him to change his mind (an unenviable task), or the whole idea would have gone out the window at that point.

Working with the unedited photo take, we selected shots that would best contrast the two fighters. Although we had their vital statistics, we spent a lot of time making blow-ups on the Xerox machine, which we held up against the largest people we could find in the vicinity to try to determine the proper scale of the images. Buster Douglas' arms, which reach eighty-three inches, needed a double gatefold to show off, and that became a dramatic centerpiece. The program was printed by Woods Litho in Phoenix using their five-hundred-line Ultra Dot system, which allowed us to show every pore and drop of sweat in the photography.

Unfortunately, Buster Douglas never did really get in fighting shape and the fight turned into a rout; so this turned out to be a case of the souvenir being more memorable than the event.
NEIL SHAKERY

FOREARMS: Douglas: 14" Holyfield: 12½" (Pictured)

WAIST *Douglas: 35" Holyfield: 32" (Pictured)*

EVER
MADE

Y ou can't
schedule cour-
age. You can't
order up courage
for a quarter 'til,
because you never
know how much you
need until a quarter
past. "Courage,"
Shakespeare wrote,

"mounteth with occa-
sion." Buster Douglas
found both when he got
up to beat Mike Tyson.
No one, including
Evander Holyfield, will
outcourage Buster
Douglas.

*Edwin Pope,
Miami Herald*

EVERYBODY'S BODY

National Medical Enterprises is the second-largest health care group in the USA. The company owns and manages acute, rehabilitative, psychiatric, drug abuse, and long-term care facilities. One of the most important aspects of their annual report was the need to show the synergy between the different health facilities within the group; after all, a person often goes into hospital needing more than one type of treatment. Our job was to describe and explain visually the relationships between a range of complex and highly technical medical services. The subject matter we were dealing with was fascinating, but how best to communicate the workings of arthroscopic surgery, sonic wave treatment or neurological brain mapping?

Explaining something to someone else always tests whether you have really understood it yourself. This is where storytelling can be so important – especially when the subject is complex and the reader has no direct experience or specialist knowledge. The trick is to draw him in and create a sense of discovery. The first (usually the strongest) idea was conceived during the initial briefing meeting. The essence of the idea was to represent symbolically the thousands of procedures performed on tens of thousands of patients, by portraying scores of the key procedures on a single man, woman and child.

We literally took the body apart bit by bit. For visual impact, we suggested a large pull-out, with a woman and child on one side and a man on the back. The remainder of the report and the financial information would be treated very simply, so that the pull-out would provide a strong contrast. It would visually describe the essence of the business as well as being an interesting object in its own right.

As nudes are not commonly found in annual reports, finding models for the photographs raised several interesting questions. What types of people should we use? They had to be average, interesting and attractive, but not too sexy (a Playboy *centrefold, I didn't need). We also had to deal with the question of body proportion in relation to the physical size of the page. Our first male model was far too big and muscular.*

As always, on the day of the shoot, various practical problems needed solutions, such as eliminating tan lines, improving calf muscles with the aid of sandbags, and ensuring that the baby would be raised high enough to be visible in the top section of the pull-out. All this was part of the pre-planning exercise. Our models were great, especially our 'Mum', who was warm and caring towards the baby, and remained remarkably calm even when it peed all over her during the shoot!

As soon as we had good photographs of the models, we contacted four artists to achieve a variety of illustrative styles. Symbolic and medical illustrations were mixed with whimsical sketches to help explain the different parts of the hospital service. The final photography, together with all the illustrations, diagrams and typography, was composed electronically to create one seamless image for reproduction. A bonus for our client was the use of the gatefold as a separate handout at hospitals across the country.
Body photographer, Michelle Clemant
Anatomical illustrator, Vincent Perez
Diagram designer, Justin Carol
Topic illustrator, Tim Lewis
KIT HINRICHS

Reading between the lines

A brief is not a design brief if it contains assumptions about
the solution. A designer has some responsibility not to follow
instructions if there is a better way.

ABOVE: *Bob Gross, co-
founder of the advertising
agency Geers Gross, asked
for an invitation to be
designed for his daughter's
twenty-first birthday party.
Rather than the the usual
invitation card, a poster was
produced with the 'party'
letters having a rave up.*
RIGHT: *A poster was also
produced for the invitation to
the Geers Gross twenty-fifth
anniversary party. The
champagne glasses were
simply a white circle cut in
half, the champagne itself a
yellow circle cut in half. All
that needed to be added were
the glass stems, bases and
the bubbles.*
Partner, Alan Fletcher

The creative designer interprets briefs as starting points rather than
as finishing lines. He feels his way by challenging assumptions,
finding chinks in the specifications and reaching through to discover
the plums. It's an unknown journey, and trying to guess how long it
will take and what it might cost is a toss-up between experience and
faith – not a good basis for negotiating a business transaction.

Kenneth Grange once told me a story of how a designer com-
missioned to design a product to a rigid brief and for a fixed fee
meticulously went to work. On the day he presented his solution the
clients were so delighted they took him to lunch. Over coffee the
designer mentioned he'd independently produced another idea out-
side the brief, but if they wished to see it he'd expect an additional
fee for his efforts. After a consternation and curiosity engendered by
the euphoria of the lunch, the client agreed. He looked at the alter-
native proposal and was even more delighted.

Moral: the aim of any creative designer is not to give the client
what he thinks he wants, but what he never even dreamt he wanted.
ALAN FLETCHER

*Country Matters is a
business that sources unique
garden ornaments from
around the world for sale to
US clients. They approached
Pentagram for a catalog.
The market is so exclusive,
however, that an ordinary
catalog would hardly have
been appropriate. Instead a
'gift portfolio' was devised.*
*Each object was
photographed and tipped into
leaves of recycled paper, with
descriptions written in the
manner of an art catalog and
printed in letterpress. The
portfolios were individually
numbered and addressed to
clients.*
*Partner, Kit Hinrichs
Designer, Susan Tsuchiya
Photographer, Barry Robinson*

These reclining lions
composition stone with deeply carved full manes were
were inspired by the designs of Bertel Thorvaldsen (1770-1884),
19th-century Danish neoclassical sculptor who
other northern European artists. The lion bodies,
are realistically carved to show anatomical details
of the classical spirit that imbued the art of the time,
used to decorate the tops of gate piers at the entrance of
the Lion Gates at Hampton Court, Middlese

HEIGHT: 17 INCHES (43 CM), LENGTH:

ITEM 105

CRAIG
JOHNSON

COUNTRY
MATTER

Portfolio No

A commemorative brochure was proposed by Lloyd's of London to mark the 1987 opening of its new building designed by Richard Rogers. Concerned that no brochure could do justice to the event, Pentagram proposed a boxed album of loose-leaf sections called Building Lloyd's. Each section has nine folios of art-print quality. Five sections are devoted to the history and buildings of Lloyd's. A sixth contains the artistic impressions of the building by winners of competition mounted by Lloyd's for art students. The final section is a serious cut-out model of the new building, designed by Victor Veldhuyzen van Zanten. Partner, Alan Fletcher

*The Audit Bureau of
Circulations is a British
organization that certifies
the circulations of newsapers
and magazines. As its fiftieth
anniversary approached,
ABC decided to produce a
souvenir brochure. The brief
was definite: it was to be
A4 size and feature the
member of the Royal Family
who was to speak at the
celebration dinner, and
contain sponsorship
advertisements from ABC
member publications.
Pentagram's proposal was
to ask each member to choose
a cover or front page from
the past fifty years, which
would then be reproduced as
miniatures and boxed as a
souvenir set.
Partner, David Hillman
Designer, Vicki Gornall*

Fields of work

Design has great influence. It affects the competitiveness of commerce through stores, products and packaging, and the flow of information and entertainment through books and magazines. It affects perceptions of institutions and industry with corporate identities, and reputations with annual reports and corporate publications. It affects the appeal and ease of the environment, and the impression and function of buildings and interiors.

Most of Pentagram's work is carried out within three design disciplines, but the borders between these are open. Architects have a long generalist tradition; graphic designers may turn their hands to interiors and products; product designers may venture into typography; and graphic and product design skills are amalgamated for packaging.

When architects, graphic designers, and product designers all work in the same studio there is a constant trickle of learning, ideas and work between them. Thus different dimensions are added to traditional areas of competence. The work itself is also carried out at different levels, from original design and detailed execution to advice and direction.

Is it what it appears to be?

COLIN FORBES sees why identity design needs such special skills – first to discover and represent the essence of an organization, and then to promote the disciplines of its application.

Dubbed the 'Seven Sisters', the world's leading oil companies were amongst the first to exploit the advantages of strong corporate design applied internationally. They had to: there is virtually no distinction between their actual products.

'In industry structure, a change requires entrepreneurship from every member of the industry. It requires that each one ask anew: "What is our business?" And each one of the members will have to give a different, but above all a new answer to that question.'
Peter Drucker,
Innovation and Entrepreneurship, 1985

Since the time of the ancient Greeks, philosophers have debated the nature of reality. Socrates maintained that the same object can evoke quite different responses in different people, even though its essential qualities remain unchanged. This debate has continued as a topic of Western philosophy: how to distinguish what things are from what they appear to be?

One of the most cerebral of all activities in design is seeking out the essence of an organization – and giving visual expression to these qualities. It touches on sociology, economics, and organizational dynamics. It requires studying the history and culture of the organization and its position in the economic and social firmament. It takes time. It calls for insatiable curiosity and skills in several disciplines. The design of corporate identity is therefore as much about behavior and attitudes as appearance. Those companies who fail to recognize this are often sidetracked by the ephemeral allure of mere cosmetic change. Design attempts to express what something is. Advertising tries to present things as the market wants them to be. Determining the elusive identity of an individual is complex, but the modern corporation poses even greater challenges. Anthony Jay succinctly describes the corporation's various guises of crystalline complexity when he says: 'The corporation is an economic unit. The corporation is a complex of organizational relationships. The corporation is an organization chart. The corporation is a concept, a pyramid, a state, a monster, a game, a jungle, a battlefield, a way of life.' (*Corporate Man*, Penguin Books, Harmondsworth, 1975.) The designer has to understand not only the individual elements, but also the relationship of each to the whole. This demands a real feeling and understanding of the structure of the organization. It precedes exploring the means of projecting this to the outside world whether through products or environmental style – that is to say names, symbols and logotypes, colors and typefaces, buildings, liveries, and so forth.

In planning an identity program, the designer helps a corporation to define its unique mix of characteristics. This has as much to do with making important distinctions clear as with presenting a unifying appearance. Resolving the contradictions of this double mandate – to unify *and* to distinguish – is where a major part of the designer's contribution comes into play.

By the mid-1970s, growth – by acquisition and internal – had left Lucas Industries, the UK-based automotive, aerospace and industrial systems group, with a clutch of different images for its different businesses. The new identity designed and managed by Pentagram gave the group an appropriate visual sense of cohesion while still allowing the differences between businesses.

Organizations need a framework in which occasionally to pause, assess, re-examine, and re-define their activities. A corporate identity program, with its uncompromising and neon-lit statements, provides a highly disciplined route towards this end. Truth is a prerequisite of an effective organization. An effective identity program provides a credible position from which to project an image of the corporation to its many audiences.

In behavioral terms, identity design harks back to early civilization. Hunting groups and tribes emerged as visual manifestations of complex organized behavior, and ancient kingdoms, priesthoods, and armies reached quite sophisticated levels of corporate design. Armies have always preserved their overall identity and distinguished between regiments and special service units to engender *esprit de corps*. In fact, the military's system of expressing a complex hierarchy by means of simple, recognizable imagery has seldom been improved on.

The UN, the Paras, the Commandos – different color berets conjure up very different images.

Early signs of change are usually visual, the symbol acting as both reflector and catalyst for those initiating the changes. Wally Olins put it well in emphasizing how 'behaviour and appearance symbolize the reality, reflect the reality and underline the reality all at the same time'. Selecting the example of Robespierre and the French Revolution, he describes how within a few days of the storming of the Bastille, the Tricolor was seen on the streets of Paris – it soon replaced the traditional Fleur de Lys. In August 1792 the Marseillaise – a new national hymn –

Unwitting symbol of the French Revolution.

was heard. The army's uniforms were also changed. The Revolutionary government was determined to obliterate totally one way of life and replace it with another. They replaced traditional weights and measures with new ones. They started an entirely new calendar. They forgot nothing. In order to despatch their opponents in a fashion more appropriate to the age they even introduced a new executing machine – the guillotine! ('Corporate Identity – the myth and reality', a lecture given by Wally Olins at the Royal Society of Arts, December 1978.)

Identity programs developed with the growth of national and international markets, mainly through the efforts of major oil companies and airlines developing systems to identify their activities – the first multi-nationals. 'Corporate identity' was honed into a perfected procedure after the Second World War by Walter Margulies in New York. The corporate identity manual, still used today by many companies, became a statement of modern organization in multi-national corporate culture. The 'Margulies method' proved to be one of America's most successful exports and was subsequently imitated in Europe and Japan.

The standard procedure consisted of interviews, inventories of existing materials, the creation of a design concept, and, last but not least, the standards manual. Time after time, these elements were incorporated into well-organized packages of name changes, logotypes, color schemes and typefaces that boards of directors could approve. Often they were merely a collation of limited applications ranging from letterheads to aeroplane tails. Consistency rather than quality was the rule. Ironically, the most impor-

tant element of all was often missing: the prescription for achieving quality in products, environment, and communications. By definition, the quest for quality is a strenuous one. Cosmetic change on the other hand is comparatively easy – but it won't change corporate behaviour or negative public perception.

The identity of a company, the quality of its products or services, and its public perception reflect the corporate culture. And this is usually created and sustained by an individual's vision and determination to achieve the best – together with an ability to communicate these goals to the corporation as a whole. Today the world economy is characterized by a proliferation of service businesses: accounting firms, legal practices,

management consulting companies. This poses special identity problems. The shift to a service economy has made the old identity techniques difficult to execute, for unlike the traditional smokestack companies, service companies traffic in intangibles. Absence of a physical product makes the traditional identity techniques less effective. Above all, it challenges the designer to create a memorable identity for companies whose distinctive features have been blurred by universal technology or regulation. For example, airlines the world over use the same equipment, and any bank that stands out by virtue of abnormal interest rates risks the attention of the law. Can a corporate identity program restore some degree of individuality to such companies?

The answer is yes. Effective coordinated design will improve the quality and appearance of products and services so that they are perceived to be better than the competition, and help differentiate the whole company with a clear, distinctive personality. Visual identity applies to any enterprise – however small. After all, a single office and a letterhead may be the only manifestation of a highly sophisticated service, and the first impression can be the most important.

'It should be borne in mind that there is nothing more difficult to arrange, more doubtful of success, and more dangerous to carry through than initiating changes in a state's constitution. The innovator makes enemies of all those who prospered under the old order, and only lukewarm support is forthcoming from those who would prosper under the new.' Niccolo Machiavelli, *The Prince*, 1514

129

Same planes, same airports, similar service: airlines use design to distinguish themselves.

The ubiquitous Coca-Cola identity is testimony to the pre-eminent quality of its design management. (Photograph courtesy of the Coca-Cola Company.)

November 1992

130

1 2 3 4 5 6 7 8 9 10 11 12 13 14 15 16
17 18 19 20 21 22 23 24 25 26 27 28 29 30

To encourage higher standards in the National Grid Company's photographic library, a competition was run in association with the British Journal of Photography, the prize being to shoot the company's 1992 calendar. The winner was Adri Berger – and the result a bit of a shock for those used to a more traditional glossy approach.

Around two thousand signs were required for three hundred and sixty sites across the country. The Wood & Wood Paneltex system was adopted.

IDENTITY INTO IMAGE:
THE NATIONAL GRID COMPANY

The world's first national electricity grid came into full commercial operation in the UK in 1935. Linking seven regional grids into one system, the National Grid ensured that demand and supply could be balanced simply and immediately, whatever and wherever the local variations. (The system only became a reality one night in 1938 when an enterprising but unauthorized experiment by engineers proved that the seven regional grids could be connected simultaneously.)

On 1 January 1990, fifty-five years after it was created and forty-three years since it was nationalized, the National Grid became a privately run business. In Thatcher's radical era of the 1980s, the idea of returning nationalized industries to the private sector was responsible for perhaps the single greatest change to Britain's economy, and has been emulated throughout the world wherever old socialist systems were being dismantled. The roster of privatizations during this time was extraordinary and included British Telecom, Jaguar Cars, Rolls-Royce, British Airways, the water industry, gas, steel, oil, and many others. Each commissioned a new visual identity to mark its new status. British graphic designers – and some American – had a field day; not always with a great deal of honour.

The electricity industry was one of the last privatizations and, because of its size and complexity and the unprofitability of nuclear power, the most problematical. It was achieved in phases, resulting in a new electricity industry in England and Wales made up of two generating companies initially, twelve distribution companies and the National Grid Company. Those distribution companies became the National Grid Company's shareholders. A number of fundamental objectives have been set in the running of the privatized National Grid Company. The first is to transmit power reliably and economically between the generators and the distribution companies, so that the distributors in turn can meet their statutory obligation to keep the lights on. The second is to give access to the transmission system to all electricity generators without discrimination – as long as they are licensed. The third is to ensure that the demand for electricity at any one moment is met by the power stations that are offering the cheapest-priced electricity – to the benefit of customers. This means that the National Grid Company effectively administers the supply and demand of the electricity market.

So the National Grid Company continues to carry its obligations for the supply of electricity to the nation through its traditional technical and operational role. In its new guise, however, the company is charged with the additional responsibilities of running the business in a way that pays a return on its assets. The National Grid Company has assets worth over five billion pounds. These include the high-voltage grid itself, two 'pumped storage' power stations, and interconnectors with France and Scotland. These represent about half of all the assets of the shareholding distribution companies.

Privatization meant, paradoxically, that the National Grid Company had to show off these qualities a little more publicly. The need gave rise to what has become a classic corporate identity design exercise. The shared attitudes, values, and priorities of a company are often called its corporate culture. Corporate design has first to identify this culture and give it visual expression. The technical and engineering achievements that originally created the grid, with the construction of thousands of miles of transmission lines all over the country, and all the legal palaver of permissions for all the pylons that carried them, produced an environmentally conscious engineering culture within the organization, which has been carried over to the new company.

The new corporate design had to project an identity which could give the people who work in the National Grid Company a symbol that they could readily identify with, and which represents the pride that is taken in the technical and operational excellence of the system. It had to distinguish the National Grid Company from the new generating and distribution companies, which together make up the whole of the new privatized electricity industry. It had also to

132

Key Operating Results

Weathering the storms

Some disruption to the transmission system was caused by the exceptional weather in early 1990, including the storm force winds on Thursday 25 January.

Although some work was needed to repair affected plant and remove wind-borne pollution, the storm conditions had greater impact on Area Board distribution networks and NGC was able to provide assistance during the recovery period.

Further high winds in February 1990 caused numerous transmission system circuit trippings in many parts of England and Wales, but with relatively minor disruption to transmission.

NGC's transmission lines are regularly inspected by helicopter patrols.

24

The specified elements of the National Grid Company's corporate image, such as typography and colours, are complemented by consistent attitudes to imagery. For the company's annual report and accounts these translate into a distinctive look that evolves year after year.
Associate, Justus Oehler

Transmission system

The Transmission Business is responsible for the planning, design, construction, operation, maintenance and control of the transmission system in England and Wales. It employs approximately 80 per cent of NGC staff.

Three geographically-based Divisions – Northern, Central and Southern – have been established with responsibility for the management and construction of the physical assets in their respective areas.

The day-to-day co-ordination and control of the transmission system is carried out by Grid System Management.

Central support is provided to the Transmission Business by System Development, Technical Development and the Commercial Department.

Regular inspections of transmission plant and equipment are carried out by staff in NGC's three geographically-based Divisions.

Charging

NGC's principal sources of income are the payments made by generators and distributors for their connection to and use of the transmission system. Charging principles are being refined with a view to establishing charges which reflect more accurately the location of generators and demand on the transmission system while providing users with a stable, equitable and understandable cost structure.

Income from charges for use of the transmission system and for connections in operation at 30 March 1990 is capped under the price control formula in NGC's transmission licence and amounted to £891.9 million in 1990/91. NGC estimates that the maximum revenue from these sources allowable under the price control formula would have been £934.8 million, giving a shortfall of £42.9 million which NGC is permitted to recover with interest through adjustments to its charges in future years. The actual shortfall compares with the estimate of approximately £38.0 million given in the prospectus. Income from new connections, which is not capped by the price control formula, amounted to £1.0 million in 1990/91.

Interconnections

The Interconnections Business is responsible for NGC's parts of the interconnections with the Scottish and French systems and for the commercial arrangements for their use. The present commercial arrangements allow the Scottish power industry and Electricité de France to trade with the Pool and to take or supply power to meet emergency requirements.

The availability of the Scottish interconnector circuits, which have an average capability of 850 Megawatts for North to South transfers, remained high throughout the year, averaging 96 per cent. Major work on the Stella West – Tonness circuit reduced availability to 62 per cent during September. The Scottish companies exported power to England and Wales for most of the year, and during this time the utilisation factor for the whole of the Scottish interconnection was 59 per cent.

The overall availability of the 2,000 Megawatt cross-Channel DC circuits was 91 per cent, but during the winter months, availability increased to 99.9 per cent. The available transfer capability of the interconnection with France was fully utilised throughout the year.

Ancillary Services

The Ancillary Services Business is responsible for contracting for the provision by generators of certain technical services, known as reactive power, frequency control, reserve and black start capability, which are used in maintaining the security and stability of the transmission system. This responsibility has been successfully discharged during the year.

Pumped Storage

The Pumped Storage Business operates the two pumped storage power stations, at Dinorwig and Ffestiniog owned by NGC. The Pumped Storage Business has developed its role as a competitive generator, while at the same time fulfilling its obligations under its Ancillary Services contract.

The stations have operated throughout the year to a high level of availability and reliability. Generated output was 1,358 Gigawatt hours from Dinorwig and 205 Gigawatt hours from the smaller Ffestiniog.

The Pumped Storage Business has entered into financial contracts for the year commencing April 1991, which will help to stabilise the income of the Business.

Generation applications

Twenty-two applications for new generation projects were made during the year for connection to or use of NGC's system. This includes an application to increase the capacity of the Scottish interconnection to 1,600 Megawatts in total; these applications involve 18,117 Megawatts of potential new generating capacity, representing about 30 per cent of existing capacity and about 40 per cent of system maximum demand.

Agreements have been signed for nine of these new generation projects, totalling 6,864 Megawatts, of which six are to be located in the Northern Division, one in the Central Division, and two in the Southern Division. With the exception of the Scottish interconnection, all will use new gas-fired plant.

Water stored at NGC's pumped storage power stations at Dinorwig, pictured, and Ffestiniog enables them to respond rapidly to changes in demand for electricity.

The availability of the NGC portion of the Scottish interconnection averaged 96 per cent during 1990/91. The Scottish companies exported electricity to England and Wales for most of the year, giving an average utilisation factor of 59 per cent for the interconnection as a whole.

| Scottish interconnection |

| French interconnection |

6 7

project an image to a number of other important spheres of influence such as government, the farming community, environmental groups, and other business and financial organizations. As investors in the company, the shareholders obviously want the National Grid run as efficiently as possible so that they get the best return they can. Thus it is important to maintain a strong and positive identity with these twelve shareholding companies. And the new design had to show the general public that the National Grid Company is a separate entity in its own right.

A common error, or even arrogance, of corporate design is that it can represent the wished-for rather than a real identity. Some companies and their accomplice designers go so far as to believe that corporate design will actually produce unwarranted, if desired, perceptions of an organization. As designers, our role is to provide the visual image of real identity – which may contain the wish – and to urge that this image is expressed in all the visual manifestations of the company's operations and activities. We do this keeping our fingers on the pulse of reality, always remembering what the company is, and not what some might wish it to look like.

Although there was some pressure – and a little temptation – to overreact to the National Grid's new commercial status, the overriding identity of the company was still firmly based in its engineering culture. So we devised a symbol that represented this culture and tradition, placing it in a commercial context. The symbol is a square set on its corner signifying the grid itself and the dynamic nature of the business. The square contains a stylized form of the pylon: the first thing anybody thinks of when you mention the National Grid. The lines of the 'pylon' also represent the lines of the grid. There are two carefully chosen colours: the bright, positive green signifies both the environment and the vibrancy of the business; the unobtrusive but confident blue is a counterpoint to the green. The symbol always includes the name of the company in solid, clear lettering on the upper edges of the square.

With considerable visible assets in overhead lines, transformers, substations, offices, as well as the service vehicles and helicopters that keep the system alive, signs became an early priority in projecting the new identity design. Almost two thousand signs were needed for three hundred and sixty sites, from the Scottish borders to the far south-west. The National Grid's inspection helicopters and a number of vehicles were also given their new livery early to promote the new

design. There followed a succession of annual reports, corporate brochures and information literature, each piece adhering to the corporate style we had introduced, but also reflecting the growing confidence of the organization as it became to used to its new commercial status. A little wit and humour has become possible in employee brochures and the corporate Christmas card. Over four years, the corporate design has proved it has the scope to accommodate the maturing identity of the organization. This is most in evidence in the annual reports, with more colour being introduced latterly.

The visual identity itself is simple and designed to be very flexible to use, remaining clear and recognizable wherever it appears. But visual identity is more than symbol, logotype and colours, and their application. It is also an attitude which extends to the appearance of everything that emanates from the organization, from its vehicles and uniforms to it physical assets – the very pylons and sub-stations themselves. These are essential aspects of the National Grid's public face. The way they are kept and their presentability also affects the public image. While we may help in its expression, the National Grid Company's identity is the way it is; every employee contributes to it with his or her attitude and performance.

JOHN McCONNELL

BELOW: *Public information on the difference in cost of cables buried underground, which have to be cooled by continually pumping water around them, and cables carried on pylons.*
BOTTOM: *Internal information on healthy eating at work.*
Associate, Justus Oehler

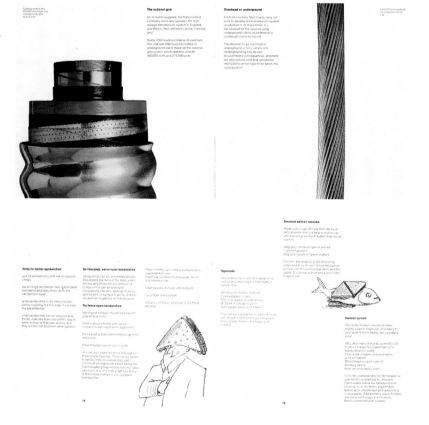

Making marks

Ancient marks of identity and ownership led to today's highly valued and valuable corporate logotypes. ALAN FLETCHER looks at connections and curiosities.

BRAND ART

The Greeks cut off the feet of silversmiths to prevent them running away, a mutilation which also identified their trade. Less drastic but equally effective was the Roman custom of 'earmarking' slaves, and the branding of criminals in Tsarist Russia with a large red diamond in the middle of their backs. In the Wild West the art of branding was extremely well organized, and rigorously enforced by the death penalty. One notable exception to the general practice was that of Texan rancher Samuel Maverick (1803-70), who declined to use a brand, either through indolence, or perhaps so he could claim unmarked steers as his.

Cattle brands, often a visual pun on the name of the ranch, were designed with initials or graphic devices. Although necessarily simple – you can't achieve much subtlety with a hot branding iron – they were carefully constructed to confound rustlers and unscrupulous ranchers. As an indelible mark of ownership the trick was to combine devices in ways which made them difficult to turn into something else (see Daniel Boorstein, *The Americans*, Vintage Books, New York, 1974), and avoid letters like C, which could be converted into O. In the aerosol age it's become switched around. According to Ralph Caplan (*By Design*, St Martin's Press, New York, 1982), maintenance manuals used in Manhattan public schools include instructions on how to use a magic marker to convert graffiti profanities such as FUCK into BOOK.

A nineteenth-century cattle brand for the Sitting Heart Lazy B ranch.

BOTTLES AND RADIATORS

Roman bricks were frequently stamped with motifs representing manufacturer, quarry, brickyard, builder, consul, and emperor – a pedigree as distinguished as any vintage wine. The reason was not pride but control. Soapmakers in ancient Rome were fined for selling unbranded soap, and medieval Flemish tapestry workers could have a hand cut off for failing to mark their work. So trademarks have always been a very serious business.

In the USA the legal definition of a trademark covers 'any word, name, symbol, or device, or any combination thereof, adopted and used by a manufacturer or merchant to identify his goods and distinguish them from those manufactured and sold by others'. For three-dimensional

Rolls-Royce's Spirit of Ecstasy emblem designed in 1911 by Charles Sykes.

objects, rules are less clear. The distinctive shape of the Coca-Cola bottle was not registerable as it was judged to be functional; the radiator of Rolls-Royce was: it qualified as symbolic.

To register a mark it has to be substantially unique, that is to say it has to look different from any other mark. The legal profession which passes judgement on these things uses word language, not visual language, so it views a design in literary rather than visual terms. Judgement is represented by a blindfolded lady holding a pair of scales – blindfolded is the salient word – and so decisions are based on what it looks like, not on how it looks. (Egbert Jacobson, *Trademark Design*, Paul Theobald, Chicago, 1952.)

The first British trademark was granted in 1875 to the brewers Messrs Bass & Co for a red triangle – a mark which soon became famous enough to appear among the bottles in Manet's painting of the *Bar at the Folies Bergère*. (Hannah Campbell, *Why Did They Name It?*, Fleet Press, New York, 1964.)

INDIVIDUALITY VERSUS CONFORMITY

A sophisticated marketing system doesn't favour the idiosyncratic emblems previously used to represent business. Among the victims of this visual laundering one affectionately recollects a host of commercial characters – the droopy dog of RCA, the winged Pegasus of Mobil, the growling lion of MGM. What have taken their place are abstract designs which are distinguished more by similarity than by individuality.

Commercial symbols are like people. Some are reasonably put together but lack personality, others are aggressive, or pompous, or merely unpleasant. Occasionally one encounters an interesting character. Whatever the case, to be effective a trademark must meet a set of criteria: the utilitarian values of being relevant, appropriate and practical and the intangible qualities of being memorable and distinctive; and that something extra, the visual tweak which creates a unique personality.

However, although the designer creates the mark it is only the organization it represents which can give it meaning – as Paul Rand has pointed out, the trademark of Chanel only 'smells as good as the perfume it stands for'.

As legibility is to words, so logobility is to trademarks. Logobility is the capacity of a name

The first British trademark was registered in 1875.

Mobil's Pegasus, first used in 1911.

Graphic surgery creates a new brand mark for Marks and Spencer.

to lend itself to conversion into a unique typographic device; for instance the name Michael by use of a ligature makes Michæl, or the name Michèle by a bit of graphic surgery makes:

MICHĒLE

PEDIGREE

The origin of many trademarks is rooted in humble beginnings. Bibendum, the trademark of Michelin, was inspired by a heap of old tyres, while Shell derived name and symbol from the days when the company imported exotic sea shells. *Volvo* (I roll) was originally backed by a Swedish ball-bearing company, and their mark derived from the cartographic sign for iron deposits. Chevrolet's parallelogram was copied from a hotel wallpaper: the pattern caught the eye of the head of General Motors who was staying there while negotiating with Louis Chevrolet.

Coca-Cola was invented by a Dr Pemberton (an Atlanta pharmacist) who also designed the logo. He thought 'the two Cs would look very well in an advertisement'. In 1889 rights were granted to a company to put the stuff in bottles. They came up with a distinctively shaped bottle so that the customers would know they'd got the right thing when they felt for it in the dark. It was designed in 1915 by Arthur Samuelson of the Root Glass Company. Raymond Loewy called it 'the most perfectly designed package in use today'.

His Master's Voice was the title of a painting by Francis Barraud. He submitted it to the Royal Academy but the hanging committee turned it down. He then endeavoured to sell it to the manufacturer of the phonograph. They also turned it down. Barraud then painted out the phonograph and substituted a gramophone – a shrewd move. The Gramophone Co Ltd bought it for one hundred pounds. The picture subsequently became the trademark of HMV and, through acquisition, of RCA. By the way, the dog, affectionately known as Nipper, was born in 1884 and died in 1895 – it says so on a plaque in Eden Street in Kingston-upon-Thames, a suburb of London.

Nobody is quite sure where Penguin's tubby bird originated. One version has it that it was revealed to Allen Lane in a brainstorming session with his brothers in the bathroom, another

has them trying to cross the dolphin symbol of Bristol with a colophon of an albatross, apparently not too happily – their secretary said it looked like a penguin. The brothers must have agreed. They summoned a junior employee (Edward Young), gave him sixpence, and sent him off to Regent's Park Zoo. He returned with a sketch which, at least in this story, became both name and emblem of the company. (Norman Lebrecht, *Sunday Times Magazine*, 25 August 1985.)

THE LOGOTYPE BUSINESS

A trademark can be more than a sign of an identity: it can become synonymous with the image it has been used to create – glamour, sophistication, *machismo*, or whatever. Although few companies take advantage of the commercial potential which resides in their property, those who do, guard them fiercely.

Protecting the reputation of brands against shoddy imitations is gleefully described by trademark agents as fast becoming a jungle. These days the visitor's impression of the Far East isn't palm trees, pink gin, and sunsets, but wall-to-wall imitations of Gucci bags, Cartier watches, and Dunhill lighters. Actually it's lucrative for everyone. There is extra revenue for manufacturers through successful legal action, quick money for shady operators, kudos on the cheap for customers. Cartier even acquired free publicity by covering a Paris street with imitation watches and trundling over them with a steamroller.

Farmers who wore International Harvester caps and truck drivers sporting Peterbilt belt buckles were the first to popularize wearing corporate logos. But the Lacoste crocodile was probably the first to become a cult symbol. The danger with cult symbols is they are open to hijack. In 1987 Mercedes fell victim to fans of a rock group who adopted their symbol as a fashion accessory. The company had to run an emergency service for outraged car owners who had their badges stolen. And less amusingly, a certain Carl Marcus was fumbling for the keys to his Rolls in Beverly Hills when he felt the cold steel of a gun against his head. A voice from behind announced: 'It's Rolex time, mother.' A Rolex can cost anything from $1,000 for the basic stainless-steel job to telephone numbers for one smothered in diamonds. Street value derives

The Penguin Books trademark by Jan Tschichold, 1947.

Keep the name, change the spelling: no offence.

Does Procter and Gamble's trademark hold devilish secrets?

as much from *cachet* as from cost. As a Rolex executive commented, our product is 'the symbol for the *nouveau riche*. They're big, they're chunky, and from Afghanistan to Zaire everyone knows Rolex – it's one of the best-known words in the world.'

A COSMETIC SOLUTION

Darkie toothpaste, a big seller in the Orient, owes its name and trademark to a visit to New York in the 1920s when the owner saw a musical starring Al Jolson. Recently Colgate-Palmolive purchased the company. They kept the symbol but changed the name to Dakkie. The reason for this resounding change was probably a wish to preserve their reputation for being whiter than white.

THE MESSAGE IN THE MEDIUM

Roland Barthes *(Mythologies,* Johnathan Cape, London, 1972), asserted that the Citroën symbol 'was proceeding from the category of propulsion to that of spontaneous motion, from that of the engine to that of the orgasm'. That may seem fanciful but the associations people make with symbols are often bizarre and frequently less favourable. Although Barthes likened the Citroën DS to a Gothic cathedral and Christ's seamless robe, he also disparagingly described it as 'the very essence of petit-bourgeois advancement'.

The CND symbol, designed by Gerald Holtom, was derived from the semaphore for N and D – at least that's what I thought until I read that someone reckons it was based on the insignia of Hitler's 3rd Panzer division. However it's not the lunatic fringe I find surprising, it's the pressure groups. What's really so offensive about golliwogs? They are a jolly caricature and no more racially offensive than Colonel Kentucky. However Robertson's, the British jam company, recently thought it prudent to drop their golliwog trademark – at least in the United States – and to avoid hassles the publishers of Enid Blyton replaced theirs with gnomes *(Financial Times*, 26 April 1985 and *The Times*, 30 October 1985). No pressure group from that quarter.

Less predictably, Procter and Gamble, the largest regular advertiser in the USA, began receiving complaints in 1982 that their trademark was not the man in the moon but a ram and the number 666, both cited in the *Book of*

Revelations as signs of the anti-Christ. A vivid imagination could just about conjure up a ram, but linking the stars and curls to form a mirror image of the unholy digits requires a dedicated sense of fantasy. Anyway the rumours crossed the Atlantic and slips of paper were circulated at Baptist meetings with the improbable suggestion that Satan 'is creeping into your kitchen'. Ironically the company had always been particularly strait-laced, and its first brand name, Ivory Soap, was selected from the *45th Psalm*. Nevertheless, they considered it expedient to withdraw the symbol from their products.

The Procter and Gamble symbol dates back to the nineteenth century when the thirteen stars symbolized the colonies. The man in the moon came later; the mark was registered in 1882.

A CROSSED CONNECTION

Saudia is the national airline of Saudi Arabia and by implication flies the flag of Islam. Muslims are sensitive about religious matters, and it only needed someone to point out that the space between the letters S and A formed a cross for the authorities to order, in 1981, that the design be changed.

saudia saudia

The subliminal cross. *The amended design.*

Swissair, whose livery is a white cross on a red ground, came up against this problem on their Middle East routes. On asking them for details they sent me this statement: 'through diplomatic channels...it was proven that the logo is a national symbol and cannot be altered or removed from our aeroplanes and offices. We simply do not do business with those who object.'

MARKS OUT OF A THOUSAND

Trademarks of the top 1,000 companies in America break down as follows: 35 per cent are typographic treatments of the name, such as Kellogg's; 27 per cent are initials, such as IBM; 14 per cent integrate a typographic name with a graphic, such as Sun; 13 per cent are pictorial, such as Shell; 11 per cent are abstract, such as Chase Manhattan Bank.

(Research by Siegel & Gale, New York, 1988)

Pentagram has designed hundreds of symbols and logotypes; a gallery of diversity in the service of identity. This is where the idea in design is at its purest – and where often the idea *is* the design.

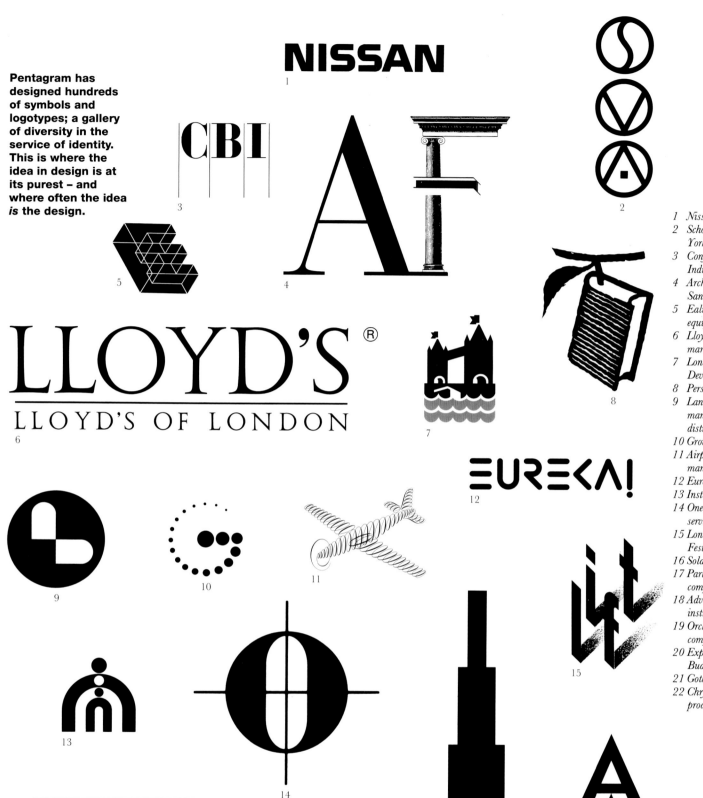

1 Nissan, motor manufacturer
2 School of Visual Arts, New York
3 Confederation of British Industry
4 Architectural Foundation of San Francisco
5 Ealing Electro-optics, optical equipment
6 Lloyd's of London, insurance market
7 London Docklands Development Corporation
8 Persimmon Books, publishers
9 Landa Pharmaceutical, manufacturers and distributors
10 Grover Printing
11 Airplane, inflatable aircraft manufacturer
12 Eureka, children's museum
13 Institute of Family Therapy
14 One Works, pre-press services
15 London International Festival of Theatre
16 Solaglas, glass merchants
17 Parthogenesis, biotech company
18 Advanced Surgical, surgical instruments
19 Orchid, computer software company
20 Expo 95, Vienna and Budapest
21 Gotham Equities, real estate
22 Chrysalis, record and TV production

137

1 The Nature Company,
 retailers
2 New York City Economic
 Development Agencies
3 Golden Grove, Welsh
 publishers
4 Nonsuch Films, production
 company
5 Mavity & Gilmore,
 advertising agency
6 Fineline, film distribution
7 Radio Ranch, radio
 commercials production
 company
8 The Big Paper, schools
 design newspaper
9 Trinity College of Music
10 Arthur Andersen,
 international accountants
11 Shilla Hotel
12 King's College London,
 London University
13 Studio of Martha Burns,
 designers
14 Travis Construction, builders
15 Simpson Paper Company,
 Railex Railroad Line
 stationery
16 Tate Gallery, London
17 Museum of Contemporary
 Art, San Diego
18 Museum, art sellers
19 Mandarin Oriental, Pacific
 hotels group
20 National Grid, electricity
 network
21 Article 19, anti-censorship
 group
22 Payot, publishers
23 Museum of Modern Art,
 Oxford
24 Al Fouk Foundation, Islamic
 cultural charity
25 Royal College of Nursing,
 representative body
26 Classic FM, radio station
27 Dallas Opera
28 Herman Hospital, health
 care
29 Science Management
 Corporation, management
 systems
30 Viscom, audio-visual
 producers
31 Bright Lights, film
 production
32 Mr and Mrs Aubrey Hair
33 Latin American Arts
 Association, promotional
 charity
34 Society of Industrial Artists
 and Designers, 50th
 anniversary
35 Sign Design, sign
 manufacturing consultants
36 Zumpano Studios,
 photographers
37 Shakespeare Globe, theatre
 centre
38 Scottish Trade Centre, trade
 association
39 Romarte, theatre services

138

9

13

14

15

MANDARIN ORIENTAL

THE HOTEL GROUP

19

20

21

CLASSIC *f*M

26

32

33

36

27

5

6

7

8

THE SHILLA
HOTELS & RESORTS

11

KING'S College LONDON *Founded* 1829

17

TATE *friends*

16

MU∃U M

18

22

23

24

25

29

VISCOM

30

31

28

S I A D M C M L X X X

34

DE**SIGN**

35

37

38

rom*Arte*

39

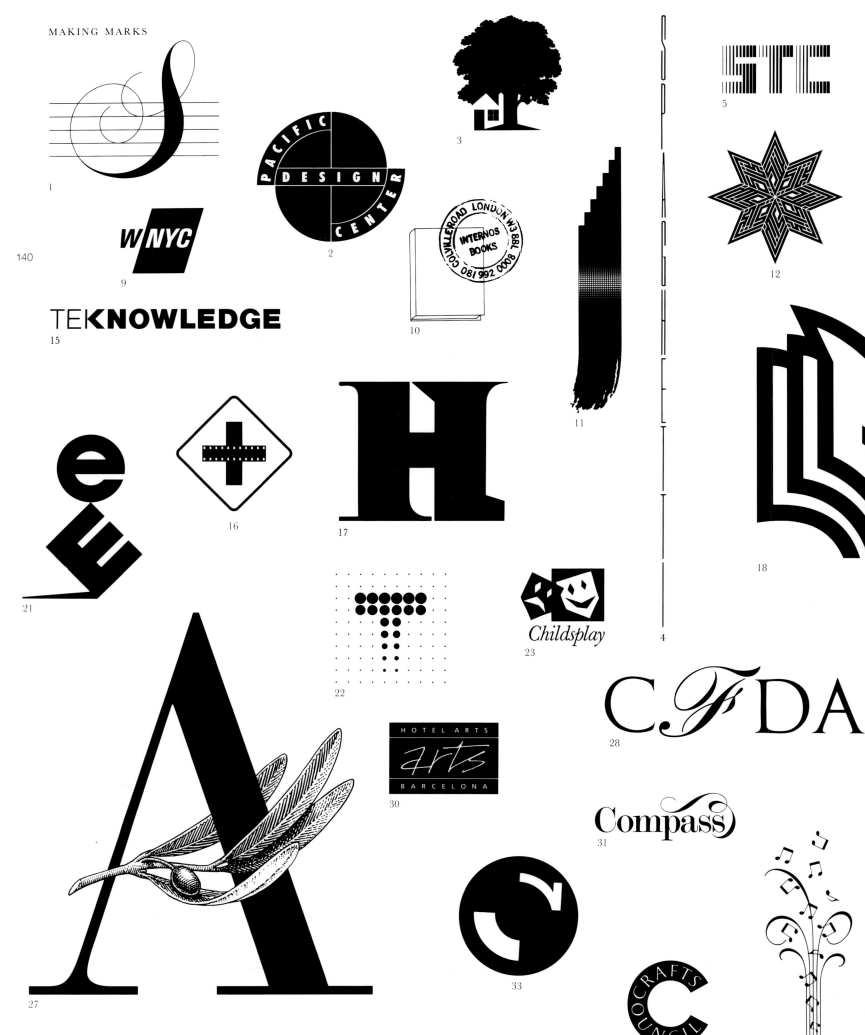

140

1

2 PACIFIC DESIGN CENTER

3

5 STC

9 W/NYC

10 COLVILLEROAD LONDON W3 8BL 8000 180 992 081 INTERNOS BOOKS

11

12

15 TEK**KNOWLEDGE**

16

17 H

18

21 e€ƎE

22 T

23 *Childsplay*

27 A

28 CℱDA

30 HOTEL ARTS *arts* BARCELONA

31 Compass

33

37 CRAFTS COUNCIL C

34 **National Music Day**

40 PARALLAX

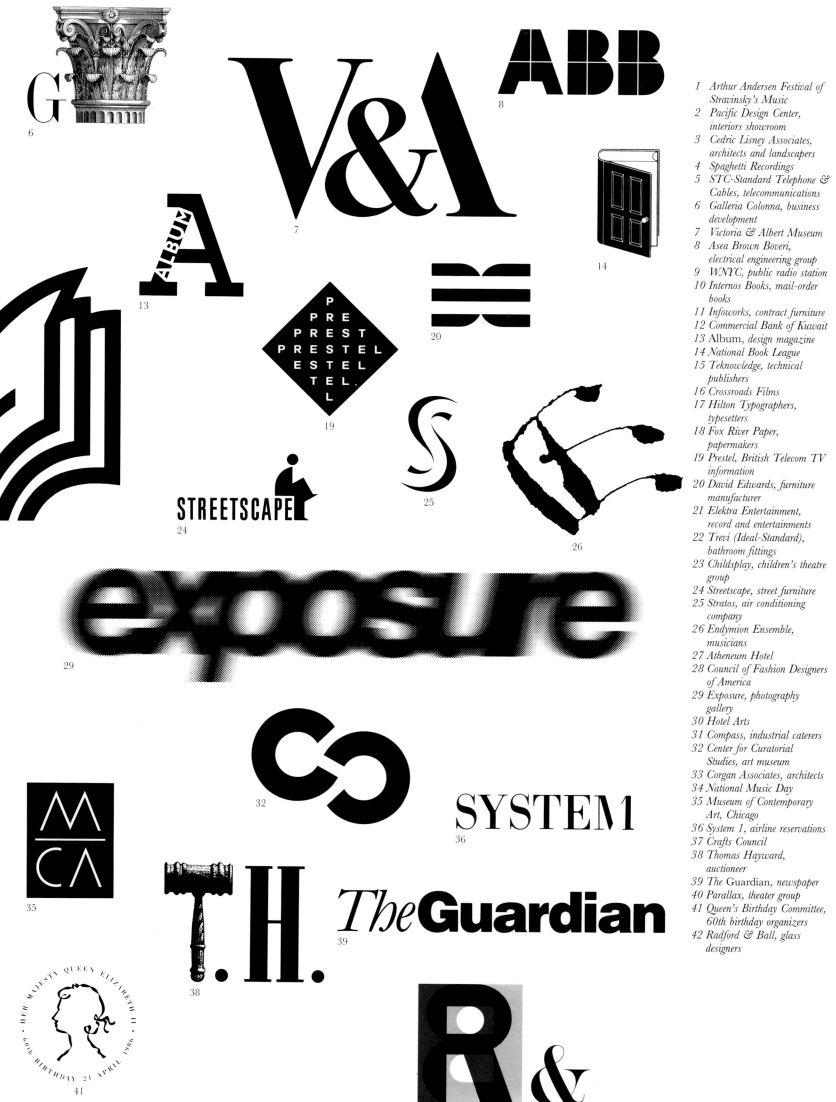

1 Arthur Andersen Festival of Stravinsky's Music
2 Pacific Design Center, interiors showroom
3 Cedric Lisney Associates, architects and landscapers
4 Spaghetti Recordings
5 STC-Standard Telephone & Cables, telecommunications
6 Galleria Colonna, business development
7 Victoria & Albert Museum
8 Asea Brown Boveri, electrical engineering group
9 WNYC, public radio station
10 Internos Books, mail-order books
11 Infoworks, contract furniture
12 Commercial Bank of Kuwait
13 Album, design magazine
14 National Book League
15 Teknowledge, technical publishers
16 Crossroads Films
17 Hilton Typographers, typesetters
18 Fox River Paper, papermakers
19 Prestel, British Telecom TV information
20 David Edwards, furniture manufacturer
21 Elektra Entertainment, record and entertainments
22 Trevi (Ideal-Standard), bathroom fittings
23 Childsplay, children's theatre group
24 Streetscape, street furniture
25 Stratos, air conditioning company
26 Endymion Ensemble, musicians
27 Atheneum Hotel
28 Council of Fashion Designers of America
29 Exposure, photography gallery
30 Hotel Arts
31 Compass, industrial caterers
32 Center for Curatorial Studies, art museum
33 Corgan Associates, architects
34 National Music Day
35 Museum of Contemporary Art, Chicago
36 System 1, airline reservations
37 Crafts Council
38 Thomas Hayward, auctioneer
39 The Guardian, newspaper
40 Parallax, theater group
41 Queen's Birthday Committee, 60th birthday organizers
42 Radford & Ball, glass designers

Where, what, how

Signs take the designer into a realm of rules which involve size, sight lines, architecture, engineering, materials and technology, as well as graphic effect.

You can ask the way, or you can look for a sign. But it's not that simple. There are direction signs, information signs, identification signs, instruction signs, statutory signs, and advertising signs. Because language may limit understanding, the use of symbols is prominent, from the skull and crossbones to the zig-zag electric flash. Anyone gets the point, instantly. Actually, a symbol stands for something else, whereas a sign is a visual message, but in loose terminology they're interchangeable – thus we have commercial symbols and the Sign of the Cross.

The oldest direction sign is the pointing index finger. The most common (and also old) is the arrow, a projectile that comes to a point where it is going. The information sign tells you what you need to know – and often what you don't. 'Closed for lunch' is useful, and the New York street sign 'Don't even think of parking here' means what it says. The identification sign says 'This is where you are' or 'This is what this is': Telephone, Car Park, Hotel. Such signs often have a promotional role as well. In this their effectiveness lies as much in what they make us feel as what they tell us: the Victorian pub sign, the sign in the Hollywood Hills, the corporate logo. We are culturally preconditioned to the imagery; the emotional association is the key. There are statutory signs that you had better heed for your own good: Exit, Turn Right, Danger. The instructional sign tells you how to do something: Pull Red Handle to Stop Train. The advertising sign, masquerading as information, may be more obscure than helpful: 'Things go better with Coke.' What things? Where are they going? Better than what?

International road signs date from the 1949 Protocol, the result of a convention held in Geneva in that year. No one remembers who designed them, but judging from the results it had to be a committee. Anyway, despite their crudity, the pictorial versions function reasonably well. I once attended a lecture by a Polish designer who showed photographs taken around the world of two little people holding hands inside a red triangle. None was the same, yet each was instantly recognizable. The more ambiguous pictograms are less happy. Although most people understand the significance of the man putting up a large umbrella, the sign that implies Beware of Low-flying Motorcycles really means something else. Then there are the abstracts with no link between form and meaning – either you know them or you don't. Apparently many don't. A recent survey unnervingly revealed that only seven per cent of drivers realize that a white circle with a red rim means No Vehicles.

Traffic signs have different requirements from gravestones.
ALAN FLETCHER

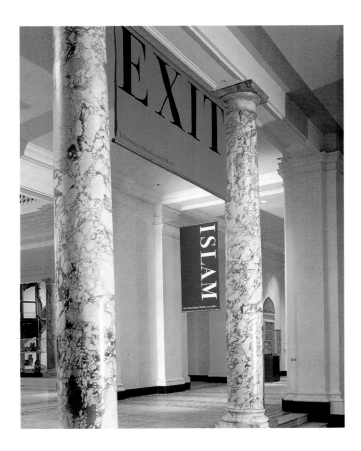

LEFT AND RIGHT: *The interior of the Victoria and Albert Museum in London is rich in detail, with decorated ceilings, marble pillars and strong colours. The new sign programme had to respect this background and account for the material and structural difficulties in application. The solution was to design the majority of the signs as hanging banners. These are colour-coded according to the main points of the compass, and keyed to the museum guide to help visitor orientation. The typeface used has appropriate historical signficance: an original cut by the typemaster Bodoni. Partner, Alan Fletcher Designer, Quentin Newark*

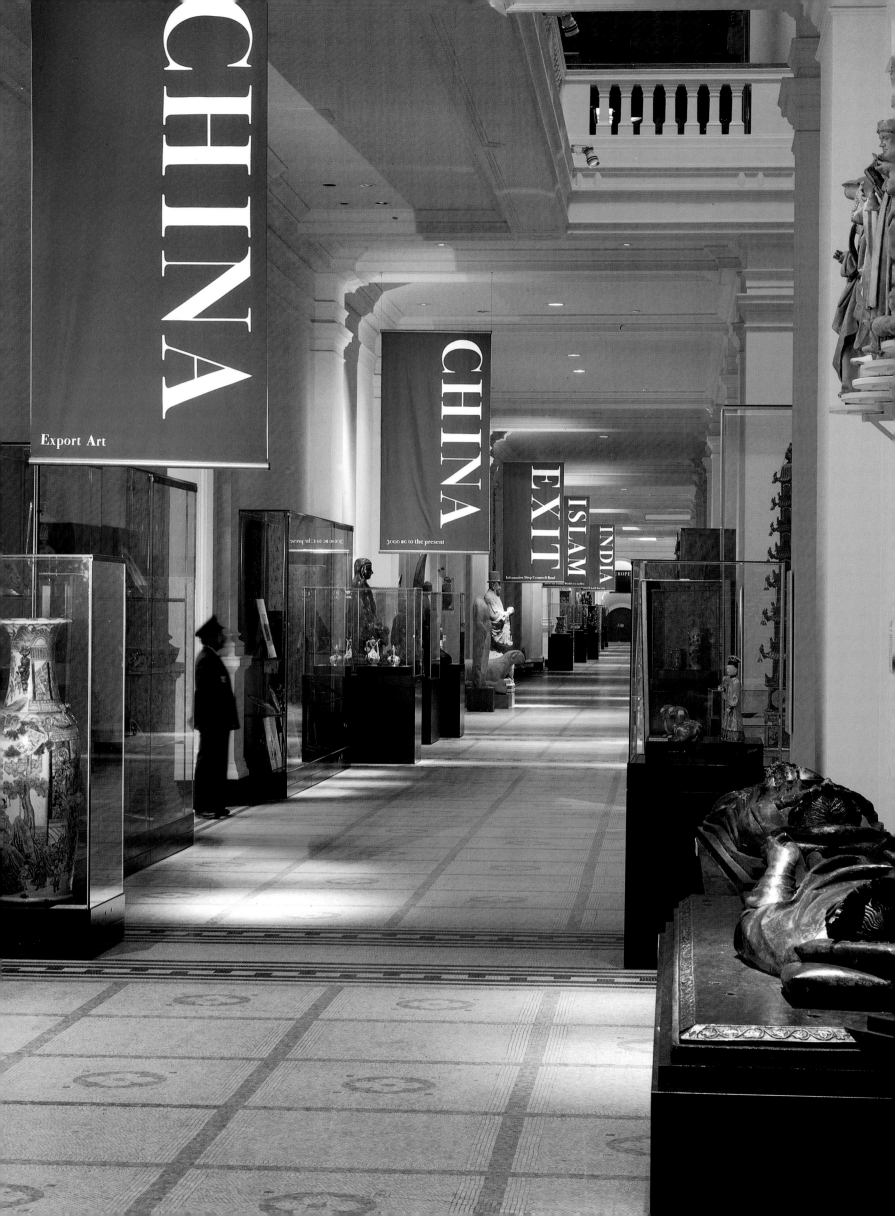

CHINA

Export Art

CHINA

3000 BC to the present

CHINA

EXIT

ISLAM

INDIA

144

The signs for Houston Zoo,
part of an overall corporate
image program, use large
monogrammatic symbols
based on the alphabet.
Partner, Lowell Williams

Barnet Center is a
development in Jacksonville,
Florida by the Paragon
Group. Working closely with
the architect Helmut Jahn,
the signs have been designed
as an integral part of the
building using the same
materials as the structure
itself.
Partner, Lowell Williams
Designer, Bill Carson

A minimum of signage was originally intended by architect Norman Foster in his highly praised new terminal at Stansted Airport, now London's third international airport after Heathrow and Gatwick. As passengers could see right through the huge open space, from the entrance to the planes, they would generally know which way to go. The signs that were commissioned reflect the scale of the building, using 'super' graphics that can be readily seen from a distance. They also had to solve the problem of fitting in with the British Airports Authority's general sign guidelines. These assume fixings to traditional walls and ceilings – which this terminal does not have. Partner, Alan Fletcher Designer, Quentin Newark

146

The Tate Gallery in London has an unobtrusive and easily changed mobile sign system. The design reflects the columns that are a feature of the gallery interior, with information on the slanting face.
Partner, David Hillman
Designer, Jo Swindell

The Tate Gallery in Liverpool is an old wharf building by Jesse Hartley, which was converted and refurbished by the architect James Stirling. Permanent floor and gallery signs are in cast iron; announcements of events are decaled on to the walls at two to three-metre intervals; moveable floor-standing signs indicate temporary closures, no entry, queue lines and the like.
Partner, David Hillman
Designer, Jo Swindell

Signs for the Museum of Modern Art, Oxford were part of a new visual identity. The graphics reflect the grid layout and cast iron columns of the building itself, with 'modern' sans serif lettering. The signs were screen-printed on to enamelled aluminium and simply hooked on to the walls.
Partner, Mervyn Kurlansky
Designer, Robert Dunnett

Eureka!, a children's museum in Bradford, Yorkshire, commissioned signs as a part of an overall identity programme. Words are set appropriately in lower case, respecting how children first learn their letters; pictures are related to words to give a literal message; the simple construction is expressed to reflect the 'hands on' approach of the museum exhibits and displays.
Partner, Mervyn Kurlansky
Illustrator, Satoshi Kondo

There is a high density of Websters pubs in and around Halifax, Yorkshire. Reflecting the stark local architecture and landscape, the intention of traditional pub signs in black-and-white is to add something to the local identity. Original miniatures were engraved by Kathleen Lindsley in her Outer Hebrides studio, then enlarged for silk-screening and enamelling to make the full-size pub signs. The wall mouldings were derived from an Edwin Lutyens fireplace at Castle Drogo, Cornwall.
BELOW: Kathleen Lindsley's engravings were also published by the brewery in a commemorative book.
Partner, John McConnell
Designer, David Stuart

The Norwest Center in Minneapolis was designed by Cesar Pelli, who used craft elements from the original building destroyed by fire in his aim to 'blend the building with the architectural character of the city.' Working closely with the architects, Gill letterforms were adapted for three-dimensional applications and bronze illuminated flags designed for the elevator lobby.
Partner, Peter Harrison

RIGHT: *Stockley Park is a business park and golf course near Heathrow airport, which has been much applauded for the standards of its environment, landscaping and architecture. The main entrance sign has two hanging sheet steel 'banners' nine metres high, formed as though they are rippling in the wind. Partner, David Hillman Designer, Leigh Brownsword*

Broadgate is the City of London's largest ever single development, with buildings designed by Arup Associates and Skidmore Owings and Merrill. Rosehaugh Stanhope Developments commissioned direction and information signs to be in keeping with the environment's high standards of material and design. The signs are in solid cast bronze with arrows tabbed out of the surface and type engraved into the material. Partner, John McConnell

LEFT: *Richard Rogers' Lloyd's of London building, which houses the insurance market and its administrative offices, features fair-faced concrete finishes inside as well as out. The signs take advantage of this muted background. The stencil-style typeface designed by Le Corbusier was cut out of brightly coloured aluminium or etched into illuminated plate glass. Column signs have secret fixings so they appear to float free. Partner, Alan Fletcher*

The full range of British architectural styles and eras can be found in the 'estate' of public houses owned by the Whitbread brewery. Each pub's particular architectural style is respected in the design of signs. RIGHT: An arts and crafts board sign. FAR RIGHT: A Victorian glazed door. Partner, Theo Crosby Designer, John Rushworth

Cover to cover

A presentation on book design was given by JOHN McCONNELL to the Royal Society of Arts in 1991, London, and subsequently published in the *RSA Journal*. This is an adaptation.

The first book series designed by John McConnell: an early 1970s Penguin series for university students. An oblique approach was adopted to express the obscure titles. 'Found images' were used for the illustrations; type was set on an Olivetti typewriter in the office.

I've been interested and involved in book jackets for about twenty-five years. I've been thinking about why jackets are such an important part of my designing life and why I'm proud to be involved in them. For my generation, the idea of doing a book jacket was fascinating. Asking around the office, I find that's less true now. Young designers relate to subjects such as videos and record sleeves. The interests seem to have changed, but for designers of my generation, the book jacket always sprang to mind if we were asked what we were doing. What follows is a very personal view of the trade.

The curious thing that first crosses my mind is that the book jacket has somehow got separated from the book. Though traditionally the cover and interior were executed by one person, sadly of late the commercial pressures on the cover to become a selling tool have caused the disciplines to part. I don't applaud this but it has happened, in fiction and non-fiction, particularly in non-illustrated books. 'Coffee-table' books are an exception, where the cover is an intrinsic part of the book, but even in that area you often will find that those responsible for the cover are specialists and put under different sorts of pressure.

Traditionally, the publishing industry used to be separated into hard- and soft-backed books. I've always felt that this was a curious division, and as the layman outside the trade I assumed that the hardback was the same thing but more expensive and heavier. But the hardback is associated with the first publication and is seen as the more serious version, while the softback is often the fun version. I have always hated these distinctions, and for my time at Faber and Faber have totally ignored them. As far as I'm concerned the hard and soft covers should be as exciting as each other.

I act at Faber in the roles of art director and designer. There is of course endless debate over the difference between those two activities and whether art direction is really a role at all. I obviously think art direction has a very important role which I will now try to make clear. But certainly the line between art direction and design is a blurred one; you move from one to the other with the influence of art direction and design bearing on the final product in varying degrees.

If I go back to why as a designer I'm so proud to be associated with books, it probably has something to do with monuments. There is a feeling that you are involved in producing something with an intrinsic life, longer than a lot of material I spend my life working with. The book has a memorable quality; it becomes a part of history, like a poster. I could argue that book jackets are miniature posters.

Putting that monumental element aside, the problem of designing a book jacket is really frightening. You have the task of summing up a multi-faceted concept, distilling time, space, and ideas in some way. On top of which the author wants his name big. Doing all this, summarizing that five-hundred-page novel, full of complexity that has taken ten years to develop, on a piece of paper no more than eight inches by five, is really a bit of a ridiculous affair. And you must of course fulfil the other obligation, which is to flog the book. So why designing jackets is so attractive I don't know; something to do with enjoying the challenge of an impossible task. It's a three-fold responsibility: first of attracting, stopping someone in that mass of books in a bookshop; second of explaining, giving people a clue to this five-hundred-page complex object; and thirdly of stimulating people to part with their money.

I ought to acknowledge the author's part in all this. He is of course the key player, and all my comments are based on an enormous respect for people who can write. The idea of writing five hundred pages is to me inconceivable. It's through this respect that I have come to terms with the problem encountered by all designers of book jackets: the confrontation between designer and author. I try to get around this obstacle by realizing that the core of it is an almost inevitable conflict between two creative acts. The author struggles for years over his novel and up bobs some bright designer to supply it with a frock it's going to have to wear for the rest of its life. This is asking for conflict, so my experience tells me to work with the author to try and manage a solution. I'll describe one or two devices which I've developed to achieve that.

I have detected a number of types of authors. There is the author who wants a tombstone. The Tombstone says, 'Look, I've thought endlessly about my cover, and really the only thing I want is some dignified lettering. I think serif lettering probably, and could I have it dark grey on a grey background?' In fact he wants a gravestone. You tell him yes, he can have all that, but

he's probably going to sell even fewer copies than he sells at the moment. This, you find, is no argument at all. The Tombstone feels he has created this object and doesn't want it to reflect anyone but himself nor any other creative act involved. This is of course perfectly understandable, but a severe risk to commercial success.

The second type I've nicknamed the Italian Bride author. The Italian Bride is a New York joke which goes: 'How do you tell an Italian Bride?' 'I don't know.' 'Well, she's wearing something old, something new, something borrowed, something blue, something pink, something silver, something green, something yellow....' These are the authors who are incredibly enthusiastic and concerned that you will sum up their book entirely. Everything goes in. The story will go something like: 'It's a period piece of course, though set in the twentieth century. It deals with homosexuality and there's a plane crash on page six and it's very important that we have the heroine on the cover and that you capture the whole of the situation so can you put all that in and can I have my name big, too, please?'

The third type I've labelled Smart Art. He or she comes somewhere between the Tombstone and the Italian Bride. They really can't think what to put on the cover but a Picasso would do rather well. Picasso and Matisse and Klee are very popular with the Smart Art author. Naturally I can understand this desire to be associated with great art, but more important, what the Smart Arts are arguing for is a certain obliqueness which I'll be saying more about.

One fact I will declare now is that I don't read the book. This usually arouses horror among editors and groups of publishers. But one of the things it does mean is that at least I keep a little distance between myself and the book. I use editors as go-betweens and force them to distil the book down to a manageable size. Designing book jackets becomes more interesting when you don't try to tackle the problem head-on, when you steer clear of being too literal about the solution and go for it at a tangent, when you worry less about being explicit and more about evoking a feeling and an idea. I've found that the more explicit you are, the deeper into trouble you get with the author and the reader. Obliqueness certainly increases the power of the effect.

All this of course is leading to the dirty word 'selling'. There are two selling processes: selling in and selling out. Selling in is persuading the bookseller to buy and selling out is persuading you and me to buy to pay for it. Having spent some time going around with representatives from publishers and seeing how these works of art are sold, I know how horrific a process it is. With luck the representative will turn up with a ring binder in which proofs of the jackets are

The title/author panel on Faber and Faber fiction imposes a common identity, although it may appear in endless different guises and colours.
Garrison Keillor covers: Illustrator, Pierre le Tan
Mario Vargas Llosa cover: Illustrator, Andrzej Klimowski
Josef Skvorecky cover: Illustrator, Jason Godfrey

151

153

inserted clamped through with holes. Otherwise he has a grubby, dog-eared bundle which has been dropped several times. The shopkeeper flicks through this assortment and makes his or her judgements on the books in fractions of a second on the basis of proofs of the cover. My heart bleeds for the authors as well as for what we do, but it really is on that level that a lot of decisions are made about buying books. Worse still, there is one very famous bookseller said to have a committee of twelve to whom the jacket is held up for them to say yes or no, in or out. A famous author will be all right – they'll recognize the name – but a newcomer doesn't stand a chance in this cattle market. The selling-in process is why jackets have got separated from books. The jacket lives a separate life and only eventually bumps into the book.

There is a struggle going on between the European and American styles of design and their relation to selling. The Americans treat each book as a unique item. One book bears no resemblance to another book from the same publisher. Despite the endless research undertaken to show that this is what's wanted, I think it's baloney and the outcome is frightful. It's why in those enormous bookshops on Fifth Avenue you are blasted by thousands of books all pretending to be the best seller. The Big Book Look is a great publishing term in the USA, and you have mountains of 'This Year's Great Book'. Publishers stretch themselves to find more ways of getting on more gold, more embossing, more 'standout', and a more distinct item.

I come down strongly in favour of the continental system, which supports very much more positively the product of the publisher. The style of the publisher is clear but each individual book still can be recognized within the publisher's range. In Italy and France the publisher's name is excessively prominent. The smart book in France is of course the softback, the hardback the cheap commercial one. An upmarket French bookshop is lined with soft books, cream on cream, with one line of type, the publisher's style very evident and very little emphasis on the individual titles. The UK attitude is somewhere between this and the American.

My support of the continental attitude is largely because I think the average bookbuyer is a highly insecure person. To use an analogy, I'm fond of music but really know very little about it. I go into a record store and try to select the record I want. If in doubt, I buy the Deutsche Grammophon recording. I don't know why, but somehow I feel that the assistant at the cash desk will not laugh at me. I am covering up slabs of insecurity with this belief in the manufacturer's product. I think the same thing exists in publishing, along with the knock-on goodwill effect of a

previous pleasurable read from that particular publisher. Certainly for new authors to benefit from some of the goodwill transmitted by preceding authors is very valuable.

There is another advantage in establishing a strong house style. Representatives always come back asking if we can't make the lettering bigger. It's already filling its five inches, it can't be any bigger. What they mean is, can we not make it stand out? I have a feeling that by repetition comes a cumulative effect of standout, the friendly face within the sea of aliens in a bookshop. As a designer, the repetitive discipline also allows you to be calmer about your solution and to produce, in my view, a better-quality book because you're not inventing the wheel with every new cover.

My other reason for supporting the high profile of the publisher comes out of loyalty to a notoriously poverty-stricken industry. Since publishers have virtually no budget for advertising they ought to use every trick in the book to establish that they deliver a worthy product, and that you should feel very secure about buying it.

The Penguin university books were the first series I designed. I was trying to find a look not for a publisher but for a series. This is when I first became interested in the repetitive process. In this case the books were for students, so I wanted them to look as available as possible. So the lettering, for example, was set on my Olivetti typewriter in the office. I started the habit of using found images, hunting around for scraps that I could use to make the point I wanted to make about the book. This is where I began to learn the business of being oblique. For this job I often had no choice but to be oblique, because some of the titles were so appallingly obscure that I needed a dictionary to work my way through them. Once I even had a brief in Latin; apparently this was the only way the editor could describe the book. I started to learn that if you illustrated the title you probably wouldn't be far wrong.

The Faber and Faber fiction series shows the style we've adopted generally for Faber and Faber. The panel is a very strong device repeated endlessly in different disguises and colours. It is always there, clearly stating that this is the product from Faber and Faber. The panel necessitates a terrific discipline of course. For the non-fiction Faber books we maintained it but moved it to the centre. I can't describe precisely why, but I needed to make some change, and it enforces extra discipline. Again, we use a range of images from fine art, commissioned photography and existing material that has been manipulated.

Faber have traditionally taken a lot of pride in the power and importance of their poetry list. I decided to adopt a very traditional English

Covers use a range of images. The trick is to complement the style of the author. Thus, illustrator Irene von Treskow is used for Paul Auster, Huntley/Muir for a book of sensual writing, Christopher Wormell's traditional linocuts for The Herbal Handbook, *and Meilo So for Chun-Chan Yeh.*

LEFT: *The Faber and Faber plays series, inspired by circus playbills, has a repetitive pattern with two-colour overprint to make a third colour.*

Film titles have the simple addition of the clapperboard device to the title/author panel, with pictures reminiscent of those old stills used in the foyer of local cinemas.

For anthologies, the idea of collections is achieved by using images of random items strewn indiscriminately.

The poetry series uses Scotch rules around the title/author panel and a repetitive pattern made from the double 'f' logotype.

154

ABOVE: *Imaginative treatments of the ubiquitous Faber and Faber title/author panel maintain variety.*
RIGHT: *With a fixed panel, the fitting of the picture adds interest.*

attitude towards the style of the cover, the typography, the Scotch rules around the panel and the use of the double 'f' and a repeat pattern. Again, each cover is identified by an image, found, generated, or commissioned.

I borrowed the idea for the plays series from circus playbills. I made a repetitive pattern with the use of a simple two-colour overprint to make a third colour and enjoyed the energy that the technique created. It was appropriate at that time, when Faber were particularly interested in

younger playwrights. It is quite clearly more progressive in style than the poetry series. For the film titles, we simply added the clapperboard device to the panel and introduced stills for the movies in the way I remember seeing them displayed as a child, always at an arty angle like a dressing-table display. For the anthologies we refer to the idea of a collection by giving the impression of random items thrown down indiscriminately. It's a marvellous technique to be able to adopt, using all sorts of images of different sizes, three-dimensional and so on, making the thing look thrown together.

Payot is a French publisher for whom I worked a few years ago. With these titles I'm really redoing the Penguin university series, in colour rather than in black, again with the game of using found objects. The difference here is that I got interested in the effect of the image on the edge of the book, working with the three-dimensional quality that a book has. The 'P' which is the publisher's mark has become much more prominent, nearly taking pride of place, and demonstrating my theory of confidence in the publisher's brand, which is also typical of French publishing houses.

In the Payot fiction list the 'P' appears again but here I wrote in another disciplinary element to give ourselves an even harder time. Each title was to be illustrated with a portrait. I then became interested in the idea that you might always be able to illustrate a novel with a portrait. We pressed this to the point where the author has turned into a typewriter because he didn't want his physical character described. Building more

RIGHT: *Covers for the French publisher Payot hark back to the 'found images' used on the Penguin university series, with the approach extended into colour and more attention paid to respecting a book's three-dimensionality. The publisher's 'P' mark is used boldly.*
FAR RIGHT: *For the Payot fiction series each title is illustrated by a portrait – as fiction is almost always about people.*

commitments and constraints around an already fairly difficult task is a designer's game.

The series I've most recently undertaken is for a French publisher. The house is called Editions de l'Olivier (Olive Tree Editions) hence the mark, which has now taken over nearly one-third of the cover.

In general, we try to marry the author's and illustrator's styles. Garrison Keillor and Pierre le Tan have become irrevocably linked. We just happened to hit the nail on the head with the homely but surreal quality of le Tan's illustrations which absolutely matches Keillor's style, and the association is now pretty much worldwide. Another series of illustrations was commissioned for the Pinter plays. Klimowski's illustrations are disturbing and difficult to cope with, and fitted very well with Pinter's ideas and feelings about his work.

How to pick an illustrator is an issue for art direction. We have a number of clues. Paul Cox is homely, domestic, intricate, so you'd choose him for a book of that style. Pierre le Tan is quite different: hard, echoey, surreal, anxious. Irene von Treskow, by whose montages I am mesmerized, is very skilful at the oblique approach I've been talking about, at evoking an atmosphere, at appearing precise, but not precise. She was perfect for Auster's New York thriller stories. You want a brutal illustrator to portray a rather unpleasant character, so you pick Ian Pollock.

Humour, period, ethnic origins: all these might be pointers. We commissioned Meilo So to illustrate a novel set in China, an African-style illustration for an Amos Tutuola. My Greek example comes with a story. During a period when I used to frequent a certain Greek restaurant, I noticed the drawings on the walls. They turned out to be by the brother of the restaurant owner, and we commissioned him to do Kazantzakis' work. Technique is another indicator: lino-cuts fit well with the homespun, country-craft quality of *The Herbal Handbook*. For a book of sensual writing we picked a pair of illustrators who would not be coy about a sensitive subject and would deal boldly with it; we chose Huntley/Muir essentially for their courage in this respect. Going back to my Smart Art category, if in doubt use a Paul Klee.

We have the opportunity frequently to use photography. Putting commissioned photographs aside, I'm interested in the problem of dealing with photographs that already exist. I enjoy the Faber biographies especially, because the discipline of putting the panel smack in the middle of the forehead makes you work very hard at cropping the picture. The idea, with a biography, of the head being life-sized or bigger gives me the sense of looking right into the soul of the character, getting in close. Positioning the panel becomes much more interesting than it would be without the problem of the big head.

The olive tree mark for Editions de l'Olivier has taken over nearly one-third of the cover. The only variable elements are the title, author and illustrator.

ANSEL

THE AMERICAN

WILDERNESS

ADAMS

156

Ansel Adams: The American Wilderness *is a large format book that celebrates the American photographer's life-long fascination with the environment. Published by Bullfinch Press/ Little, Brown and Company, 1992. Partner, Neil Shakery*

A Visual Feast *by Arabella Boxer and Tessa Traeger, published by Random Century, 1992. Partner, David Hillman Designer, Julie Fitzpatrick*

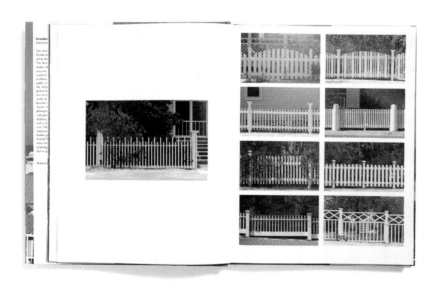

Seaside, a new town in Florida, was voted one of the ten most important works of architecture of the 1980s by the American Institute of Architects. Seaside: Making a Town in America chronicles the development with descriptions, photographs, and drawings of over one-hundred-and-twenty buildings by forty architects. Published by Princeton University Press (Phaidon Press in the UK), 1991.
Partner, Michael Bierut
Photographers, Michael Moran and Steven Brooke

TOP: Real Estate *by Jane De Lynn, published by Simon & Schuster, 1988. Partner, Paula Scher*
ABOVE: Goodbye, Columbus *by Philip Roth, published by Houghton-Mifflin, 1989. Partner, Paula Scher*

B R I T O N S
. .

Neal Slavin

LEFT: *The photographer Neal Slavin's* Britons *portrayed the diversity and idiosyncracy of the race in a series of photographs shot on a huge 20 by 24 inch Polaroid camera. Published by André Deutsch, 1986. Partner, Peter Harrison*

The Phaidon Colour Library *is a series of some thirty inexpensive art-plate books. Instead of adopting the traditional full-page bleed reproductions on the covers, a repetitive system was designed, appealing to the collector of sets. Partner, David Hillman*

159

Golden Grove was an independent publisher of fiction and non-fiction by Welsh writers. The books were made in high-quality materials with covers using found images in black-and-white. Partner, David Hillman

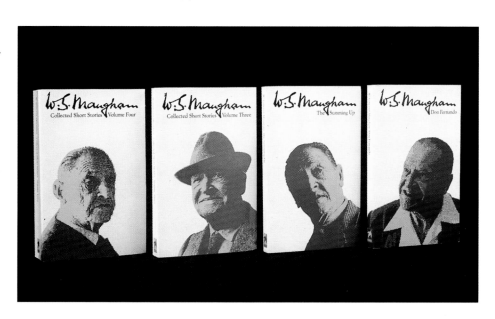

The first idea for a series of Somerset Maugham fiction was to have a photograph of the author on each cover taken at the time he wrote the book. This proved impossible; covers were eventually illustrated with a series of portraits of the author and his signature. Published by Mandarin Books, 1991. Partner, Alan Fletcher Designers, Quentin Newark and Leah Klein

The shop as product

Retail design that concentrates on the business of the store itself rather than the style of the times, escapes the prevalent straitjackets of uniformity and conformity.

Glancing around some shopping streets and malls, you may be forgiven for thinking that all the shops are selling the same thing – even owned by the same company. The design of multiple chains especially seems to have converged in a current 'wisdom' that says that shops can only compete by proclaiming current modish style for all their worth. The result: they all proclaim the same thing; content and context seem to be nowhere. If instead the design of retail outlets concentrates on expressing the nature of the business while maintaining interest and ease inside and out, the difference will do the competing.

Context is all. First, what the shop is selling determines the style of the retail design, which becomes an unequivocal statement of the business. Inside is all about how easily customers can move about the various attractions and be served. Compare the retail design process with the design of a magazine. The designs of *Vogue* and *The Economist* tell you the difference between them. A shoe shop ought to tell you that it's different from a travel agent. The fascia is the title, the shop window the cover design. The rest is about organizing information and function – often the most difficult part of any design job. It is a matter of making it easy and interesting wherever you are and whichever way you want to go in the shop. The function of space has to be more than respected: it has to be promoted.

The second contextual imperative is respect for environment and architecture. There is nothing worse than a standard pre-designed fascia, complete with glaring neon, imposed on a fine old Georgian façade; the building suffers, the shop suffers. Identity does not have to be compromised if there are no pre-set or imposed systems and styles. Design and quality which are sensitive to the location and building still communicate identity, and even enhance it. This may mean more work (each store is individually designed), but it also produces for the customer a more conducive and appropriate retail environment, which will pay for the extra.

DAVID HILLMAN

On Manhattan's Upper East Side Neuman & Bogdonoff has been transformed from a specialty food store into as full-service neighborhood market. Borrowing from the traditions of the local American deli, the French charcuterie *and the elegant English food hall, the interior design acts as a stage for the fresh and packaged foods.*
Partner, James Biber

162

Local ceramics, glass, jewelry and decorative fiber objects are sold in the Fireworks store in Seattle's Westlake Center. A confined and awkward space is dealt with by creating an illusion of openness.
ABOVE: *Two rows of columns taper into the glass walls above eye level, alluding to licking flames. Glass shelves project forward from supports so that display objects appear to float in space.*
RIGHT: *To accommodate changing themes and displays, space is organized flexibly, aided by mobile display units with uplit glass shelves. Partner, Etan Manasse*

The Wakefield Fortune network of UK high-street travel agencies undertook a new corporate design and communications programme, which included the redesign and refurbishment of its shops. A giant folding pack of postcards faced the street to signal the nature of the business. The postcards could be read from the inside, each relating an aspect of the Wakefield Fortune service. The interiors were designed with a blue tiled area, with brochure racks to encourage easy browsing, and a red carpeted platform area for customers to sit and discuss business. Partner, David Hillman

öola

*Öola is a chain of
Scandinavian candy stores
located in American shopping
malls. The identity design
borrows from the Dutch De
Stijl movement.*
TOP: *Symbol.*
ABOVE: *Shopping bags.*
LEFT: *Display window.*
Partner, Paula Scher

*'A motive of the artistic life, after all, is
the completion of sets. That childhood
instinct we have to make collections, to
tidy up and round off, affects adult
enterprises as well.' (John Updike at
the American Booksellers Association
convention, Las Vegas, 1990.)*

*I've been motivated since I was a
child by the idea of sets and collections.
Rows of toy soldiers in a shop window
were an enthralling enticement. Buying
one (because that was all I could afford)
produced nothing but unfulfilled
disappointment. It was quite forlorn –
meaningless, endless, beginningless. I
really wanted them all: rows and rows
of toy soldiers would give the one I had
status and purpose. So I wanted another
one. And another. Until I had the set.
The market stall-keeper has a similar
idea. Oranges piled up in neat rows
inspire. They make you want to buy lots
to take with you and put them all together
at home. Lots of the same ones is the
sharpest enticement I can think of. Warhol
did it, the stall-keeper does it, and I do it.*

*Not all clients see it the same way.
'Branding and marketing are highly
complex disciplines,' they say. 'We have
to target, to segment, we have to organize
ourselves in a way that respects and
drives the variety and complexity of our
sophisticated and demanding markets.
We have to match market expectations
with our own product research, testing,
marketing, and sales efforts. All this tells
us we have to change, innovate,
differentiate – all the time.' Such an
approach requires great effort. The effort
feeds on itself and creates internal
structures to justify itself. The belief is
that the results are exactly what the
customer wants. But the reality is that
the impenetrability and control created
deliver what the client actually wants
above all else: not customer satisfaction
but his own security. They may coincide
but they are not the same thing.*

*There is a simpler way. Variety is the
enemy of sets and collections. Variety is
just lots of different ones. Instead I like to
give customers the security of repetition –
repetition in the name, repetition in the
design, repetition in the display and the
promotion. Why ask the customer to
learn something new when the familiar
gives more satisfaction? The familiar just
needs repeating and repeating and
repeating. The promise goes on being
delivered again and again and again,
each one reinforcing the last. I want one;
I want another. The more toy soldiers I
get, the more I want.*
JOHN MCCONNELL

All wrapped up

MERVYN KURLANSKY considers the designer's new responsibility towards the environment in the traditional juggling of material technology and conceptual imagery in packaging design.

A wine label designed for a friend's new husband. Partner, Woody Pirtle

Packaging design is as accurate a reflection of a society's tastes, needs, and technological accomplishments as any. The fragments of pots and vases which remain from Roman, Greek, and Egyptian times have long provided us with some of the best clues as to the true nature of those civilizations.

Originally, packaging was born out of the need to transport food and weapons. The skilled craftsmen of the tribe would be entrusted with the task of making the packaging and they drew their inspiration from nature: the spider's web, the eggshell, the skin of fruit, and so on. From these beginnings, where those natural materials at hand were used, more sophisticated materials were adopted from wood, clay, and straw to metals, glass, and papers through to the synthetic materials we use today.

The greatest acceleration in the progress of packaging technology occurred in the last century with the Industrial Revolution. The handmade paper bag and later the collapsible cardboard box were huge and welcome leaps forward for the new manufacturers and retailers. Through these innovations, along with that of printing, came another: branding. With more than one manufacturer producing similar products there was now a need to differentiate. As the notion of advertising developed, packaging had to fulfil a selling requirement on top of its purely functional one.

The importance of this new purpose for packaging became greater as the twentieth century progressed. The increasing mobility of the consumer, through the development of public transport and the proliferation of the private car, led to the advent of the supermarket. Here goods were stacked side by side on shelves and, in the absence of a shopkeeper behind the counter, had to do all the talking for themselves.

Even in its earliest forms, packaging was always decorated by the craftsmen who made it. But with the advent of mass production and the competitive marketplace, the markings were no longer decoration for its own sake. Instead they carried important messages designed to give information about the product and to persuade the customer to buy.

Today, much of mainstream packaging is slick propaganda, and the emphasis has shifted from describing the contents to expressing a concept. Myriad subcultures and lifestyle groups now exist, and can be identified and targeted through the rapidly advancing science of consumer research. Mass media and mass marketing have given customers huge choice. In such an environment, no company hopes to win over every consumer. Instead, each targets specific groups. In an affluent society, where choices are no longer made purely on the basis of cost, groups are targeted on the basis of age, social class, income and – crucially – how they perceive themselves. This increasing sophistication of consumer culture and visual literacy has led to the idea of object as image and presenting things to the market through variations in packaging. Many would argue today that the packaging of a product is as important an influence on its success as its intrinsic quality.

This segmentation of the retail market is one of the things that will be apparent to future generations when they study our packaging. Another is the increasing awareness of the environmental issue, now widely seen as the most important item on the agenda of our times. The (belated) realization that the globe has finite resources has meant that ideas on progress have had to be rethought.

The designer finds himself at the forefront of this new challenge. In the past his activity has been driven by two interrelated goals: to invest the packaging with a unique quality through his own artistic machinations, and to contribute to the product's success in the marketplace. Now there is a third: to protect the environment. Increased consumer awareness and concern about green issues has meant that packaging must not only satisfy these new criteria but be seen to do so – hence the presence of words such as 'ozone-friendly' and 'biodegradable' on packaging.

It is not just the considerations of the market that should modify the designer's approach, however. Taking responsibility and working within the new criteria and restrictions should be regarded as an opportunity to savour. Packaging has much to answer for in terms of the damage already done, and the opportunity to right previous wrongs should be grasped seriously and enthusiastically. The challenge to all design disciplines is to meet these new requirements whilst maintaining the momentum of progress and continuing to create things which are as culturally enriching as the beautiful pottery of ancient times now admired in our museums.

Tactics has become a big consumer success story in Japan. It started when Shiseido began looking in Europe for designers to develop ideas for a new range of men's toiletries. Eventually contact was made with Pentagram's Kenneth Grange while he was in Japan on another project.

Working with fellow partner Mervyn Kurlansky, a clearer definition of the product style and market proposition was developed and the brand name Tactics was proposed. It has a certain Western cachet that appeals in Japan and refers to clever interplay, both sporting and business.

The overall effect of the packaging design is intended to signal the coincidence of Western and Eastern cultural influences: the graphic manipulation of the Western typography combined with the very Japanese snap-top containers. The original range of toiletries has now spawned a wide range of other products with the Tactics brand name – from watches and other accessories to clothes and furniture. Partners, Kenneth Grange and Mervyn Kurlansky

Trendy is a Japanese range of unisex hair, face and body-care toiletries from Shiseido, aimed at the late teens and early twenties. The packaging has haphazard symbols of contemporary lifestyle such as music, architecture, video, film, and fashion, with free-form English typography known in Japan as 'scrambled communciation'. Allowed only to make minimal changes to existing mouldings, the shoulders of containers were stepped and colours used to code different products.
Partners, Kenneth Grange and Mervyn Kurlansky

Packaging for Rain Forest fruit and nut products from the Brazilian rainforests uses recycled paper, cellulose wrapping, vegetable inks and reusable cans. A percentage of the profits is donated to the environmental organization Cultural Survival.
Partner, Paula Scher

A new label was designed in 1990 to reflect the quality and price of an increasingly successful vintage Chardonnay, primarily sold in California shops and restaurants.
Partner, Linda Hinrichs

The Farmers Dairy Co was established in the UK to help organic farms retain their own identity while competing with large brands in the marketplace. The organization is non profit-making, and exacts a levy from members. The distinctive white packaging with the Farmers Dairy Co logo features a different type of flower or fruit to represent each product, with the individual member farm name printed separately.
Partner, John Rushworth Associate, Vince Frost

Dualux, a high-quality shower fitting from Ideal-Standard, used to come wrapped in corrugated board. New packaging was designed to make it equally suitable for the DIY market as for the plumbing trade.
Partner, David Hillman

Inflatable models of the Earth's creatures, past and present, are packaged flat in descriptive envelopes for The Nature Company, which provides products through stores and mail order that promote the environment and never exploit or jeopardize nature.
Partner, Kit Hinrichs

170

TOP LEFT: *The cover for New Order's* Fine Time *single on the Factory label. Acid house imagery is produced using the 'dichromat' process (see page 282). Partner, Peter Saville*
TOP RIGHT: *The album cover for New Order's* Power, Corruption and Lies *features a painting by Fantin-Latour as a visual oxymoron. Partner, Peter Saville*
ABOVE: *The 'industrial' look cut-out grill pattern and Gill typography made the cover for Dindisc's 1980* Orchestral Manoeuvres in the Dark *album more like an object than a record sleeve. Partner, Peter Saville Co-designer, Ben Kelly*

While we must strive to halt the destruction of our planet we must ensure that we also combat another form of pollution – that which is visual and cultural. The accelerated growth of the global marketplace, recently boosted by the dismantling of the communist systems in Eastern Europe, threatens to intensify this danger. Driven only by the profit motive, the forces of economic imperialism will be tempted by the expediency of crossing the barriers of culture and language via homogeneity and mediocrity. That loathsome adversary of quality and innovation, design by committee, threatens to rear its ugly head. The North American Indians believed that when you made something you were investing it with your own spirit, which gave it its true value. Similarly, good design today is still the product of the unique qualities of one person's creativity.

The fear of losing the cultural identity of individual countries and regions is already being debated in the advertising and design industries, where many feel that pan-global campaigns spell the end of real creativity and innovation. What differences between Siberia and Solihull will be revealed to future generations when they unearth the same can of baked beans in both places?

The challenges to designers in the 1990s and beyond are clear. Responsibility for the future well-being of our planet must be grasped, and attempts to dilute the contribution that design makes to the cultural and social world must be firmly rejected. Only then can we be confident that future generations will treasure their legacy as we treasure ours.

OVERLEAF: *Packaging is designed for its display impact in the overall identity for the Öola chain of Scandinavian candy stores in American shopping malls. Partner, Paula Scher*

RIGHT: *The Pantone color reference and specifying system for designers and printers has a library of different color swatches and manuals, each one with a specially designed cover. Partner, Woody Pirtle Designer, Matt Heck*

Important doesn't have to mean boring

KIT HINRICHS decries the fearful blandness of so many annual reports and other corporate publications, and shows how much more can be achieved by searching beyond the obvious.

It's a crisp fall afternoon. I'm on time, and the gleaming elevator hurtles me to the executive floor of a Fortune 500 company. The tailored receptionist does not mispronounce my name and whisks me silently over lush, mile-deep broadloom past original Rauschenbergs and Warhols into a tastefully appointed boardroom. Surrounding the conference table (which would put a bowling alley to shame) are the expectant faces of at least three Executive Vice-Presidents and Directors. I am filled with visions of the annual report we will create together. The door opens and in walks the Chief Executive Officer. Confident, self-assured, resplendent in his Armani suit, he joins us and we begin to plan next year's report. An hour later, dazed, I shuffle from the boardroom unable to speak until I reach the street. Could I really have heard what I thought I heard about the concept for next year's annual? Did I get off on the wrong floor? Would a company as sophisticated as this plan a report as bland as yesterday's oatmeal?

An exaggeration of course, but not quite as far from the mark as you might imagine. Many corporations don't really understand how vital and interesting their companies are. If they weren't interesting, business magazines around the country would be producing crossword puzzles instead of corporate profiles. When reporters want to talk to an expert in a certain field, they don't call a business school academic; they call a company that is successfully manufacturing products in the industry. These are the people who talk reality, not theory. Whether the business is microcomputers, pharmaceuticals, insurance, or generators, the people who really know the subject are the ones producing a product and turning a profit.

This is one reason why trend-watchers keep a sharp eye on business to determine where the country is going. Business is where many exciting inventions come from, where the first signs of consumer shifts become visible. If you want to know what is happening in housing, talk to someone in forest products or real estate; or check with the steel industry to see if automobile sales will remain steady in the coming quarters. No matter what the industry, there are dozens of interesting stories to be found, needing only a look beyond the obvious.

Yet somewhere in the hallowed halls of business school, it has been forgotten that business is more than a profit and loss statement. We are so close to the numbers that we've lost sight of the people, manufacturing procedures, international cultures, and historical processes that are behind them. We've also become so intent on delivering the corporate message that we've neglected to

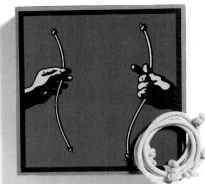

ABOVE AND OPPOSITE: *The announcement of the corporate merger between James M Montgomery and Watson Hawksley, which formed Montgomery Watson, 'the best environmental engineering and consulting firm in the world.' It was mailed in a box complete with string.*
Partner, Lowell Williams
Illustrator, Michael Schwab

Geers Gross was the first British advertising agency to set up in the USA. In a series of annual reports, an eminent guest illustrator was invited to interpret and relate London and New York, the two cities where the agency had its offices.
Partner, Alan Fletcher
Illustrators, left to right: Bob Gill, Peter Blake, Folon, Seymour Chwast, Paul Hogarth

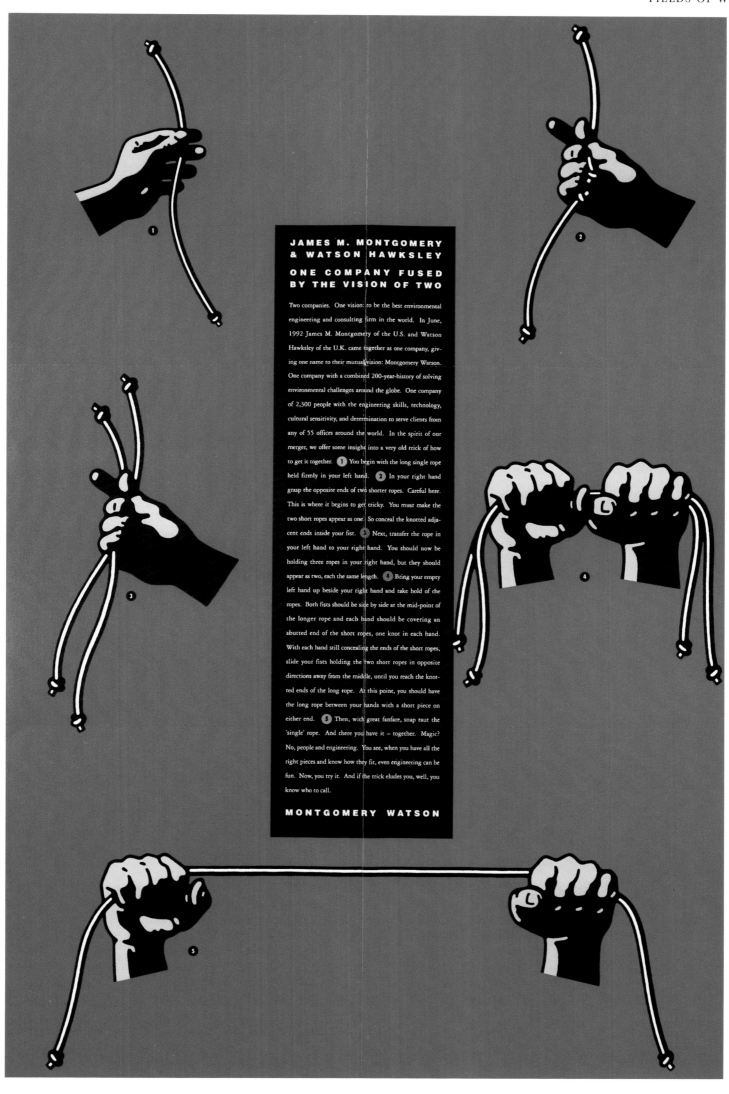

176

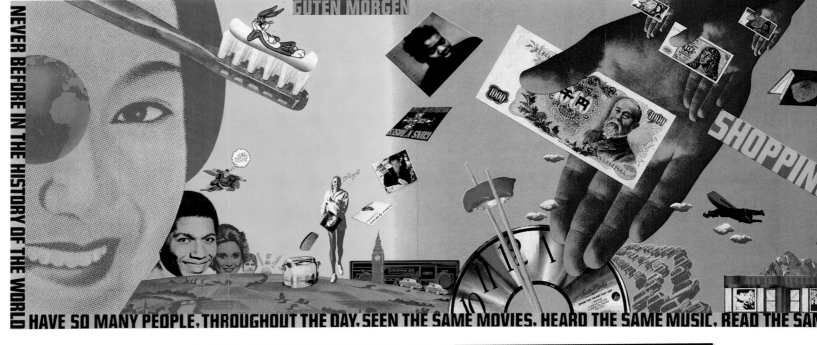

RIGHT: IBM's Basic
Beliefs *is a corporate
manifesto describing the
enduring philosophies that
have turned a 1930s cash
register manufacturer into the
world's largest computer
company.*
Partner, Michael Bierut
Photographer, Tim Simmons

check whether it is being delivered in a form that will appeal to the audience. I do not mean to imply that an annual report or corporate brochure should pretend to be *Newsweek* or *Time*, but they do present the opportunity to tell a unique corporate story.

Let's examine the average annual report reader. He or she may receive the report in the mail with a family letter, a handful of bills, a copy of *Life*, and a catalog from Macy's. Given the choice of reading material, the chances are

that the annual report will go to the bottom of the stack unless something catches the reader's eye. Otherwise the recipient may get a report in the office along with a dozen memos and critical correspondence. Once again, unless it promises solid information and a certain degree of entertainment value, it may be given only a cursory look. Studies indicate that the average reader spends less than five minutes looking at an annual report before tossing it aside. That means that unless we catch the reader's interest

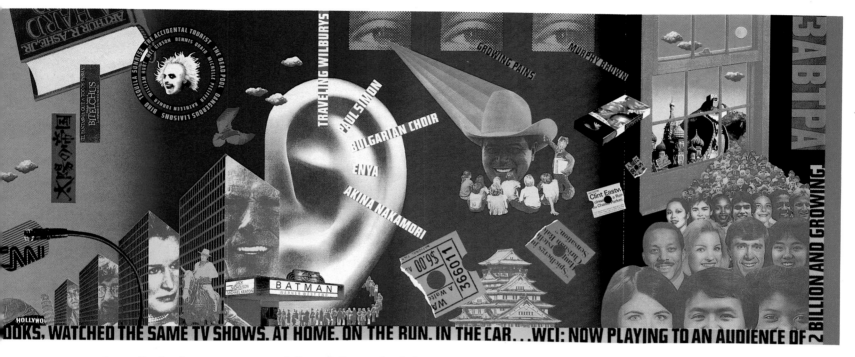

immediately, the message goes undelivered. One solution for attracting readers is to present information on different levels of interest. For the average shareholder, there can be financial highlights, easy-to-grasp charts, and a quick summary of operations. A lengthier review can follow. The point is to let the reader choose what to read. Given only long columns of grey text, readers may well decide that they just aren't interested at all.

In any given year, many annual report essays dwell on customer service or the importance of employee contributions. Certainly these are essential facets of every company, and that is why, as theme topics, they have become clichés. Again, the annual report producer might argue, 'But what else can we say? We aren't one of those new frontier companies, making a discovery a day.' Maybe not, but I have never found a company that didn't have interesting stories waiting to be told.

Getting out of the office and talking to the line foreman on the graveyard shift in Muskogee will give you enough stories of quality and care and pride for the product to keep you supplied for years. Looking into historical archives can invite comparisons between processes today and yesterday. Interviews with corporate 'experts' on new trends in the industry can provide some quotable thoughts on where the business is going or the contributions it has made to date. Devising an annual report 'mini-series' over perhaps five years can explain a business in detail. It's all there, and it's all fascinating.

But some reports remain lack-luster because key individuals – the project manager, CEO or

the designer – are not focusing on the main goal of communicating with the shareholder and primary audiences in the most effective way possible. In the same breath that an annual report manager describes how important it is in achieving corporate goals, he or she often unknowingly introduces a set of restrictions that severely hampers the accomplishment of these goals.

Annual reports and corporate publications don't have to be dull. If they are really as important as every corporation believes, then they are worth the time to look beyond the obvious for the special story.

ABOVE: *The theme for Warner Communications' 1988 annual report was the increasing globalization of the company. 'A day in the life of the world' on the cover illustrated the extent of its international involvement. Partner, Peter Harrison Associate, Harold Burch Illustrator, Gene Greif*

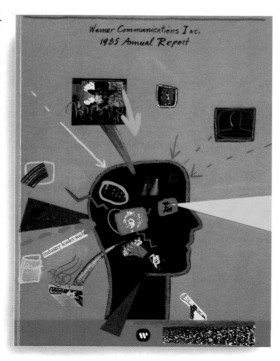

Warner Communications' 1985 annual report announced a profound resurgence of profits and growth after two bad years. The cover illustration prompted the New York Post *to describe it as the 'first punk annual report'. Partner, Peter Harrison Associate, Susan Hochbaum Cover illustrators, Huntley/ Muir*

178

The 1990 annual report for the high-technology company EG&G, whose credits include the invention of strobe lighting and the manufacture of X-ray security machines for airports. Visuals feature two styles of photography: color for graphic effect and black-and-white for 'architectural' shapes and patterns. Partner, Peter Harrison Associate, Harold Burch Photographers, Burton Pritzka (black-and-white), Scott Morgan (color)

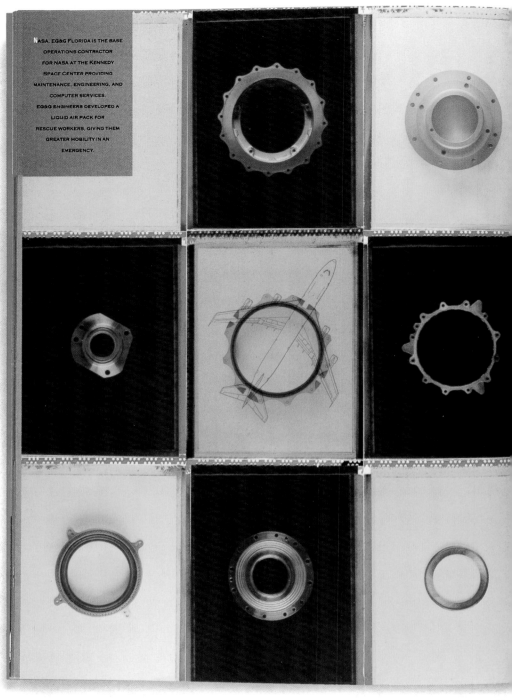

A series of souvenir journals was designed for Royal Viking Lines passengers so that they could keep a day-to-day record of their experiences. Each journal had a distinct cover and photo portfolio relating to the specific cruise; they all shared a sixteen-page introduction on the history of cruising. Partner, Neil Shakery Designer, Mark Selfe Illustrator, Mark Summers

◀ EG&G Sealol products are used in commercial and military aircraft throughout the world. These high-performance seals have the capability to withstand the high pressure, temperature, and operating speeds essential during engine operation, while improving fuel consumption and enhancing engine performance.

AEROSPACE

▶ This cone-shaped plug and nozzle assembly, that constitutes the primary exhaust system for the 737, controls the exit area of the jet engine's exhaust. This control is critical to the thrust performance of the engine. This precision assembly is fabricated at EG&G KT Aerofab from high-strength, heat-resistant alloys.

OSCILLOSCOPES. AN ULTRA-HIGH-SPEED CATHODE RAY TUBE DESIGNED BY EG&G ENERGY MEASUREMENTS IS ONE OF THE FASTEST SIGNAL MEASUREMENT INSTRUMENTS IN EXISTENCE. THIS SCOPE CAN CAPTURE FLEETING ELECTRONIC SIGNALS FROM LASER FUSION EXPERIMENTS AND FROM THE TESTING OF MICROWAVE DEVICES.

Think is IBM's prime management communication magazine, circulated throughout the corporation worldwide.
Partner, Woody Pirtle

A brochure illustrating the successful transactions of the investment firm Arcadia Partners uses dramatic conceptual photography as its theme.
Partner, Michael Bierut
Photographer, Scott Morgan

180

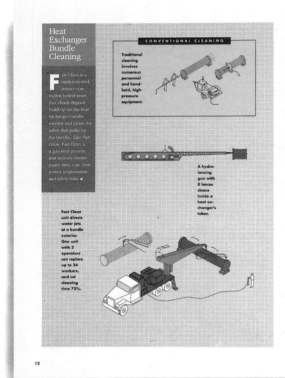

*The Potlatch Corporation
is a manufacturer of forest
products such as papers,
lumber for building, pulp
and paperboard, napkins and
tissues.*
RIGHT: *The first of three
books pubished by Potlatch
on Minnesota, which cover
the forests, culture and
geography of the state.
Partner, Kit Hinrichs
Photographer, Tom Tracy*

*A service brochure for
Serv-Tech, an industrial
maintenance firm, used
illustration and photography
to achieve an appropriate
'engineering' feel.
Partner, Lowell Williams
Illustrator, Troy Ford
Photographer, Jim Simms*

*The Rockefeller Foundation
provides aid to international
scientific development, the
arts and humanities, and
promotes equal opportunities.
The 1991 annual report
features photographic essays
in the different fields of the
philanthropic organization's
work.
Partner, Woody Pirtle
Designer, John Klotnia*

At our Cloquet nursery and greenhouse, Potlatch raises millions of seedlings annually from pine seeds selected for superior characteristics such as fast growth, insect resistance and high fiber yield. In 1991, the company planted 1 million red pine seedlings on 1,596 acres of our Minnesota land.

Growing trees to make lumber and paper products requires nurturing them from seedlings to maturity. That represents a 60- to 70-year cycle for pine and a 45-year cycle for quaking aspen.

Over the past decade, 30,423 acres of company land in Minnesota have been replanted with more than 18 million softwood seedlings germinated at our nursery and greenhouse in Cloquet. Since 1956 this facility has been raising genetically superior softwood seedlings from parent stock exhibiting high growth and fiber yield characteristics. In the case of aspen, which reproduces from root systems, Potlatch has facilitated natural regeneration on hundreds of thousands of additional acres.

Northern Minnesota's forests grow in mixed stands of about 70 percent hardwood (mostly aspen and birch) and 30 percent softwood. However, 46 percent of the company's 318,000 acres of Minnesota land is in softwood.

Company land supplies a fraction of the fiber needed for our Minnesota operations. The rest is purchased from outside sources. About 42 percent of Minnesota's woodlands are privately owned. Potlatch's Private Forest Management Program assists these owners by encouraging stewardship methods that enhance regeneration, productivity and long-term income, as well as benefit wildlife and provide recreational opportunities. Our forest management closely follows and often exceeds the State of Minnesota's best management practices designed to minimize site disturbance, prevent soil erosion and degradation of streams and lakes, and protect wildlife. Through careful management of our lands and expertise we provide to private owners, Potlatch supports environmentally conscious use of the land and its resources.

Osprey sometimes build nests on Potlatch land. The company takes measures to enhance wildlife habitat in our forests.

How to make a date

Once a year many commercial calendars compete for only one available space on the wall. The designer is asked to ensure that the right one is chosen.

Some people insist that calendars are useless unless dates can be read across a room, others prefer pictures with only discreet reference to the passage of time, others think both have equal roles.

The 'number set' can basically be divided into two types. The pragmatists have a preference for sans serif letters and numbers without feet (after all that's how they sign motorways.) The literati tend to favour serif faces, which they consider more tasteful. The 'picture set' are equally subjective. Sentimentalists are fond of cats, spaniels, and rural scenes; the traditionalists discreet reproductions of Old Masters or, of course, sunflowers. The trendy faction fancy out-of-focus black and white photographs – preferably by middle Europeans who ended their days in Pigalle or on the Lower East Side! It's really more a matter of taste than numeral information. A calendar on the wall says something about the person who looks at it every day. Soft porn distinguishes the fashionable from the fusty, and only 'trade' would display the confections sent out by the local automobile dealer emblazoned with logotypes and sales slogans.

There are other issues. Should the week start on Sunday or Monday, should the dates follow a vertical or horizontal reading, what are the advantages of having one or three months to view? Then there is the format. Some prefer spiral-bound, others the perforated page, some a stapled block of numbers. There is also presentation. One paper maker mails out a vast design concoction printed in about twenty colours on paper with the consistency of sheet formica, at the other extreme you get cute little tin tags to bend around your watch strap. There's no end to the possibilities in informing people time is running out. As for my preferences – if I want to know the date I ask my secretary.
ALAN FLETCHER

Part of the extensive corporate gift programme created for the Commercial Bank of Kuwait included a calendar of Kuwait city's minarets (see also page 206). Partner, Alan Fletcher Photographer, Tony Evans
OPPOSITE: *The 1991 calendar designed for customers and colleagues of Coyne Electrical Consultants depicted an event characteristic of each particular month. Partner, Michael Bierut*

January
Work Related Seminar

**Coyne Electrical
Contractors, Inc.**
298 East 149 Street
New York, New York 10451
Tel 212.292.9100
Fax 212.402.2228

184

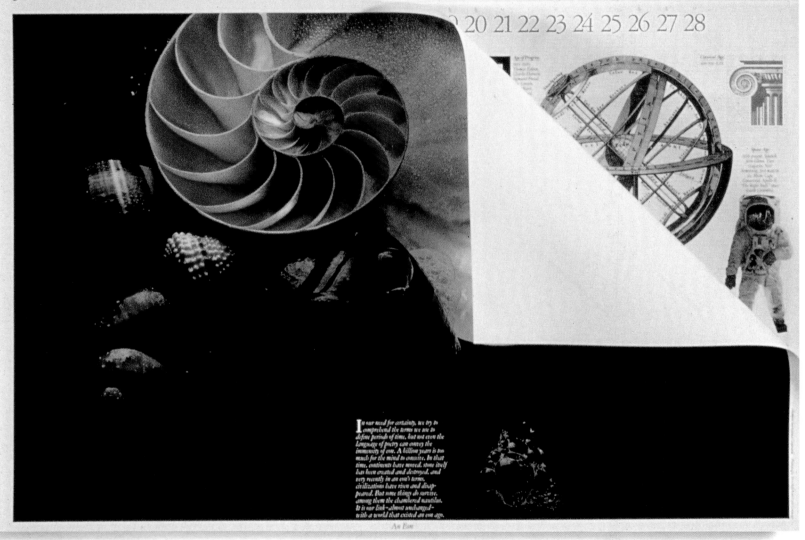

*Twelve levels of 'time', from
the eon to the second, were
interpreted in a calendar for
Champion Papers. The
calendar also acted as a
swatch demonstrating
different papers and printing
processes. The calendar pages
were 'stepped', with the depth
of each reducing to show a
successively shorter period
of time and ultimately
displaying the twelve different
papers together.
Partner, Kit Hinrichs*

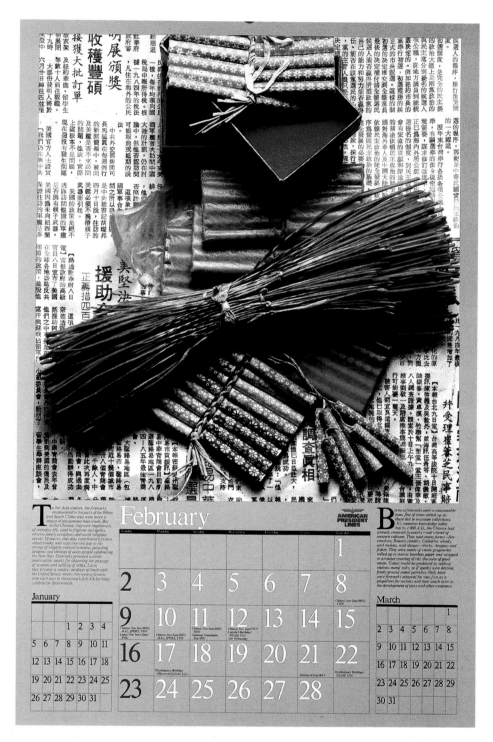

Nine calendars have been designed for American Presidents Lines, cargo carriers operating across the Pacific. Each year used metaphors to illustrate aspects of Pacific rim cultures.
Partner, Kit Hinrichs
Photographer, Terry Heffernan

Peter Harrison commissioned twelve different designers to illustrate the 'birthday' theme of a calendar for the printer Applied Graphics.
TOP TO BOTTOM: Woody Pirtle, Peter Harrison, Kit Hinrichs
Associate, Harold Burch

Each year is dedicated to one theme for the Pentagram calendar, published in association with the printer G&B Arts. A characteristic personal style of interpretive graphic illustrations is used. RIGHT: *1990 was on the theme of the sporting year.* BELOW: *1992 was based on the twelve countries of the European Community. Partner, Alan Fletcher*

186

Jour de fête

picture of a small place

Ireland – as seen from Wales

hysterical sunset – Naples

The Black Forest

a greek summer

Costa Brava

white cliffs of Dover

Amsterdam

sardines

a field in Flanders

Denmark is over the north sea

Wimbledon finals

S S M T W T F S S M T W T F
1 2 3 4 5 6 7 8 9 10 11 12 13 14
15 16 17 18 19 20 21 22 23 24 25 26 27 28
29 30 31 July

The reader is always right

When a new magazine hits the news-stands the designer may hold his breath. But success stems from the appeal of the whole editorial stance, of which design is simply a component.

To know if a magazine is to look and feel right for the reader who pays for it, the designer must understand something not easy and sometimes impossible to learn: who the reader is and what the reader wants. If you are looking for something new in magazine publishing – and every new title is looking for some unexploited niche – you have the problem of readers not knowing what they want until they see it: It cannot be market-researched, because it doesn't exist. Instead the designer has to forgo personal preferences, prejudice, and wishful thinking, and rely on experience of what works and what doesn't.

Designers in touch with the realities of the times – the moods, the drifts, the beliefs, the fashions – stand a chance of pleasing the person at the bookstall. Designers who have a proper and unbiased comprehension of the total media scene – where there are gaps, how much things cost, from the creative to the technical, production and distribution – can help to make the intricate editorial mixture work. And designers with a touch of intuition and a little informed inspiration may find a new way to magazine success.

Design is of course involved in most aspects of a magazine's appeal, from the readability of the type, and the effectiveness of the photography and illustration, to the choice of paper and quality of the print. If a designer had only to master the technical components of magazine design – cover, logotype or masthead, typography, image and page layout – then it would not be too difficult to make a magazine appealing. What is more difficult is keeping an overall visual balance and particular style from issue to issue, while changing the pace within each to prevent visual monotony. Big headings, overcoming the fear of white space, the use of pictures – these are the main weapons that can modulate the pace of a magazine.

A designer from outside can bring a fresh eye to a magazine's design problem, which is just as likely to stem from faulty organization or systems as from inadequate design skills. An outsider sometimes has difficulty in getting to know how the magazine works, but this is essential if a way of working is to be established to deliver the new design intact.

Incidentally, an outside designer should never take on a commission if the magazine's circulation is falling. Readers, editors and designers all know that design cannot save a magazine from failure. But they also know that an ingredient of its success will be its design: the design that touches off that intangible feeling of rightness, of identification in the reader browsing at the bookstall. But even then the designer should not expect that much credit. The tendency is to give the editor a raise if a magazine with a new design is a success, and to fire the art director if it is a failure.

DAVID HILLMAN

190

Hong Kong reaches for the future ... the spectacular Exchange Square (far left), the Hong Kong Club (left), and (above) the Bank of China building and, symbolically, the Hong Kong Bank building beyond and above it

Launched in 1986,
Business *magazine aims to provide authoritative business publishing with the same kind of design, photography and production values previously associated only with up-market women's magazines.*
Partner, David Hillman

Audubon *is the USA's oldest magazine dealing with nature and the environment; it was traditionally sent to subscribing members only. With the advent of 'green' consciousness the opportunity arose to freshen the appeal of the magazine and widen the readership. In a new format, layouts owe much to the old layout style, whose use of white space coincided with contemporary practice. The format specifications include century-old wood typefaces that have been digitized for modern production.*
Partner, Michael Bierut

The Elk-Ranch Boom
By Ted Williams

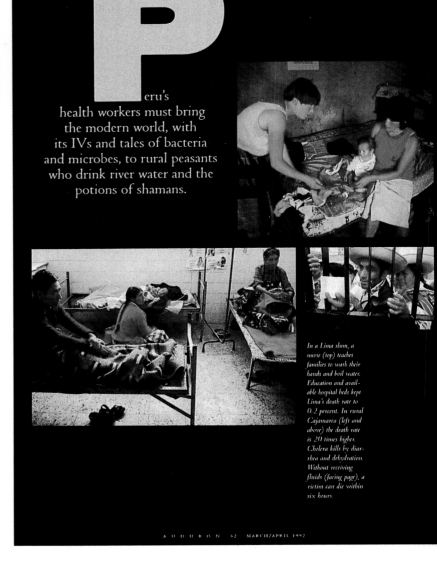

In a Lima slum, a nurse (top) teaches families to wash their hands and boil water. Education and available hospital beds kept Lima's death rate to 0.2 percent. In rural Cajamarca (left and above) the death rate is 20 times higher. Cholera kills by diarrhea and dehydration. Without receiving fluids (facing page), a victim can die within six hours.

P**eru's**
health workers must bring the modern world, with its IVs and tales of bacteria and microbes, to rural peasants who drink river water and the potions of shamans.

AUDUBON 62 MARCH/APRIL 1992

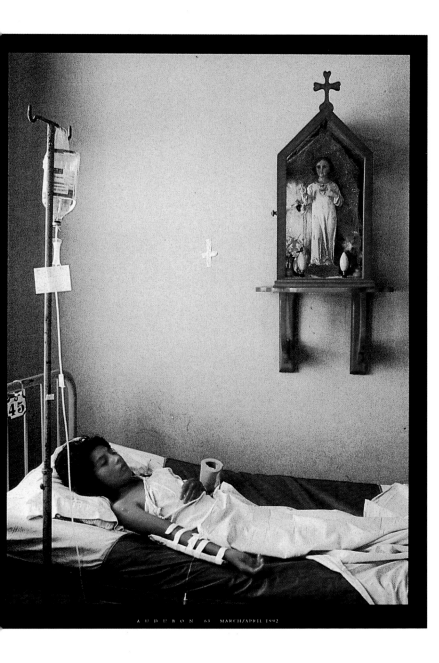

*The quarterly magazine
Glass is published by a
small, specialist community
of glass workers who operate
an experimental glass
workshop in New York.
Partner, Michael Bierut*

192

Art Center Review is the quarterly tabloid review of Art Center, the design school in Pasadena, California. It is primarily aimed at alumni, but its readership includes current staff and students as well as the professional world outside. The magazine is part of a comprehensive communications design programme undertaken for the school, which included a visual identity system. LEFT: The front covers feature a custom-designed alphabet by Photo Lettering for the masthead, a table of contents strip with illustrative images, and Bodoni numerals and text. BELOW: Different pencil illustrations are used in the news section of each issue. FAR RIGHT: Bodoni is used in narrow newspaper-style columns as a counterpoint to the variety of the student work, regular features and compositions of artefacts, alphabets and quirky elements which fill the Art Center Review pages. Partner, Kit Hinrichs (an Art Center alumnus)

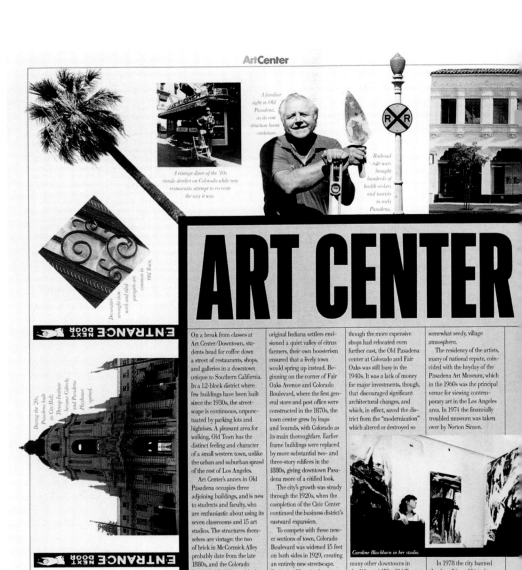

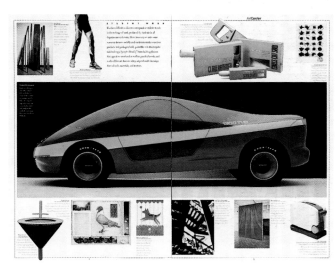

194

TANGRAMS

Whatever shapes you decide to make with the Tangram, there is just one rule: all seven pieces must be used for each figure. It's not as easy as it looks, although the solution to one puzzle will often occur to you while you are doing another ■

1 EASY Make your own Tangram ● Trace the pieces that make up a shape on this page ● Can you recognize the shape of each piece? Spell them out to a friend ● Try designing your own boat and rabbit shapes.

2 NOT SO EASY Without looking at the answer, make the single square using all of the seven Tangram pieces.

3 QUITE DIFFICULT Make your own shapes, draw the outline, and then test your friends ● Is there one shape, in particular, that doesn't 'behave'? Describe why it doesn't ● Draw the net you might need to make any of the above shapes in three dimensions.

4 VERY DIFFICULT Convex shapes have no inside angles greater than 90 degrees ● How many convex shapes does this Tangram make?

The Big Paper is a design education journal for primary schoolchildren and teachers, published each term by the Design Council in the UK. Partner, David Hillman Designer, Jo Swindell

P is a half-yearly professional photography magazine from Polaroid. Partner, John Rushworth Associate, Vince Frost

The Design Council's monthly Design *magazine is a leading journal for designers and management in the UK. It was redesigned in 1990 to bring it into line with current attitudes and values and give its editorial content a more solid foundation.*
Partner, David Hillman
Designer, Julie Fitzpatrick

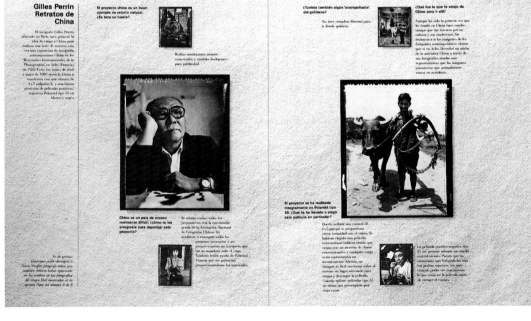

Client varieties

Design is a two-handed business that depends on the commissions of clients, and most designers are motivated by the challenges of a brief and the deadlines imposed by the requirements of the project. The few designers who have the opportunity to work for themselves will usually end up producing something that has a commercial point. They will need a client in the end; it is in the nature of design.

Varieties of client are almost limitless, and there are few if any rules concerning the relationships that are formed with them. Each project has demands that go way beyond the commercial arrangements of supplier and buyer. The designer has to be adaptable and responsive.

The quality of ideas, and the design service that supports them, depend on the level of sympathy and understanding between designer and client. Part of this understanding is cultural: working in the designer's own city, country, or industry is easier than striving for universal effectiveness. Where design crosses cultures and designers have to work and succeed in a foreign vernacular, their adaptability is tested to the limit.

The client as patron

The most valued clients are those rare visionaries who can build a working friendship with the designer. KENNETH GRANGE has worked with five men who meet this definition of patron.

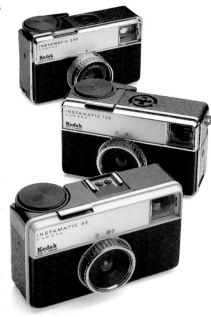

ABOVE: *Kodak's Instamatic series proved to be the best-selling cameras ever made.* OPPOSITE: *The brilliantly engineered battery-powered Milward Courier razor introduced in 1963, years ahead of its time.*

What is now commonly called design is quite simply commercial art. Can we then conclude that commercial art is equally simply art for sale? Artists paint what interests them and then offer these paintings for sale. How then can we differentiate between their output and ours as designers? Some of the difference surely lies in the personality and artistic choice of the begetter and initiator of the work.

With designers, the initiative is not self-generated but is brought to us by people representing organizations; invariably it is a single person from that organization who wishes to employ our creativity for commercial gain. Great patrons of the past have traditionally been thought of as individual benefactors, but surprisingly often, if we investigate carefully, we find that they too represented a group of people. Michelangelo's great patron, Pope Julius II, was the head of a mighty corporate organization, the Roman Church, which certainly displayed an enthusiasm for financial gain, and to this day involves itself in banking activities.

But whether it is an executive of IBM or a Cardinal acting for the Pope, the common link between them and the crudest commercial art or the most spiritually uplifting fine art is the person who orders the work – the client. The client commissions a design for a train, a poster, a pen or a monument, a building or an identity for a corporation. The same client may also commission a portrait of the Chairman, which we more readily describe as fine art; the distinctions are sometimes subtle. But no matter whether it is the fine artist believing that he is free of the imperatives of commercial life, or the staff designer designing teapots in return for a salary, we are all dependent on the enthusiasm and good will of the client.

Clients may come in many forms. Some quite simply employ designers and artists because it is an essential part of the commercial process: no record producer would sell a record in an unmarked packet, and no one would today market a product without considering its aesthetic impact. These commissioners regard the design much as they regard the product, simply as a means of making money. There are other clients who more positively enjoy the opportunity to commission a designer because much of their daily life is a dreary round of meetings generally complying with a known process. For these peo-

ple, design provides a glimpse into a foreign world. The advertising agencies understand this relationship very well and cultivate it. They know how seductive their world appears to the outsider: amusing people, casual behaviour, lovely ladies and a creative atmosphere – heady stuff for the product manager let out of the corporate headquarters. Some clients simply enjoy seeing talented people at work. Such championship is not unlike the commissioning of a beautiful piece of jewellery: the caring commissioner does not lose sight of why the work is done, but enjoys the association with a skill he does not personally possess.

Such clients come closest to the artist's vision of the patron – a person so interested in the output of the artist that he orders or sponsors work in the belief that it will be valuable to him. Admittedly a few in history have been altruistic and sought only to help a fellow man, an artist or craftsperson who, without their patronage, would be unable to function, but these are few indeed.

The patrons that we cherish do have a commercial motive, but seek out designers with whom they can enjoy the building of a working friendship. Such patrons mature the association and, with the designers, conceive and help give birth to an artefact or product. The labour may be prolonged and painful, but ultimately the result is positively pleasurable. A patron plays many roles in such a partnership: he or she defines the commercial objective: justifies the costs and the means of achieving it: provides a critique, support and praise as appropriate; and shields the partnership from external doubt and dissent.

These patrons are often visionaries, able to identify a particular talent which an artist or designer may not even be able to see; thus by demanding more they force talents to grow, as a gardener may break the dormancy of a seed. Perhaps these patrons are themselves artists, understanding that their larger role is to lead and facilitate. Certainly in a lifetime the patron may lay claim to more than the artist he commissions. Today we marvel at the extraordinary fecundity inspired by the Medici – the paintings, the sculptures, the buildings – but do we now remember the names of all the artists they commissioned? In my working life, I can nominate five people who could genuinely be described as

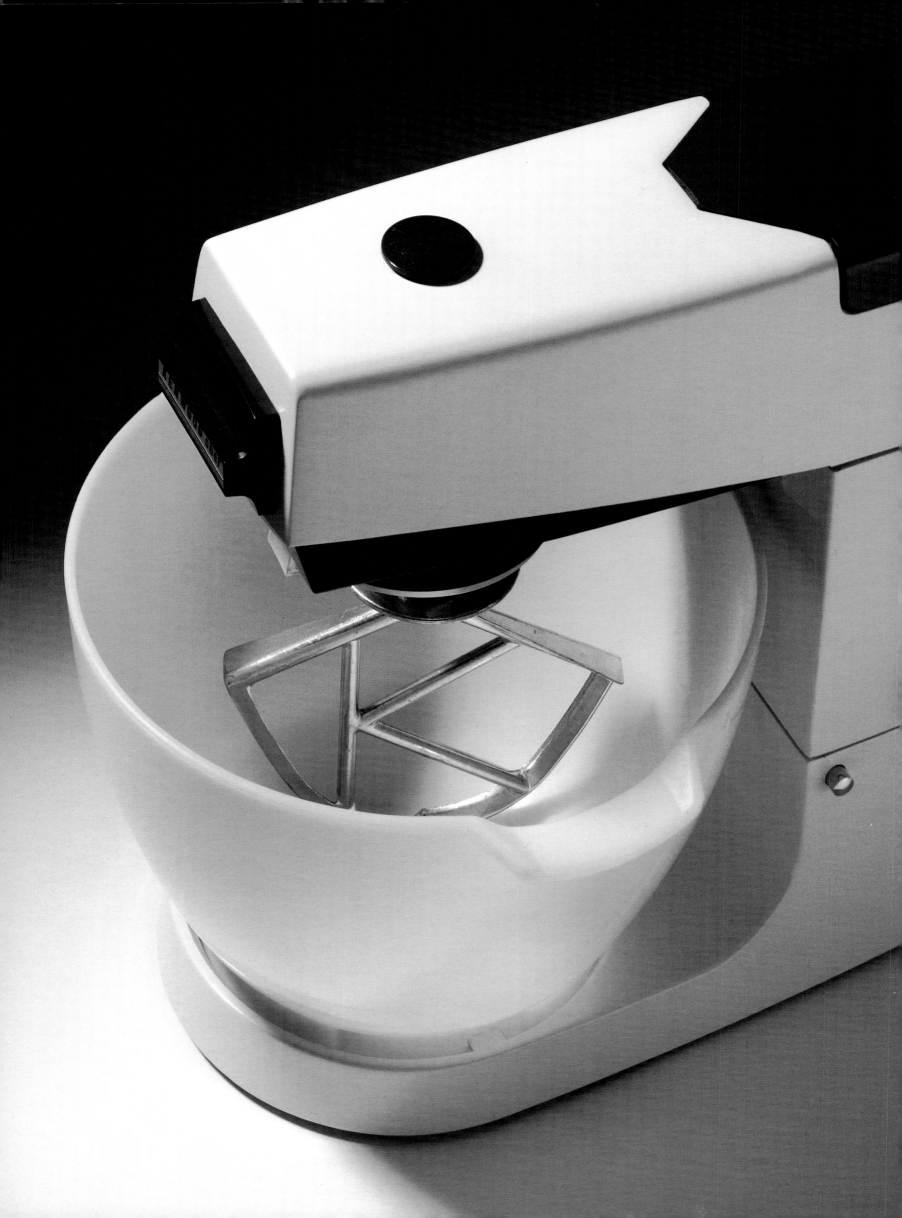

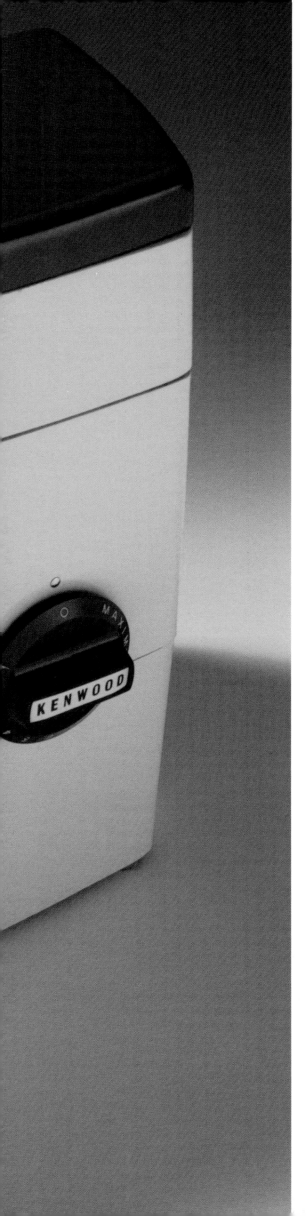

patrons: Dr Pitt, Kenneth Wood, Norman Saunders, James Cousins, and John Bowers.

Dr Pitt was a scientist and the Development Director of Kodak Limited and with him I designed twenty years' worth of cameras, including the Instamatic cameras that were the most successful cameras ever made and a great contributor to the company wealth and to my own professional career. He taught me many things, including the importance of sustaining the client's view of my value. His generosity and determination that I should do well inspired me to go to any lengths to please him.

Kenneth Wood founded Kenwood, the company for whom, thirty years later, we still work. We met after he had established a reputation for making an excellent, functional kitchen utensil. A visionary, in 1955 he saw the need to make his products of excellent design. We found a common enthusiasm and grew up together. His new company prospered and he always gave the credit for the design contribution. He was also an instinctively generous man and very loyal. With him I made the great blunder of my life and rejected the chance of a royalty in favour of a fixed fee and a retainer – I would by now be a millionaire many times over.

Norman Saunders was Technical Director of Needle Industries, an ancient company, who in 1956 decided to diversify. A brilliant creative engineer, he invented a battery-powered razor. Our razor, for it was certainly his as much as mine, was exquisitely engineered, with tiny sensors to make it safe. He was a client who put excellence before price, a little unworldly it is true, but a starting point for a product ambition more Germanic than British. I remember Norman Saunders teaching me about mass production and the sewing needle. That product is

ABOVE: *The High Speed Train for British Rail came into service in 1976 and has become one of the most successful locomotives ever to serve the British Isles.*
OPPOSITE: *The 1961 version of the Kenwood Chef, the machine that made Kenwood's name.*

ABOVE AND OPPOSITE:
*The B & W 500 (above)
and 801 loudspeaker systems
developed by John Bowers.*

wonderfully made. Look carefully at the polish, the smoothness of the eye, and its sharpness. Each one takes hours of polishing, yet the eventual sale price is a miracle of value.

James Cousins is a qualified architect and a man of substantial taste and aesthetic judgement. He came from the Design Council to take up the position of Director of Design for the railways and stayed there for fifteen years. He persisted in developing the corporate identity for the railways that had been established before he took office, and this identity programme, its famous mark and the rigorous program of signing have been admired and imitated worldwide. Those imitators in Denmark, Germany, the Netherlands and elsewhere now find it extraordinary that today, British Rail appears to be losing the valuable discipline and substantial value established by that identity programme.

For James Cousins I designed a few unspectacular parts of the railway including a change to the timetable design, which for the first time presented the information primarily for the benefit of the traveller. For historic reasons the timetables were set out as schedules of more immediate value to the operators. Such changes go unremarked but are part of the most valuable work of the designer, namely that of making the consumer's life more pleasurable. Eventually we undertook our largest railway job, the design of the high-speed train, an initiative originating with James Cousins, who spent a huge amount of time watching for opportunities to employ designers, believing that no stone should be left unturned in his ambition to make the railways a modern, functional, and visually rewarding feature of public culture.

We owe men like Cousins a huge debt because they spend vast amounts of their time frustrated and caught in the endless squabbles of corporate politics, yet are able to sustain an unremitting enthusiasm which is truly rare. In global terms, companies which have a real commitment to design and the common aesthetic are few. A tiny number of corporations embrace a responsibility for design. The weight of politics and the process of facilitating design is so debilitating that most of those in key positions of influence settle for the quieter life and the convenient agreement.

John Bowers was a man in a small way of business. His enthusiasm was beautiful music, and he started his working life selling hi-fi equipment in a tiny retail shop. Privately he was always experimenting with loudspeakers, and developed this activity from making the odd pair for a friend, to eventually running a company which – purely by his insistence upon excellence – has become one of the world leaders as far as loudspeaker quality is concerned. It is a seeming aberration that in the 1990s the greatest producers of domestic hi-fi systems are in Japan, yet the eventual part of any system that makes or breaks the quality of the original recording, the loudspeaker, is dominated by British and American manufacturers.

I met John Bowers though an introduction from Lord Snowdon, and for fourteen years we immensely enjoyed one another's company and enthusiasm for the product. He constantly wanted change, constantly wanted to develop the latest state of the art product. I managed to bring to this association an interest in the potential for the mass production of high-quality and visually interesting products, and from this we grew a very substantial business.

John Bowers, who died in 1988, lived for his product. He frequently worked seven days a week and the only criticism that could fairly be made of him was that he expected others to work a similar time. He was always prepared to experiment in the fabrication of loudspeakers in just the same way that he would experiment in the fundamental accoustical engineering. He had a natural personal care for fine quality, whether it was in food, or clothes, or furniture, and therefore he made an excellent patron for our work because he was already persuaded of the need to strive for excellence in the finished product.

There can be very few Englishmen in postwar Britain who have as firmly captured the respect and admiration of his colleagues abroad. All over Europe and in Japan and America he was acknowledged as a leader and as a man who understood quality of the highest level. Today, eighty per cent of his products are sold abroad, a fact which in itself tells us something about the marketing conditions in Great Britain relative to other parts of the world. Fortunately ours has been a business where the product is universal, and therefore quality and design standards need not be compromised by any one local tradition or prejudice.

Crossing cultures

Designing with authenticity outside the English-speaking world
involves learning and responding adeptly to the ideas and idioms
of other cultures.

It might be thought that a designer's main problem is the genera-
tion of creative ideas. Wrong. The problems lie in negotiating the
hurdles to get them realized. Throw in a few thousand miles
between designer and client, include linguistic and cultural factors,
and by contrast the design process is comparatively simple.

I once presented a complex design project to a client with
offices in Hamburg and Milan. I arrived at the German office and
was ushered into the boardroom to confront a dozen serious grey
suits. I unzipped the portfolio and turned to the first page, which
displayed the brief. I then meticulously took them through the
design process from initial sketches to finished design. They
seemed satisfied. In Milan the next day I met the Italian execu-
tives. We had a chat over espresso, and I unzipped the presenta-
tion. I showed the first page to remind them of the brief. They
nodded. About three pages in, I noticed they'd begun to fidget.
My cultural vibes registered. I quickly turned to the last page with
the final design. I enthusiastically showed the solution. Bravo. We
sat down to another espresso.
ALAN FLETCHER

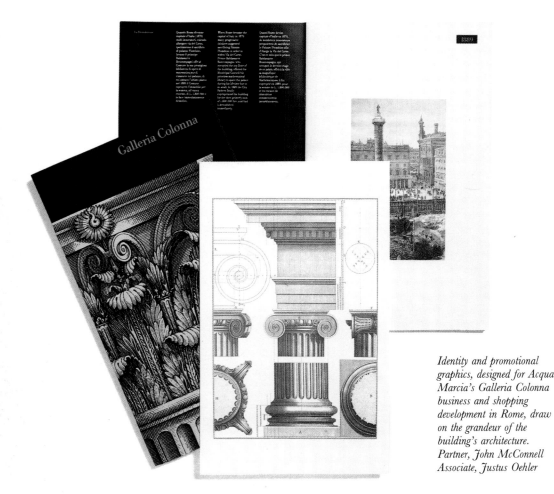

*Identity and promotional
graphics, designed for Acqua
Marcia's Galleria Colonna
business and shopping
development in Rome, draw
on the grandeur of the
building's architecture.
Partner, John McConnell
Associate, Justus Oehler*

TAKASAGODEN WEDDINGS BOOK

*Takasagoden arranges weddings in
Japan – that is, not the choice of partner
but all the minutiae of planning:
invitations, photography, catering, gifts
and clothes rental, down to the smallest
accessory of the bride's decorative combs.
This may seem a curious idea to a
Westerner, but a traditional Japanese
wedding ceremony is an elaborate and
theatrical affair, sometimes involving up
to six changes of costume. Planning a
wedding is also big business in Japan,
where most young couples use the services
of Takasagoden or one of its rival
companies to arrange their special day
up to two years in advance.*

*But although many affluent young
Japanese opt for a traditional wedding
ceremony, their taste and lifestyle is often
highly westernized. This is why
Takasagoden contacted Pentagram in
San Francisco to help position their new
catalogue to replace their previous more
commercial brochures. At first, I was
sceptical that a Western designer could
begin to understand and communicate the
symbolic nuances of so different a culture.
But the emotional and visual richness of
a Shinto ceremony proved too intriguing
to resist. The experience convinced me
that Takasagoden should be using
stunning visual imagery to emphasize
the specialness of the occasion.*

*The photography by Douglas
Kirkland suited the company well. As
intended, the Takasagoden catalogue
became a stylish, romantic 'book', an
object for hours of perusal and planning.
Perhaps most important of all, it carried
the message of individual choice within a
highly sophisticated 'package'.*

*I was intrigued by the importance of
the costume and its dramatic effect on our
young model's behavior. From exuberant
westernized fashion model to passive
bride, she was physically transformed by
each change of outfit. The costume and
wigs are so elaborate that the only vestige
of the person is the face, and then that
too is transformed by the makeup.*
NEIL SHAKERY

すがしい木の香が、心をつつみます。

今日の時間を、このままとめて。

البنك التجاري
Commercial Bank

206

COMMERCIAL BANK OF KUWAIT

Designing in the Middle East requires certain cultural adjustments to one's normal working pattern and lifestyle. The Gulf States are seven hours' flying time from London with a time difference of three hours. Travel by Arabic airlines is like arriving in the Gulf before you've left. It's a dry journey – no alcohol. At midday, Muslim passengers are likely to say prayers prostrated in the aisle; one wonders about the flight deck! Normal working hours are 8.00 am to 1.00 pm, and even then a government survey indicated that the oil-rich Kuwaiti only works an average of ten minutes each day. Friday is a holiday but they work Saturday instead. Appointments are not necessarily appointments, and frequently involve hours (if not days) of waiting.

The Commercial Bank of Kuwait had catered only for institutions and businesses within the Gulf States until it decided to expand into international markets and enter retail banking. The new policy created the need for an appropriate visual identity. Since the Bank had neither the experience nor resources, it appointed Tony Vines, via Ogilvy and Mather, New York, to set up a marketing department and create a new identity within eighteen months. Vines flew to London in 1979, interviewed various advertising agencies and designers, and

on reaching a rapport with Pentagram commissioned us to work on the programme. His fast response to locating a design resource set the pace for the hectic schedule that followed.

In architecture the term 'fast tracking' describes the method of designing whereby the architect keeps one jump ahead of the builder. In this case the severe deadlines and cultural differences made it more of a jump in the dark. The brief stipulated that the corporate identity and design style should be Arabic in flavour, but be understood internationally. The symbol, in particular, was required to mean something to both an Arab and a Westerner. Designing within these constraints reduced the normal available options. The two different scripts precluded using the alphabet to form a logotype such as Unisys, or initials such as IBM. An abstract mark would take too long to establish. A pictorial device might have encouraged the client to insist on a heraldic solution such as a scimitar crossed with palms. However the design of the symbol proved to be the least of the problems. Designing from right to left, in a script and language one didn't understand, and within an unfamiliar culture, required keeping one's head fast on its feet.
ALAN FLETCHER

Rather than undertaking expensive international corporate advertising, the bank launched a prestige financial magazine in 1980 targeted at key figures in the international community. The editor David Gibbs came up with the name Dinar *and the art director David Hillman designed the logotype.*

ABOVE: *Signs and bank façades have to withstand blistering hot sun, cold nights, and sand and dust storms. Low-quality buildings and little maintenance required quality engineering and generous manufacturing tolerances.*
TOP LEFT: *The new symbol is an amalgamation of calligraphy and image. The words 'commercial' and 'bank' are rendered in Kufic, a geometric script, to make a decorative star, recognisable by anyone as a distinctive pattern and, additionally, readable to an Arab. The dual language identity has English type in Paul Renner's Futura with a compatible Arabic script especially drawn by Ahmed Mustafa.*

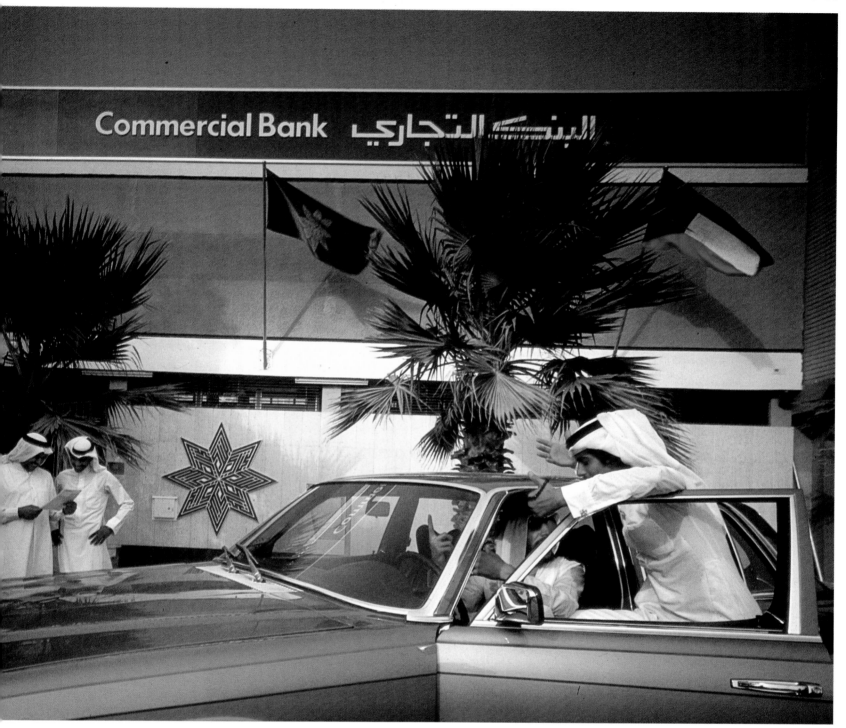

Commercial Bank البنك التجاري

Gifts are a customary part of Arab business etiquette, and the bank commissioned a variety of unique items including calendars, diaries, clocks, executive puzzles, playing cards, scarves, pens, and games. The jigsaw of the Gulf States was made by Ralph Selby, with each state a different rare wood and Kuwait itself in gold. The playing cards were designed by Alan Fletcher.

INAX CORPORATION AND THE JAPANESE BATHROOM

'We now take the quality and safety of products for granted. Thus the difference built into a company's product in terms of its individuality or beauty, that is, its "cultural level", is now crucial. Value added was once thought of only in a material sense. While that may still be the case even now, a new sense of value added in terms of culture is intrinsic to this process.' (Motoo Nakanishi, President, PAOS Inc, Japan.)

INAX is the leading manufacturer of ceramic tiles in Japan, and also a close rival to the market leader in ceramic sanitary ware. As part of a new corporate identity programme planned by their Tokyo-based consultants, PAOS, the company was looking at plans for re-positioning and diversifying into new types of business. PAOS had started to examine various environmental notions of the bathroom, including the idea of 'third space design' – a 'space yet to come' or 'space of the future'. PAOS planned to use its influential contact network to bring in a foreign designer to imbue a luxury home market product with a European sense of style and elegance.

Pentagram had worked successfully with PAOS on various international graphic and product design projects. We were given a wide design brief: to look at new trends in the domestic bathroom and to conceptualize a spatial relationship between products. The idea was to interpret the bathroom as an environ-mental living space, rather than thinking in terms of individual products such as bath, basin and shower placed in a room.

But before generating any conceptual design work, I wanted to demonstrate the relationship of design to INAX's overall business strategy. I put forward the proposition that if one thought about generating the component parts of the bathroom from the surrounding or the actual surfaces and fabric of the room, this approach would suit the client's background and strengths as a tile manufacturer. My idea was that the tile would be the underpinning element that carries everything with it. Also, from our design point of view, it would be a route into the design and the personality of the product that would make it quite unique.

I was well aware of the different cultural attitudes to bathing between East and West, having enjoyed the hospitality of Japanese friends and clients over a period of twenty years, including the honour of a family bath invitation. Taking a bath is an important social ritual in Japan, deeply rooted in the tradition of the bath house.

Whereas in the West, bathing is mainly seen as a private activity to keep oneself clean, for the Japanese the bathroom is a place to relax socially at the end of the day. Bathing involves the whole family and this means that the bathroom can be in use for up to two or three hours at a time. For practical reasons, the toilet is therefore always separated from the bathroom. Another important difference is that the Japanese always shower in a seated position before bathing, whereas for a Westerner, a shower taken standing up is an alternative

to a bath, or vice-versa, depending on personal mood and circumstance.

Started in 1986 and launched in 1989, the INAX bathroom system is probably the largest and most complex job ever undertaken by the Pentagram product design team. It represents many thousands of hours of effort by a large team of company engineers and technicians who responded to the manufacturing demands of the highest levels of quality and craftsmanship.

Working and designing in another culture presents its own problems. And making a presentation in Japan as a Westerner is a case in point. I mentioned that perhaps the clients should consider a very elaborate finish which was potentially workable but difficult. At the meeting two days later, they started by telling me that my proposal was presenting great difficulties and that I had stepped outside my brief, but ended by saying 'However Mr Grange, we think you are right to press us to do this, because if we can solve this problem we will be streets ahead of our competition.' This statement about not succumbing to the difficulty, but rather welcoming the incentive to break new ground, reveals a fundamental difference of attitude on the part of Japanese companies. It also points up one of the difficulties for a Westerner in presenting to the Japanese. You have to adopt a special kind of language to avoid a casual remark's suddenly being interpreted as part of the formal proposal.

KENNETH GRANGE

Instant international

JOHN RUSHWORTH describes the evolving effectiveness of the design service provided to the Polaroid Corporation and its national marketing subsidiaries worldwide.

The launch of the Polaroid Image camera in Europe (known as the Polaorid Spectra in the USA and other markets) marked a turning point in the Corporation's attitudes to its visual identity. Partners, John McConnell and John Rushworth

Polaroid's marketing is handled outside the USA by national subsidiaries – in Europe, the Middle East, Pacific Asia, Australasia, South America, and Canada. Pentagram's role is to develop and translate the strategic design requirements of the Polaroid Corporation in Cambridge, Massachusetts for local market use. The responsibility covers everything related to the Polaroid brand image where it meets the customer – point-of-sale packaging, display, counter-cards, posters, consumer literature, and more.

Polaroid's relationship with Pentagram primarily grew out of the need to mend what had become a badly damaged Polaroid brand image around the world. To begin with this was to be achieved, in Europe at least, by providing each national marketing organization with a full-time design service. Polaroid had had its own in-house design office in Amsterdam, which supplied the European market for many years. But the office was closed in 1985, as it had not proved cost-effective. National marketing subsidiaries in Europe were then given the responsibility of buying their own design to meet their requirements country by country, project by project. The new arrangement soon caused major identity problems for Polaroid. At the point of sale the brand, not surprisingly, began to be presented quite differently in each of the twelve European countries.

The damage being done to Polaroid's visual identity alarmed the Corporation. Not only was the brand image being presented inconsistently, but the underlying perception of the value of the organization itself was being eroded. The cause was not hard to find. The national marketing subsidiaries, bereft of any strategic direction, produced design that only addressed immediate and local needs. Design was also bought as cheaply as possible because little was being demanded or expected of it under the direction of tactical sales organizations intent only on maximizing their own profits. The designer's role had been reduced to that of a supplier with no responsibility for upholding brand values. Each product was being positioned in a separate market segment and promoted almost to death with money-off and gift promotions. The effect was to bring the Polaroid brand image down-market and introduce chronic inconsistency.

As with most photography brands, Polaroid relied, then as now, on dealers to sell and display their products. The range of related products included cameras, instant films, and identity pictures. Polaroid's first new camera and film in over ten years was being developed, and product diversification was being planned, with video tapes and conventional transparency film set to join traditional instant photography products –

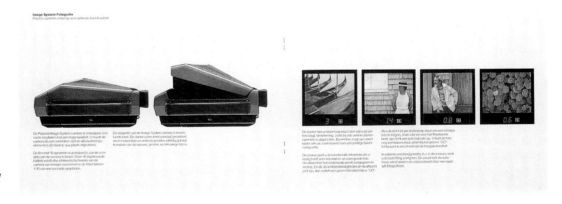

The launch brochure for the Polaroid Image was adopted by all international markets.

CLIENT VARIETIES

211

all to be sold in the same outlets. The prospect was for worsening chaos in the way the Polaroid brand was presented.

The problem came to a head in 1988 when Polaroid started to plan the launch on to the consumer market of its new camera and film. This was Spectra – known outside North America and Australasia as Image. It was to be a relatively high-priced, quality product aimed at the top end of the market – where Polaroid had not ventured for a long time. Spectra/Image was the result of a changed approach to management at Polaroid: from being product-led to being market-driven. Not only was there a concern to control the launch of the camera worldwide, but Spectra/Image was also to enhance the general image of instant photography and thereby pull the rest of the range upmarket again on its back. This was a heavy burden of responsibility.

For the plan to succeed, the new product brand was to be positioned so that it was closely associated with the still respected and innovative Corporation itself. Polaroid decided to centralize and control identity design by buying point-of-sale design services through a single company which, reporting directly to the Corporation, would serve all international markets. The design company selected for the task was Pentagram. Polaroid were intent on developing brand image strategies with us so that we could then act as a control mechanism as well as a resource for the international markets.

The familiarization programme was formidable. It involved visiting major markets around the world to review the design requirements of national marketing subsidiaries and the design identity being presented. The variance was great and the quality on the whole poor. Building good relationships became crucial, as the national marketing subsidiaries were not mandated to work with Pentagram – and they were still expected to pay for the service from their own budgets. Evidently Pentagram's fees were higher than those of the typical small local designer who had become the mainstay of the European design effort, and this was going to be a major stumbling block. A high volume of work was expected, and it was essential that the financial arrangements were right for the success of the new system. So the Corporation decided to help the process along by agreeing to pay Pentagram's direct fees for initial design concepts, while the individual subsidiaries met artwork and

production costs. This allowed the marketing subsidiaries to work direct with Pentagram without reference to the Corporation.

Pentagram was also responsible twice-yearly for packages of thirty or so related elements for international point-of-sale programmes. These were established to enable smaller markets to buy more sophisticated and strategic material in support of local marketing plans for the high-activity periods of spring and autumn. For these we were briefed by the corporate marketing centre, and once the design issues had been worked through we presented our proposals to all the markets at bi-annual meetings. The markets were given shopping lists. Remaining in control of their own budgets, and knowing their own markets, they were able to choose which elements to buy.

For two to three years we developed our relationships with the markets so that they could work with us, and we with them, with confidence and understanding, and thereby begin to realize strategic goals. During this time we re-established protection of the Polaroid corporate mark – the five-bar stripe and the name in Helvetica medium – and the corporate typeface. We developed a European attitude to the Polaroid corporate blue which was being established to compete with Kodak's yellow and Fuji's green. We also decided that point-of-sale programme material should be designed to concentrate on the themes of the offers, rather than how to attain them.

Greater consistency between local markets began to be achieved with the point-of-sale material for the Polaroid Image camera.

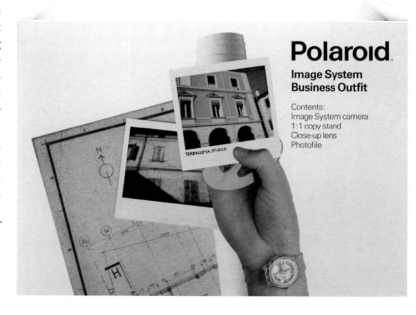

The aims and elements of the Polaroid visual identity are defined in design guidelines for point-of-sale packaging and display. These describe how the Polaroid brand name is protected and promoted, and indicate the design responsibilities of both the Corporation and the local marketing companies.

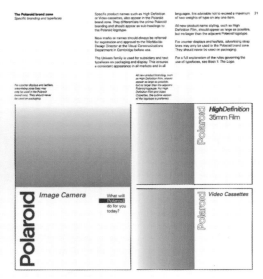

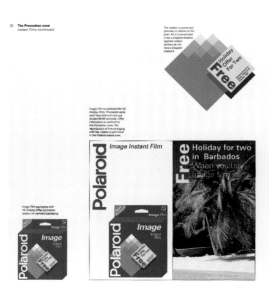

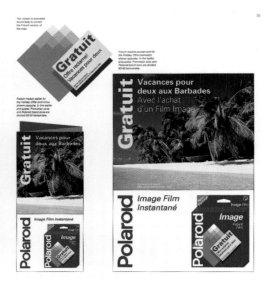

Initially the characteristics of each country were a large factor in designing material which would be accepted locally; for instance the Germans fell in love with the clean white backgrounds and simple typography we were using, while the Italians wanted more colour and vitality. The main markets we were dealing with at this time were Germany, Italy, France, and the UK, and to overcome cultural barriers and difficulties we employed designers who spoke the languages. There was some resistance to the new way of working, with certain markets feeling that the Corporation was being too intrusive, seeing Pentagram only as Corporation agents. For ourselves we felt we were helping both 'sides', but this did meant channelling and curtailing to a degree the old design freedom (some would say anarchy) of the markets.

Any reluctance to cooperate was resolved with the passing of time as the subsidiaries learned that the new system posed no threat to their operational freedom. Our rapport with the various marketing managers strengthened. We

began to build up a central bank of materials such as original photography, illustration, and product photography, which could be used repeatedly by different countries. This resource ensured that managers could have their own high-quality material, which was cheaper for them than producing it themselves and ensured that the consistency and quality of strategic aims were maintained. We also established a 'library' of marketing programmes so that examples could be frequently circulated between different markets in order to stimulate and enable European managers to learn from and draw on each other's ideas and successes.

The close relationship that has built up between us and Polaroid has been key to the success of the system. Time develops mutual trust and confidence. For our part we experienced a growing familiarity with Polaroid's business practice, products, and people who manage the system, and a growing understanding of how products are designed, developed, manufactured, packaged, and distributed. Pentagram's

understanding of purchasing behaviour in Polaroid markets and how Polaroid is able to respond internally to meet the demands, also grew. As intended, the system was facilitating a control mechanism for upholding and improving the image and quality of the brand. Through design Pentagram has been able to ensure that control is put back into the market, together with respect for identity and long-term aims.

There have been some down-sides to the system that we adopted. Where freedom allows individual markets to operate more profitably, the same freedom means they can still choose where to buy their design. In the case of major markets, they have the financial power still to ignore the carrot which is offered by the Corporation, in preference working with their own designers. The fate of brand identity still relied on persuasion and example rather than on dictates. Smaller markets on the other hand tend to purchase only the design made available to them in the international programmes, in effect adopting only the programmes which have been financed by the major markets.

Our involvement with Polaroid began to move into a new phase once it was felt that the relationships between us and the Corporation on the one hand and the local markets on the other were properly established and the fruits of the system were beginning to be seen and appreciated. This coincided with the launch of the new mid-range Impulse camera. Much had been achieved in promoting instant photography and the qualities of Polaroid in the Spectra/Image launch. Impulse gave us the opportunity to strengthen further the generic messages of instant photography and the Polaroid brand identity.

Having learned about the advantages or the disadvantages of the system we had adopted, it became possible to evolve in a way that retains the benefits we had achieved without sacrificing the important desire of the markets for autonomy. To ensure that the crucial element of control was not lost we took two important initiatives. One was to hold meetings twice a year between ourselves and local marketing managers. These are run like seminars and review the processes of design, strategic aims and relationships within the system. The other was to draw up design guidelines in the form of a manual for point-of-sale promotional packaging and display. This provides a control which

allows local freedom and variation while insisting on rules that protect and preserve the Polaroid brand identity. Local designers continue to be involved in design programmes, but Pentagram provides the help and advice if there are any problems.

Improving the synergy between markets and providing the markets with a design service and resource which suits them as well as the Corporation's strategic aims are the cornerstones of our strategy. We continue to produce the central programmes for the Corporation and we consult and guide individual markets with design advice based on the point-of-sale design guidelines that have been produced. The lessons learned in Europe are being increasingly applied in the other international markets around the world. Our involvement with the Corporation has become broader-based, with commissions for work in Polaroid's quite separate professional market. There has been a magazine for professional/industrial Polaroid users, and the Pentagram partner Kenneth Grange has designed Polaroid sunglasses. We are also turning our attention to the Corporation's own packaging, so that it projects a stronger, more consistent brand image at the point of sale (essential in the photography market) without confusion from strategic messages, which are the province of advertising.

As consultants and practitioners, Pentagram has become in effect part of Polaroid and part of the international marketing network. We have been integrated with the management systems of both; yet we retain the essential strength of outside observers. From the beginning, we have based our value to Polaroid on our impartiality and our own vision of their business. These remain the keys to the future of the partnership.

Point-of-sale promotions are also used to build awareness of the professional range of films and photographic techniques.

Polaroid Vision, the Corporation's latest instant camera, was launched first in Europe in 1992. A contemporary look is achieved within the framework of the identity.

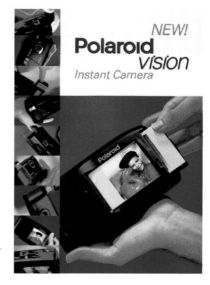

214

IMPULSE AND '600' FILM POSTERS

Pentagram is not an advertising agency, but designers can often bring a lateral solution to an advertising campaign. For the Polaroid Impulse poster project Pentagram used an international contact network of leading artists and designers to produce one of the least expensive and most effective campaigns the company had ever run.

When Polaroid was preparing to launch Impulse, a new mass-market camera and film, into the European market, they were looking for something different from the conventional advertising pack shot. Within three years it was hoped that Impulse would account for seventy per cent of the company's total consumer market sales.

Market research indicated that the market for these products was not the traditional camera market but more the high-tech accessory market, not unlike that for products such as the Swatch watch and Sony Walkman. In discussions with Pentagram, it was agreed that something innovative and dramatic was needed to capture the affluent young market. Until now, a Polaroid camera was not

something to be seen with at a party. Impulse had to break this mould.

Pentagram suggested the creation of a 'poster gallery', commissioning leading international artists and designers to create poster advertising for the new camera and film. I contacted fourteen designers through the Pentagram grapevine and convened a preliminary briefing at the Gritti Palace Hotel in Venice. The brief was simple: there should be a visual reference to the product, and the poster should communicate that it was a 'colourful camera for colourful people'.

Polaroid's European director of marketing and advertising Rick Kirkendall was surprised and taken by the idea: 'I thought it was terrific. Because of our budget, television was out of the question. We wanted something splashy and adaptable for both print and outdoors. But acceptance wasn't universal at first. When I presented the idea to each country's manager, they hated it. Traditional thinking says have a big cut of the product and say, "Here it is. It's new. Buy it." But that wasn't enough. We needed to aim at a younger market and communicate in a medium they understood.'

Six weeks later artwork started to arrive, and Polaroid kept to their agreement of no editorial interference. Recognizing that the Polaroid organization in each country knew its market best, the selection of designs was left to each local manager. It was anticipated that they would gravitate toward their own country's designer, but this proved to be almost the exception.

Pentagram's approach to promotion was new to Polaroid. An additional advantage of the strong high-impact graphics was the avoidance of nationalistic and linguistic barriers common to international campaigns. It solved the problem of copy lines that didn't translate well, and pre-empted any 'not invented here' resistance. Each country could be as nationalistic as it wanted to be, but there would be a cumulative gallery effect – one country might look at the camera as a very high-tech object, another might see it as a fun fashion accessory. All had the freedom to tell a different story from their own cultural perspective.

JOHN RUSHWORTH

The international poster campaign for the Polaroid Impulse camera and new Polaroid 600 film.
BELOW: *In London, by Fernando Medina.*
BOTTOM: *In Geneva, by John Rushworth.*
OPPOSITE: *In Paris, by Alan Fletcher.*

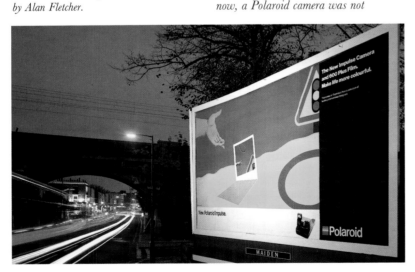

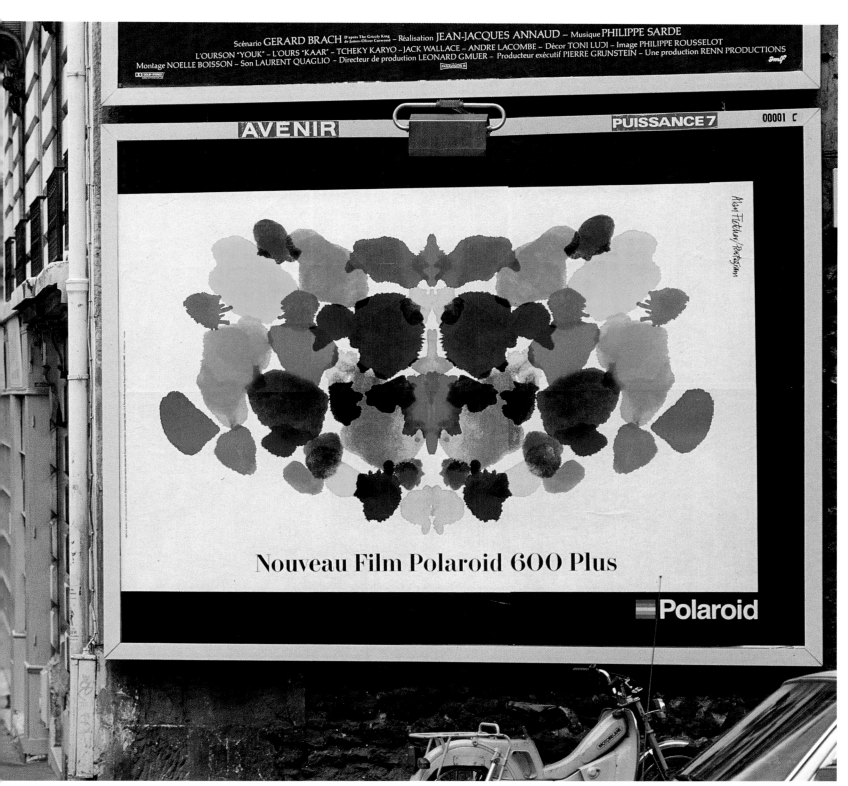

Details aren't details

American designer and architect Charles Eames once said: 'The details aren't details, they make the product.' THEO CROSBY demonstrates the truth of this axiom in the refurbishment of the Unilever headquarters in London.

Unilever House was one of the last of the great Imperial Baroque buildings in the City of London, conceived in high hopes and confidence in the 1920s and completed in a great, penny-pinching rush in the depression of 1930. The site was most efficiently crowded and every inch of space allowed by the regulations was included. In fact, when its demolition and rebuilding were contemplated in the 1970s it became clear that no floor space could be gained, and that the cost of rebuilding would be nearly forty million pounds.

A consultant was employed to work on the interior design at a fairly late stage in the programme. Here Unilever acted with characteristic thoroughness by interviewing most of the London design firms and appointing two to make competitive proposals and to establish a strategy for dealing with the building. In the event the decision went to Pentagram, and considering the relatively unknown territory involved it was a courageous one. The strategy proposed was to accept and restore the original elements of ornament and decoration wherever possible, to understand and extend this language, and also to enrich it with the work of modern artists and craftspeople. In the process something might be learned, and it would be an adventure for both client and designer.

RIGHT: *The new entrance hall of Unilever House. The Travertine and plaster columns unify the space carved out of old workshops and lavatories, while the oak grid and chain curtain disguise an unrelated and heterogeneous window pattern. The marble floor finishes extend existing art deco patterns in the building. The new stairs lead to the vehicle set down.*
BELOW: *A drawing by Diane Radford for the decorated mirror roundel in one of the refurbished lifts.*
OVERLEAF: *Two details using decorated glass. On the left is a stained glass door panel (fire regulations require a glazed opening); on the right is an etched mirror panel in oak framing, part of the column casing in the main conference foyer.*

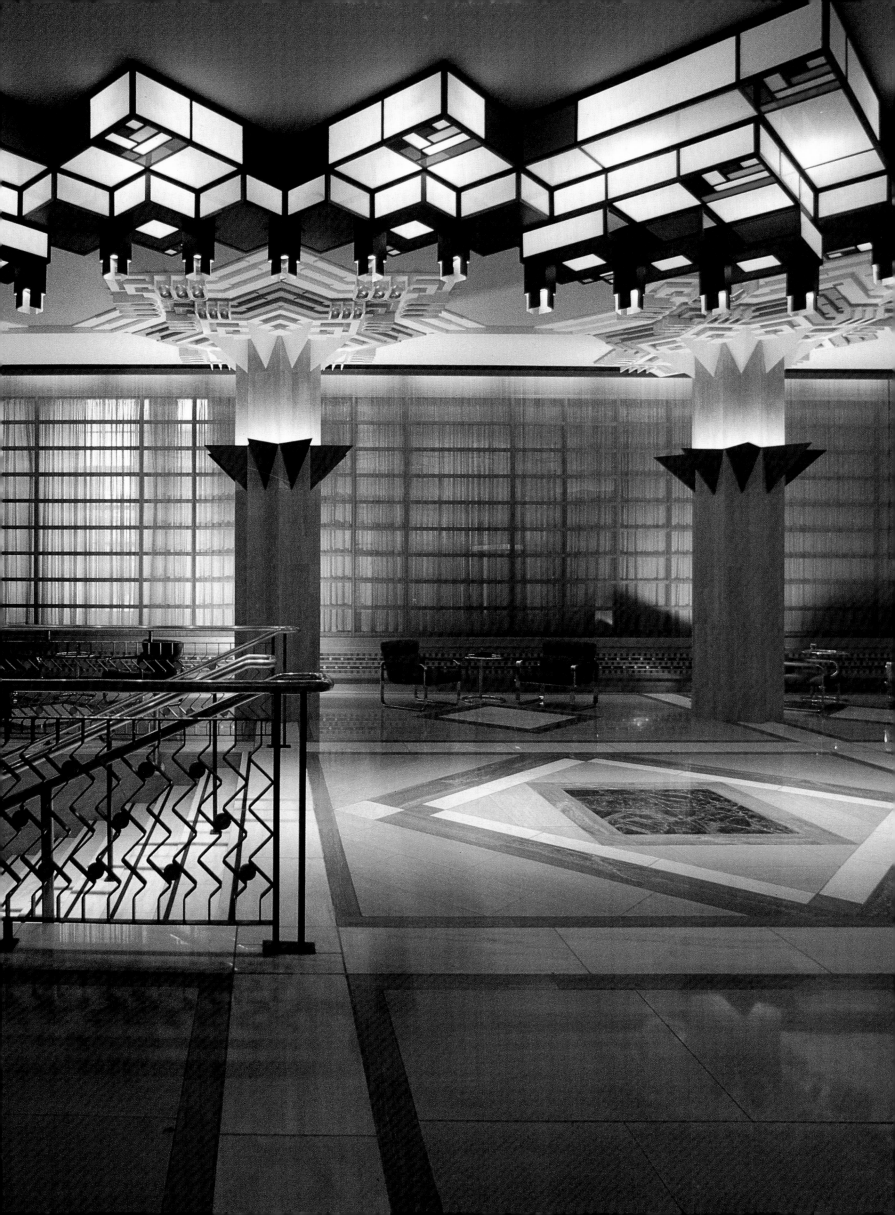

FAR LEFT: *The marble patterns in the entrance hall are based on those found elsewhere in the building, but are more complex and elaborate.*
TOP LEFT: *The new vehicle set-down canopy and entrance on the north side. The gilt sculpture by Bernard Sindall symbolizes Unilever's universality: a Goddess of Plenty.*
BOTTOM LEFT: *The original entrance hall became unusable when the traffic pattern was changed to motorway proportions on the Embankment. The entrance hall was made into a visitors' restaurant separated by an oak and stained glass screen with mirror and enamel by Radford & Ball. In the foreground is marble inlay flooring carefully retained from the original finishes, as are the Travertine walls.*

Unilver House contains art works and details redolent of the art deco period in which it was built. These details were cherished, and the new work uses them as exemplars.

Unilever is now a world force in commerce, dependent on a complex trading organization. The headquarters building is now representative of a wide culture, filled with gifts from around the world, and a growing collection of modern British art. It is rich in memory and associations. Every possible element is charged with the attention of the artist and the craftsman.

The materials used match those of the original: oak, glass, marble, and much use is made of African and oriental textiles. The panels of copper light glazing were carefully preserved and reused in the new work.

This method, by emulation, extension and occasional excess, gives the place an enviable coherence. It is wonderfully maintained and reflects the pleasures of use.

Talking to yourself

Designing for printers, platemakers, typesetters, and papermakers, those unsung heroes who serve the design industry, is a bit like talking to yourself.

On the surface, it seems as though nothing could be easier than designing for other designers. Whether the client is a paper company, a printer, a typesetter, or a design organization, you can't have a better audience than yourself. Or so it seems.

Presented with a project with next to no limitations, one quickly starts to crave restraints. Sometimes the problem-solving process becomes sharper when the designer wrestles with complicated messages, limited budgets, and crushing deadlines. Designing for designers, the brief often boils down to no more than 'Do whatever you like, as long as it's gorgeous.' As James Russell Lowell wrote, 'Granting our wish one of Fate's saddest jokes is!' Surveying an infinite field strewn with possibilities can be inhibiting rather than liberating.

And the audience is anything but forgiving. Designing for designers, you can rest assured that each member of the audience will know with metaphysical certainty that he or she could have, in fact, done a better job than you, had they only gotten the chance. (After all, there were no limitations!)

As a result, every designer knows (sometimes uncomfortably first hand) of some spectacularly disastrous design for designers. Paralyzed by a surfeit of choices, withering under the critical scrutiny of one's colleagues, one can easily become mesmerized by the prospect of failure as the deadline draws near. A common reaction is to overcompensate, which is why so much of this kind of work is characterized by nightmarish excess and libertine self-indulgence.

Every once in a while, though, it does come out well. Usually it's when the designer keeps in mind that, as Charlie Chaplin said, 'one entertains others best when one entertains oneself.' But like so many simple-sounding things in life, this is easier said than done.
MICHAEL BIERUT

The Graphic Arts Center is a printing company in Portland, Oregon. Most people visiting there come from out of town and have to stay overnight. So the promotional piece for the company's services introduces the Portland 'experience', featuring such diversions as the city's Advertising Museum of America, skiing or fishing in the beautiful surrounding country, and sports.
Partner, Kit Hinrichs
Designer, Belle How
Photographers, Terry Heffernan, Gary Brasch and Barry Robinson
Illustrators, Gary Overacre and Don Picasso

A promotional brochure for
Colordynamics demonstrates
the Texas company's color
separation and reproduction
capabilities.
Partner, Woody Pirtle

224

A promotion for Sundance, a recycled paper from the Simpson Paper Company, is themed on things that have come back into fashion.
Partner, Kit Hinrichs
Designer, Piper Murakami

'Other People's Mail' was a promotion for the papermaker Champion International's Mystique line, using letters to or by famous people. These were illustrated to demonstrate the various subtleties and qualities of the paper.
Partner, Paula Scher

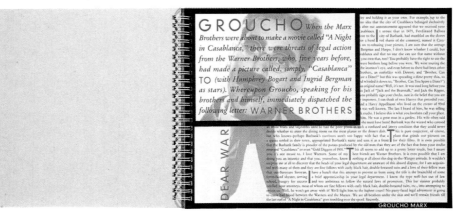

ATS 1930s

...ace respectable men never ven-

...red out of the home without

...hat to protect themselves from

...ammer sun and winter chill.

...ut as climate-controlled auto-

...obiles allowed people to avoid

...e "elements," hats lost their

...cessity. By the late '50s, hats

...egan to disappear from business

...tire. Considered an expression

...f youthful vitality, bare heads

...ecame the vogue.

HATS 1990s

Times have changed. Now hats are often worn by dapper young men as a deliberate statement of style and individuality. The classically beautiful fedora, designed in Austria in 1882 and named after a French play of the day, looks just as smart and fashionable today. Popular among both sexes, this soft felt hat, with its jaunty silhouette, conveys an attitude of sophisticated confidence.

...undance Felt, Bright White, Text 70 lb.

...one recycled with 50% waste paper,

...0% post-consumer fiber.

The big A.

'Maximum impact.
Minimum price': a 52
by 36-inch newsprint poster
promoting the competitive
cost of Ambassador Art's
silkscreening service.
Partner, Paul Scher

A booklet of smart remarks
for Gilbert Paper.
Partner, Michael Bierut

A promotion for Champion
International Paper provides
ready-made patterns and
alphabets for use by graphic
designers.
Partner, Paula Scher

The introduction of
Evergreen, the first line of
recycled papers from Simpson
Paper, was marked by a
catalog with typography and
themes relating to American
naturalists.
Partner, Kit Hinrichs
Designer, Belle How

Time heals all wounds.
Terence
Time wounds all heels.
Jane Ace

Remember that time is money.
Benjamin Franklin

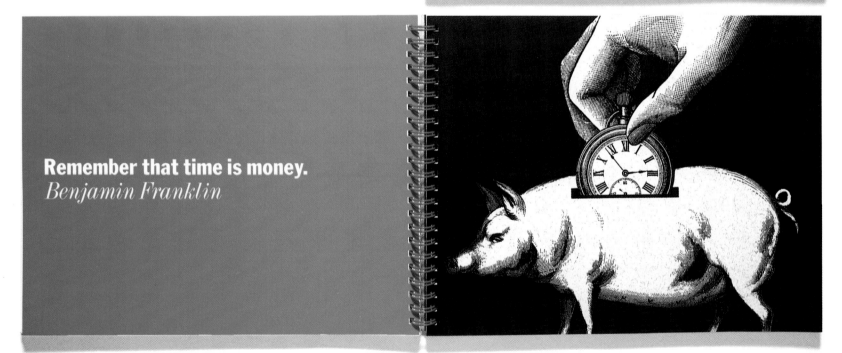

An appointments diary for
the Simpson Paper Company
had six sections on the theme
of time, each using a
different paper.
Partner, Michael Bierut

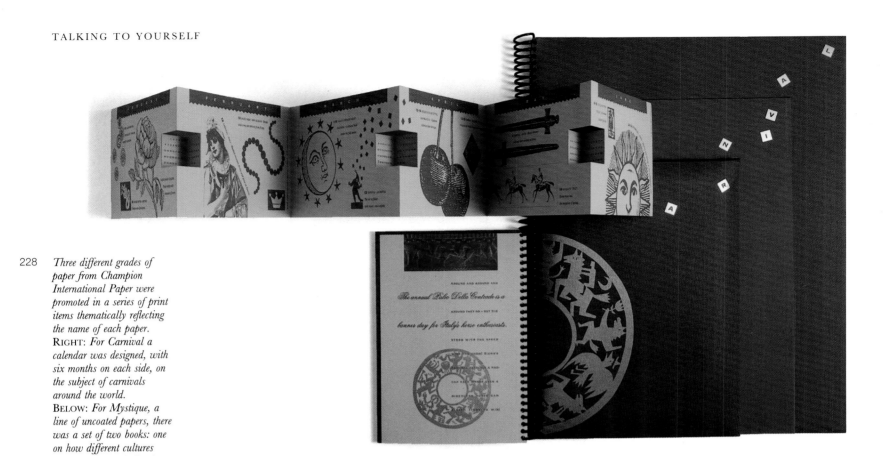

228 *Three different grades of paper from Champion International Paper were promoted in a series of print items thematically reflecting the name of each paper.*
RIGHT: *For Carnival a calendar was designed, with six months on each side, on the subject of carnivals around the world.*
BELOW: *For Mystique, a line of uncoated papers, there was a set of two books: one on how different cultures cover the human body; the other on writings, illustrated with such works as Edison's notebooks, Mozart's compositions, William Blake's* The Marriage of Heaven and Hell *and* The Book of Kells.
BOTTOM: *For Benefit, a recycled paper, illlustrations by James Marsh of trees as faces were used to reflect the promotional copy line: 'We benefit from trees in a thousand diferent ways…'.*
Partner, Woody Pirtle

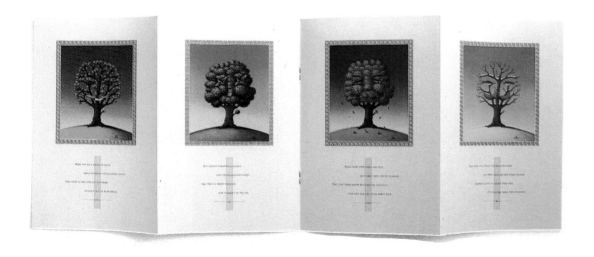

RIGHT: *A travelling trade show for Mohawk Paper Mills was part of an advertising campaign urging thrift on designers as part of their environmental responsibility. Basic forms such as the table and chair were wrapped in the same paper used for reams and rolls of Mohawk paper – a metaphor for simple design and no waste. (Even the display's packing case is part of the display.)*
Partners, James Biber and Michael Bierut

Home from home

The hotel has to play the part of home from home but, like any temporary affair, it also has to provide a little more than what you are used to.

The Atheneum is an all-suite hotel renovated from an industrial turn-of-the-century building, which opened in 1992 in the Greek Town district of Detroit. The visual identity is based on an olive leaf motif, which is used in a variety of ways: from singly as in the logo, to repeat patterns for furnishings and decor.
Partner, Colin Forbes
Associate, Michael Gericke

A hotel's *raison d'être*, apart from providing a temporary roof over your head, is to cosset, pamper, and serve. To express these values they often resort to the cliché.

The name is usually imbued with aristocratic associations and traditional values such as the George V in Paris, or The Savoy in London. I can only assume the undistinguished Hotel Bristol, which you find in most cities of Europe, must have once represented a long forgotten desirability.

Hotels, at least those with which we are concerned, can broadly be divided into two personality types. Those which are identified and promoted as clones – members of chains or, as they prefer, of groups follow the anodyne principle that service, food, interior, and environment will be the same whether you are in Jakarta or Reykjavik. The corporate identity and graphics reflect this standardization. Nothing too different in case one frightens the horses.

Then there are the hotels which promote their individuality and independence. These cater for the discerning, the connoisseur, the snob, or perhaps even the adventurous. They strive to look different: *art deco*, *avant-garde* (epochs are all the vogue), over-the-top country house, or blatant *de luxe* with wall-to-wall silver service, linen sheets, ironed newspapers, palm court orchestras. For posh places the graphics favour the monogram, discreet insignia, or in the case of the overtly design-conscious, anonymity. One such hotel in New York doesn't even have the name over the door.

Whatever style it adopts, the hotel emblem has to be appropriate on several levels: the commercial, the social and the intimate. By way of example it has to be distinctive on an advertisement, project a prestigious association, and yet be discreet on things like bathrobes, and elegant on guest stationery. It also has to be technically versatile. It has to look good stamped in soap, woven in bathmats, etched on swivel-sticks, embroidered on uniforms, embossed on menus, or illuminated in neon. In other words it has to play several roles without losing quality and identity.

Another aspect of a hotel's identity is utilitarian. Hotels brand practically every object in sight, not so much to promote as to protect – in other words to stop stuff being nicked. The 'gone missing' syndrome is a serious problem with cutlery, crockery, towels – in fact anything which can travel and fetch a price on the black market. Guests, on the other hand, who take 'souvenirs' are tolerated, as wherever they end up the hotel is promoted. Next time you check out with an ashtray don't feel too guilty: you are probably doing the hotel, the manufacturer – and the designer – a favour. However, if you take a silver coffee pot – you're not.
ALAN FLETCHER

RIGHT: The Oriental, Singapore, is one of the Mandarin Oriental Group's chain of élite hotels, which includes the famous Oriental in Bangkok and the Mandarin in Hong Kong. The stylized fan emblem is used in a different colour by each hotel, giving appropriate distinction and individuality within a common group identity.
Partner, Alan Fletcher

LEFT: *The acquisition of the Empire Hotel in New York City by Metromedia led to a program to upgrade the building and update the visual identity. The concept for the new graphics had to respect the Empire's well-established image and reputation for service. A logotype and coordinated system of elements were designed to suit any detail, from the canopies and banners outside to the guest amenities and toiletries in the rooms. Combined they give an appropriately rich and elegant image to the hotel. Partner, Peter Harrison Associate, Michael Gericke*

233

The luxury Hankyu International at Japan's new Osaka international airport is the flagship hotel of the conglomerate Hankyu Corporation Group. The concept was to give the hotel the refinement and charm of a private mansion, harking back to the days of the grand hotels of the late nineteenth and early twentieth centuries. This quality is expressed in attention to the finest detail, with a repertoire of stylized flower symbols differentiating and embellishing accessories, fittings, furnishings, decor, and print. Partner, Colin Forbes Associate, Michael Gericke Pattern drawer, Donna Ching

Place settings

If eating is a social occasion, then restaurants can heighten the experience by becoming participatory theatres, enabling and enlivening the cameo performances at each table.

Once one accepts the premise that restaurants, particularly the high design variety, are a form of participatory theater, then the problems of restaurant design become considerably clearer. The question 'Who is the audience and who is the show?' can remain a useful ambiguity. The designer must establish an architectural promenade: pacing the entry, coat removal, *maître d'* acknowledgement, wait and stroll to the table as a series of events during which the seated crowd and the arriving guests enjoy a mutual sense of being observer and observed.

The space and design elements can reinforce the sense of theater; lighting can heighten drama and should be flattering; unique seating areas can help create special, more intimate places within a vast space; sound levels can be controlled to create an appropriately hushed or bustling atmosphere; and spaces can be linked visually or thematically to help create connections among the diners. When all the design features are shaped to create an experience reflecting the concept of the restaurant, the food, the owner's personality and the context of the space, the success or failure will rest with the obvious: the food and the service.

JAMES BIBER

BELOW AND OPPOSITE:
*The Gotham Bar and Grill in Greenwich Village, New York is in the converted loft space of an old auction house. Following the plan of an Italianate cathedral, the design is based on the metaphor of the urban garden. The entrance is made as a garden house, a stone wall surrounds the eating area, banquettes are upholstered with floral tapestry, cast stone garden ornaments punctuate the space, and geometric light diffusers suggest clouds overhead.
Partner, James Biber
(as project architect/designer for Paul Segal Associates, Architects)*

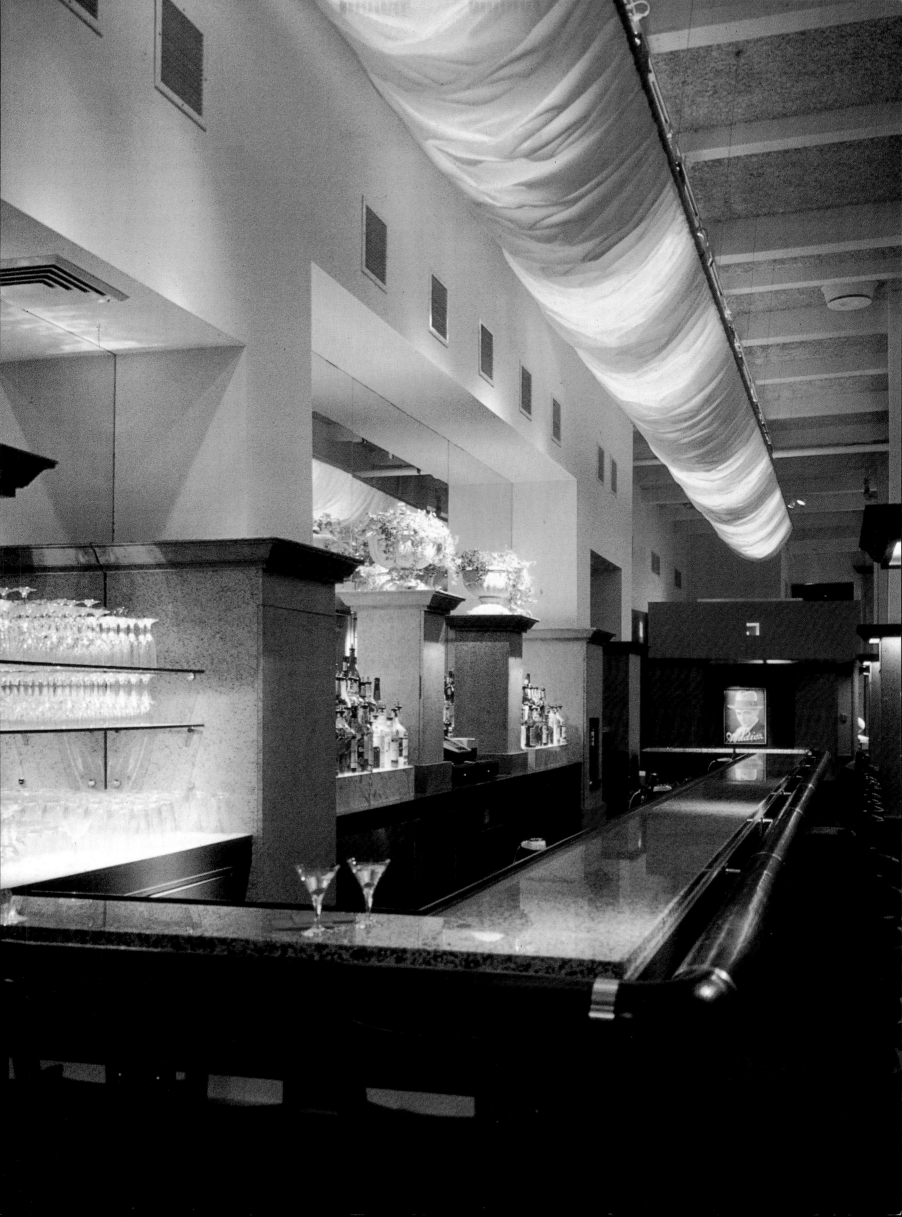

236 FAR RIGHT: *The Mesa
Grill restaurant on Fifth
Avenue, New York serves
American food Southwestern
style. The deep rich colours
are inspired by the food.
Large column capitals, black
floors, dramatic light fixtures,
1950s 'cowboy' coverings on
the banquettes, and the
collection of Americana
artefacts all suggest the
influence of the Southwest,
without actually mimicking
Santa Fe. (Random
perforated patterns in the
fixtures refer to the typical
highway signs shot full of
holes by passing motorists.)
A rear window allows diners
to see into the kitchen.*
RIGHT: *A three-dimensional
black canvas M forms the
awning over the doorway of
the Mesa Grill.*
Partner, James Biber

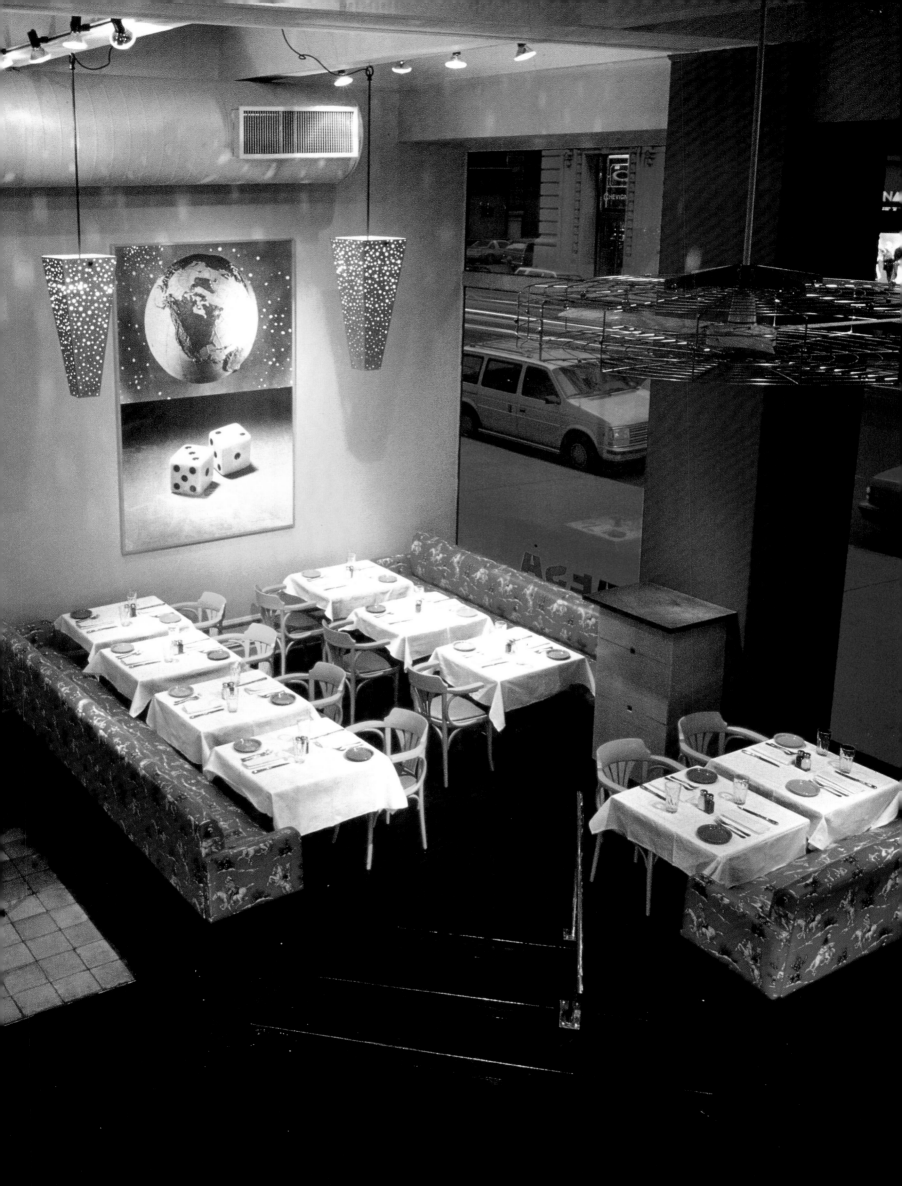

'21'

The '21' Club
21 West 52 Street
New York, New York 10019

The experience of dining out is as much about being entertained and feeling comfortable in an unfamiliar environment as it is about simply eating. Formal or fun, the important thing is to get the feeling right; to ensure that every element of the environment – the food, the rooms, the service, the graphics – contributes to a consistent overall aspect. Pentagram's design work for the '21' Club and TGI Friday's restaurants represents appropriate design solutions for opposite ends of the dining table.

240 The '21' Club is a grande
dame with a past – a
tradition of elegance, history,
status, and romance. It
started as a speak-easy in
1922 and reigned for many
years as one of New York's
most exclusive restaurants,
attracting the likes of Ernest
Hemingway, Dorothy
Parker, and Jack Kennedy.
Like all well-loved things,
'21' gradually began to show
its age and it became
necessary to update its image
while retaining its cachet.

Peter Harrison and
Susan Hochbaum were
commissioned to create a
graphic identity that would
preserve the best of '21' 's
character yet allow it to
attract a new generation
of influential people. The
graphic design work was
carried out in collaboration
with the interior designer
Charles Pfister, to achieve
color and textural
coordination. The three
identifying elements of the
program included a
modification of the existing
'21' logo, a newly
commissioned painting
by Paul Davis of the
emblematic jockey and
racehorse, and the use of
richly colored marbled
paper patterns.

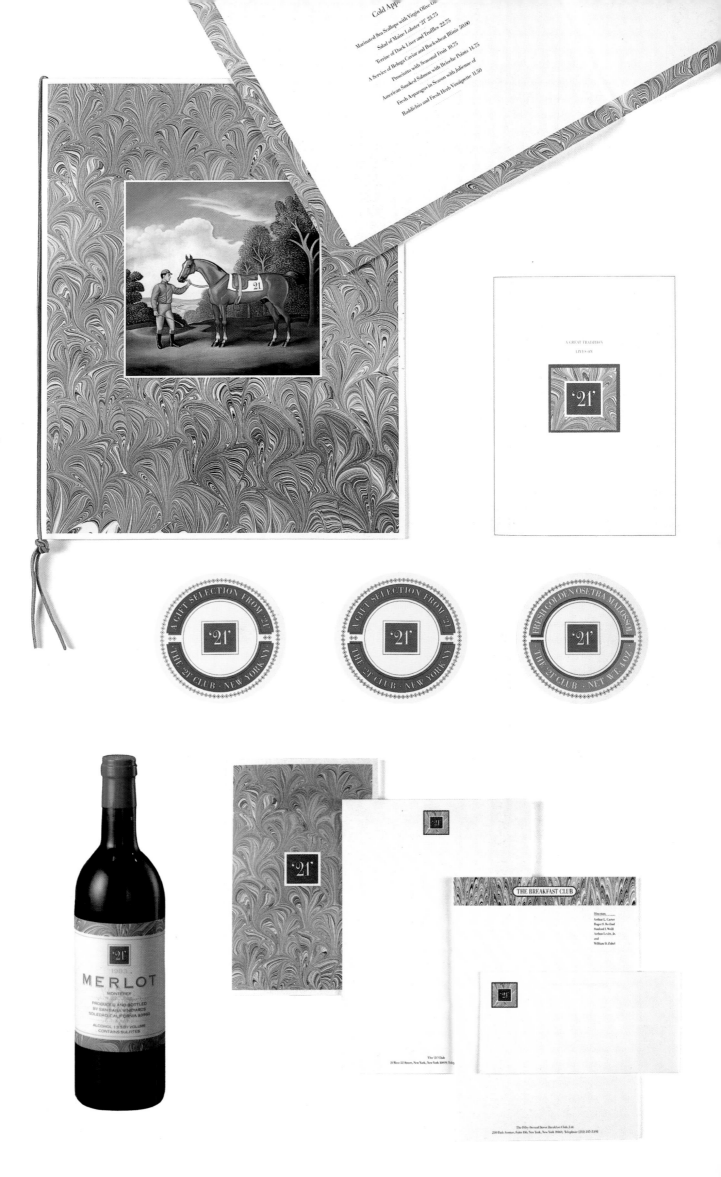

TGI Friday's, on the other hand, is everyone's neighborhood bar and grill. Its atmosphere was borrowed from a turn-of-the-century saloon: beer and victuals in the ambience of original Tiffany lamps, dark wood and brass. In their early days, the late 1960s and early '70s, the restaurants attracted college students and singles in search of a casual, lively evening out. Gradually, the clientele grew up with the restaurants and the singles became parents, bringing their children to Friday's for an inexpensive meal.

The original Friday's owners believed that menus and other internal publications should be the primary form of promotion for the restaurants. Woody Pirtle was retained as design consultant for nearly eleven years as the business developed from two restaurants with $5 million in annual revenues to four hundred restaurants earning $350 million. Woody Pirtle designed a series of menus, invitations and in-store promotions and consulted on the interior design of new restaurants for the growing Friday's chain and its subsidiary, Dalts, another chain based on an art deco diner concept, until Friday's became a publicly owned corporation in 1984.

Design for art's sake

When design is brought into the service of art, some feelings of rivalry may be stirred. Properly understood, this tension can bring out the best in a designer.

A new identity was commissioned for the fiftieth anniversary of the Santa Barbara Museum, California. Variations of the word 'art' were designed reflecting the different collections in the museum, such as Egyptian, Greek architecture, and Victorian posters. The museum could then select the appropriate one for any particular occasion or application. Partner, Alan Fletcher

Design that serves the institutions of the arts becomes very conscious of its own status. The old question arises: is design itself art or is it not? Should design emulate or even compete with the arts it is promoting or should it deliberately steer clear of any comparisons, and simply act as a functional frame? A gallery client once criticized some of our work for looking too artistic (did he mean too good?). The concern was that it would interfere with the 'real' art on show. This kind of gentle snobbery has to be carefully handled in designing for the visual arts. Apart from that, the two most common problems in this field are money and management. Arts clients are certainly different from commercial clients. Although often called upon to be commercial themselves, they have a more philosophical view of the possible and at least a more erudite appreciation, if not understanding, of design. In the UK (less so in the USA) budgets tend to be restricted by funding authorities not known for their generosity. They may be disbursed through quite bureaucratic processes and determined by committees and curators who are not always entirely in sympathy with the views of the person commissioning the design.

A way around the bureaucracy one encounters is to try and get into a position where one is answerable only to the museum or gallery director. This can help cut red tape. And the answer to the worries that design may compete with the art is to pursue utter integrity, designing in harmony rather than counterpoint. If the designer is too much in awe of the artistic talent associated with the project, the results may be nervous or jokey. Design has to be clear in its role. For example, the same poster that promotes an artist's show is also sold in the foyer or the poster shop for people to frame and put up on their walls. These posters traditionally feature a famous work by the artist and some respectful typography of the artist's name, the gallery or museum and the date. We pointed out that, as there are two different types of use (one for selling and one for sale), so a promotional poster should be designed as such without having to double up as an art print, which is separate (and needs no design). There is very little difference between the way one goes about designing for the arts and for the world of commerce; perhaps just the need for a little more sensitivity in the ways one presents it and an understanding that one is not going to make much money out of it. Then working for those who are inclined to be artistically sympathetic to one's efforts can be immensely rewarding.
DAVID HILLMAN

RIGHT: *The Beaux Arts Ball is held annually by the Design and Architecture wing of the San Francisco Museum of Modern Art and sponsored by the local design and architecutral community. It is a masked ball. Partner, Kit Hinrichs Mask designer, Susan Tsuchiya Photographer, Barry Robinson*

Saturday, November 18
9:00 PM – 2:00 AM
San Francisco Marriott
777 Market Street

Ball Tickets: $75
Dinner and Ball: $300

Tickets Available at:
City Box Office: 392-4400
Bass Ticket Outlets:
762-BASS

For further BALL
information call: 362-7397

WITH
ENTERTAINMENT BY:

Peter Mintun
Viva Brazil
Timmie Hesla and the
Converse All-Stars
The Solid Senders
The Ultras
Pastiche
E.C. Scott

Plus a MIDNIGHT
SURPRISE not to
be missed!

243

B E A U X

A R T S

1 9

8 9

B A L L

COSTUME PARADE

AWARD CATEGORIES:
Tremendously Titillating
 Teams
Dynamic Duos
Sensational Single
Triumphantly Tasteless
Best of Ball

JUDGES:
Andrew Belschner
Michael Casey
Orlando Diaz-Azcuy
Charles Pfister
Bill Thompson

TO
benefit the Department
of Architecture and
Design of the San Francisco
Museum of Modern Art.
Presented by the American
Institute of Architects, San
Francisco Chapter and the
Modern Art Council of
the San Francisco Museum
of Modern Art.
Sponsored by the
San Francisco Marriott.

Design: Pentagram Photography: Barry Robinson
Printing: ColorGraphics Paper: Simpson Paper Co. Typography: EuroType

N O V 1 8

244

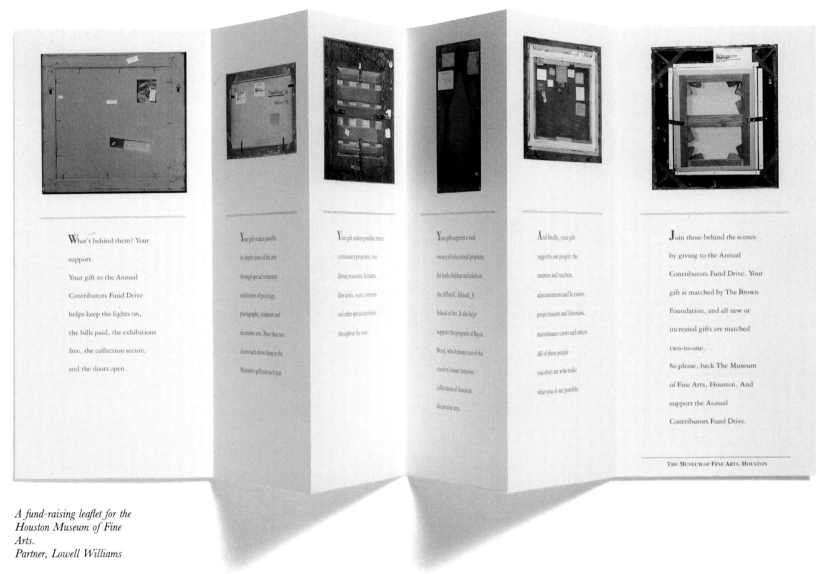

*A fund-raising leaflet for the
Houston Museum of Fine
Arts.
Partner, Lowell Williams*

*Part of a graphics program
for the Peter Joseph Gallery
on Fifth Avenue, New York,
which specializes in artists'
furniture design, from craft to
sculpture.
Partner, Michael Bierut*

RIGHT: *The Museum of
Modern Art, Oxford
undertook a refurbishment and
expansion programme and
commissioned a new identity,
which includes a logo system
that is applied to signs,
literature and posters. Details
of artists' works formed the
basis of one poster series.
Partner, Mervyn Kurlansky*

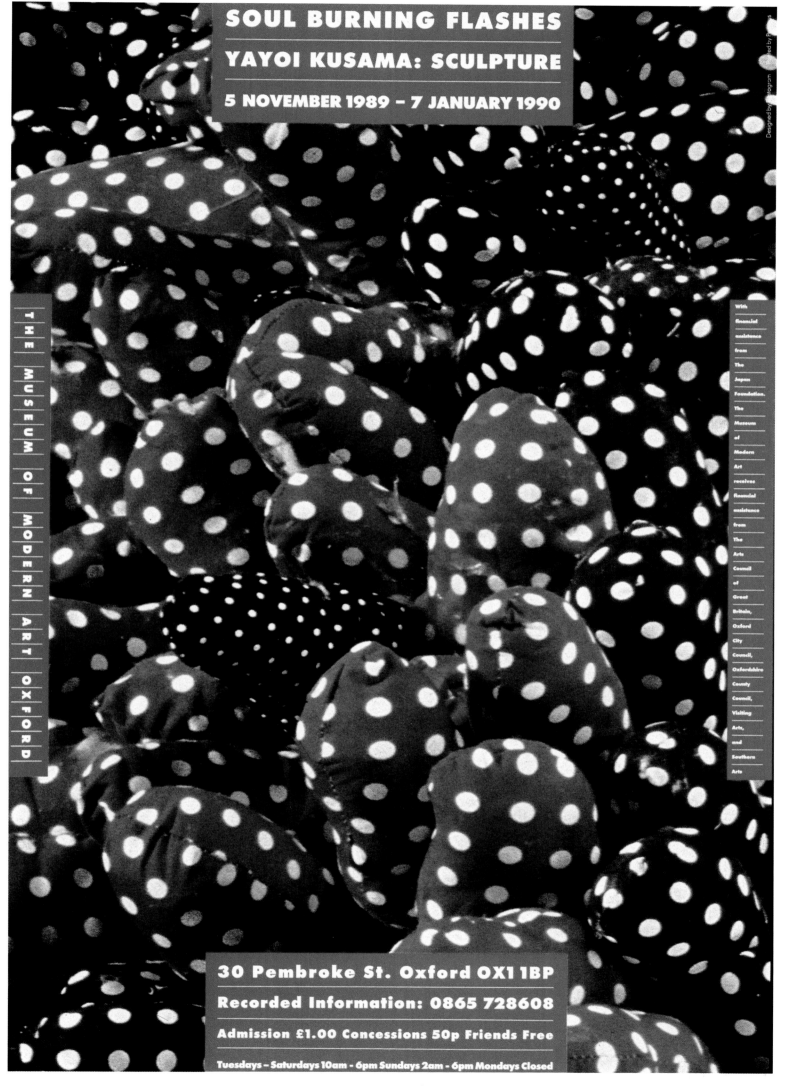

ON CLASSIC GROUND

Picasso, Léger, de Chirico and the New Classicism, 1910–30

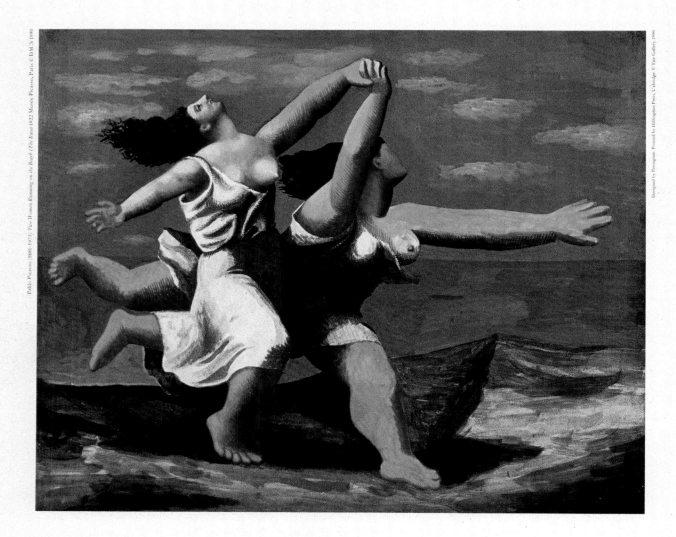

6 June – 2 September 1990

Monday – Saturday 10 – 5.50
Sunday 2 – 5.50 (last admission 5.15)
Admission £4 Concessions £2
Pimlico Underground (Victoria Line)
Tate Gallery, Millbank, London SW1

Sponsored by

TATE
GALLERY

REED INTERNATIONAL

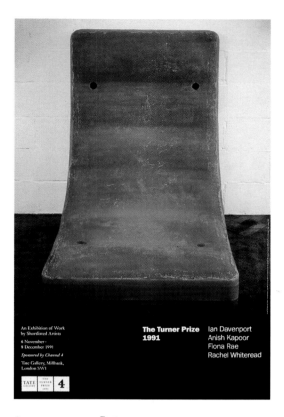

ABOVE AND LEFT: *Posters designed for the Tate Gallery, London. Partner, David Hillman Designer, Jo Swindell*

Programmes and poster for the Whitechapel Gallery in London. Partner, Peter Saville Associate, Brett Wickens

THE ISAMU NOGUCHI GARDEN MUSEUM

248

The Isamu Noguchi Garden Museum in Long Island City, New York, houses the architect's work in stone, metal, wood, clay and Akari light sculpture, as well as documentation of his gardens, playgrounds, fountains, and stage sets. The promotional brochure is designed like a folding postcard souvenir, which can be a square booklet or, unfolded, a double-sided hanging poster.
Partner, Woody Pirtle
Photographer, Shigeo Anzai

"AMERICAN THEATRE'S GREATEST CHALLENGE IS THE WORK ITSELF. IT MUST BE ECLECTIC: WE MUST PREMIERE PLAYS, COMMISSION NEW WORKS OF DRAMA AND MUSIC AND DO THIS HAND-IN-HAND WITH THE CLASSICS. I HAVE NO DOUBT WE'LL MEET THE CHALLENGE WITH THE SUPPORT AND ENTHUSIASM OF OUR AUDIENCES."

♦

GREGORY BOYD
ARTISTIC DIRECTOR
ALLEY THEATRE

MAN WHO CAME TO DINNER

TOM SAWYER

SEASON'S GREETINGS

TRELAWNEY OF THE WELLS

MIDDLE AGES

TREAT TOURS

THE ELEPHANT MAN

MIDDLE AGES

The Alley will continue to produce classic, proven works, always with an eye to revitalizing and making them relevant to today. A major commitment is being made to creating, as well as presenting, New Works of all kinds: contemporary drama, comedies and musical and experimental theatre.

To improve its calibre of work, the Alley will build a true resident company, a core group of artists-in-residence: actors, directors, playwrights, composers, designers.

An Associate Artists Program is also underway, designed to attract the world's most respected artists to participate not only in Alley productions but also in its educational programs.

Through the University Alliance Program, the Alley is expanding its collaboration with the educational community to improve the training and development of tomorrow's professional theatre talent.

The Alley's desire in these efforts is to produce theatre with a capital T. Theatre that engages, entertains and challenges, that demands to be seen and is demanded by a broad spectrum of the theatre-going public. Theatre, in other words, that continues the legacy.

"OF ALL THE MAJOR ARTS ORGANIZATIONS IN HOUSTON, THE ALLEY APPEALS TO ONE OF THE BROADEST AUDIENCES. THAT AND THE QUALITY OF THE ALLEY'S WORK ARE MAJOR FACTORS IN SHELL'S LONG-STANDING SUPPORT."

•

DORIS O'CONNOR
SENIOR VICE PRESIDENT
SHELL OIL COMPANY
FOUNDATION

A fund-raising brochure for the Alley Theatre in Houston, Texas.
Partner, Lowell Williams
Photographer, Terry Vine

A family guide to the Museum of Contemporary Art, Los Angeles, is designed to appeal both to children and adults, and is written in five languages.
Partner, Kit Hinrichs

When John Rushworth first met the Crafts Council in 1991 to discuss a new identity, they told him how they still remembered and admired the poster Colin Forbes had done for them eighteen years earlier.
A stone engraver had been commissioned to carve the letters into slate. Rather shamefully, this had cost less than the typesetting for the same poster.
Partner, Colin Forbes
Photographer, Enzo Ragazzini

Mingei
The living tradition
in Japanese arts

The Furnished
Landscape
Applied art in public places

The Crafts Council's new identity was commissioned following its campaign to counter proposals for its merger with the Arts Council as part of a major reorganization of arts funding in Britain. In the event the Crafts Council survived. A new building was donated by a patron in 1991, and the opportunity was taken to relaunch the Council with a new corporate design.

The idea of carving the new logo in slate was derived from Colin Forbes' 1973 poster. It is applied to to a growing number of sponsored exhibitions and posters, as well as to catalogues, stationery, and the signs for the new building.
Partner, John Rushworth
Associate, Vince Frost
Stone cutter, Tom Perkins

Lucie Rie

30 January - 5 April

Crafts Council Gallery
44a Pentonville Road
Islington London N1 9BY
Telephone 071 278 7700
Just 2 minutes from Angel tube

Free admission
Tuesday-Saturday 11-6
Sunday 2-6
Closed Monday

ANCIENT NEAR EAST GALLERIES, METROPOLITAN MUSEUM OF ART

The permanent exhibition in the Ancient Near East Galleries at New York's Metropolitan Museum of Art presents an extensive collection of gold, silver, bronze, and ivory objects, sculptures and bas-reliefs from Turkey, Iran, Syria, Lebanon, Israel, Jordan, and the rest of the Mesopotamian region, from 6000 BC to AD 200.

While the original brief for this project called only for the design of display cases, I chose to make a presentation on what could be done with the entire gallery space. I hoped to illustrate to the curator how a total renovation would enhance the visitor's museum experience. The design problem was complex. The exhibition needed to cater to a wide audience including scholars, schoolchildren, and the general public. Aesthetics had to be balanced with geographic location, dates, and conservation requirements which affected the grouping of objects and the construction of the displays.

The design proposal was based on my research in the Met's vast archives. Being a history buff, I particularly enjoy historical research. I was born in that part of the world, and felt it was important to place the viewer in arid, simple spaces, calling to mind the region in which the objects were created. My approach to this project was twofold. First, I considered the overall layout of the gallery space. Second, I focused on the display area of each piece appearing in the exhibition.

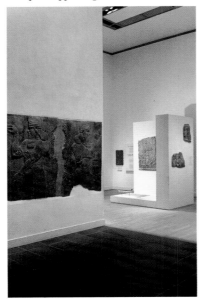

The original gallery was a long corridor. Its design allowed the visitor to walk rapidly through the exhibit without stopping to examine each artefact. In the new plans, the visitor's pace was slowed down by creating a zigzag traffic flow. Also, floor-to-ceiling display cases were positioned perpendicular to walls so that only one exhibit area would be visible at any one time.

I felt that the viewer should get as much experience of the objects and their original environment as possible. I considered the architecture of the period: the rectangular theme of the ancient square palaces, their courtyard columns, massive walls, and simple geometric wall reliefs. Specific placement of the floor-to-ceiling cases created courtyard environments for the individual exhibit areas. Also, to help associate each object with its archeological region, the interior displays were color-coded according to geographic zone.

I wanted the lighting to create an atmosphere of late afternoon sunlight in the Mesopotamian region. Larger display cases were treated individually, and key objects were highlighted. Special care was taken with pottery to prevent a silhouetting effect which might obscure details. By softening the background lighting, shadows were eliminated. The overall space was designed with the notion that the structures should be unobtrusive and that the artefacts should seem to float in the display areas. Delicate objects were discreetly secured on walls and in the cases.

Having developed the general layout of the exhibition, I formulated design strategies for the display cases. As mentioned, my primary aim was a case which would present objects without the distraction of structural details. Different plans were used to achieve this goal. The first was a mechanism which eliminated the need for display doors: by installing an overhead pulley system, a glazier's section tool could be used to elevate and lower the glass. The second means employed was the design of case access doors so that they were integrated into the architectural environment.

ETAN MANASSE

RIGHT: *Delicate objects had to be carefully secured to color-matched surfaces.*
FAR RIGHT: *Display cases are lit individually and key objects highlighted, with special care taken not to lose details on pottery.*

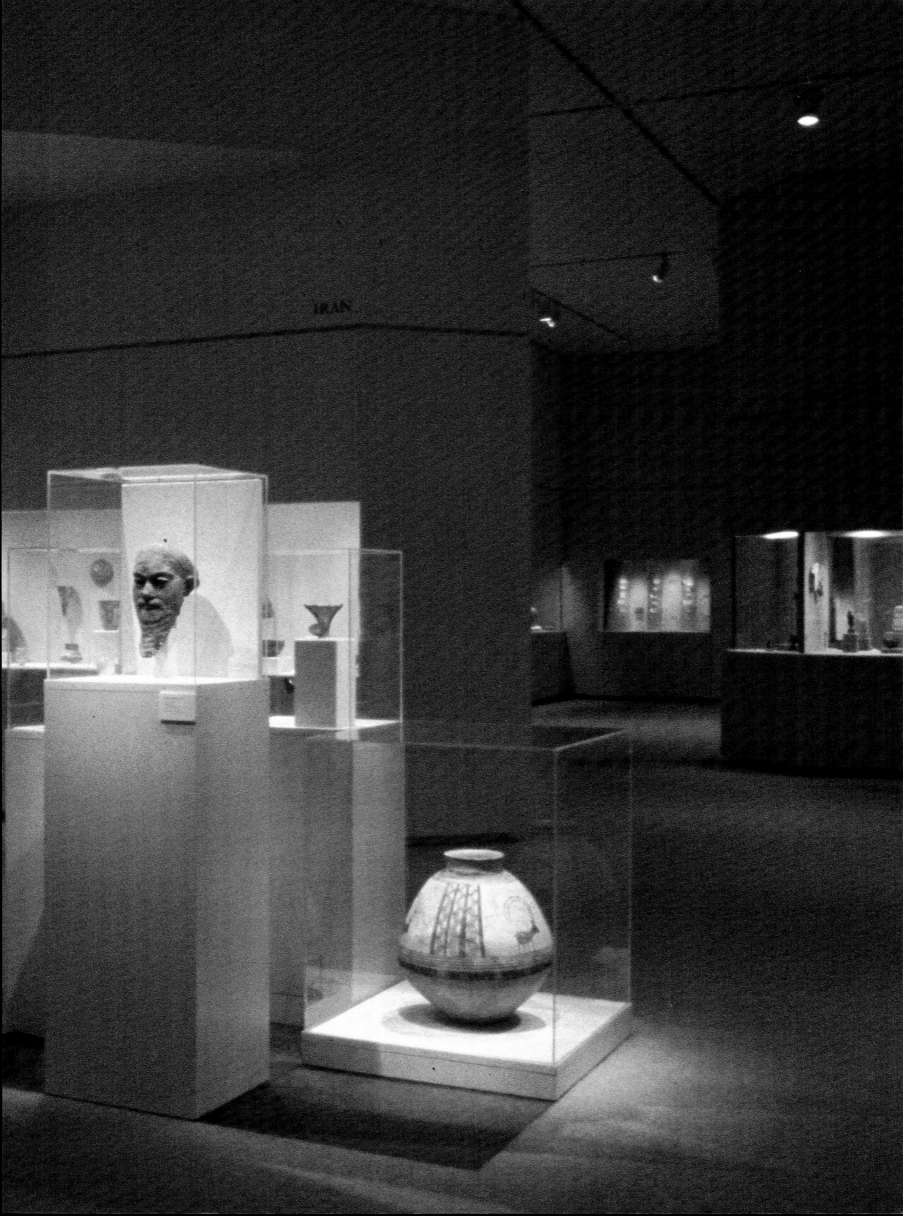

More than meets the eye

The redesign of the *Guardian* was essentially an editorial rather than a marketing process, effectively changing perceptions of the editorial appeal. DAVID HILLMAN reports.

It is said that the kind of clothes we wear affect the way we behave. At the end of the 1980s, the re-design of the *Guardian*, one of five 'quality' national daily newspapers in the UK, raised the question of whether the new look actually influenced the quality and tone of the paper's editorial stance.

There is no doubt that there is more than meets the eye in the role played by design in the overall complexion of any newspaper. It has long been held, for instance, that a tabloid format automatically brings the content and appeal of a newspaper downmarket. For so long it has been the journalists who designed their newspapers. Their responsibilities included typography, printing, and production. Even now, in the age of specialists, this tradition lives on. The journalist is trained in page layout, in printing and typography as well as in shorthand and keyboard skills. It is implicit that the journalist automatically designs to respect the paper's editorial values.

Where journalistic design falls short is in prime talent and objectivity. With specialist design consultants now being employed by the UK newspaper industry – notably by the *Guardian* and the *Independent* – more imaginative, disciplined and educated design skills are being brought to bear. But the outside designer has to tread very carefully. Everyone on the newspaper thinks he or she knows about design and can easily claim that a design consultant's objectivity is in fact ignorance. So the designer undergoes rigorous scrutiny of his sympathy and understanding for a newspaper's editorial stance, before he or she can prove his ability to make a considered contribution to it. That contribution may well prove to be crucial to a newspaper's fortunes.

The decision to re-design a national newspaper is often a matter of when to do it and how far to go. With the overdue introduction of new technology in the 1980s, the British dailies found a new freedom. Fleet Street, the old home and generic name for the national press, had stood for lots of things – but never for good business practice. For decades, weak management had allowed a system of production to become entrenched that was archaic, inflexible and very expensive. The unions took advantage of the situation and ended up in virtual control of production – with restrictive practices, over-manning, very high wages and no chance of introducing the technology that would make national newspapers pay a decent profit.

In the mid-1980s *The Times, Telegraph, Financial Times* and *Guardian* were being put together in the same way as they were in the 1920s. Newspaper publishing had become largely a status symbol and tax-loss vehicle for rich companies and proprietors mainly interested in the power it gave them. But some brave men decided enough was enough. Gradually the power of the unions was broken and Fleet Street became history.

All the newspapers have now moved to new buildings and equipped themselves with new technology and new working practices. Once the band-wagon started rolling, no one could afford to be left off. The *Guardian* has always stood somewhat apart from the other 'qualities'. It was, of course, born and bred in Manchester, not London. This and its traditional appeal to the more radical reader have given it a special status amongst the British press. But when the Fleet Street revolution broke, the *Guardian* was caught up in the ferment like all the others. The moment had arrived to reaffirm its radical reputation – and go the whole way. It moved to a new building and took on the new technology. It was saddled with a twenty-year-old design and faced increasing competition. So the time was right for a new design.

When we set out to work on the *Guardian* we understood that what we did would affect more than just layout and readability. It would have an impact on the overall perceptions of the paper held by readers – and journalists – and would thus have some influence on the paper's fortunes. With this in mind, our approach had to be knowledgeable, very clear and deliberately thorough. The editor came to us and asked us for our thoughts.

We started working on proposals which originally paid no regard to how they would be achieved – just how they would look. Our first task was to assess the history, the market, and the competition: the *Independent, The Times*, and *Daily Telegraph*. (The *Financial Times* has a different market.) The *Independent* was brand new at the time, and its immediate success owed much to the post-revolutionary conditions; the old Fleet Street would have strangled it at birth. Because it was new it had to go for a traditional-looking design – simply because it didn't have a tradition.

Only an established newspaper can break new ground in design terms – and *The Times* and *Telegraph* showed no sign of doing it. The

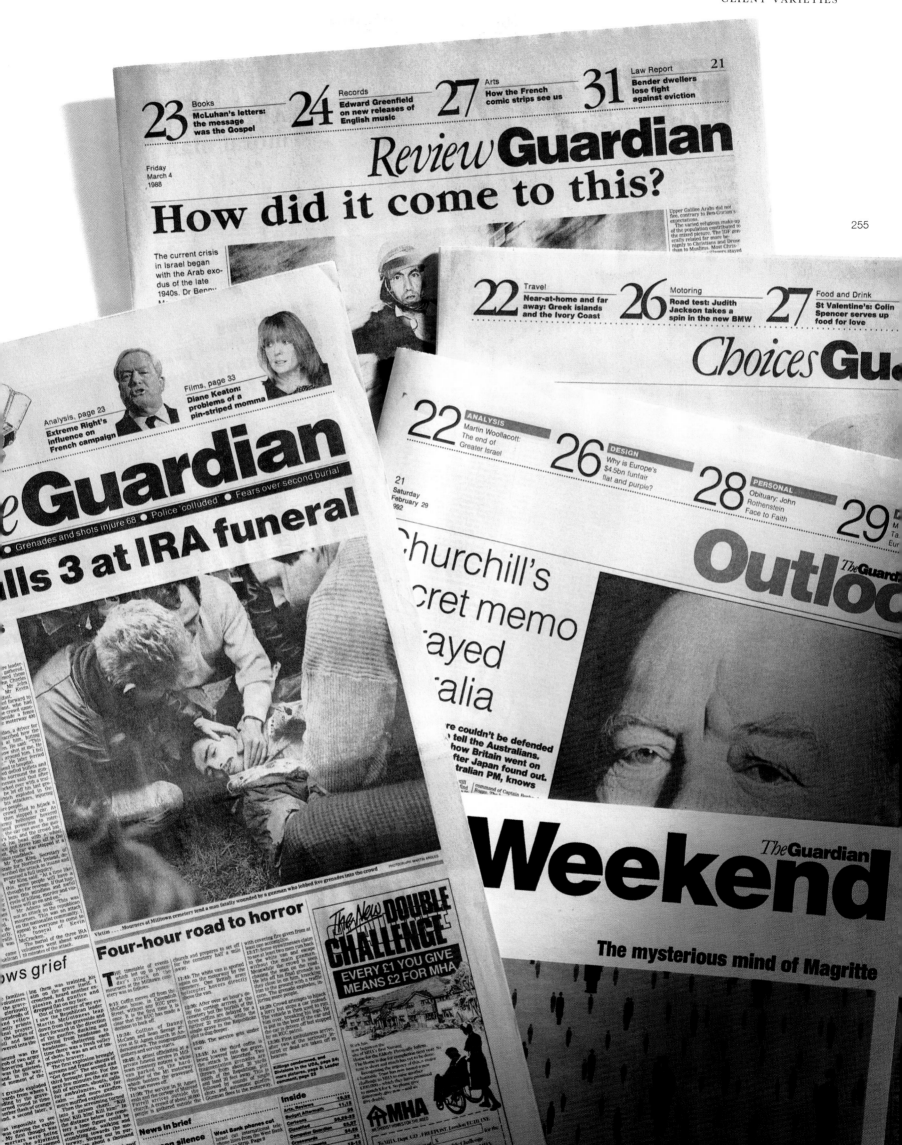

23 Books
McLuhan's letters:
the message
was the Gospel

24 Records
Edward Greenfield
on new releases of
English music

27 Arts
How the French
comic strips see us

31 Law Report 21
Bender dwellers
lose fight
against eviction

Review **Guardian**

Friday
March 4
1988

How did it come to this?

The current crisis
in Israel began
with the Arab exo-
dus of the late
1940s. Dr Benn...

Upper Galilee Arabs did not
flee, contrary to Ben-Gurion's
expectations.
The varied religious make-up
of the population contributed to
the mixed picture. The IDF gen-
erally related far more be-
nignly to Christians and Druse
than to Muslims. Most Chris-
tians stayed

22 Travel!
Near-at-home and far
away: Greek islands
and the Ivory Coast

26 Motoring
Road test: Judith
Jackson takes a
spin in the new BMW

27 Food and Drink
St Valentine's: Colin
Spencer serves up
food for love

Choices **Gu**

Analysis, page 23
Extreme Right's
influence on
French campaign

Films, page 33
Diane Keaton:
problems of a
pin-striped momma

e Guardian

• Grenades and shots injure 68 • Police 'colluded' • Fears over second burial

lls 3 at IRA funeral

22 ANALYSIS
Martin Woollacott:
The end of
Greater Israel

26 DESIGN
Why is Europe's
$4.5bn funfair
flat and purple?

28 PERSONAL
Obituary: John
Rothenstein
Face to Faith

29

21
Saturday
February 29
1992

Outloc The Guardian

Churchill's
cret memo
ayed
alia

re couldn't be defended
tell the Australians.
how Britain went on
fter Japan found out.
tralian PM, knows

command of Captain Bom...

PHOTOGRAPH: MARTIN ARGLES

Victim Mourners at Milltown cemetery tend a man fatally wounded by a gunman who lobbed five grenades into the crowd

Weekend The Guardian

The mysterious mind of Magritte

Four-hour road to horror

ws grief

News in brief

Lawson silence

Inside

Pages from the Guardian
*in the week after the new
design was launched.
Partner, David Hillman
Designer, Leigh Brownsword*

256

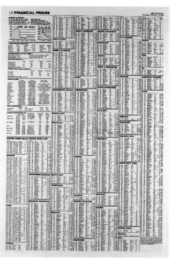

Section Two on Fridays has a slightly different look – within the same type rules and grid – from other days. This signals that it is produced in partnership with other newspapers in Europe, so the perspective is not so much British as pan-European. The different masthead style has begun to be adopted for Section Two on other days.
Designer, Julie Fitzpatrick

Manchester Guardian of the 1950s and '60s was a classic. When it moved to London and became just the *Guardian,* the same design served for a while longer, until a new, highly distinctive design was introduced twenty years ago, which attracted much praise. This same design had carried us up to the beginning of 1987. So we had a golden opportunity to keep a worthy design tradition going, and for the *Guardian* to distinguish itself yet again. We took the opportunity and made the most of it.

When it was announced to the public that a re-design was on the stocks we were only a month away from the launch – and we soon knew we weren't going to please everyone; in fact the new design was such a closely guarded secret that nothing was seen in public until the launch. That morning, posters went up on hoardings, and the sign on the *Guardian* building was changed. Some readers were so bemused that they didn't realize that the paper being delivered to them was their old friend in new clothes.

The work had actually started the previous summer, after the early exploratory meetings between myself and Peter Preston, the editor. The brief being so open, it was clear that the *Guardian* didn't really know what it wanted in visual terms – although the conditions that had to be met were fully and succinctly explained. Having analysed the background and the market, we set ourselves five design criteria that would guide our design efforts: the paper had to be readable, well organized, clean, simple to put together, and distinctive.

First, readability is a matter of respecting the way the eye moves around a page: it starts at the top left and works down and across. Most newspapers have forgotten this and have a column of text then the headline on columns two and three. We put the headline on top of the text at the beginning. Then you read the story. Then

you arrive at the next headline and the next story. Second, a crucial point about the new design was that the new technology would be introduced at the *Guardian* at the same time. This gave us considerable scope in ensuring the new paper was well organized: we were able to back-set the paper, ie print the edition in two sections and prepare some pages beforehand.

This is common practice elsewhere, especially in North America, but was revolutionary in the UK. The paper as a whole could then be organized more rationally. We also wanted to give the same feeling of good organization on the page itself. Next, producing a clean design is a matter of discipline, and the careful use of white space. Fourth, making the paper simple to put together was largely a task of re-education, both in design terms and of course in the new technology we were going to use. The sub-editors had been trained in, and become used to, an entirely different way of working. We had to devise a simple system of handling forty-eight pages a day in the new design. This involved some basic layout training and introducing a new way of thinking – without riding rough-shod over valuable existing skills. Last, the new design had to be distinctive: we had to win the battle of the news-stands. The masthead was our main gambit here. After early criticism, its device of trailers and photos at the top of the paper has been imitated more and more. It is radical; it works.

The development of the new design was carried out in two phases. The first phase involved producing a series of options to find out what was really wanted – by finding out what wasn't wanted. 'Tabloid' is an emotive word in itself, in Britain at least, but there is no reason why what I prefer to call the 'small-format' newspaper cannot represent the same quality as the traditional broadsheets. Design would be able to challenge the preconceptions about tabloids. I was keen to

persuade the *Guardian* that their requirement for a broadsheet format should at least be tested. So amongst other things we produced the small-format option. We also demonstrated how a small-format design could arrive folded through the front door – and how it opened up on the long edge into a conventional broadsheet. I did not convince the editor that the time was right for this approach, although there has been more and more interest in the format since then (a small-format *Weekend Guardian* has been produced for inclusion with the Saturday edition, and the UK quality Sunday newspapers are following in this area).

Having made some of the basic decisions by developing and deciding on options, we now moved on to a kind of comparative development, which meant taking actual pages from day to day and working them into the new design to see if they would succeed. Thus we were not working in theoretical terms, but solving real problems. We proposed that there should be a strong visual distinction between the two sections; so we used a serif typeface for the headlines in the second section, and set the text ragged.

To some conventionalists in newspapers this was little short of anarchy. We did a series of tests comparing the ragged with the justified, but at the end of a week's trials we still hadn't convinced anyone – except, that is, the editor, who agreed that it read more easily. It wasn't exactly democratic, but has proved to be the right decision.

We then moved into the second phase, which involved the whole staff's translating the designs into a real working system for a real daily newspaper. The foundation for this process was the excellent training manual produced by the *Guardian*. Our task was to communicate the aims and the practices of the new design to fifty or so journalists and subs. For a month, every one of them spent around three hours a week at a computer terminal working on the new design – whilst also producing a paper every day in the same way as it had been done for nineteen years.

Educating the *Guardian* staff was one thing. Teaching their new computer the rules was quite another. The success of translating the design to computer production whilst completely retaining its integrity is entirely due to David Watts at the paper. He always made the computer do what we wanted, not what it wanted. There was no compromise. And if the computer allowed us to make a design decision that would not have been possible with old technology, then we made sure we knew about it. Everything we did had to be translated into computer commands; the computer manual covers every detail of how each instruction is programmed into the machine.

One major design advantage was that the computer allowed us to invent our own point system. Everything was based on an 8½ point size because the type was set on an 8½ body. This meant that 60 point actually became 59½ point so that everything aligned on the page. For dropped caps, a separate programme was written for the computer. Thus the basic layout and design rules do not have to be remembered by the staff: they are made automatically by the computer. The page make-up system became fully automated a year or so later.

As the launch date approached, a complete dummy edition of the paper was produced in the new design – alongside producing the paper in the old design for the streets. The dummy run actually took three days to produce, and the results weren't bad. Old attitudes about headlines were still refusing to lie down, and the use of white space – and how to break up a column of text – were entirely new skills, which would only become second nature after days of practice on the real thing.

On 12 February 1988 the new *Guardian* was launched. Now the paper has a new design, less production staff, more journalists and better coverage, and improved finances. Technology has helped; but it was the people who did it. Predictably perhaps, most criticism of the new design came from journalists on other national newspapers. One of the more enlightened journalists on the *Times Educational Supplement* did say that he thought that the new design had changed the cards in the pack, which could only be a liberating influence.

Has the *Guardian* changed editorially? With the new design it certainly began to attract new and different readers. In the three years after its introduction readership among fifteen to twenty-four-year-olds had risen by thirty-three per cent. It has also lost some of its previous regulars. The perception is that the paper has changed more than just its design. For us as designers, for the readers and professional media watchers, and for the people at the *Guardian* itself, there is more to the new design than meets the eye.

The original Weekend Guardian *in black-and-white was launched in 1988. Designer, Jo Swindell It was superseded by a colour* Weekend Guardian *in 1992. Designer, Karin Beck*

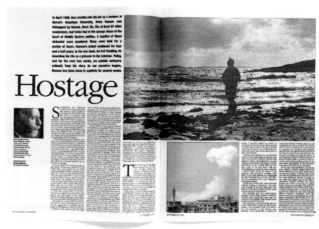

Minding our business

The industry that provides designers with their livelihood needs
the energy and creativity of designers to maintain and promote
its own health and wealth.

Our work is not confined to office hours, and we don't cease to
operate when we are not working for Pentagram clients. It has been
said that Pentagram is as interested in the state of the design culture
as much as it is in the design business. Frankly we don't see such a
great distinction between the two. We simply take an expanded view
of our role. Working for the design industry is really working for
ourselves. Disseminating our views, attitudes and knowledge to the
wide audience ultimately helps our own business cause as well. But
the real reason that we work for the design industry is that we can-
not really help it. Design is the way we live; it is an attitude – so we
are bound to be involved in everything that affects it.

The Pentagram partners graft on to what are already hectic lives
a busy schedule of industry activities – according to our individual
inclinations. We variously sit on committees and panels, judge
design awards and student work, write articles and books on design,
lobby business and government, and are generally active as mem-
bers of our own industry institutions and bodies. When teaching at
colleges we are able to bring an experience in the design business to
complement the views of the professional college teacher. In teach-
ing management courses we are able to bring an understanding of
the role and power of design in influencing far more than the way a
corporation and its products look.

We do believe in the power of design. We believe that it is under-
estimated and underemployed. There is plenty of work to do in
changing general attitudes to design. The work is necessary – and of
course it's enjoyable.

JOHN McCONNELL

RIGHT: *The American
Center for Design holds an
annual competition – on real
work for real clients from
practising designers. The
notebook 'manifesto' was
dictated to a five and a half-
year-old by its author, the
poster's designer.
Partner, Michael Bierut.*
BELOW: *The hand/eye image
of 'vision is power' encourges
entrants to the AIGA's
1991-1992 Communications
Graphics show.
Partner, Kit Hinrichs
Photographer, Bob Esparza*

CALL FOR ENTRIES
THE FIFTEENTH ANNUAL AMERICAN CENTER FOR DESIGN
ONE HUNDRED SHOW

ALEXANDER ISLEY, JILLY SIMONS, ERIK SPIEKERMANN, JUDGES
MICHAEL BIERUT, CHAIR

ENTRY DEADLINE: MAY 1, 1992

DESIGN: MICHAEL BIERUT / PENTAGRAM
LETTERING: ELIZABETH ANN KRESZ BIERUT / TRANSFIGURATION SCHOOL

262

*A poster announcing a joint
exhibition – on two floors –
between Per Arnoldi, Danish
poster designer, and the
Polaroid Impulse posters (see
page 214) at the New York
Art Directors Club.
Partner, John Rushworth*

*Publicizing the satellite
transmission to New York of
a Design and Art Direction
awards ceremony in London.
Partner, Woody Pirtle*

*A 1990 cover design for the
AIGA's Graphic Design
USA: 11.
Partner, Paula Scher*

*The 1982 European
Photography annual uses a
colour negative for the cover.
(The previous year used a
black-and-white negative.)
Partner, David Hillman
Designer, Bruce Mau*

On the cover of the 1990 D&AD annual a rather vulgar figure (debunking the winners) hides inside a much more sober slipcase. Partner, John McConnell

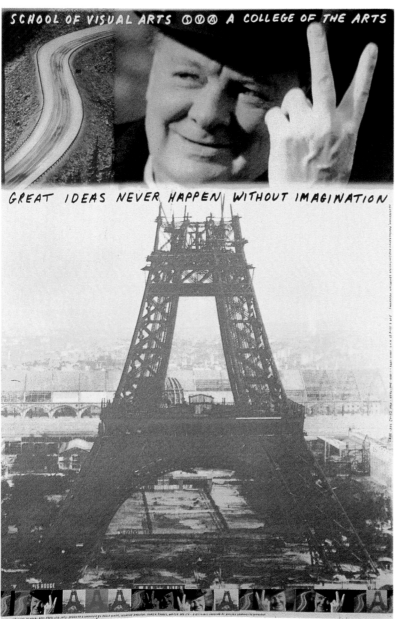

A 1992 promotional poster for New York City's School of Visual Arts. Partner, Paula Scher

A poster to announce two lectures by Paula Scher: one in Oklahoma City and the other in Tulsa, Oklahoma. Partner, Paula Scher

The client was Colin Forbes, then president of the AIGA, who commissioned a poster for the Institute's first conference, to be held in Boston. Chasing progress on the phone with the rather hesitant designer, Forbes quoted Bob Gill: 'If you can't explain it on the phone, you don't have an idea.' The designer was Woody Pirtle before he became a partner – and he did have an idea.

THE STANFORD DESIGN FORUM

There have been many attempts to advocate the importance of design in contemporary society in general and to business in particular. There are government and private organizations dedicated to this purpose, but with only a few exceptions, these have failed to reach or fully involve leaders in industry, education, or government in a serious dialogue about design. In September 1988 I chaired the first Stanford Design Forum, a meeting of international leaders in design which took place at Stanford University in California, as an effort to begin to fill this cultural void.

Over a period of nearly ten years, from the time I first started working in New York, I thought about how an international forum for the promotion of design might best be organized. The perfect opportunity arose in 1986 with an introduction to the Stanford Alumni Association, which eventually agreed to become a sponsor. An executive committee was formed by a group of people from various disciplines who were so prestigious in their fields and so committed to the forum idea that we were thereafter assured of success. We applied for and were granted funding from the US National Endowment for the Arts.

The executive committee decided that the forum group would be limited to design-aware leaders in three major fields: Chief Executive Officers or heads of divisions of large corporations or governments; principals of design consultancies and design managers in major corporations; and heads of educational and cultural institutions who have the responsibility for communicating design issues to a broad audience.

We also established the three major issues which would form the basis of the discussion: design as a business strategy, designing for international markets, and communicating the importance of design. In advance of the actual meeting, three statements on these issues and related questions were prepared, and responses were requested from each participant. These were collected and bound into a book of meeting papers which each forum member was given to read before the meeting began.

Stanford University was the perfect location for such a special group to meet: on a campus in the California sun. The spirits and enthusiasm of the group were very high, and each person remembers it as a stimulating occasion. Introductory remarks to the meeting were given by Donald Peterson, Chairman, Ford Motor Company, who described the success of the Taurus automobile achieved through innovative design and management. Kazuyoshi Ishizaka, President, Kenwood Corporation, outlined the development of his firm's corporate identity program and its application in an international marketplace. Peter Lawrence, Chairman of the Corporate Design Foundation, introduced the question of how to communicate the scope and importance of design to the public at large. These introductions provided individual analysis of the key issues and served as a springboard for the following discussions. Harold Evans, Editor-in-Chief of *Traveler* magazine and former editor of London's *Sunday Times,* acted as moderator. The discussion sessions encouraged an animated and multi-disciplinary debate within a carefully structured framework. The pre-circulated conference papers provided everyone with an insight into other participant's views before the meeting.

It was agreed that a priority of the forum should be to disseminate the message of the importance of design to a wider audience of influential policy and decision-makers in corporations, business schools, educational and cultural institutions, publishing and broadcasting. A book called *Design in the Contemporary World* was written and published in English and Japanese on the discussions and conclusions. To date we have distributed nearly two thousand copies all over the world.

It is difficult to assess the effect of the forum and our book, but we have been successfully reviewed and quoted in the business and design press in the USA, Europe, and Japan. Sara Little Turnbull, Director of the Process of Change/ Innovation and Design Laboratory at the Stanford University Graduate School of Business, wrote: 'What seems unattainable was a formidable assemblage of talent and know-how, and the event is recorded with depth and scholarship.' Randy McAusland, then Director of the National Endowment for the Arts Design Arts Program said, 'Bravo! *Design in the Contemporary World* is a major achievement, a contribution to the entire field of design.' There is no question that the Stanford Design Forum is part of a larger movement towards design awareness; the TRIAD project organized by the Design Management Institute in conjuction with Harvard University, and Design America out of the University of Michigan, are other initiatives in the same vein. The long-term test will be the degree to which we succeed in influencing the education of designers and businessmen.
COLIN FORBES

LEFT: *The Stanford Conference on Design is held every July on the campus of Stanford University in Palo Alto. For three days large audiences listen to and exchange ideas with an international roster of speakers from a wide range of creative disciplines. This poster promoted the 1985 Conference.*
Partner, Neil Shakery (a member of the Stanford Design Conference Executive Committee)

ORGANIZING A CONFERENCE IS LIKE A LOT OF THINGS

It's like having the biggest dinner party in the world. You invite old friends, people you've always wanted to meet, people you think might like to meet each other, and, just to be interesting, a few people who might have an entertaining argument once a few drinks have been washed down.

It's like putting out a magazine. You come up with ideas for little columns and big feature stories, serious things and funny things, and you assign them to smart people who you hope will have something interesting to say. You have to pace words and pictures, long and short, make sure things keep moving, and see to it that the thing has a beginning, a middle, and an end.

It's like working in the control tower of an airport. You have to make sure planes are taking off on time, landing on time, not running out of gas in mid-air, and not bumping into each other on the runways. And you have to do it while it's all happening around you, usually on the verge of getting completely out of control.

For us, being the co-chairs of America's largest gathering of graphic designers – the American Institute of Graphic Arts' 1991 National Conference – was an extraordinary adventure. Our theme, Love, Money, Power: The Human Equation in Design, was meant to force us all to re-examine the motives that got us into design in the first place, and the motives – sometimes quite different ones – that keep us doing it, four, fourteen, and forty years later.

Fifteen hundred people came to Chicago for four days in October to hear over ninety speakers. Just like at a good party, a few fights broke out, and one or two people memorably disgraced themselves, but for the most part everybody seemed to have a good time. Just like in a magazine, not everyone produced the piece that was assigned, but often the surprises were better than the expected performances. And just like at a rainy night at the airport, there were some delays, 'snafus', and inconveniences.

Each of us has different memories of the Conference: heroes such as Milton Glaser, Massimo Vignelli, Josef Muller-Brockmann and Deborah Sussman talking about the work they love best; young designers baring their souls movingly (Rick Valicenti) or hilariously (Chip Kidd); Bill Bonnell and Phil Meggs brilliantly dissecting Container Corporation of America and Tony Hendra savaging Disney; Ivan Chermayeff remembering partner Robert Brownjohn; AIDS activists Gran Fury igniting a debate on the role design should play in society; and Ralph Caplan brilliantly summing up the impossible, overstuffed abundance of the four days just past.

As co-chairs, we were kept too busy to do much drinking in Chicago. Odd, then, that the two of us came back with hangovers that lasted nearly a week.
MICHAEL BIERUT AND
PAULA SCHER

Three years of posters for the International Design Conference in Aspen, Colorado, which has a different theme each year.
TOP: 'British Design' in 1986.
Partner, Alan Fletcher
ABOVE: 'Success and Failure' in 1987. (Try turning it upside down.)
Partner, Michael Bierut
RIGHT: 'The Cutting Edge' in 1988.
Partner, Woody Pirtle (started in Dallas, Texas, completed in New York, New York as he joined Pentagram)

The announcement of a lecture by James Stirling at the Architectural League of New York.
Partner, Michael Bierut

 Art & Architecture

268

Sutherland Lyall Landscaping and Architecture

Landscaping has regained its importance in architecture over the past two decades. Sutherland Lyall, author of many books on modern British architecture and landscaping, talks about this trend using examples from his latest book, *Designing the New Landscape*. Copies of *Designing the New Landscape* as well as *Rock Sets* will be on sale at the lecture at Pentagram Design, 11 Needham Road, London W11 on Wednesday 27 January at 6.30 for 7.00pm. Admission is free for members, £2.50 for non-members. For further information contact Coralie Langston-Jones on 071 792 3812.

Art & Architecture is a group that works and argues for an enriched environment, for more beautiful and more humane towns and cities. It strives to add its voice to what has become a national debate. The group has produced a register of artists and craftspeople and has a written code of practice.

The group, which meets at Pentagram each month, has for many years campaigned for 'per cent for art' schemes. The Arts Council of Great Britain has now taken up this project, which allocates one per cent of the cost of any building project to art, with great vigour. It will change our lives.
THEO CROSBY

When I first became involved with the Art & Architecture group it was trying to raise its profile and make things happen on the 'per cent for art' idea. The message was good but it wasn't presented very coherently in a graphic sense. We started with a poster for a conference. I eventually came up with the idea of using a letter A to represent architecture and decorating the counter of the letter with stained glass to represent the 'one per cent'. Everything else developed from this idea, so that whenever we use the letter A for Architecture it is given a decorative variation. The symbol of the group evolved from cutting a decorative serif A into a plain sans serif A.

The Art & Architecture manifesto contains twenty-three decorative variations of the letter A. The idea was to represent the variety of style and expression that there could be if artists were to become more fully involved in the architectural process.
JOHN RUSHWORTH

Art & Architecture posters.
Partner, John Rushworth
Designers, Vince Frost and
John Powner

Pentagram and partners

Pentagram began with five partners, now there are seventeen. They work in London, New York and San Francisco. They have their own clients, and work in their own ways with their own teams. They share equally, and contribute equally. There is no seniority, or hierarchy. Similarities in style, temperament and aspiration between them are few. What they do have in common is Pentagram itself.

Pentagram's distinct approach and unique organization serve the partners' freedom and individuality so well that they earn both enthusiasm and loyalty. The partners work in Pentagram offices, use Pentagram letterheads and sign their work not in their own names but in the name of Pentagram. Yet they still maintain individual reputations and identities.

Every six months they come together at a retreat somewhere in the world to plan and direct the organization. From these meetings also come the ideas and initiatives to produce Pentagram's publications, sponsorships and other collective enterprises.

Under cover

Pentagram's publishing habit has proved to be an appreciated way of keeping in touch, and has grown in ambition and diversity over the years.

Theo Crosby has articulated our motivation to publish: 'Everyone loves to have a book published. The printed word carries a somewhat archaic flavour of merit and respectability. The size of the edition does not seem to matter, what does is the imprint. Books win friends, and buying friendship is perhaps the most economical investment one can make. They are also excellent propaganda if you can produce the proper concern for the public good. Pentagram loves books and produces all sorts.'

We have three different criteria for our publications: books that promote our ideas as broadly as possible; *Pentagram Papers, Feedback,* annual greetings booklets, and reviews that maintain our connections with clients and friends; and thirdly, monographs that in essence act as portfolios of our work.

Our books started when Crosby/Fletcher/Forbes merged with Kenneth Grange and Mervyn Kurlansky and we agreed to a new name for our company, Pentagram. We decided we wanted to do something dramatic to transfer the goodwill of our names to Pentagram, so we decided to produce our first book, which was *Pentagram: The Work of Five Designers.* We then thought how good it would be if it was published in Europe and the USA under a publisher's colophon. The book was published in three languages by Lund Humphries and Watson-Guptill, and to our surprise sold ten thousand copies in the USA. This made us realize that there was a need for designers to write about their ideas and practice. Five or six years later, the book was out of date and out of print. We clarified our thinking in terms of what we wanted from our publishing ventures, and the purpose of our next book was to promote Pentagram's philosophy on design rather than the case history concept of our first book. *Living*

by Design sold twenty-five thousand copies and became required reading in many university foundation courses. *The Compendium* is the latest example of our efforts to communicate the Pentagram message to other designers, students and interested laymen.

One of our consultants came up with the concept of 'Friends of Pentagram', saying: 'Your existing clients and friends are your best advocates.' *Feedback* was originally created by Pentagram for and with the help of our friends, as we felt it would be of interest to people like ourselves who frequently travel abroad. Artists, designers, architects, writers and photographers have a unique advantage in that, by the nature of their work, they belong to an international fraternity. One of the benefits of having made a reputation in design is that our community extends to almost every city in the world. When travelling to unfamiliar cities and at a loss as to where to go, one is often taken by a friend or colleague to an interesting corner of the city. We continue to update the edition.

The little books which are mailed for Christmas and the New Year have been based on games and puzzles that people can share over the holiday season. They are also, obviously, a demonstration of our graphic expertise. We have also published annual reviews, the latest being *Pentaspeak* which we mail to existing clients, friends and contacts to keep them informed of our activities. The article which follows, reprinted from *Print* magazine, clearly explains the idea behind the *Pentagram Papers.*

In the final category are our Pentagram Library monographs which are divided by project categories such as Identities, Packaging, Product Design. These are produced as a response to new business inquiries.

COLIN FORBES

FAR LEFT: *Pentagram's very first book; the second edition was retitled simply* Pentagram.
LEFT: *The poster that helped to sell* Living by Design.
RIGHT: Ideas on Design, *published by Faber and Faber, 1986; editions of* Feedback; Pentaspeak; *and monographs from the Pentagram Library.*

ABB

Asea Brown Boveri
Electrical engineering group

PENTAGRAM MARKS

PENTAGRAM IDENTITIES

PENTAGRAM PACKAGING

PENTAGRAM PROFILE

A
Bi-lingual*
Annual Review
of the Work
of the Pentagram
Partners in
London, New York,
and San Francisco

Pentaspeak

*Written in
the Queen's English
and that
"Other English"

AS
N
IGN

PARALLAX

FEEDBACK 1974

MORE FEEDBACK

A collection of places *by* Pentagram and Friends

Another
Feedback—
a a
wit
res
and
ove
che
w
fi
p

Feedback

duct Designs of Kenneth Grange of Pentagram

Inter-City 125

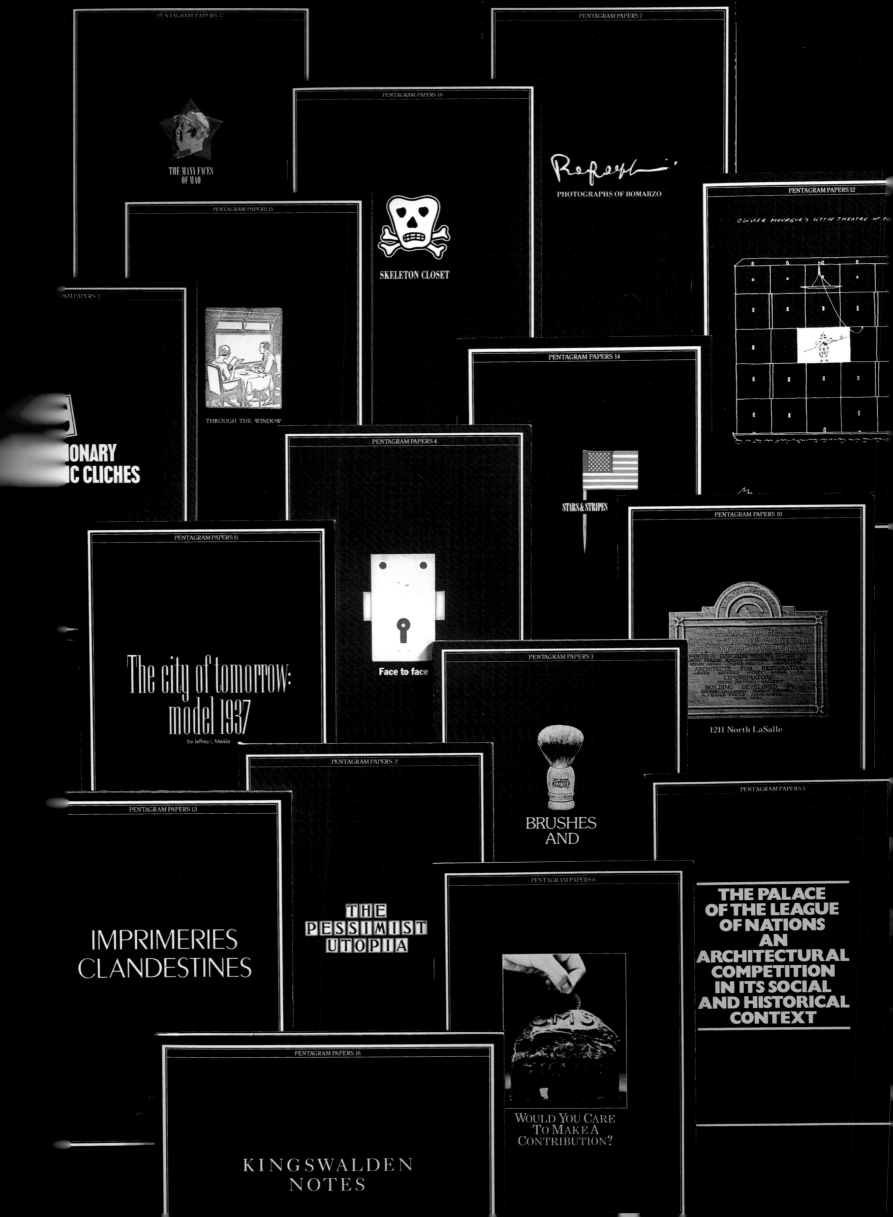

PENTAGRAM PAPERS
Adapted from an article in Print *magazine,*
January/February 1989

Pentagram Papers, begun some ten years ago and published at regular intervals ever since, compose a series of idiosyncratic, sometimes esoteric volumes whose stated philosophy – printed on the back cover flap of each book – is to express 'curious, entertaining, stimulating, provocative and occasionally controversial points of view that have come to the attention of, or in some cases are originated by, Pentagram'. The volumes, 8¼ inches by 5¾ inches, all follow the same graphic format. They are black with a white border and a fold-out cover giving the appearance of a book jacket, although in some cases separate jackets are included. The only editorial comment supplied by Pentagram, besides the philosophical statement on the back, is a brief explanatory paragraph or two in front suggesting the value of the subject matter or the reason for publishing. The volumes are slim – something between twenty and fifty pages. A very high-quality paper is used, and type and layout are sensitively attuned to the character and period of the material shown. The booklets, as was intended, are satisfying objects on their own account. People who receive them tend to hold on to and even collect them, and complete editions are now hard to find. Some of the subject matter first exposed to the world in this format has later been expanded and published commercially by someone else for a much wider audience.

The idea – a brainchild of John McConnell and Colin Forbes – arose from discussions while traveling and a comment by a Pentagram admirer. On a trip to Europe in the mid-1970s, Forbes and McConnell spent some of their spare hours talking about the essential philosophy of Pentagram and what they saw as the firm's place in the design community. In particular, they found themselves mulling over a remark made by a friend and admirer of the firm, who, says John McConnell, 'told us that he thought Pentagram was the nearest thing to the Bauhaus that existed today – very flattering but patently untrue. But as we thought about and discussed it, we realized that it confirmed an attitude shared by all the partners – that what we were really interested in was teaching, and that in the commercial world there is an absolute value in being the teacher – the passer-on of information or ideas. When I got back to the office, I worked on the idea of developing some kind of publishing vehicle through which we could realize this goal and disseminate information that we thought important in one way or another. And at the following partners' meeting, I made a presentation.'

The partners were generally enthusiastic, but two critical points were stressed. The subjects covered must be of broad interest; they should never boil down to a self-serving catalog of Pentagram's own work, but rather, should make use of the innumerable interesting things and fascinating people and places encountered by the Pentagram staff in the course of their work and travels. The *Pentagram Papers* would be truly valuable only if they provided a forum for discussion or a vehicle for airing concepts and endeavors that might not otherwise find an opportunity for publication.

'So,' says McConnell, 'when we find something interesting, we invite its author to contribute a volume to the series. We don't normally pay an honorarium, but we give the author copies of the book to keep and to hand around. And of course we pay for everything else: printing, distribution, and so on. We thought at first, and even said so in our philosophical blurb, that we would publish the papers at regular intervals, but we found this too restricting. A regular

275

BELOW: A Dictionary of Graphic Clichés (Pentagram Papers 1) *was compiled by Philip Thompson and Peter Davenport.*
BOTTOM: Imprimeries Clandestines (Pentagram Papers 13) *reproduced an edition of* Le Point, *a clandestine arts and literary review published under the Nazi occupation of France, and discovered by David King in a Parisian second-hand book shop.*

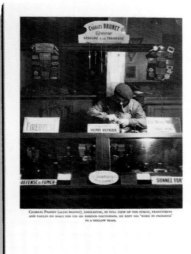

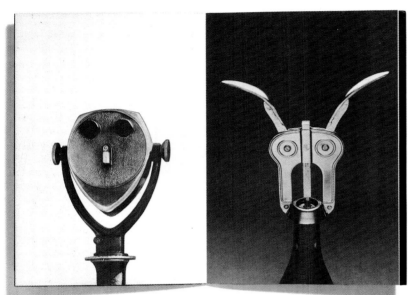

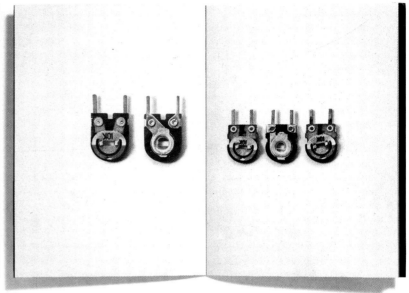

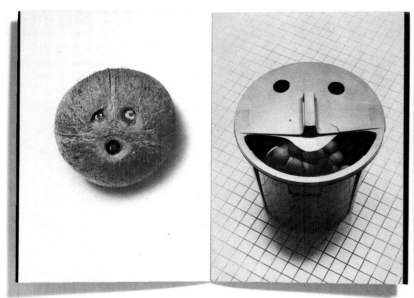

ABOVE: Face to face
(Pentagram Papers 4) *was
compiled over two years by
Jean Robert discovering
hidden faces in objects and
architecture. Paradoxically
the faces sometimes take over
and the object becomes hard
to identify.*
OPPOSITE: Brushes and
Brooms (Pentagram
Papers 3) *was taken from
an extraordinary collection
belonging to Lou Klein.*

13

order to relieve the strain of night driving. These vast highways would bypass cities and towns, which would be linked into the system by feeder highways, some as many as twelve lanes across. Although Bel Geddes worked out this transcontinental system in intricate detail and provided the Thompson agency with renderings, maps, and, in some instances, actual plans for construction, he and his staff concentrated most of their effort on solving the urban traffic problem. After all, the typical motorist in New York City could expect to travel no faster than his grandfather had done with a horse and buggy.

It was William Day who on November 12, in conference, offered the solution which continued to intrigue Bel Geddes for several weeks. "The simplest method of eliminating cars in New York City or elsewhere," he suggested, "would be to pass a law prohibiting private ownership." While such a measure would obviously have worked, he concluded that it "would not make a good ad…because it tends too much toward the socialistic." Not only did Americans value their newly attained mobility too dearly, but the executives of Shell Oil could hardly have been expected to approve an idea which would cut into their gasoline sales. Bel Geddes, on the other hand, admired simplicity if it could be had on a grand enough scale. Refining Day's hastily withdrawn idea a bit, he suggested placing a "huge city-owned parking terminal on the edge of the city," from which office workers and shoppers would commute in vans carrying from twelve to fifteen passengers.

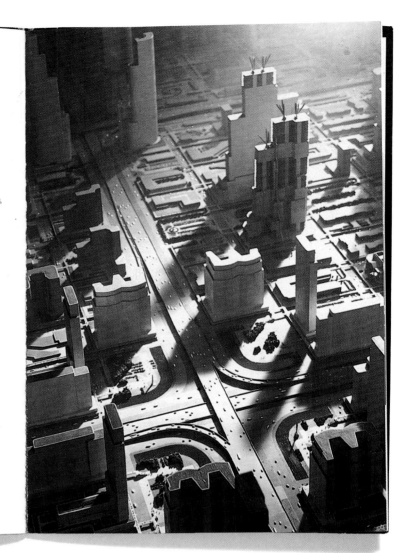

The City of Tomorrow, circa 1960, with a high-speed expressway intersection and pedestrian bridges at local street intersections clearly visible.

The Ionic Order. (half inch scale).
By strictly aesthetic proportional standards, this column is short, the entablature is large, the cornice is very large. Alberti says — the most expert artists among the ancients were of the opinion that an edifice was like an animal, so that in the formation of it we ought to imitate nature'. He then gives an example to illustrate the difference in the parts or members

Quarter F.S. Details of Ionic Capital.

F.S. Eye of Volute

Base.

schedule would have tended to inhibit us from concentrating on other things of genuine originality and interest, and might have tempted us to start dragging in mediocre material to make our deadlines. Initially we asked for subscriptions. We charged £1 a copy and got people to sign up for three years. But in the end we found the cost of administering the subscription list outweighed the revenues received, so we discontinued this. Now, we circulate the books to friends of the firm, staff and their families, clients, other consultants, architects, schools, libraries, and so on. Our print run is about four thousand, and we probably send out up to three thousand copies to people on our mailing list. The rest are kept and distributed by our three offices in London, New York, and San Francisco.'

McConnell has directed the operation from the outset. 'There's a very simple process that works here,' he says. 'If you produce an idea that the other partners like, they say, "Go ahead and do it!" So what you do is find nights, weekends, and spare time to make it a reality. But you're not let off the hook in helping run the business – you do that as well.'

'It is the extreme diversity of content within the repetitive precision of the format that has given *Pentagram Papers* their strong identity and prevented them from becoming a bore,' says Colin Forbes, who can justly claim joint credit with McConnell for the initial inspiration. 'We have been able to pick out things that deserve to be aired but which can't quite find the appropriate communication channel anywhere else, and sometimes develop them to the point where they become commercially viable and are taken up by a major publisher.'

Designers are famous (or notorious) for witty or offbeat Christmas cards and handsome design monographs, and major corporations sometimes afford themselves the luxury of sponsoring apparently philanthropically published collections of sporting prints or watercolors. But an in-depth publishing program produced by a moderately sized design firm, dealing objectively with the ideas, events, issues and visual memorabilia of design, is surely exceptional. Both John McConnell and Colin Forbes confirm that the feedback from *Pentagram Papers* has been extraordinary, positive and, vastly exceeding original expectations, has gone well beyond expressions of admiration from longstanding clients or professional peers, to lead to new commissions of impressive scope.

Refreshingly, no one at Pentagram affects a totally disinterested posture, or pretends to motives that are entirely pure. '*Pentagram Papers* are a clear statement of what we wanted to do,' says McConnell, 'but we recognized that to be associated with teachers, academics and intellectuals would put us in a very positive commercial position, especially as there can be no question of an 'ivory tower' approach, for Pentagram is a sophisticated, sizeable design firm with an active international practice.'

Not only has the venture reaped rewards in commercial terms; it has also contributed something of genuine significance to the design community in the checkered, fashion-dominated declining years of the twentieth century. Without pontificating and only rarely approaching the precious, *Pentagram Papers* have communicated some of the enduring values derived from the intellectual underpinnings of design.

ABOVE: Kingswalden Notes (Pentagram Papers 16) *is Classical architect Quinlan Terry's journal recording the design and building of Kings Walden Bury, a house in Hertfordshire by Raymond Erith, Terry's mentor.*
OPPOSITE TOP: City of tomorrow: model 1937 (Pentagram Papers 11) *by Norman Bel Geddes was originally commissioned by Shell for an advertising campaign. It is an apt summary of the futuristic designer's ever optimistic vision.*
OPPOSITE BOTTOM: 1211 North LaSalle (Pentagram Papers 10) *is a step-by-step record by François Robert of the transformation entirely by paint of a Chicago apartment building under the direction of the master of* trompe l'oeil, *Richard Haas.*

Pentagram's annual greetings booklets are intended to provide diversions in the less busy moments of the Christmas and New Year season.

Partner, Alan Fletcher

Partner, John McConnell

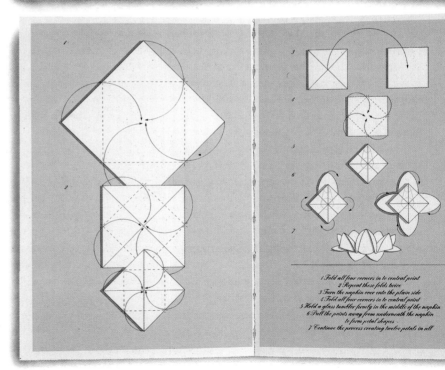

⑥

Re-arrange two matches
to make
six squares

Déplace deux allumettes
et recompose
six carrés

Verschiebe zwei Zündhölzer
so dass sich
sechs Quadrate ergeben

Partner, John McConnell

Year of the Dog

犬

The attentive, faithful Dog is one of
the most likeable personalities in the
Chinese horoscope. Plain dealing and
straight talking are the hallmarks of this
good natured creature. The noble Dog is
universally trusted, and has every reason
to be happy. In reality, though, an innate
streak of pessimism makes for endless,
unnecessary worry.

Dogs care more for justice than wealth,
and they need to find social value in
their work. They are most at home as
counsellors, psychologists or priests.
Dogs make good, if reluctant, leaders
but are not cynical enough for the
business world. Nevertheless, they have
a curious knack of finding money when
they need it.

Not surprisingly, Dogs prefer long
lasting relationships to casual affairs.
They are protective and affectionate
lovers, but are tiresomely prone to
jealous anxiety. And a word of warning.
If their trust is betrayed, these gentle
creatures can turn quite ferocious.

The symbol of
the famous
recording
company.

Partner, Mervyn Kurlansky

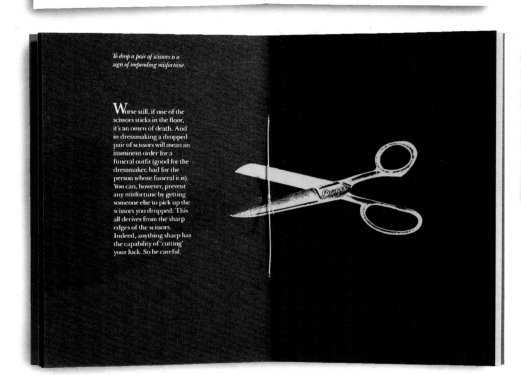

To drop a pair of scissors is a
sign of impending misfortune.

Worse still, if one of the
scissors sticks in the floor,
it's an omen of death. And
in dressmaking a dropped
pair of scissors will mean an
imminent order for a
funeral outfit (good for the
dressmaker, bad for the
person whose funeral it is).
You can, however, prevent
any misfortune by getting
someone else to pick up the
scissors you dropped. This
all derives from the sharp
edges of the scissors.
Indeed, anything sharp has
the capability of 'cutting'
your luck. So be careful.

Partner, John Rushworth

Out of thin air

The partners have the freedom to indulge themselves in design for its own sake. Uncommissioned, original ideas flow without inhibition – often becoming commercially successful.

Designers traditionally describe themselves as problem-solvers. A client will come to them with a project that requires some sort of design solution, and the designer will analyze the problem and then proceed to solve it. However, it is often the case that the designer may create his or her own project and become a problem-maker.

Designers may write books, create a product, even initiate and manage conferences and symposiums, or start private companies. They switch hats and solve their own problems. The designers will create these projects out of thin air, for their own amusement, mostly because they have a personal passion for them. And personal projects are often the best problems to solve.

PAULA SCHER

LEFT: *While playing with photographic ideas for record covers, although none in particular, Peter Saville and the photographer Trevor Key developed what they call the 'dichromat' process, a kind of photographic silk-screening technique. Images have been produced for the sheer fun of it, and have been used in exhibitions and magazines – some have actually made it on to record covers.*
RIGHT: *The calendar* Another Blooming Year *was based on the idea of punning the names of flowers in their images. It was produced speculatively and taken by the Conran Shop in London.*
Partner, John Rushworth

May

Tuesday	Wednesday	Thursday	Friday	Saturday	Sunday	Monday	Tuesday	Wednesday	Thursday	Friday	Saturday	Sunday	Monday	Tuesday	Wednesday
1	2	3	4	5	6	7	8	9	10	11	12	13	14	15	16

Thursday	Friday	Saturday	Sunday	Monday	Tuesday	Wednesday	Thursday	Friday	Saturday	Sunday	Monday	Tuesday	Wednesday	Thursday
17	18	19	20	21	22	23	24	25	26	27	28	29	30	31

Tulips bloom from April to May

Paula Scher wrote and designed The Honeymoon, *a pot-pourri of honeymoon facts and lore. The book was intended as a wedding gift and was published in 1980.*

284

The idea for The Vegetable Book *was hatched on a plane during a conversation between Kit Hinrichs, photographer Tom Tracy, and writer Delphine Hirasuna. The book that emerged was based on four aspects of vegetables: California as the prime American growing region, history and lore, photographs, and recipes. The book was published by Chronicle Books, USA.*

Produced to raise funds for the AIGA, Stars and Stripes *is a compilation of contemporary interpretations of the US flag by ninety-six artists, designers and photographers.*
Partner, Kit Hinrichs

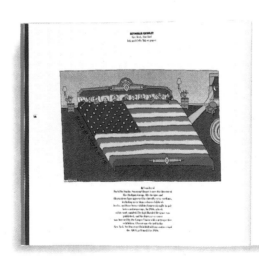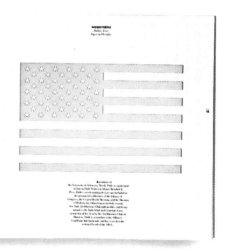

INDULGING OURSELVES

It is an argument that designers are artists who take orders to produce original-looking artefacts – or is it that designers are ordered to render their art makeable in large numbers while the artist works on one piece at a time? Or perhaps the artist selfishly chooses what to make and so may never sell any output because no patron shares the same view? This is arguably an indulgence – a selfish satisfaction of his or her own private interest. It is not limited to creators who use canvas or stone: it is equally indulgent endlessly to invent new processes or devices, and particularly so when the designer decides for him or herself to spend energy and time devising a new artefact whose prime reward is seeing it transformed from idea to working object.

My talented partner, Alan Fletcher, has emerged as a master of selling his indulgences to the benefit of Pentagram. For instance, on a regular basis sponsored by a printer, he designs a calendar. Alan chooses the ideas behind the images. He experiments with the technique and makes witty, attractive images. We all benefit: the printer who poses as the patron, his client, our friends, and my partners.

At another level of investment we have the ShowerAge – an ugly but understandable name for a shower for the elderly which was spawned by a competition to design an object useful for us as we become older. We decided to examine the problems around bathing for old people, the bathroom and in particular the bath.

This witless invention is still being installed by thoughtless builders and architects in Britain, without regard to the hazards of getting in and out of it. The real risk of injury is obvious from a cursory look at its features: a handle on one side but not on the other, and a smooth and slippery edge on which a soapy hand will rest the full body weight of its owner. Yet the sensible shower is mistrusted by the majority of the bathing British! Baths may be hazardous, but they are warm, comforting and womb-like. How then to make the sensible shower warm and comfortable and take the bath's place?

We can start by arranging a seating facility, by providing reassuringly non-slip flooring and by ensuring that the

active water cannot change its mind and go from warm to scalding. But how can a household be persuaded to move from bath to shower when young and old should share the same facility? The ShowerAge has a seat, a water control to fix before you get in, a real grip floor and many other devices, each one adding intelligently until the whole suits young and old. A universal product is thus evolved, taking as its focus the need highlighted by the elderly, and yet not a mere sop to the geriatric. A new product is created from old systems: a handle here, a control there – not an invention, but an assembly of easements and a surprise at the end.

KENNETH GRANGE

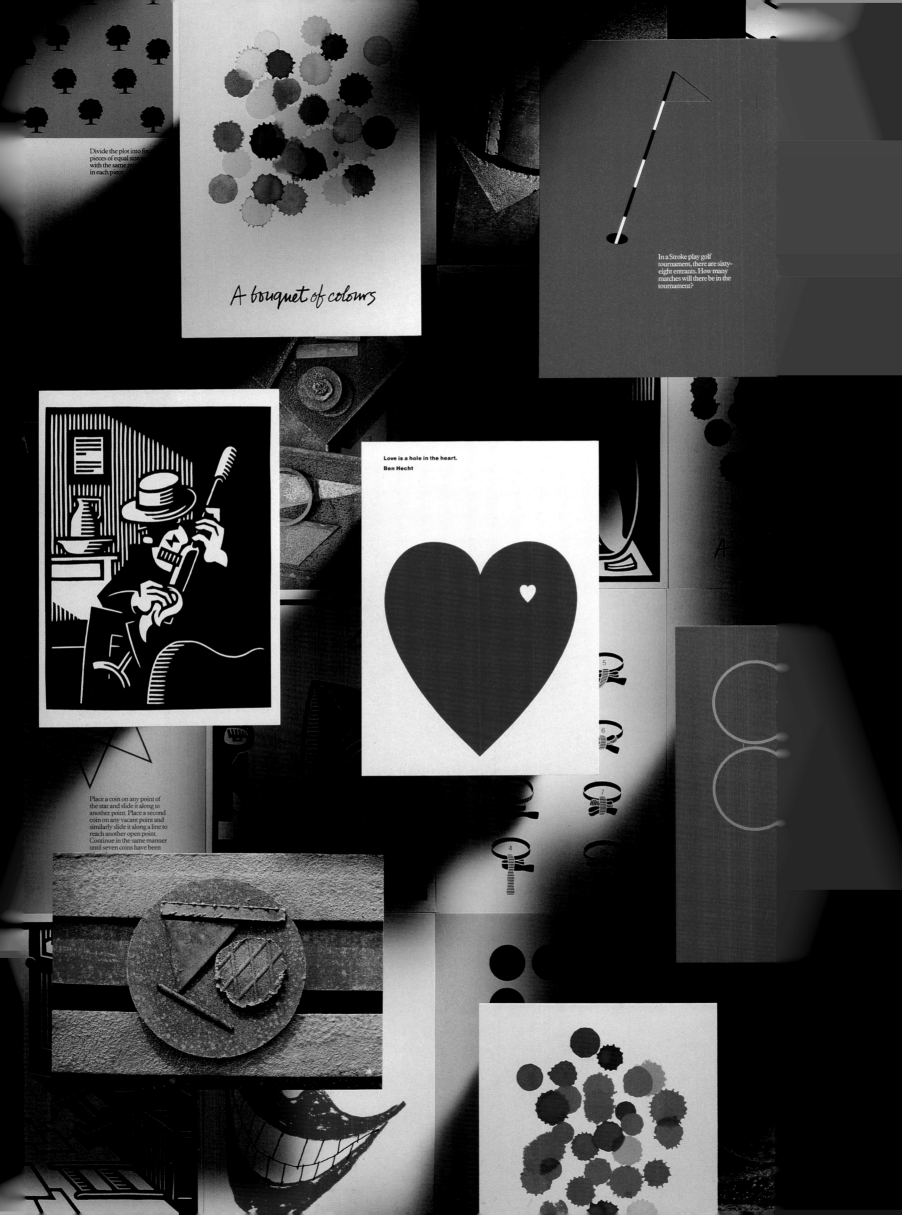

Divide the plot into four pieces of equal size with the same number in each piece.

A bouquet of colours

In a Stroke play golf tournament, there are sixty-eight entrants. How many matches will there be in the tournament?

Love is a hole in the heart.
Ben Hecht

Place a coin on any point of the star and slide it along to another point. Place a second coin on any vacant point and similarly slide it along a line to reach another open point. Continue in the same manner until seven coins have been

OUN: A DESIGN VENTURE

Started in Tokyo in 1986, OUN described itself a 'a design venture that is in a very real sense both a business and a philosophy'. The ambition was to make new design products, to act as intermediary between Japanese corporations and the international design scene, to create a design magazine, and to begin a design school.

The concept was initiated by Suntory Corporation and Tak Igarashi, a distinguished Japanese designer. As the design consultant in Japan, he proposed that OUN appoint myself and Massimo Vignelli to create an international advisory board – a combination which introduced OUN directly to the global design fraternity, and in turn to their contacts with craftsmen and manufacturers, distributors and specialist retail outlets.

The first task of the consultants was to recommend a product line. This, it was decided, would include classics no longer manufactured but worthy of revival, improvements to existing items, and totally new designs. Because between them they knew virtually every designer and design-related business in the world, the OUN Collection was rapidly put together. The consultants were also able to accelerate matters by designing a core product line, dividing up the market potential between them. Tak designed a table and travelling clock, Massimo produced pens and desk accessories, and Pentagram concentrated on an extensive upmarket retail stationery programme.

Building on this international design network, OUN moved into the second phase to put Japanese clients together with prestigious designers. This rapidly created them a reputation among the national business community, and soon resulted in a large number of commissions. Some of these included further designs by Pentagram: Kenneth Grange's heating and cooking equipment for the Osaka Gas Company, and Colin Forbes' corporate identities for Kubota, a manufacturer of agricultural tractors, and the Hotel Hankyu International in Osaka.

Business is motivated by profit, and since this is the margin between cost and sales, it can only be achieved dramatically by making the product more desirable. The most effective and most economical way to do this is by better design – at least that's OUN's theory.
ALAN FLETCHER

ABOVE LEFT: *Boxes of Japanese woods contain various notepads.*
Partner, Alan Fletcher
ABOVE: *Perhaps the most expensive electric pencil sharpener in the world was originally produced in a limited edition as a corporate gift for Dentsu. It was then taken on by OUN.*
Partner, Kenneth Grange

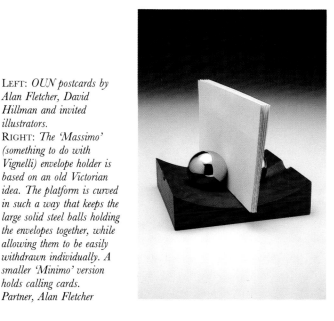

LEFT: *OUN postcards by Alan Fletcher, David Hillman and invited illustrators.*
RIGHT: *The 'Massimo' (something to do with Vignelli) envelope holder is based on an old Victorian idea. The platform is curved in such a way that keeps the large solid steel balls holding the envelopes together, while allowing them to be easily withdrawn individually. A smaller 'Minimo' version holds calling cards.*
Partner, Alan Fletcher

288

Alan Fletcher's London home originally had electrically operated cast-iron main gates, which kept jamming because the gateposts were not properly bedded. In order to re-bed the posts the gates had to be taken off – and they disappeared one night (on to the back of a lorry).

The insurance quote to replace the Victorian ironwork came to the same as having new gates made to Alan Fletcher's own alphabet design. The letters are based on an old condensed wood typeface discovered in a type book belonging to David Hillman. Pedro Guedes helped turn the design into reality. The letters are held together by the hinge straps; the tail of the Q acts as the gate-stop.

Puzzlegrams, Pentagams, and Phantasmagrams (Pentamagic in the USA) were compiled by David Hillman from research and various Pentagram partners' own collections of fascinating visual ideas. They were published respectively in 1989, 1990 and 1992 by Barrie and Jenkins/The Ebury Press in the UK, and Simon and Schuster (Fireside Books) in the USA.

Distinguishing features

At their regular weekends, partners put on a pose for collective portraits. Individually they become more accessible when characterized by their own foibles and obsessions.

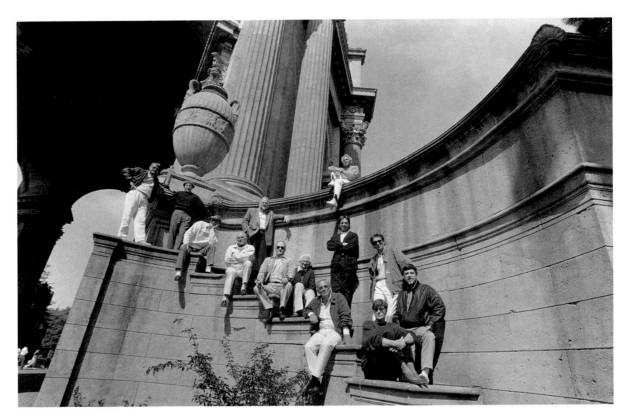

THE PARTNERS' WEEKEND FAMILY PORTRAITS

I have taken a family portrait of almost every Pentagram partners' meeting for twelve years. It is a somewhat compulsive exercise, which I enjoy, partly because I am recording a little history and partly because I have always loved photos of family groups. Of course, being a partner at Pentagram puts this particular family very close to my heart.

For me, there is something engagingly vulnerable about the eyes and body language of each person in group pictures which says, 'I know the camera does not lie – so what will it say about me this time?' It is the same with my partners; they tend to be a little vulnerable and unruly during the event and relieved and pleased when they finally get to see the picture – which, of course, can take anything up to six months.

PETER HARRISON

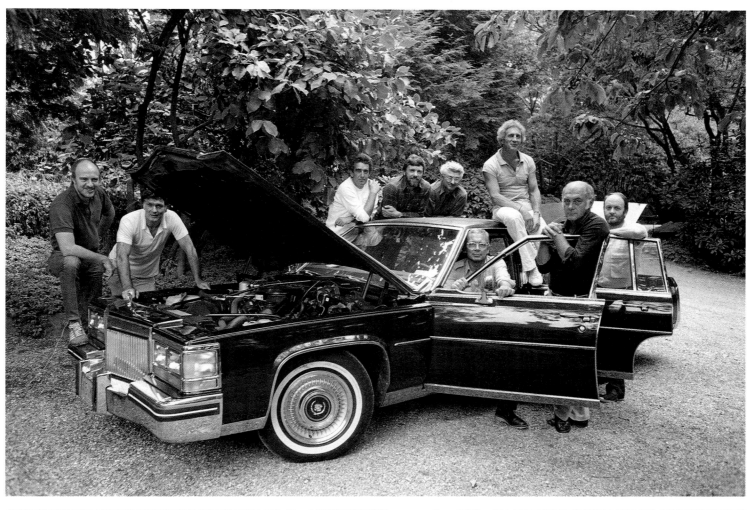

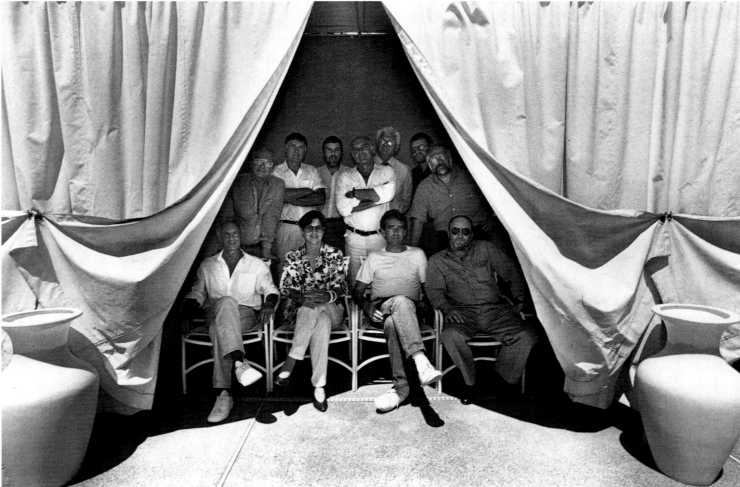

OPPOSITE: *Palace of Fine Arts, San Francisco, California, December 1989*
TOP: *Morefar, Connecticut, May 1980*
ABOVE: *Sonoma Mission, California, June 1986*

292

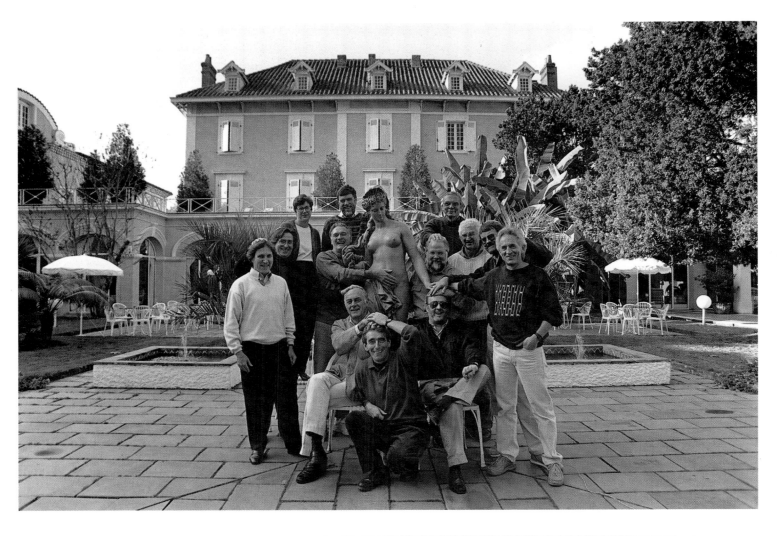

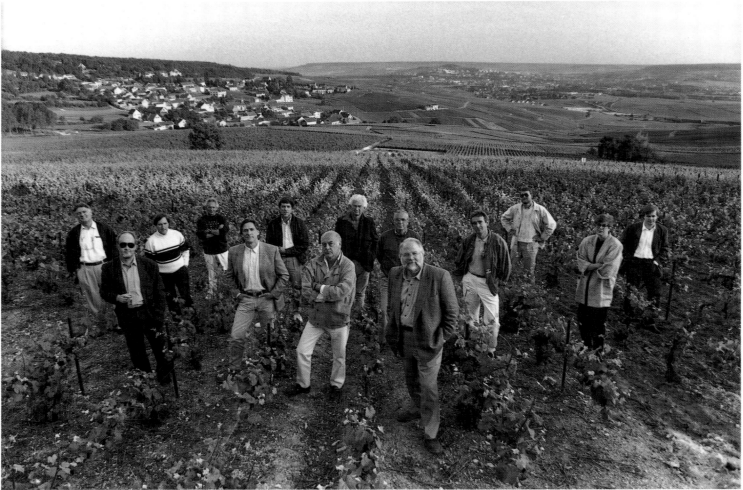

TOP: *Eugénie-les-Bains, France, November 1988*
ABOVE: *Epernay, France, May 1990*

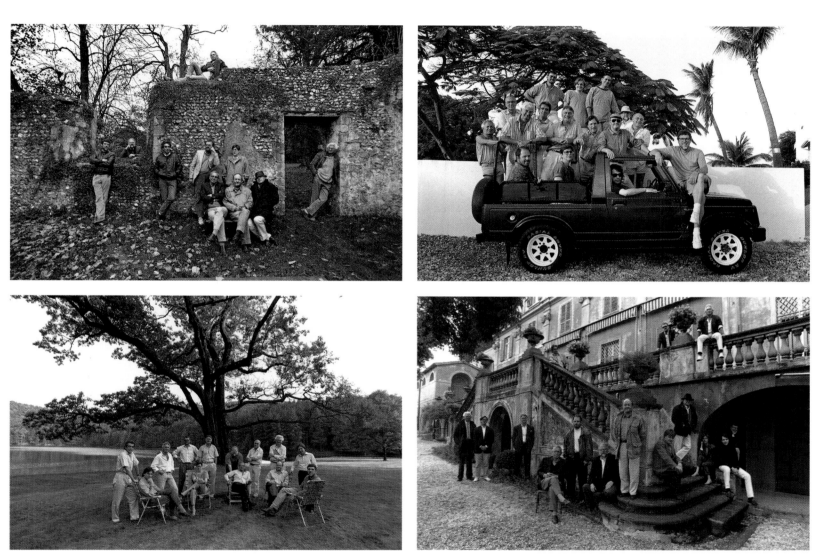

TOP LEFT: *Lainsten House, England, November 1986*
ABOVE LEFT: *Avril Harriman's House, New York, May 1988*
TOP: *Antigua, December 1990*
ABOVE: *Villa Aurelia, Rome, Italy, May 1991*

Designers are held to be obsessive people. This is usually the judgement of outsiders who see obsessiveness where the designer sees mere commitment. The partners' own accounts of their obsessions distinguish them as personalities rather than designers.

Caricatures by Alan Fletcher, mainly drawn when distracted from the proceedings at partners' weekends.

294

COLIN FORBES
NEW YORK

In 1968 my wife Wendy and I bought a house with ten bedrooms, eight bathrooms, two cottages, a coach house and various farm buildings, all in various stages of dereliction. We occupied two bedrooms in one wing of the house and survived winter weekends with totally inadequate heating and the children having to bathe standing in a bowl. We employed whatever casual labor we could afford, clearing twenty years of neglect in the gardens, taking up floorboards and removing panelling to assess the scope of work still to come.

We converted the third story into a self-contained apartment with a kitchen, a children's bedroom, and bathroom in addition to a living room with an open balcony to the clock tower and the visible oak timbers of the main roof. These quarters were completely above and separate from the exposed walls, broken floorboards, debris and, most important, dust below. We lived like this for three or four years while we installed central heating and new footings for the rotted posts. We exposed wall structures, floors and ceilings for the endless five-gallon drums of wood preservative that had to be sprayed to stop the spread of woodworm and deathwatch beetle.

With a specialist stainer we stripped multiple coats of badly applied varnish off the oak paneling and two historic Jacobean fireplaces. These were eventually repaired and French-polished. We brought flagstones to improve the broken floor in the kitchen. Gradually we worked our way down and conquered large areas of the house. In a way it was the best of times, always with anticipation of the change and still the charm of the derelict old house we had fallen in love with. Albeit living with ever-increasing comfort and style, we were still working constantly after ten years. I had experienced and learned for myself, rather than reading about others' experiences, that one needs passion, that

to go completely against the conventional economic wisdom and to have a desire to do things right can, by coincidence, even bring economic reward. It was extremely painful when we had to sell the house; but in an ironic way, because the house was virtually finished, some of our interest was already gone. We left for America with capital. We were still painting the front of the house after we had closed the deal but we made sure to finish that final coat.

WOODY PIRTLE
NEW YORK

I'm obsessed with collections. Each time I discover that I have acquired more than two or three of almost any interesting 'thing' I realize that I have the genesis of a new collection. It started when I was a young boy collecting trading cards, and has evolved into a 'collection of collections' including the following: antique tins, matchbooks, fountain pens, mechanical pencils, farm implements, corkscrews, masks, American Indian pottery, rubber stamps, antique clocks, whirligigs, and much more. The list goes on and on. What's interesting is how frequently an obscure detail from any one of these 'things' finds its way into the solution to a design problem or, ironically, how often the search for a unique or interesting design element leads to the beginning of yet another collection.

LOWELL WILLIAMS
SAN FRANCISCO

Design for me is driven by passion – ask my clients. The more passionate they are about what they're trying to do, the more driven I am. Absolutely nothing has greater impact on my work, not message, not budget, not schedule – nothing. When the attitude is 'This matters', I know the client's putting responsibility on me and expecting creativity from me. That's all it takes; I'm hooked, I'm theirs. Without this, I don't want any part of it, because there's no common ground for us. Let me dig around and find what they care about, what's in their gut, and I'll translate that into something uniquely expressive to them and their audience and to me and mine. That's my passion.

DAVID HILLMAN
LONDON

I'm obsessed with success. That means I am fascinated by other people's success. And I am very unhappy until I have succeeded myself – in solving a design problem, in painting a room, in finding a new pair of shoes. Success has its own standards; the more you try to succeed, the higher the standards become.

KENNETH GRANGE
LONDON

Obsession is too strong a word, but I have a serious enthusiasm for my workshop.

It is a plaything where every single tool has its own dedicated home – indeed, a discipline I have is to give a home to every new tool I buy before I allow myself to use it. My justification is that I have very little time to spare and, therefore, I am never frustrated by looking for a tool and hindering the repair or whatever I am making for which I always allow myself too little time.

It is a place where I feel comfortable; every guest to the house is treated to a visit. I suppose the truth is that I feel it is more comfortable than any sumptuously furnished living space I know.

JAMES BIBER
NEW YORK

It may be said that the architect is obsessed with (in architectural parlance) the 'plan' while the rest of the world cares only about the 'elevation'. The image conjured up is that of the architect poring over plans, immersed in an arcane view of the world, while everyone else, walking erect, has no trouble understanding the world without even thinking about that 'other dimension'. The only link between these two views is, of course, the map. The road map, the city plan, the topographic survey, et al, are the layman's insight into the world as it is organized in the plan dimension. My obsession is that link. Maps provide, to me, a view of relationships, a sense of proximity, a study of geometry, and a survey of the art of drawing. The agenda of the map-maker, even a culture, is beautifully expressed in the map.

Nolli's magnificent 1748 map of Rome depicts the world as solid and void, public and private, city and country. Late nineteenth-century puzzle maps of the United States treat the states as thoroughly independent entities joined by boundaries. Baedeker's turn-of-the-century travel guides provided the most thorough, comprehensive, beautiful, and intelligent maps available to a new breed of travellers. Modern road maps produced by the oil industry for gas station distribution attempt to influence the public with the omission of mass transit and train lines. A child's map of the neighborhood is also a map of his psyche.

When we 'read' a map we can, in the right circumstance, get closer to a distant place or understand the layers of history. Like a painting or a book it is, at its best, an artful combination of opinion and fact, of idea and data, of form and content. I have used maps in my work as the inspiration for a series of tables based on the shapes of the fifty states; as a permanent map in the floor of a public reception lobby; and for a whole variety of both subtle and obvious details. They continue to be an obsession both as collectable objects of art and as inspirational views of the universe.

PETER SAVILLE
LONDON

Any and every desire becomes an obsession for me. Eventually realized it will either diminish rapidly in importance (why did I bother?) or become a total indulgence that I can hardly justify even to myself. Obsessiveness always seems to take me a little too far – my attention to detail becomes 'neurotic', the pleasure of just looking becomes voyeuristic and the tendency towards reduction ends in a void.

NEIL SHAKERY
SAN FRANCISCO

I don't know if this amounts to an obsession, but I love old group photographs. When I was a kid, my mother used to get out the family photographs which we kept in a shoebox and show them to me, carefully explaining who each relative was and when and where they were taken.

Our family had an old box camera tucked away in the cupboard and on very special occasions it was dug out and dusted off, and after checking the little red window to see if there was any film left, we would take a couple of photos, never more, usually of a group of us standing in front of something, and then the camera would be put away until the next very special occasion.

During the war, I don't think you could buy film in England and we nursed what was in the camera until the war was over, so there aren't very many photos of me from the age of four through ten. Maybe for this reason photographs took on a sort of preciousness to me.

About fifteen years ago I bought an old photograph at a flea market, sixty old guys sitting on a verandah taken in Rochester, New York, around 1915. I wasn't quite sure why I wanted it, but it fascinated me. I could look at it over and over again and each time I would see something different or find someone I'd never noticed before. I'd wonder who the people were and what they were thinking when the shutter clicked.

Since then I've collected dozens of these groups: rugby teams, firemen, soldiers, graduating classes, masons, schoolchildren, people on company picnics. I have a big bunch of them hanging on my living-room wall. People come in and ask if they're all my relations.

296

PAULA SCHER
NEW YORK

For as long as I can remember I've been obsessed with making jokes. I've been told that humor is a form of hostility, or a method of relieving tension. Regardless of this, I've always felt the need to point out the absurd, punch holes in pomposity and generally disrupt all solemnity.

I confess that I often do it when it is not requested or appreciated; I can't seem to contain myself. The act is involuntary, but it is my way of giving.

THEO CROSBY
LONDON

My obsession with sculpture began at seventeen, a year or two after going to university. It arose, I suppose, out of a prolonged love affair with Le Corbusier, a man of many dimensions: architect, sculptor, poet, and polemicist. One wanted to be like that.

When I came to London in 1947 I went to art schools by night: the Cass, the Central, and finally St Martins. I set up a studio and I still work in it at every spare moment. Sculpture has led me to the problems and joys of public art, and to much involvement with art, artists, and art organizations.

There are now a great many artists, expensively trained and often highly skilled, who could make our lives richer, warmer, and more pleasant. They seldom work in public places, for the current styles preclude the arts and crafts from a share in the productive or constructive process. Our environment therefore becomes steadily worse (as we all know, without quite knowing why). Where are those new places to which we can make pilgrimages? Where is the current equivalent of a comfortable nineteenth-century city, like Parma or even Manchester?

It is clear that we have much to do, to change the world, to re-educate ourselves, to make beautiful, secure, lively cities that are new. We discovered (in about 1964) the value of the past, at the very moment it was poised to disappear. Now it is museum-ized, commercialized, and the vital connections are hard to make under the blanket of the heritage business. Yet art has always provided the key to continuity and change, so we should begin by encouraging and incorporating painting and sculpture in our buildings. They add a dimension of humanity, myth, narrative, and scale to involve and console the visitor – which is, and has been for centuries, the function of the artist.

There can be few urban problems that would not be solved by a statue of a fat lady. Now there's a nice little obsession.

MICHAEL BIERUT
NEW YORK

My obsession is particularly shameful. As Peter Sellers said in the filmed version of Jerzy Kozinski's Being There, *'I like to watch.'*

I envy the pioneers of design, who entered the field when it was all uncharted wilderness. I envy designers I know who can work in splendid isolation, blissfully unaware of design history and the fads of the moment. Me, I like to watch. I like to watch my colleagues. I like to watch their work. I am an insatiable glutton for design, for magazines about design, for books, for lectures. I am a compulsive collector of design, for rare pieces unearthed in musty bookstores, and for the latest trendy thing I can fish out of my partners' trashcans.

I'm not proud of this. Being an excellent mimic makes things worse. Like another character from the movies, Woody Allen's Zelig, I'm unmistakably influenced by what I see around me. Being surrounded by the likes of my brilliant partners is almost unbearable. I hope that by confessing publicly I can change my ways. I doubt I will.

KIT HINRICHS
SAN FRANCISCO

I have a particular obsession with discovering the many different ways a single object can be visually interpreted. I've expressed this fascination in many forms from the obvious to the obtuse, whether a series of 'pencils' for Art Center Review *to 'faces' on the covers of* Skald *magazine. While I'm exploring a subject, it slips into my work appearing in illustrations, photos, and graphics. Hands, for example, may be depicted holding, gripping, clinched, or caressing.*

My lifelong obsession, however, is with the Stars and Stripes. This began with a family heirloom hand-sewn by my great-great-great aunt in 1866 and has continued through Desert Storm memorabilia. The way Americans interpret their national symbol provides an interesting view of the country's character. My collection now includes nearly six hundred flags in forms of quilts, Navajo weavings, paintings, assemblages, typographic ornaments, postcards, posters, sheet music, books, spoons, knives, cups, plates, cookie tins, edibles, ice cream molds, pins, belts, buckles, tin toys, lead soldiers, pin cushions, pencil cases, cigar boxes, war medals, battery cases, radiator caps, bumper stickers, political memorabilia, and, of course, traditional banners. Over the years, I've haunted antique shops, begged, borrowed, inherited and found flags to 'feed' my obsession – now so widely known that friends continually provide wonderful additions to my collection. My drive is so extreme that I even organized an exhibition, enlisting ninety-six designers and illustrators to do interpretations of the American flag, which were sold at a fund-raising auction and published in a book for the American Institute of Graphic Arts.

MERVYN KURLANSKY
LONDON

I am an indiscriminate collector of ephemera and junk. I have boxes and drawers full of old maps, matches, hotel soaps, travel tickets, playing cards, cigar boxes, carrier bags, badges. My collection is totally random; it goes back years and is drawn from all over the world. There is no rationale; just hundreds of arbitrary fragments stored with no real purpose in mind. Yet the drawers and boxes which house this chaotic image-bank are all carefully numbered and indexed.

When I am working on a design job, I collect seemingly random pieces of information but there is a point when I suddenly make order out of chaos, when I restrain and control diverse elements to create the design. My indiscriminate collection works like that too. I will pull out a found object randomly from a drawer and it will trigger the solution to a complex design problem. Sometimes it is precisely the object I am looking for, its image recorded indelibly in my mind by the long-forgotten act of adding it to my collection. Sometimes it is an object I simply stray across while searching for something else, yet it becomes the catalyst for a creative response. So is there a hidden mental logic in my relentless collecting? Or am I just a magpie who can't bear to chuck anything away?

PETER HARRISON
NEW YORK

For my eleventh birthday my father gave me my first camera: an Ensign Fulvue! I was instantly besotted with photography and rushed out to take pictures of my brother riding his Rudge bicycle. Although they came back from the chemist blurred and out of focus, I was hooked for life.

Without a doubt had I not become a designer I would have become a photographer. Why this particular obsession? Because it is magic: an alchemy of stealing light and putting it on a piece of paper – much better than turning lead into gold because here is a way to stop a moment in time.

What truly fascinates me is how the photograph changes over time. When it is taken it is one thing, but ten or twenty or a hundred years later it becomes something quite different. The picture has its own life and character which is modified by the passage of time. A photograph may or may not be art, but for me almost any photo will have this curious time-warp quality.

This obsession pursues me to this day. I am still constantly insisting that my friends and family and particularly my partners stand still for just one more please. And I keep every negative. I still have those pictures of my brother on his Rudge. Maybe one day I will print them all!

JOHN RUSHWORTH
LONDON

Posters turned me on to graphic design in the first place. They remain my passion. I love the size; you can't do bigger graphics. I love the art; it's self-contained, a single, pure note, not a chorus or cacophony. Of course I collect them – hundreds and hundreds. The greatest are from the 1930s and '40s, the golden age of the poster artist – before the art director and advertising team took over. Yet posters that are created as a personal interpretation rather than a managed process are still produced, and I continue to admire and collect them. I'm grateful to posters for seducing me into the work I do. To repay the debt (and indulge my passion) I try to manoeuvre every project I take on so that I can get a poster out of it. Even if the client won't pay for it, I may do it anyway.

297

JOHN MCCONNELL
LONDON

Looking for the perfect dovetail.

ALAN FLETCHER
LONDON

I feel that the good company of a fellow designer at a restaurant needs something to mark the occasion. So, over the last bottle of wine, when the eating is over, talk at its best and artistic inhibitions reduced, I ask for a drawing on a serviette. I've been doing this for years – I have over a hundred: a personal collection of wild graffiti from the world's leading designers.

Alan Fletcher by Milton Glaser. Finger and burgundy on linen. A New York restaurant, 1989.

Index

298 Page numbers in *italic* refer to the illustrations and captions

A

Acqua Marcia *204*
Adams, Ansel *156*
Advanced Surgical *137*
Airplane *137*
Al Fouk Foundation *138*
Album magazine *141*
Aldersey-Williams, Hugh 23
Allen Lane 135
Alley Theatre, Houston *249*
alphabets 66-9, *66-9*
Ambassador Art *225*
American Center for Design *260*
American Export Lines *18*
American Institute of Graphic Arts (AIGA) 22, *22*, 78, *260, 262, 263, 266, 284*
American Presidents Lines *185*
Amis, Kingsley 12
analogies 72, *72, 92-9*
Ancient Near East Galleries, Metropolitan Museum of Art 252, *252*
Andersen, Arthur *138, 141*
André Deutsch *159*
annual greetings booklets *280-1*
annual reports 174-7, *174, 177-8, 180*
Anzai, Shigeo *248*
Apollinaire, Guillaume 69
Applied Graphics printers *26, 185*
Arcadia Partners *179*
Archer, Bruce 100, 110
Architectural Foundation of San Francisco *137*
Architectural League of New York 76, *266*
architecture 56-65, *56-65, 106*, 216-21, *216-21*
Arnoldi, Per *262*
art, relation to design 242
Art Center Review 192
Art Directors Club of Tampa, Florida *109*
Article 19 *138*
Arts Council 58, *250*, 269
Arup Associates *149*
Asea Brown Boveri *141*
Atheneum Hotel, Detroit *141, 230*
Audit Bureau of Circulations (ABC) *125*
Audubon magazine *190*
Auster, Paul *153, 155*
Avon Books *72*

B

B & W loudspeaker systems *202*
Bailey, Dennis *56-9*
Barnet Center, Jacksonville *144*
Barraud, Francis 135
Barret, Serge 18
Barrie and Jenkins *288*
Barthes, Roland 136
Bass & Co. 134
Bauhaus 59, *275*
Beatles 12, *12*
Beaux Arts Ball *242*
Beck, Karin *259*
Behrens, Peter 69
Bel Geddes, Norman *279*
Berendt, Jon *105*
Berger, Adri *130*
Berlewi, Henry *104*
Bertram, Simon 46
Biba *17*
Bibendum 135
Biber, James 22-3, *23, 54, 87, 95, 106, 109, 160, 228, 234, 236, 295, 295*
Bierut, Michael 22, *22, 74, 76, 78, 88, 96, 99, 157, 176, 182,* 190-1, *222, 226-8, 244, 260, 266, 266, 296, 296*
The Big Paper 138, 194
Binns, A J *45*
Blake, Peter *174*
Blaustein, John *20*
Blyton, Enid 136
Bodley, John *33*
Boltin, Lee *31*
Bonnell, Bill 266
book design 150-5, *150-9*, 272, *272-81*
Boots The Chemists *32*
Bowers, John 201, 202, *202*
Boxer, Arabella *156*
Brasch, Gerry *222*
Bright Lights *138*
British Journal of Photography 130
British Petroleum (BP) 13, *13*, 19
British Rail *201*, 202
Broadgate *149*
Brooke, Steven *157*
Brookstone *76*
Brown, Howard *32*
Brown, Patricia Leigh 19-21
Brown & Root 46
Brownjohn, Robert 266
Brownsword, Leigh *149, 256*
Bullfinch Press *156*
Burch, Harold *177, 178, 185*
Burgee, John *39*
Burns, Martha *138*
Buro Happold *62*
Business magazine *190*

C

calendars *13, 26-8,* 182, *182-7, 228, 282, 285*
California Crafts Museum *90*
Caplan, Ralph 10-11, 100, 134, 266
Carol, Justin *121*
Carson, Bill *39, 144*
Cartier 135
Cassandre *102, 104*
CBS Records 23, *104*
Cedric Lisney Associates *141*
Center for Curatorial Studies *141*
Champion International Paper *184, 224, 226, 228*
Chase Manhattan Bank 136
Chermayeff, Ivan 266
Childsplay *141*
Ching, Donna *233*
Chirico, Giorgio de' *108*
Chronicle Books *284*
Chwast, Seymour *74*
Chrysalis Records *137*
Citroën 136
Clarks of England *33*
Classic FM *138*
Clemant, Michelle *121*
Clements, Tod *13*
clichés 72, *72, 88-91*
CND 136
Coca-Cola *129*, 134, 135
Colgate-Palmolive 136
Colordynamics *223*
Columbus Avenue, New York *54*
Commercial Bank of Kuwait *49, 141, 182, 206, 206-7*
Compass *141*
Confederation of British Industry *137*
conferences 266, *266*
Congrès International d'Architecture Moderne (CIAM) 56
Connecticut Mutual *36*
Conran Shop, London *282*
Le Corbusier 56, *149*
Corgan Associates *141*
Cornstock Inc *31*
corporate design 128-36, *128-41*
corporate publications 174-7, *174-80*
Costello, Elvis 23
Council of Fashion Designers of America *141*
Country Matters *122*
Cousins, James 42, 201, 202
Cox, Paul 155
Coyne Electrical Consultants *182*
Crafts Council *141, 250*
Craig, John *84*
Crosby, Theo 12-13, *12,* 14, *14, 15*, 17, 19, *19, 56-64,* 112-15, *115, 149,* 216-21, 269, 272, 296, *296*

Crosby/Fletcher/Forbes 13, *13*, 272
Crossroads Films *141*
Cunard 13, *15*

D

Daimler Benz *87*
Dallas Opera *138*
Davenport, Peter *275*
Davidson, Bruce *19*
Davis, Paul *240*
De Stijl 165
Deewater, Andy *77*
De Lynn, Jane *157*
Dentsu *287*
Design and Art Direction (D&AD) *102, 262, 263*
Design Council *194, 195*
design industry 260, *260-69*
Design magazine *195*
Design Museum, London *96, 108*
Designers Saturday *87*
diagrams 46, *46-7*
'dichromat' process *282*
Dinar magazine *206*
Dindisc *170*
Doblin, Jay 32, 100
Doublespace *87*
Douglas, Buster *116-19*
Dreyfuss, Henry *102*
Drucker, Peter 128
Dualux *169*
Duchamp, Marcel 102, *102*
Dunnett, Robert *146*
Dylan, Bob *102*

E

Ealing Electro-optics *137*
Eames, Charles 46, 216
Ebury Press *288*
Eden Group *88*
Editions de l'Olivier 155, *155*
Edwards, David *141*
EG&G *178*
Elektra Entertainment *141*
Empire Hotel, New York *233*
Endymion Ensemble *141*
Ericsson Information Systems *104*
Erith, Raymond *279*
Esparza, Bob *90, 260*
Eureka! Museum *137, 147*
European Photography annual *262*
Evans, Harold 265
Evans, Matthew *33*
Evans, Tony *182*
Expo 67 *12*
Expo 95 *137*
Exposure *141*

F
Faber and Faber *33*, 150, *151*, 153-4, *153*, *154*, 155, *272*
Face calendars *28-9*
faces 26, *26-31*, *276*
Factory Records *22*, *170*
Fannie Mae *105*
Farmers Dairy Co. *169*
Feedback 272, *272*
Fineline *138*
Fireworks *162*
Fitzpatrick, Julie *156*, *195*, *258*
Fletcher, Alan 12-15, *12*, *14*, *15*, *19*, *26*, *49*, 66-9, *72*, *87*, *92*, 100-1, *102*, *108*, 122, *122*, *124*, 142, *142*, *145*, *149*, *159*, *174*, 182, *182*, *186*, 204, 206, *207*, *214*, 230, *230* *242*, *266*, *280*, 285, 287, *287*, *288*, *294-7*, 297
Fletcher, Forbes and Gill 12, 14
Folon *174*
Forbes, Colin 12-23, *12-14*, *16*, *18*, *19*, 32, 46, *76*, *78*, *79*, 128-9, *230*, *233*, *250*, *263*, 265, 272, 275, 279, 287, 294, *294*
Ford, Henry *84*
Ford, Troy *180*
Ford Motor Company 265
Foreman, Michael *49*
Foshaug, Jackie *54*
Foskett, Peter *42*
Foster, Norman *145*
Fox River Paper *141*
Freeman, Robert *12*
French Revolution 128-9, *129*
Frost, Vince *169*, *194*, *250*, *269*

G
G&B Arts *186*
Galleria Colonna, Rome *141*, *204*
galleries 242, *242-53*
Gallup, George *84*
Geers Gross *122*, *174*
General Motors 135
Gericke, Michael *230*, *233*
Gibbs, David *206*
Giedion, Siegfried 60
Gilbert Paper *226*
Gill, Bob 12, *12*, 13, 14-15, *174*, *263*
Glaser, Milton *102*, *266*, *297*
Glass magazine *191*
Globe Theatre, London 56-64, *56-61*, *64-5*, *138*
Godfrey, Jason *151*
Golden Grove *138*, *159*
Goldsmith, Harvey *141*
Good Diner, New York *88*
Gorb, Peter 32
Gornall, Vicki *125*
Gotham Bar and Grill, New York *234*

Gotham Equities *137*
Graham, Diana *53*
Gran Fury 266
Grange, Kenneth 13, *13-15*, 15-16, *19*, 32-3, *35*, 42-5, *88*, *102*, 110-11, 122, *166*, *169*, 198-202, 208, 213, 272, 285, 287, *287*, 295, *295*
Graphic Arts Center *222*
Graphis 21
Greater London Council 59
greetings booklets *280-1*
Greif, Gene *177*
Gropius, Walter 56
Gross, Bob *122*
Grover Printing *137*
Guaranccia, Steven *53*
Guardian *141*, 254-9, *254-9*
Guedes, Pedro *288*

H
Haas, Richard *279*
Hair, Mr and Mrs Aubrey *138*
Hankyu Corporation Group *233*
Hankyu International Hotel, Osaka *233*, 287
Harr, Bob *36*
Harrison, Peter *18*, 19, *19*, 20, *26*, *53*, *105*, *147*, *159*, *177*, *178*, *185*, *233*, *240*, 290, 297, *297*
Hartley, Jesse *146*
Hayward, Thomas *141*
Heck, Matt *170*
Hedrich, Jim *40*
Heffernan, Terry *20*, *185*, *222*
Hemispheres magazine *54*
Hendra, Tony *72*, 266
Herman Hospital *138*
Herron, Ron *19*
High Speed Train 42, *201*, 202
Hilbersheimer 56
Hillman, David 15, *18*, *19*, *91*, *96*, *102*, *104*, *125*, *146*, *149*, *156*, *159*, 160, *162*, *169*, 188, *190*, *194*, *195*, *206*, 242, *247*, 254-9, *256*, *262*, *287*, *288*, 294, *294*
Hilton Typographers *141*
Hines, Herman *31*
Hinrichs, Kit *20*, 21, 23, *31*, *33*, 48, *51*, *54*, *84*, *90*, *98*, 116, *121*, *122*, *169*, 174-7, *180*, *184*, *185*, *192*, *222*, *225*, *226*, *242*, *249*, *260*, *284*, *296*, *296*
Hinrichs, Linda *20*, 21, 22, *169*
Hirasuna, Delphine *284*
HMV 135
Hochbaum, Susan *105*, *177*, *240*
Hogarth, Paul *174*
Hollar, Wenceslaus *56*, 62
Holtom, Gerald 136
Holyfield, Evander *116-19*

Hope, Polly *112*
Hotel Arts *141*
hotels 230, *230-3*
Houghton-Mifflin *157*
Houston Museum of Fine Arts *244*
Houston Zoo *144*
How, Belle *222*, *226*
Hugo, Victor 67
Hulanicki, Barbara *17*
Huntley/Muir *153*, 155, *177*

I
IBM *39*, *40*, 46, *92*, 136, *176*, *179*, 198
Icograda 26
IDCNY (International Design Center, New York) *99*
Ideal-Standard *141*, *169*
'Ideas on Design' exhibition *90*
identity design 128-36, *128-41*
Igarashi, Tak 287
INAX Corporation 208, *208*
Information Resource Management magazine *104*
Infoworks *141*
Inigo Jones Theatre, London *59-61*, 63
Institute of Family Therapy *137*
International Design Conferences, Aspen *91*, 266
Internos Books *141*
Isamu Noguchi Garden Museum, Long Island City *248*
Ishizaka, Kazuyoshi 265

J
Jacobs, Jane 58
Jahn, Helmut *36*, *144*
James, Henry 101
Jay, Anthony 128
Johnson, Philip *39*
Jones, J. Christopher 110

K
Keillor, Garrison *151*, 155
Kellogg's 136
Kelly, Ben *170*
Kent State University *104*
Kenwood *35*, 42, *201*, *201*, 265
Key, Trevor *108*, *282*
Kidd, Chip 266
King, David *275*
King's College, London *138*
Kirkendall, Rick *214*
Kirkland, Douglas *204*
Klein, Leah *159*
Klein, Lou *276*
Klimowski, Andrzej *151*, 155
Klotnia, John *180*
Knapp, Peter *13*
Knoll Furniture *74*

Kodak 13, *13*, 42, 45, *198*, 201, 211
Kondo, Satoshi *147*
Kubota 287
Kurlansky, Mervyn 13, *14*, 15, *17*, 18, *19*, *46*, *104*, *108*, *146*, *147*, 166-70, *166*, *169*, *244*, *272*, *281*, *297*, *297*

L
Lacoste 135
Lambie-Nairn and Company *32*
Landa Pharmaceutical *137*
Latin American Arts Association *138*
Lawrence, Peter 265
le Tan, Pierre *151*, 155
Leeming, David 42
Leonardo da Vinci 110
letters, evolution of 66-9, *66-9*
Lewis, Tim *121*
Liddell, Ian *62*
Lindsley, Kathleen *147*
Lippincott & Margulies 20
Lloyd's of London *124*, *137*, *149*
Loewy, Raymond 135
logotypes 134-6, *137-41*
London Docklands Development Corporation *137*
London International Festival of Theatre *137*
London, Pentagram office *16*
Look magazine 20
Lowell, James Russell 222
Lucas Industries 128
Lund Humphries 272
Lutyens, Edwin *147*

M
McAusland, Randy 265
McConnell, John 15, *17*, *19*, 22, 23, *26*, *28-9*, 32, *32*, 33, *33*, *88*, *94*, 130-3, *147*, *149*, 150-5, 165, *204*, 210, *263*, 275-9, *280-1*, 297, *297*
Machiavelli, Niccolo 129
McNay, Michael 13-14
magazine design 188, *188-95*, *206*
Magritte, René *109*
Maguire Thomas *40*
Mailer, Norman *17*
Manasse, Etan 22, *162*, 252, *252*
Mandarin Books *159*
Mandarin Oriental Group *138*, *230*
Manhattan Records *107*
Manss, Thomas *26*
maps 46, *48*, *52-3*
Marcus, Carl 135
Margulies, Walter 129
Marks and Spencer 135
Marsh, James *228*
Matisse, Henri 101
Matter, Herbert *102*

300

Matthews Miller Dunbar *17*
Mau, Bruce *262*
Maugham, Somerset, *159*
Maverick, Samuel 134
Mavity & Gilmore *138*
MCI Communications *53*
Medina, Fernando *214*
Meggs, Philip *66*, 266
Mercedes-Benz 135
Mesa Grill restaurant, New York *236*
metaphors 72, *72, 82-7*
Metromedia *233*
Metropolitan Museum of Art,
 New York 252, *252*
Michelin 135
Mies van der Rohe, Ludwig 101
Milward Courier *198*
Mizono, Bob *116*
Moberly, Lewis *32*
Mobil Oil 134, *134*
Mohawk Paper Mills *228*
Montgomery Watson *174*
Moore, Marianne 100
Moran, Michael *157*
Morgan, Scott *178, 179*
Morse Diesel *40*
Mosgrove, Will *31*
Muir, Donna *16*
Muller-Brockmann, Josef 266
Munro, Nicholas 221
Murakami, Piper *48*, 225
Museum *138*
Museum of Contemporary Art,
 Chicago *141*
Museum of Contemporary Art,
 Los Angeles *249*
Museum of Contemporary Art,
 San Diego *138*
Museum of Modern Art, Oxford *108,
 138, 146, 244*
museums 242, *242-53*
Mustafa, Ahmed *206*

N
Nakanishi, Motoo 208
Napoli Foundation *94*
Narr, Jon *17*
National Book League *141*
National Grid Company 130-3, *130-3,
 138*
National Medical Enterprises *121*
National Portrait Gallery *72*
Nature Company, The *138, 169*
Needle Industries 201
Nelson, George *18*, 19
Neumann & Bogdonoff *160*
New Order 22, *91, 108, 170*
New York Art Directors Club *262*

New York City Economic Development
 Agencies *138*
New York, Pentagram office 19-21, *19,
 22*
New York State Council for the Arts *96*
Newark, Quentin *142, 145, 159*
Newell & Sorrell *32*
newspaper design 254-59, *254-59*
Nikolai, Alwin 100
Nissan *137*
NMB Headquarters *112*, 115
Noguchi, Isamu *248*
Nonsuch Films *138*
Norcen *48*
Norwest Center, Minneapolis *147*
Nova magazine 18

O
Oehler, Justus *132-3, 204*
Ogilvy, David 69
Ogilvy and Mather 206
Olins, Wally 128-9
One Works *137*
Öola *165, 173*
Orchestral Manoeuvres in the Dark *170*
Orchid Company *137*
Oriental Hotel, Singapore *230*
Orrell, John *56, 62*
Osaka Gas Company 287
Osborne, John 12
OUN 287, *287*
Overacre, Gary *222*

P
P magazine *194*
Pacific Design Center *141*
packaging 166-70, *166-73*
Palladio, Andrea *106*
Pantone *170*
PAOS Inc 208
Paragon Group *144*
Parallax Theater, Chicago *74, 141*
Parker, Tim *35*
Parker pens 42
parody 102, *103-9*
Parthenogenesis *137*
Partners, The *32*
patrons 198-2
Payot *138*, 154-5, *154*
Pearce, Lippa *32*
Pelli, Cesar *147*
Penguin Books 135, *135*, 153, 154
Pentagram calendar *26, 186*
Pentagram Library monographs 272,
 272
Pentagram Papers 19, 26, 272, 275-9,
 275-9
Pentagram Prize *21*
Pentaspeak 272, *272*

Perez, Vincent *121*
Perkins, Tom *250*
Persimmon Books *137*
Peter Joseph Gallery, New York *244*
Peterson, Donald 265
Pfister, Charles *240*
Phaidon Press *159*
Picasso, Don *222*
Pinter, Harold 155
Pirelli calendars 13
Pirtle, Woody *21*, 22, 23, 72, *72, 74,
 81-3, 88, 98, 102, 109, 166, 170,
 179, 180, 185, 223, 228, 241, 248,
 262, 263, 266*, 294, *294*
Pitt, Dr *42*, 201
Platignum 42, *42*
Plaza Centre, Rotterdam 115, *115*
Plessey 42-5, *45*
Polaroid Corporation 22, *194*, 210-14,
 210-15, 262
Pollock, Ian 155
Ponti, Gio 59
Ponty, Max *108*
portraits 290, *290-7*
Potlatch Corporation *180*
Powner, John *269*
Poynor, Rick 22
Prentiss Properties *39*
Preservation Policy Group 58
Prestel *141*
Preston, Peter 258
Princeton University Press *157*
Pritzka, Burton *178*
Procter and Gamble 136
product design 42-5, *42-5*, 110-11, *285,
 287*
publishing 150-5, *150-9*, 272, *272-81*
puns 72, *72, 74-81*

Q
Quant, Mary 12
Queen's Birthday Committee *141*

R
Radford, Diane *216*
Radford & Ball *141, 221*
Radio Ranch *138*
Ragazzini, Enzo *250*
Rain Forest *169*
Rand, Paul 69, 134
Random Century *156*
Rank Xerox 13
RCA 135
Renner, Paul 206
restaurants 234, *234-41*
Reuters 13, *46*
Richter, Charles *84*
Rigsby, Lana *39*
Riney, Hal and Partners *116*

Robert, François *279*
Robert, Jean 26, *276*
Robertson's 136
Robinson, Barry *122, 222, 242*
Roche 13
Rockefeller Foundation *180*
Rogers, Ernesto 59
Rogers, Richard *124, 149*
Rolex 135-6
Rolls-Royce 134, *134*
Romarte *138*
Rosehaugh Stanhope Developments
 149
Roth, Philip *157*
Royal College of Nursing *138*
Royal Viking Line *31, 51, 178*
Rushworth, John 22, 72, *87, 88, 149,
 169, 194*, 210-14, *210, 214, 214,
 250, 262, 269, 269, 281, 282, 297,
 297*
Russell, Bertrand 100

S
Samuelson, Arthur 135
San Francisco Museum of Modern Art
 242
San Francisco, Pentagram office 21, 23
Santa Barbara Museum *242*
Santer, Johan *45*
Saudia 136, *136*
Saunders, Norman 42, 201-2
Saville, Peter 22, *22, 78, 91, 108, 170,
 247, 282, 295, 295*
Scher, Paula 22, *23, 53, 54, 72, 102,
 102, 104, 107, 157, 165, 169, 170,
 224-6, 262, 263, 266, 282, 284, 296,
 296*
School of Visual Arts, New York *137,
 263*
Schwab, Michael *174*
Science Management Corporation *138*
Scott, Sir Giles Gilbert 62
Scottish Trade Centre *138*
Seaburgh, Max *48*
SEITA *108*
Selby, Ralph *207*
Serv-Tech *180*
Shakery, Neil *20*, 21, *116, 156, 178,
 204, 265, 295, 295*
Shell Oil 135, 136, *279*
Shilla Hotel *138*
Shiseido *166, 169*
shop design 160, *160-5*
Shoshin Society *79*
ShowerAge 285, *285*
Sign Design Partnership *138*
sign design 142, *142-9*
Silverstein, Donald *14*

Simon & Schuster *157, 288*
Simpson Paper Company *84, 138, 225, 226-7*
Sims, Jim *40, 180*
Sindall, Bernard *115, 221*
Skald magazine *31, 51*
Skidmore Owings and Merrill *149*
Skvorecky, Josef *151*
Slavin, Neal *159*
So, Meilo *153*, 155
Society of Industrial Artists and Designers *138*
Socrates 128
Solaglas *137*
Solana *40*
SOS Kinderdorf *87*
Spaghetti Recordings *141*
Stahl, David *31*
Stanford Conference on Design *265*
Stanford Design Forum 265
Stanislavski, Konstantin 100
Stansted Airport *145*
STC (Standard Telephone & Cables) *141*
Steinberg, Saul *49*
Stevenson, Dave *84*
Stirling, James *146, 266*
Stockley Park *149*
storytelling 116, *116-21*
Stratos Company *141*
Streetscape *141*
Stuart, David *147*
Summers, Mark *178*
Suntory Corporation 287
Sussman, Deborah 266
Swatch *102*
Swindell, Jo *146, 194, 247, 259*
Swissair 136
Sykes, Charles *134*
symbols 134-6, *137-41*
System 1 *141*

T
Tactics (toiletries) *166*
Takasagoden *204*
Tate Gallery, Liverpool *146*
Tate Gallery, London *138, 146, 247*
Teknowledge *141*
Terry, Quinlan *279*
TGI Friday restaurants *238, 241*
Thompson, Philip *275*
Tofler, Alvin 101
Towndrow, Jenny 16-17
Tracy, Tom *31, 180, 284*
trademarks 134-6, *134-41*
Traeger, Tessa, *156*
Travis Construction *138*
Trendy (toiletries) *169*
Treskow, Irene von *153*, 155

Trevi *141*
Trinity College of Music *138*
Tschichold, Jan *135*
Tsuchiya, Susan *51, 122, 242*
Tufte, Edward 46
Turnbull, Sara Little 265
Tutuola, Amos 155
'21' Club, New York *238, 240*

U
Unilever House, London 216-21, *216-21*
United Airlines *54*
University of California, Los Angeles *82-3*
Unwin, Raymond 56
Updike, John 165

V
Valicenti, Rick 266
Vargas Llosa, Mario *151*
Veldhuyzen van Zanten, Victor *124*
Victoria & Albert Museum, London *141, 142*
Vignelli, Massimo 266, 287
Vikander, Brian *31*
Vine, Terry *249*
Vines, Tony 206
Viscom *138*
Volvo 135

W
Wakefield Fortune *162*
Wallace, Robert *33*
Wanamaker, Sam 62
Warhol, Andy 165
Warner Communications *177*
Watneys *88*
Watson-Guptill publishers 272
Watts, David 259
Websters pubs *147*
Westwood, Vivienne 101
Whitbread brewery *149*
Whitechapel Gallery, London *247*
Whitehurst, Bill *82*
Wickens, Brett *247*
Wilcox, David *46*
Wilkinson Sword *42*
Williams, Lowell 23, 36, *46, 77, 144, 174, 180, 244, 249*, 294, *294*
Wittkower, Rudolf 60
WNYC radio station *141*
Wolf, Henry 18
Wood, Kenneth 42, 201
Wood & Wood *130*
Woods Litho *116*
Workhouse *32*
World Heavyweight Championship *116-19*

Wormell, Christopher *153*
Wright, Frank Lloyd *84*

Y
Yamamoto, Yohji *78*
Young, Edward 135

Z
Zeitgeist 102
Zumpano Studios *138*